Josephine Foard
and the Glazed Pottery
of Laguna Pueblo

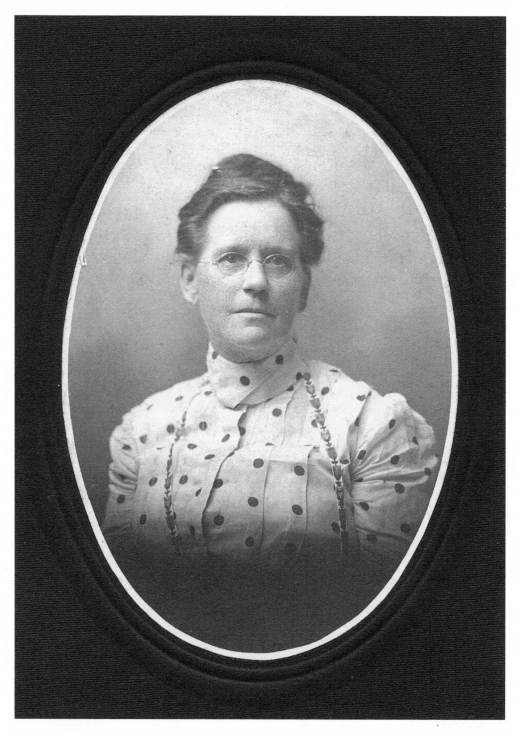

Josephine Jefferson Foard (1843–1918). Photograph by G. W. Keene, ca. 1900. Photograph courtesy of the School for Advanced Research, Santa Fe, gift of Mrs. Millicent Berghaus.

Josephine Foard

and the GLAZED POTTERY
of LAGUNA PUEBLO

Dwight P. Lanmon,
Lorraine Welling Lanmon,
and Dominique Coulet du Gard

University of New Mexico Press
ALBUQUERQUE

© 2007 by University of New Mexico Press
All rights reserved. Published 2007
Printed in the United States of America

13 12 11 10 09 08 07 1 2 3 4 5 6 7

Library of Congress Cataloging-in-Publication Data

Lanmon, Dwight P.
 Josephine Foard and the glazed pottery of Laguna Pueblo / Dwight P. Lanmon, Lorraine Welling
Lanmon, Dominique Coulet du Gard. — 1st ed.
 p. cm.
 Includes bibliographical references and index.
 ISBN 978-0-8263-4307-9 (cloth : alk. paper)
 1. Foard, Josephine, 1843–1918. 2. Potters—United States—Biography. 3. Pueblo pottery—Pueblo of
Laguna, New Mexico. 4. Pueblo pottery—New Mexico—Acoma. 5. Pueblo Indians—History.
6. Pueblo of Laguna, New Mexico—History. 7. Acoma (N.M.)—History. I. Lanmon, Lorraine
Welling, 1932– II. Western, Dominique Coulet. III. Title.
 NK4210.F56L36 2007
 738.3089'974078991—dc22

 2007020019

Book design and composition by Damien Shay
Body type is Minion 9.5/13
Display is Adastra Royal and Aldus

CONTENTS

FOREWORD

I n 1899 a remarkable woman, Josephine Jefferson Foard, moved at the age of fifty-six from the East Coast to Laguna Pueblo in New Mexico. On an unusual personal mission—to show Pueblo women how to "improve" their pottery—she moved to Laguna, built her own house and a pottery kiln there, and worked with the potters. Sponsored in part by the federal government and an Indian assistance league in Boston, she attracted public attention in the East at the time, but since her death in 1918 her name and work have been largely lost to history.

We learned about Miss Foard through collecting and studying historic Pueblo pottery. While living in Winterthur, Delaware, we saw an exhibition of Pueblo pottery at the University Gallery of the University of Delaware in 1993. Pottery from Ácoma and Laguna Pueblos was featured in the display, but we were surprised to see that several of the pieces were glazed on the interior (plates 1 and 6).

The collection had been transferred to the gallery in 1978, where it was recorded as the Josephine Foard Collection.[1] Dr. Belena Chapp, gallery director, gave us the names of Dr. Dominique Coulet du Gard and Dr. E. D. Bryan, MD, of Dover, Delaware, who had researched Miss Foard. They generously shared the results of their research, which further illuminated the Foard story, and also offered to contact Foard descendants for us, to see whether they had additional information on Miss Foard and her work. (Dr. Coulet du Gard contributed to this book the discussions of Miss Foard's ancestors and early life in Delaware, some of the information on her later life in Colorado, and her death in New Jersey.)

About a year after seeing the glazed pottery in Delaware, we traveled to Santa Fe on our annual trek and made rounds of the dealers' shops. We saw a water jar with elaborate geometric decoration in the gallery of Will Channing; it was from Ácoma or Laguna Pueblo and dated about 1900. Surprisingly, it was much heavier than we expected, and we were interested to see that it had a glossy coating on the inside.

At first glance, the coating looked like yellowed varnish. Collectors and others have sometimes coated Pueblo water jars with varnish on their exteriors, not to make them waterproof, but to counteract the decoration-muting effect of white mineral residues on their surfaces resulting from their use in Pueblo homes for storing water. The coating on Will's jar, however, was apparently added to waterproof it; it was on the jar's interior and harder than varnish, not unlike those we had seen in Delaware. We asked for a photograph, thinking that if we found more examples of Miss Foard's glazed pottery her story would make an interesting article, since none of the dealers or collectors we talked to knew about Foard or were able to explain the glazing.

The next example of Miss Foard's glazed pottery we saw turned up in 1998. It was an elegantly decorated small Hopi jar described in an auction catalog as being "covered with a thick,

clear varnish" on the inside (plate 5). Aside from the glaze, it was noteworthy that the jar had a paper label from the Indian Industries League in Boston on the bottom—the first example we found bearing the league's label. Seven years later, collector/dealer Richard M. Howard generously gave us a glazed jar with a similar label. (It is shown in plate 3.) These two pieces document the fact that Miss Foard sent some of her glazed pueblo pottery to Boston for sale.

The label led us to the Massachusetts Historical Society in Boston, where we found detailed records of the Indian Industries League concerning its members' efforts to aid Indians financially throughout the country by encouraging their production of crafts and then marketing the products in the East. Later, we found Erik Trump's comprehensive dissertation on the league and its programs, including mention of Miss Foard's work.[2]

In 1999, we moved to Santa Fe and found additional examples of Miss Foard's glazed pottery in the collection of the Indian Arts Research Center at the School of American Research (now School for Advanced Research). We wrote an article on Foard and her pottery and submitted it to *American Indian Art Magazine* in 2001; it was published the following year.[3] Since then, we have seen several more specimens of Miss Foard's glazed pottery.

Fortuitously, as we were reviewing the edited manuscript for the article, we received a letter from Millicent E. Norcross Berghaus (Mrs. John E. W. Berghaus), a grand-niece-in-law of Miss Foard.[4] Dr. Bryan had contacted her when we initially asked to be in touch with descendants, but because of family illness she was unable to write to us then about the treasures she had. She enclosed photocopies of a few pages of letters Miss Foard had written to her younger sister Louisa Foard Berghaus and others from New Mexico between April 9, 1899, and April 24, 1900. She later kindly provided the results of her considerable genealogical research into the Foard and Berghaus families to the authors.

Mrs. Berghaus offered to send us photocopies of all the letters, but by coincidence a trip to the East was scheduled a week later so we were able to examine the letters in person. In addition to the letters, we were delighted to find that Mrs. Berghaus also had an album containing fifty-four photographs Miss Foard had either taken or acquired in New Mexico.[5]

In her letters we read about Josephine Foard's intense interest in showing Laguna potters how to improve their pottery by strengthening it and waterproofing it with glaze, and also marketing it in the East. She did not go to the Southwest as a tourist, nor was she seeking to document the ethnology of the Indians or to be a "do-good" reformer. She went to improve and market Pueblo pottery for the Lagunas' economic benefit.

Miss Foard's letters document her pleasure in the experiences she was having, but they also expose her biases and preconceptions about Indians and Mexicans (attitudes many easterners shared at that time). She records her delight and dismay with appearances, personalities, customs, and beliefs, often with admiration, but occasionally with disdain. They also document how her opinions changed as she lived and worked among the Lagunas and formed friendships with the people.

The letters Mrs. Berghaus shared with us are actually transcriptions Miss Foard herself made of thirty-two long letters in which she recorded her life at Laguna Pueblo. They total 233 pages (plus several fragments) in length, and the letters and pages are numbered sequentially. (They are transcribed verbatim in appendix 1.) Foard titled her correspondence "Letters from Among the Lagunas," and it seems likely she intended to publish them, judging by her editing of them and by a comment she made:

I hope that you may not tire of the details of my long letters. I am selfish enough to write more than I otherwise would because I keep no notes and I expect to cull reminiscences, when I get home, from what I write you and others. I fear that sometimes I forget that I am writing letters and go on as though I were simply writing for myself....[6]

Miss Foard records many fascinating experiences in New Mexico that we do not discuss. We knew we could not extract every interesting tidbit of information about her experiences from her correspondence and did not wish to do so. Instead, we urge the reader to turn to appendixes 1 and 2 to gain the flavor of her narrative and the range of her experiences. These include (in appendix 1), to mention just a few:

- Santa Fe: Miss Foard describes the region, city, and people in 1899 (letters 1–4).
- Traveling by train: Including comments on passengers and a confrontation with members of an agnostic society (letter 1).
- Indian stereotypes: Miss Foard comments on the inaccuracy of whites' widely held stereotypes of Indians—and the differences between them and the Anglos whom she observes at Laguna (letters 19 and 23).
- The Penitentes: She comes into contact with members of the Los Hermanos Penitentes, whose beliefs and practices harkened back to the time of the Spanish Inquisition, and comments on their practices (letters 6 and 14).[7]
- Pueblo dances: Miss Foard witnesses several social and ceremonial dances and events at Laguna, Ácoma, and Isleta Pueblos during her first year in the Southwest. These include a Christmas dance (letter 27); a Doll Dance, in which flat Pueblo dolls are described, the earliest such description known to the authors (letters 5 and 14); children dancing (letter 27); a Comanche Dance (letter 27); and a healing ceremonial (letter 30), all at Laguna. She also attends and records details of a "Gio" [Gallo] race on the annual feast day of San Juan at Isleta Pueblo (letter 16).
- Ácoma Pueblo: Miss Foard visits Ácoma Pueblo during her first year in New Mexico and records her impressions and experiences. On the way there, she describes seeing the famous landmark called the Enchanted Mesa, known to the Indians as Katsímo and to the Spanish as la Mesa Encantada, and relates stories about the ascents by (and controversies about) Prof. William Libbey of Princeton and Prof. F. W. Hodge of the Smithsonian (letter 23). She climbs the precarious stone stairway to Ácoma (letter 23) and relates stories she hears about the Spaniards (letter 30). She also attends and describes the St. Stephen's Day ceremonials and the harvest dance (letter 23).
- Sebolleta (Seboyeta): Foard visits the old village of "Sebolleta" (Seboyeta) near Laguna and describes the people, the village, and a nearby cave-shrine (letters 15 and 16).

Just as we were completing a draft of the manuscript for this book, we experienced another fortuitous coincidence. We attended a lecture by Dr. Elizabeth Hutchinson of Barnard College. She was a research fellow at the Georgia O'Keeffe Museum Research Center in Santa Fe and lectured

on women in the East who studied, collected, and supported the preservation of Indian crafts in the early 1900s. After the lecture, we asked Dr. Hutchinson if she had ever heard of Josephine Foard. To our amazement and delight, she said that not only did she know about her work, but had also written a paper about her, based on correspondence that she had discovered between Foard and the commissioners of Indian Affairs between 1900 and 1908. Later, she generously shared her detailed list of that correspondence. Those letters reveal more of the story of Miss Foard's work following the year covered by her "Letters from Among the Lagunas." The text of that correspondence is transcribed in appendix 2.

A third extraordinary coincidence occurred in 2007, just two weeks before we reviewed the edited text for the book. We received an e-mail from Tilly Laskey, curator of ethnology at the Science Museum of Minnesota in St. Paul, informing us that the museum owned fourteen glazed vessels associated with Miss Foard. Seven are inscribed with potters' names (one is indecipherable); three of the names are hitherto unrecorded. Five of the vessels have paper labels: three of the Indian Industries League in Boston and another of an unidentified exhibition. Two have incised letters, perhaps the initials of the makers. In addition, there are two jars from Hopi, one of which may be attributed to Nampeyo, the famous potter of Hano (plate 4). Fortunately, the timing of the e-mail was perfect, and we were able to add this important new information to the text and illustrate six of the vessels.

After reading Miss Foard's letters, we concluded that they are unique documents of historical importance that give insights not only into her life and work but also into the lives of the people of Laguna Pueblo. That conclusion led to this book, which includes the text of the Foard letters in full, in addition to many of her photographs. In the chapters that follow we introduce Laguna's historical culture and expand upon Josephine Foard's milieu while she was living and working in New Mexico. We include excerpts from her letters and from articles about her that give insights into her goals for the project and her experiences with Laguna people, in addition to conveying the knowledge and biases she brought to her work in the Southwest.

It is our intent to pay homage to the work and words of this vigorous, dedicated woman. We hope her story will be of interest—and even more examples of her work identified.

Dwight P. Lanmon and Lorraine Welling Lanmon
Santa Fe, New Mexico
2006

ACKNOWLEDGMENTS

We offer special thanks to Millicent E. Norcross Berghaus, Dr. E. D. Bryan, MD, and Dr. Elizabeth West Hutchinson for their assistance. Without their interest and help the book would not be what it is.

We are also grateful to the following for their generous contributions in support of this book: Adobe Gallery, Robert and Cynthia Gallegos, Jim and Jeanne Manning, Ann Matey and Don Frodge, the Santa Fe Art Foundation and the Gerald and Kathleen Peters Family Fund, Martha H. Struever, the Dewey family, and two donors who wish to remain anonymous.

The authors are also indebted to the following for their assistance: Duane Anderson; Al Anthony; Arizona State Museum: Diane Dittemore; Robert Bauver; George Blitz; W. Scott Braznell; Dr. J. J. Brody; Cecil County Historical Society, Elkton, Maryland; Center for Southwest Research, University Libraries, University of New Mexico, Albuquerque; Will Channing; Martin Chasin; Colorado Historical Society, Denver; Cumberland County Historical Society, Carlisle, Pennsylvania: Kathryn G. Beaty; Delaware Public Archives, Dover: Joanne A. Mattern; Delaware State Museum, Dover: Ann Baker Horsey, Claudia Leister; Denver Public Library; Historical Society of Delaware, Wilmington: Dr. Barbara Benson and staff members; Steve Elmore; Historical Society of Pennsylvania, Philadelphia: Dan Rolf; Richard M. Howard; Bruce van Landingham; Maryland State Archives, Annapolis; Massachusetts Historical Society, Boston; Ann Matey and Don Frodge; John Molloy, Spanish and Indian Trading Company, Santa Fe; Museum of Indian Arts and Culture/Laboratory of Anthropology, Santa Fe: Mara Yarbrough, Minnie Murray; National Archives and Records Administration, Washington, DC: Mary Frances Morrow; New Jersey State Bureau of Vital Statistics, Trenton; New Mexico State Library, Santa Fe: Joanne Jager, Guadalupe Martínez, Al Regensberg; Nicklason Research Associates: Mark Leutbecker; Photo Archives, Palace of the Governors, Museum of New Mexico, Santa Fe: Daniel Kosharek, Cary McStay; Pueblo of Laguna: Robert Mooney Sr., Elizabeth Wacondo; Royal Society of Arts, London: Lara Webb; School for Advanced Research, Santa Fe: Jennifer Day, Laura Holt, Daniel Kurnit, Len Leschander, Carolyn McArthur, Shannon Parker, Kathleen Whitaker, Deborah Dodge Winton; Science Museum of Minnesota, St. Paul: Kate Larson, Tilly Laskey; Skinner, Inc., Boston and Bolton, Massachusetts: Douglas Diehl, Anne Trodella; Southwest Museum, Los Angeles; University of Arizona, Tucson: Alan Ferg, Nancy Parezo; University of Delaware, University Museums, Newark: Janet Broske, Jean K. Brown, Belena Chapp; Wheelwright Museum of the American Indian, Santa Fe: Jonathan Batkin, Willow Roberts Powers; Dwight E. Williams; Ken Zintak; and another who wishes to remain anonymous.

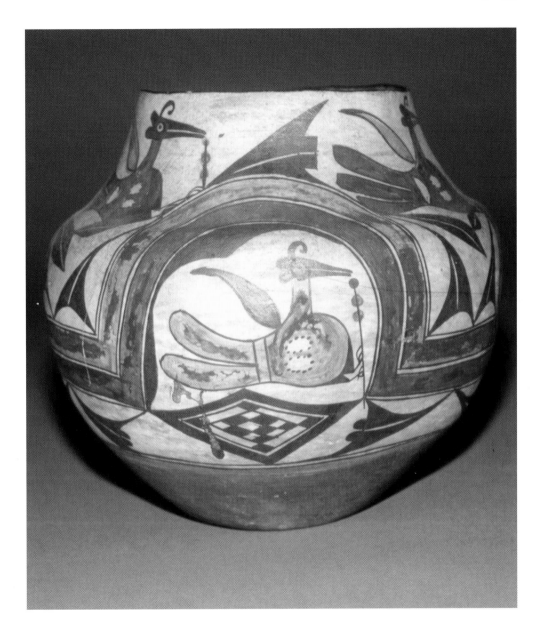

Plate 1. Jar with interior glaze, Ácoma or Laguna Pueblo, ca. 1900. University of Delaware,
 University Museums (University Gallery), Josephine Foard Collection (78.13.41).
 25 cm. x 24 cm. Photograph by Dwight Lanmon.

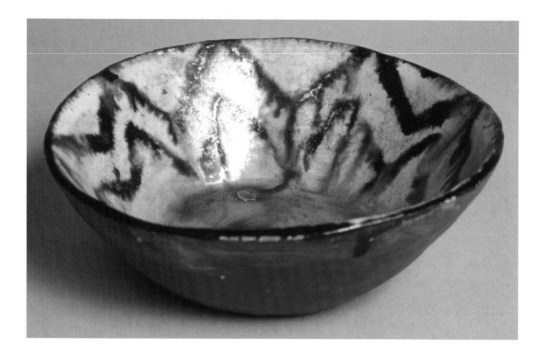

Plate 2. Small bowl with interior glaze, Ácoma or Laguna Pueblo, ca. 1900. Indian Arts Research
Center, School for Advanced Research, Santa Fe (IAF.2319). 4.4 cm. x 12.7 cm.
Photograph by Dwight Lanmon.

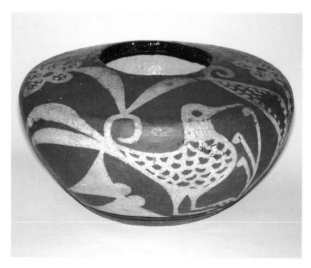
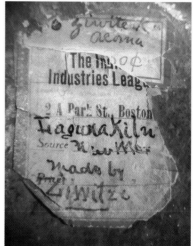

Plate 3. Small jar with interior glaze, Ácoma Pueblo, ca. 1908–9, made by Ziwite K. or Ziwitze.
Private collection; ex collection Richard M. Howard. 6.3 cm. x 12.4 cm.
Photographs by Dwight Lanmon.

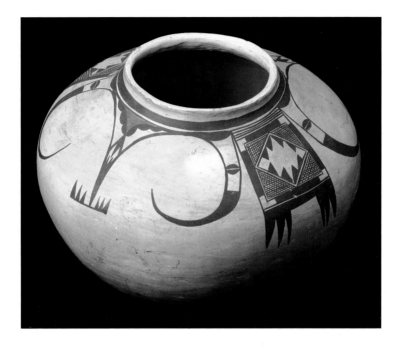

Plate 4. Jar with interior glaze, Hopi, ca. 1906–7, attributed to Nampeyo. Science Museum of
Minnesota, St. Paul, gift of Mrs. A. W. Trenholm, 1928 (1–126:153). 19.1 cm. x 25.4 cm.
Photograph by Craig Thiesen, courtesy of the Science Museum of Minnesota, St. Paul.

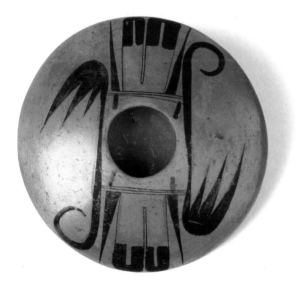

Plate 5. Small jar with interior glaze, Hopi, ca. 1906–7, made by Konike, Kowike, or Komike.
Private collection. 6 cm. x 21 cm. Photographs by Dwight Lanmon.

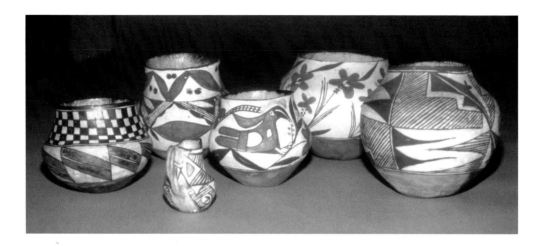

Plate 6. Five small jars and a creamer, all with interior glaze, Ácoma or Laguna Pueblo, ca. 1900.
University of Delaware, University Museums (University Gallery), Josephine Foard
Collection (left to right: 78.13.30, 78.13.31, 78.13.6, 78.13.5, 78.13.32, and 78.13.17). 10 cm. x 12 cm.;
14 cm. x 16 cm.; 7 cm. x 7.5 cm.; 11 cm. x 11 cm.; 14 cm. x 16 cm.; 15 cm. x 15 cm.
Photograph by Dwight Lanmon.

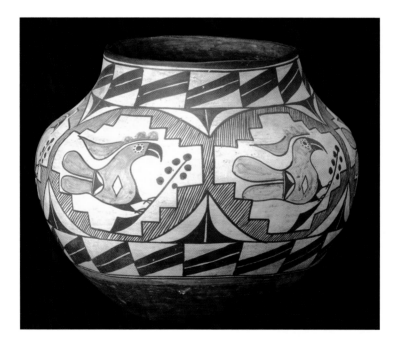

Plate 7. Jar with interior glaze, probably Ácoma Pueblo, ca. 1900–10, inscribed "K Juwateaya."
Science Museum of Minnesota, St. Paul, gift of Mrs. A. W. Trenholm, 1928 (1–128:153).
27.3 cm. x 33.0 cm. Photograph by Craig Thiesen, courtesy of the Science Museum of
Minnesota, St. Paul.

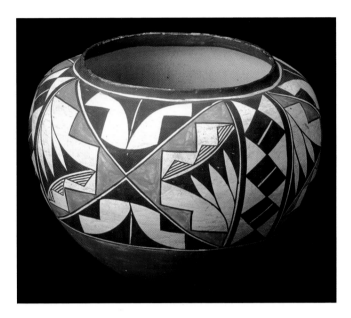

Plate 8. Jar with interior glaze, inscribed "Ocēcēta," probably Ácoma Pueblo, ca. 1900–10. Science Museum of Minnesota, St. Paul, gift of Mrs. A. W. Trenholm, 1928 (1–125:153). 19.7 cm. x 26.0cm. Photograph by Craig Thiesen, courtesy of the Science Museum of Minnesota, St. Paul.

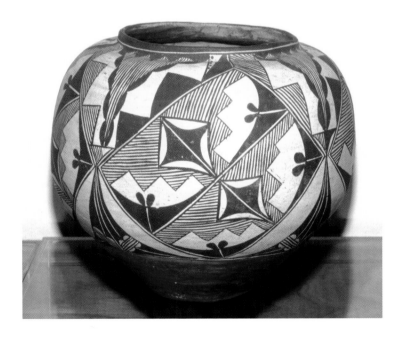

Plate 9. Jar with interior glaze, probably Ácoma Pueblo, ca. 1900–10, inscribed "Quea[ustea] / 18." Private collection. 24.1 cm. x 30.5 cm. Photograph by Dwight Lanmon.

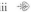

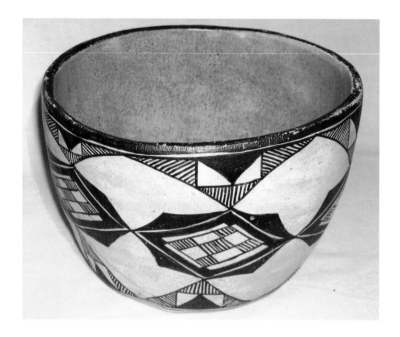

Plate 10. Bowl or jardinière with interior glaze, Ácoma or Laguna Pueblo, ca. 1900–10, inscribed
"Cookone." Collection of Ann Matey and Don Frodge. 14.6 cm. x 22.5 cm.
Photograph by Ann Matey.

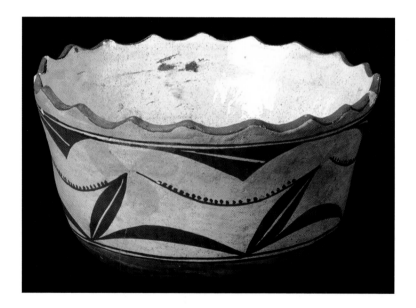

Plate 11. Bowl or jardinière with interior glaze, probably Ácoma Pueblo, ca. 1900–10, inscribed
"Queaustea / 18." Science Museum of Minnesota, St. Paul, gift of Mrs. A. W. Trenholm,
1928 (1–110:153). 12.7 cm. x 23.5 cm. Photograph by Craig Thiesen, courtesy of the Science
Museum of Minnesota, St. Paul.

Plate 12. Bowl or jardinière with interior glaze, Ácoma or Laguna Pueblo, ca. 1900–10, inscribed "Wa-Ki." Science Museum of Minnesota, St. Paul, gift of Mrs. A. W. Trenholm, 1928 (1–111:153). 17.1 cm. x 21.3 cm. Photograph by Craig Thiesen, courtesy of the Science Museum of Minnesota, St. Paul.

Plate 13. Bowl with interior glaze, possibly made by Josephine Foard at Laguna Pueblo and decorated by a potter at Ácoma Pueblo, ca. 1900–10, inscribed "Marie Iteye / #6." Collection of Mr. and Mrs. Bruce van Landingham. 11.0 cm. x 25.2 cm. Photograph by Dwight Lanmon.

Plate 14. Glazed tile, Laguna Pueblo, ca. 1906–11, made by Yamie Leeds. Indian Arts Research Center, School for Advanced Research, Santa Fe, gift of Yamie Z. Leeds, Seama, 1930 (IAF.1457). 15.2 cm. x 15.2 cm. Photograph by Dwight Lanmon.

Plate 15. Pouring vessel with interior and exterior glaze, probably Ácoma or Laguna Pueblo, probably ca. 1900–10. Science Museum of Minnesota, St. Paul, gift of Mrs. A. W. Trenholm, 1928 (1–115:153). 18.7 cm. x 20.3 cm. Photograph by Craig Thiesen, courtesy of the Science Museum of Minnesota, St. Paul.

Josephine Foard
and the Glazed Pottery
of Laguna Pueblo

CHAPTER ONE

A Woman on a Mission

I n the wake of the enunciation of the philosophy of Manifest Destiny, many people in America in the late 1800s became concerned about the future of Indian tribes throughout the country and devoted their lives to ensuring that their cultures did not vanish. Among those who labored to help the Indians sustain themselves was Josephine Jefferson Foard (1843–1918). By the time she reached her majority at the time of the Civil War, women were being encouraged to become educators, missionaries, charity workers, and agents for reform. By the end of the century, the female individualist had come of age.

Josephine Foard, part of that milieu, was among the avant-garde who went to the Southwest to work among the Indians, residing and working at Laguna Pueblo off and on for a period of a little more than a decade, beginning in 1899. Those who preceded her in the Southwest included female reformers and educators who worked at the Zuni and Santa Clara Pueblos from the late 1880s.[1] In addition there were the Bureau of Indian Affairs (BIA) field matrons, schoolteachers, at-large reformers, and missionaries' wives who had begun to work throughout the New Mexico Territory after 1890.[2] Unlike those women, however, Josephine Foard went west as an artist, potter, and entrepreneur.

Her mission and that of many others who became committed to the Indian cause permeated the country in the late 1800s. Like the Indian Industries League's (IIL) statement of purpose, she endeavored "to open individual opportunities of work, or of education to be used for self-support, to individual Indians. And to build up self-supporting industries in Indian communities."[3] She also emulated the ambition the Board of Indian Commissioners had for white women working in the Southwest:

> If it has fallen upon the women of a tribe, from time immemorial, to weave the blankets or plait the baskets or make the pottery, is not the field matron to show them, as "other household duties," more economical and more sanitary methods of doing this work, and better means of marketing their products?[4]

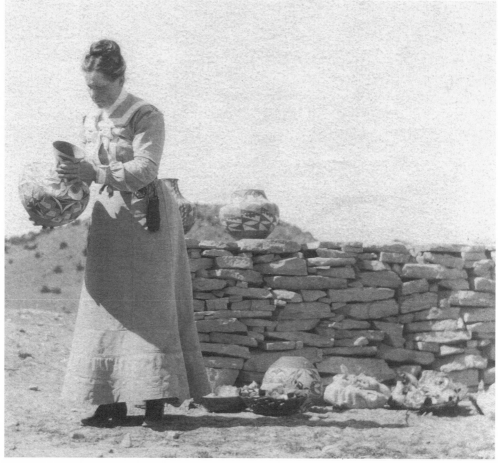

Figure 1. Josephine Foard examining Pueblo pottery at Laguna Pueblo, ca. 1902. A detail from this photograph was used as an illustration in an article in the *New York Herald*, January 27, 1907, where it was captioned "Miss Josephine Foard in charge of Indian pottery works." Photograph courtesy of the School for Advanced Research, Santa Fe, gift of Mrs. Millicent Berghaus.

Miss Foard's project reflected this common, yet contradictory, goal of many Indian-assistance groups at the time: preserving an ancient handcraft—in this case, pottery making—while simultaneously endeavoring to improve it by adopting industrial methods. She traveled to the Southwest specifically to work with the Laguna Pueblo Indians, where she intended to aid the potters by introducing improved firing methods that would strengthen the pottery, enhancing its usefulness by glazing it to make it waterproof, and developing markets for it in the eastern United States, thereby supplanting the focus on tourist items and ensuring that the potters would always be sure of sales of their products. Laguna potters were ambivalent about the worth and desirability of Miss Foard's project, because glazing negated one of the principal attributes of Pueblo pottery: the porosity of a jar cooled water through evaporation.[5]

While her focus was on improving the quality of Laguna pottery, Miss Foard also exhibited a vision that was unique among easterners who were intent upon preserving Indian crafts: she aimed at making Pueblo pottery *functional* in eastern urban settings, rather than merely serving as exotic decorations. In this regard she was unlike curio dealers and other people interested in promoting and preserving Indian crafts, but who never adapted the objects to Anglo household use.[6]

In addition to her work, Miss Foard enjoyed the life of a paid adventurer who benefited from experiences unavailable to her in the East: she intended to learn as much as she could about the Pueblo Indian culture—dances, religious ceremonies, food, clothing, and housing. In the last decades of her life, Josephine Foard transformed her interests and talents into a way of life and a philanthropic business that consumed her.

Miss Foard's Early Life

What prompted Josephine Foard to abandon a reasonably comfortable life in the East to venture two thousand miles across the United States, to undertake an uncertain mission at a rural pueblo village in the New Mexico Territory, alone, and at age fifty-six? The surviving documents tell part of the story, but we are left with many unanswered questions and must speculate about what motivated her to move to Laguna Pueblo. It must have been a great adventure; clearly, she did not exemplify the mid-nineteenth-century stereotype of a frail, delicate, passive, sedentary spinster. She was a woman dedicated to her mission—capable, independent, spunky, sensitive, compassionate, diplomatic, and not without a sense of humor—traits useful in coping with the new environment, people, and often difficult times of living and working at Laguna Pueblo.

Josephine Foard's upbringing and early life in rural Delaware help us begin to understand why she undertook this project. Just as she sought a new life in the American Southwest, so too had her ancestors sought a new life in America, settling before 1670 in what is now Cecil County on Maryland's eastern shore. Josephine's paternal grandmother, Ann Bayard Foard, was the daughter of Samuel Bayard, an extensive landholder in Cecil County. The Bayard family, lineal descendants of Czech émigré Augustine Herrman, had acquired the Herrman ancestral home and much of his original property; it was named Bohemia Manor and covered more than four thousand acres.[7] The Bayards of Delaware became prominent in state and federal political and commercial circles and philanthropic endeavors.[8]

Josephine's father, Edward Levi Lingen Foard (1813–65), was one of three sons of Anne Bayard and Levi G. Foard. He was described as "a young man, handsome in person and pleasing in his address. Like his brother Richard, he possessed the social qualifications for a successful politician."[9] Edward was listed in Cecil County tax records as purchasing and owning land in the Bohemia Manor area, farming it along with his father and two older brothers. Various wills and other records show that the family was financially comfortably situated.[10]

During the early and mid-1800s Edward remained on the family farm for a time and then became involved in a number of businesses in Delaware City, including a general store. Later he sold the businesses and returned to farming in Red Lion Hundred, near Delaware City. He also gained political appointments that enhanced the family's status and income.

Edward Foard married Mary Ann Jefferson Henry (1815–83) on November 26, 1837.[11] They had four children: Ann Bayard Foard (b. 1839), Richard Henry Foard (b. 1842), Josephine Jefferson Foard (b. November 23, 1843), and Louisa Clayton Foard (b. 1846).[12]

There are no known references to the earliest days of Josephine's life at Bohemia Manor, but it must have been a typical rural life of fairly well-to-do landed individuals with social connections to the most prominent families of the area. When she was age seven or younger, Josephine and her three siblings moved with their mother, but without their father, to Delaware City and lived on one of the properties her maternal uncle, John Jefferson Henry, owned.[13] It is probable that the mother and children were supported by Josephine's maternal grandfather, sea captain James Henry, or by her uncle, John, who owned property just south of Delaware City and was listed in the 1850, 1860, and 1870 censuses as a farmer. He was also a merchant, banker, and member of the prominent Henry family, owning a number of properties in Delaware City and Red Lion and Appoquinimink Hundreds in New Castle County. He also may have owned the brickyard across the road from his property. All this suggests financially comfortable circumstances for the family.

Delaware City, in New Castle County, Delaware, was a small but thriving port during the 1800s. Located a few miles south of Wilmington along the Delaware River and near the mouth of Delaware Bay, the town was at the eastern terminus of the Chesapeake and Delaware Canal that was completed in 1829. The city became an important stopping point for the busy maritime trade among Philadelphia, Wilmington, the Delaware and Chesapeake Bays, and other mid-Atlantic, Southern, and Gulf/Caribbean ports.

At age seventeen, Miss Foard was enumerated in the 1860 federal census in Delaware City, still living with uncle John and his family, while her mother and her younger sister Louisa had moved back to Maryland.[14] By 1864, Josephine's mother had moved to Missouri.[15]

In later years, Miss Foard reminisced about her early involvement in pottery in the Delaware City area. In a 1907 *New York Herald* article, she is quoted as saying that she had access to pottery while in Delaware (perhaps using clay from the brickyard across the street from her uncle's main property). She states that "it was this pottery work that saved my life...for I was going into a decline when my interest in clay working awoke, and with it my determination to live and keep on working."[16] Her depression may have resulted from her mother's and sister's move to Maryland around 1860, her father's death in 1865, the emotional effect of the Civil War on a southerner, or simply boredom.[17]

Little is known about Miss Foard between her young adult years in Delaware City and the 1890s, a significant number of years.[18] Allusions in her letters to Philadelphia and the Cumberland Valley in Pennsylvania place her in that region, however. During this time, she may have furthered her artistic abilities at one of the art schools in Philadelphia such as the School of Design for Women (now Moore College of Art), for she reported having taken lessons "in pottery in Philadelphia."[19]

The scant record offers us only the barest outlines of a fascinating person. Yet her distinction for us is that her interest in pottery was developed at an early age, and her interest in Indians had been kindled at least by the latter part of the century. Together, they were to motivate her later life's work at Laguna Pueblo.

Preparation

By the time she arrived in New Mexico in 1899, Josephine Foard had become acquainted with some of the problems she would confront and had assessed the potential for success of her ambitious

project. The northeastern region of the United States was a center for Indian-aid causes and organizations, and Miss Foard undoubtedly took advantage of opportunities to learn about Indians before she made the journey to the Southwest. For example, she said that "when there were conferences of the friends of the Indians to study ways and means of benefiting the original owners of the country, she would attend and contribute according to her means." These may have been the three-day Conferences of the Board of Indian Commissioners that began in 1883 at Lake Mohonk in upstate New York.[20]

In addition to the Lake Mohonk conferences, there were several organizations in the East that were devoted to Indian causes. She must have known about and perhaps attended the meetings of some of the national Indian-aid organizations that were formed in Philadelphia, including the Women's National Indian Association (WNIA). Founded in 1882 and active until 1951, the WNIA was one of the most effective reform groups in North America; it labored on behalf of Indian tribes, providing teachers, missionaries, and field matrons to various locations in the West.[21] In addition, there was the Indian Industries League in Boston, founded in 1893 and incorporated in 1899. It fostered opportunities of work for individual Indians and helped to build up self-supporting industries in Indian communities.[22] Curiously, the Indian Industries League and other Indian associations (such as the Massachusetts Indian Association) had contradictory aims. While endeavoring to preserve traditional Indian crafts, which thereby required preserving Indian tribal identities, they also worked to assimilate Indian women to Anglo ways, indeed to "uplift" Indian women to white, middle-class ideals—thereby diminishing traditional Indian cultural values and inevitably undermining tribal authority.

Miss Foard also may have visited and studied major exhibitions of Indian materials. The static exhibits of ethnographic material at the 1876 Centennial Fair in Philadelphia, staged twenty-three years before she traveled to the Southwest, probably had little or no effect on her plans for later life, but the World's Columbian Exposition in Chicago, which opened just six years before she departed for New Mexico, may have played an influential role in her developing plans. She does not mention visiting the exposition in her letters, but she perhaps implies it in a letter written shortly after June 15, 1899, saying that she had visited Deer [she spelled it "Dear"] Park, Illinois, a Chicago suburb located about thirty miles northwest of the center of the city. She said that she was there "long years ago and I thought it was a great event in my life...."[23]

At the exposition, she would have seen the Midway Plaisance (the honky-tonk sector), where the white American view of the nonwhite world was portrayed simultaneously as barbarian and childlike, and where the current evolutionary theory of the "progress" of race, from savage to barbarian to civilized, was espoused.[24] The displays included replicas of pueblo villages (with houses made of plaster) to represent the conditions in which the people lived. Indians were brought to the exposition to demonstrate their life-styles and make crafts, which were sold to visitors.[25] A model school for Indian children was constructed as evidence of the important role of education in "civilizing" Indians. The first Indian children to occupy the school and allied facilities were mostly Pueblo children who were brought from the Albuquerque Indian School and stayed in Chicago for more than a month.[26] The Indian commissioner, Thomas J. Morgan, declared that the Indian village scenes and school would demonstrate to visitors "the efforts of the Government for the bringing of them into civilized life concretely presented."[27]

The displays of artifacts in the Anthropological Building, which the heads of the Smithsonian and Harvard's Peabody Museum organized, were more varied in format than those in Philadelphia

in 1876 and were also designed to educate visitors about Indian life and culture. They showed objects that the Indians made and used and included realistic mannequins dressed in native clothing and paraphernalia, representing several American Indian tribes.[28] There was also a scale model of Ácoma Pueblo in New Mexico.[29] In addition, a mock cliff dwelling, built into a huge rocklike structure, displayed ancient Puebloan artifacts collected in the Four Corners region, mainly by the Wetherills at Mesa Verde in Colorado.[30]

Frederick Ward Putnam, director of the Peabody Museum and head of the Department of Ethnology and Archaeology for the Chicago fair, intended the displays to be more than just a visual demonstration of how Indian tribes lived; he advanced a powerful message that would highlight the vast social changes that were overtaking the Indians of North America:

> What, then, is more appropriate, more essential, than to show in their natural conditions of life the different types of peoples who were here when Columbus was crossing the Atlantic Ocean and leading the way for the great wave of humanity that was soon spread over the continent and forced those unsuspecting peoples to give way to a mighty power, to resign their inherited rights, and take chances for existence under the laws governing a strange people?…These people, as great nations, have about vanished into history, and now is the last opportunity for the world to see them and to realize what their condition, their life, their customs, their arts were four centuries ago. The great lesson then will not be completed without their being present. Without them, the Exposition will have no base.[31]

The displays included objects collected during the late 1800s, a boom-time period for American ethnographic expeditions in the Southwest, which both the U.S. government and private individuals financed. Fearing that Pueblo cultures might soon die out or become corrupted by the influence of tourists, traders, missionaries, and settlers, the Smithsonian Institution's Bureau of Ethnology (later renamed the Bureau of American Ethnology [BAE]) and other eastern museums dispatched ethnologists to all the pueblos, beginning in 1879.[32] They were sent to record various aspects of Pueblo cultures, including religious beliefs and practices, and collect artifacts and religious paraphernalia in vast quantities. Much of what was retrieved was earthenware pottery, which Pueblo people had been producing for about fifteen hundred years before the ethnologists arrived.

Foard may have seen some of the Pueblo pottery collections at the Smithsonian, assembled for the BAE from 1879 to 1887, or at the Peabody Museum of Archaeology and Ethnology at Harvard University, where pottery was collected between 1886 and 1894 in an expedition Boston philanthropist Mary Hemenway financed. Or perhaps she saw collections resulting from expeditions financed by John Wanamaker (of Philadelphia department store fame) for the University of Pennsylvania Museum of Archaeology and Anthropology in Philadelphia or by George Heye for his Museum of the American Indian in New York City.[33] In addition, there were growing collections of Pueblo pottery at the American Museum of Natural History in New York City and the Field Columbian Museum in Chicago.

There was not, however, much published information on Pueblo pottery in the late 1800s. What did exist was mainly in the publications of the BAE, but those did not enjoy wide circulation (although they were available in some public libraries).[34] There were, though, numerous

books and articles published in the late 1800s that dealt with various aspects of Indian life. Miss Foard may have learned about Indian causes from several that appeared in the 1880s. Helen Hunt Jackson's letters to newspaper editors in 1879 and her later books brought the mistreatment of Indians to public attention.[35] Her social-protest publications, strong and effective pleas for Indian reform activities, may have helped motivate Miss Foard to devote the remainder of her life to helping the Pueblo Indians. In addition, the sensational book, *My Adventures in Zuñi*, which Frank Hamilton Cushing wrote about his experiences at that pueblo, was published as a monograph in 1882; it also appeared as a three-part serial in *Century Magazine* in 1882–83.[36]

For one interested in Indians, Foard likely also read some of the publications of Charles F. Lummis, one of the American Southwest's greatest promoters, who waged a "See America First" campaign. He wrote several books that included captivating descriptions of Pueblo country.[37] One in particular, *A Tramp Across the Continent*, published in 1892, enjoyed wide readership; in it, Lummis described a visit to Laguna at the time of Christmas dances in 1884.[38] (Lummis visited Laguna twenty-three more times between 1888 and 1913.[39]) He also edited the magazines *The Land of Sunshine* (beginning in 1895) and *Out West* (first published in 1903), in which he championed the American Indian and attacked the government's Indian policies. *The Land of Sunshine* had a huge circulation in the East, larger than *Harper's*, *Century*, *Scribner's*, *McClure's*, *Cosmopolitan*, and *Overland Monthly* combined.[40] Because it made sensational national news and brought attention to the Indian pueblos of New Mexico, Lummis's being shot at Isleta Pueblo in 1889 could hardly have been missed.[41]

Moreover, by 1880, interest in Indian crafts was widespread throughout America. The Arts and Crafts movement was in full swing; it emphasized the value of owning and using handmade, antimodern, "honest" furnishings, and Indian arts fitted comfortably into those interiors. Thus, it became fashionable to collect Native American art and display it in curio cabinets, "cozy corners," and especially in the grand rustic houses of the Adirondack mountain camps. Articles on Indian crafts were published in newspapers and magazines, where the objects were not only praised for their beauty and craftsmanship but also were touted as examples of "real American" arts and as important examples of traditional women's domestic roles. By 1899, when Foard arrived at Laguna, the idea of Indian crafts as desirable objets d'art, suitable to the Arts and Crafts movement's philosophy of design, had been well accepted throughout the country. Even so, Indian pottery vessels were typically viewed as decorative accessories. Miss Foard's aim was to transform them into utilitarian objects as well as attractive art—which no one before her had attempted.

Why Laguna Pueblo?

Many considerations probably influenced Miss Foard to decide to work among the Pueblo Indians, but where best to help was undoubtedly a complex question. She likely chose Laguna Pueblo for several reasons.

First, the quality of education and religious liberalism among the Lagunas was apt to have been a critical reason for her decision to settle there in preference to other pueblos. Miss Foard likely thought that the Lagunas would be more accepting of her "foreign" ways because of the "accomplishments" of Anglo missionaries at Laguna during the previous half century. Evidence of their success was the value Lagunas placed on Anglo education. As a result, many were fluent in English, probably more so than any other Pueblo tribe.

Second, Miss Foard knew that less and less pottery was being made at Laguna for use in Pueblo homes and that the pottery-making craft there was declining precipitously in quality. She may have read the 1890 summary report of Indians in the Southwest, where one of the reasons for the decline was explained—pottery was being displaced at Laguna (and at other pueblos) by manufactured wares:

> The people of Laguna are in some respects more advanced than the other Indians in the direction of household comforts, many of the families there having in use modern beds, chairs, and tables, but all of them, including the other Pueblos, have taken up with the modern tin coffeepot, teacups and saucers, plates, knives, forks, and spoons, and are adopting modern ways of cooking.[42]

Third, she was aware that Laguna Pueblo was a main stop on the Atchison, Topeka and Santa Fe Railway line (ATSF) but realized that was a mixed blessing. The railroad enabled convenient access to the amenities of Albuquerque and large cities farther to the east and west and provided a cost-effective and safe means of transport of her glazed pottery to markets in the East. At the same time, however, the easy access to tourists on the trains strongly motivated Laguna potters to produce small, inexpensive curios for the travelers, thereby inevitably contributing to a lesser aesthetic and technical quality. Around 1896, a person buying pottery at Laguna wrote that

> they make excellent pottery, which they sell to tourists when the day trains stop at the station. Even at night you will find them there. Ten years ago the writer bought some ollas there at night. Although artistically decorated and of graceful shape, and superior to some other potteries, it has not the compactness, coherence and ring of the Acoma pottery, where they have the knack of firing their ovens more successfully.[43]

Miss Foard commented that Laguna pottery "was very poor pottery: unglazed, not water-tight and so fragile that it often broke in the tourist's hand."[44]

Finally, some time before moving west, Miss Foard "travelled to different parts of the country, studying different kinds of clay, and the possibilities of each. During her trips she went into the Far Western States [the Southwest] and investigated the pottery made by the Indians."[45] Her trip undoubtedly took her to Laguna.

Basing her decision on these considerations, Miss Foard decided she could single-handedly reverse the deterioration of pottery-making skills at Laguna Pueblo. She conveyed her belief that conditions existed at Laguna for the successful development and growth of pottery making as an industry to the U.S. Commission on Indian Affairs in 1898 and 1899, which then awarded stipends to her to "go to Laguna, to build kilns, teach the Indians modern ways of work, and act as an agent for the distribution of their products."[46] Several people supported her project, including commissioners Sybil Carter and Albert K. Smiley (who was also treasurer of the Indian Industries League in Boston), in addition to other members of the Indian Industries League. With this backing, her own modest resources, and the support of the people who had initially suggested the venture, she moved west.

A few days after she arrived in New Mexico, Ford noted, "I wonder what curious life awaits me here and if it may be long? I shall make the most of it let it be long or short."[47] In the following

weeks and months, she was flooded with memorable experiences she related in her lengthy letters from the pueblo to her younger sister, Louisa, her nephew, Charles (Charlie) Berghaus, and others. Her letters reflect a toughness of mind and an adventuresome spirit necessary to the success of her project at Laguna. They inform the major portion of this volume.

CHAPTER TWO

Miss Foard in New Mexico

Josephine Foard had done a good deal of advance planning for her trip, probably through the auspices of the Episcopal Church, and perhaps with the aid of her brother-in-law, Rev. Valentine Hummel Berghaus. The day after her arrival in Santa Fe on April 7, 1899, she called on the rector of the Episcopal Church, the nearly ninety-year-old Reverend Gay, who had engaged a room for her at the Claire Hotel, located on the southwest corner of the historic Santa Fe Plaza.[1] Her travel plans also must have been conveyed to prominent citizens in Santa Fe, for on her second day the Hon. LeBaron Bradford Prince, former governor of the territory, called on her and introduced her to the historical rooms of the Governor's Palace. She said he told her "more than any one else could have done about Indians, their customs, and pottery," and showed her the collections of Indian curios and pottery there (figure 2).[2]

That evening, she attended a dinner at the Palace of the Governors, hosted by Secretary Wallace, the secretary of the territory (and former U.S. minister to Australia), and Mrs. Wallace and met other guests that included people from Chicago and Santa Fe, as well as the U.S. Indian agent. It was strange, she said, "to meet so much refinement in a mud house."[3] She reflected on the historical setting she was in and wondered at the changes that had occurred in the place throughout the centuries.[4]

During the evening, Mrs. Wallace accompanied Foard on another tour of the palace and showed her the "wide window sill (painted blue) on which Gen. [Lew] Wallace [who was not related to her tour guide] wrote much of *Ben Hur*; while standing there she read a letter written by Gen. Wallace, telling her what part of *Ben Hur* had been written in that room." Foard observed, "I never saw such a sill. It was as large as the floor of a small closet."[5]

Reverend Gay later accompanied her on a tour of important buildings in Santa Fe, where she was introduced to the people in charge. These included the Territorial Penitentiary (meeting with superintendent Colonel Bergman) and the Federal Building (meeting with General Hobart). At the Federal Building, she was startled to see a monument to Kit Carson, which the Grand Army of the Republic had erected, and admonished herself for not knowing her history better.[6]

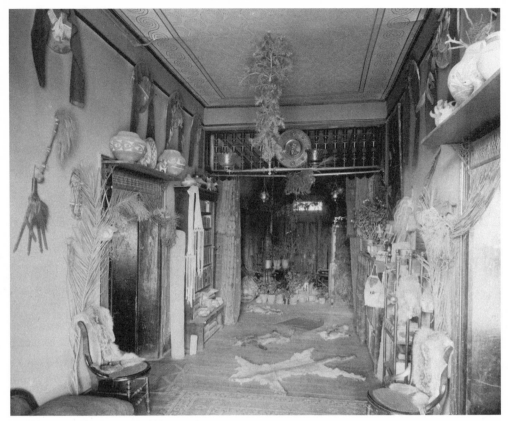

Figure 2. Interior hallway in the Palace of the Governors during the incumbency of Gov. LeBaron
Bradford Prince, February 14, 1893. Note the Pueblo pottery jars on the shelves
and the Pueblo shields above them, on the left and right sides of the hallway.
Photograph by Thomas J. Curran, courtesy of the Palace of the Governors, Santa Fe
(MNM/DCA), neg. no. 46776.

She also went to the oldest parts of Santa Fe, which she found to be a "jumble of adobe houses
with mere alleys for streets." When she visited the oldest church in Santa Fe, San Miguel, she said
it looked like an ancient mausoleum and dutifully recorded observations about its history, inte-
rior, and paintings, related to her by a "grey bearded, old Sexton."[7]

Miss Foard had also planned to visit the nearby pueblos of Santa Clara, San Juan, and San
Ildefonso because the Indians there "are said to make the best pottery in this neighborhood."[8]
Sadly, on arriving at Española by train, she learned that those villages were infected with smallpox
and closed to visitors. Greatly disappointed, she said there was nothing left to do but return to
Santa Fe and from there go to Laguna, where the village had been disinfected from a smallpox epi-
demic the year before.

On the train's return trip, Foard recorded her impressions of the landscape between Española
and Santa Fe. She found the valley's formation outwardly similar to that around an area she
knew—Chambersburg, Pennsylvania—but without the verdure, for there is "not a spray of grass

nor scarcely a tree."[9] Española, "with its scattered houses looks like a few brown beans, in a dish of pale soup.... When the Indians are about with their picturesque costumes, it looks like the same soup with a few small, red peppers and Mexican beans interspersed."[10]

The Indians, lounging in "blankets of reds, pinks, blues, browns, greys and greens," caught her approving eye.[11] She went on to say that "the greys that predominate it all are the soul of this won-derful day's ride."[12] She was not simply a romantic, though, luxuriating in the newness and strangeness of her different environment. Realistically, she also wrote:

> I do not see how man or beast lives on these rocks [and] sandy plains; but the wealth of
> history and natural science which confront us at every turn compensate for the sand
> storms and other privations [crossed out: inconveniences]. If I did not love geology
> and the picturesque part of these native Americans and adobe homes, combined with
> the greater interest I have in the object of my sojourn [her pottery project] I would not
> stay one minute.[13]

Frustrated in her attempt to visit the pueblos farther north along the Rio Grande, Miss Foard decided to visit Tesuque Pueblo, the nearest to Santa Fe.[14] George Dorsey, curator at the Field Columbian Museum in Chicago, wrote shortly after she was there that there were about a hundred inhabitants in Tesuque and added

> it may be easily reached from Santa Fé by a good road in a drive of one and one-half
> hours. Conveyance may be secured for the journey at three dollars for two
> people...this price including the services of a driver.... The journey to this pueblo
> is a favorite among tourists who visit Santa Fé and they generally return with some
> of the peculiar forms of pottery which have come to be specialties with the people
> of Tesuque. This pottery comprises little images, or so-called idols, and curious
> animal forms. Of these they make a great variety, and, as a rule, they may be had
> very cheap.[15]

Because Tesuque Pueblo was not on the railroad route, Miss Foard hired a carriage, driver, guide, and interpreter, (Hyman or David?) Lowitzky, who knew and "was on good terms with the Indians."[16] They forded the Tesuque River, which she dryly acknowledged to be no great accom-plishment; Governor Prince had mentioned it was "an insignificant affair dry some months of the year...."[17]

Although there was no smallpox at Tesuque, Foard said she was not too eager to visit because their pottery "is the least desirable."[18] Nevertheless, she climbed a ladder to a second-story room in the pueblo to see pottery and "bought a newly made idol; it is a clay doll and has its mouth open like a cat fishes [sic]. It is out of all proportion, its head being about four times larger than it should be. The hideous thing sets me laughing every time I see it. In the first place I was surprised to learn that they worship red idols"[19] (figure 3).

Miss Foard was ill informed about the purpose of these figurines, which eventually became known as rain gods. Pottery human and animal figures have a long tradition in the pueblos, but the ones she saw and bought were made exclusively for tourists and curio traders and had no reli-gious significance.[20]

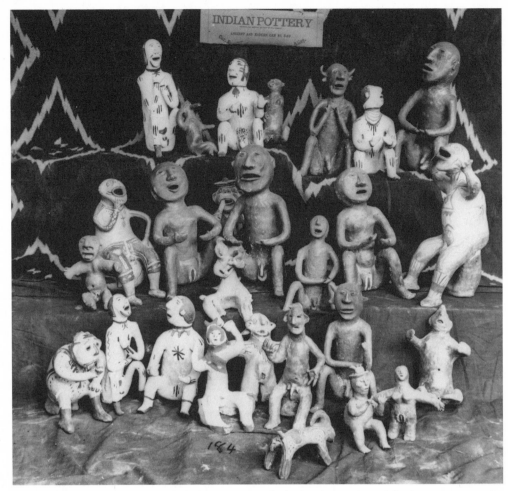

Figure 3. "Pottery Figures, Cochiti Pueblo, ca. 1885." The heads on some of the figures are out of
proportion to their bodies and their mouths are open "like a cat fishes" (as Miss Foard
observed about the one she purchased). Photograph by Ben Wittick, courtesy of the
Palace of the Governors, Santa Fe (MNM/DCA), neg. no. 16294.

Although Governor Prince and others "used every argument to induce" her to stay in Santa
Fe, she soon declared her intention of departing for Laguna, her original New Mexico destina-
tion.[21] She wrote, "I will say adios to Santa Fe with many regrets; her charming hospitality will be
remembered with grateful pleasure by me longer than any one here will remember me. I hope that
I may return."[22]

Arrival at Laguna Pueblo

Miss Foard arrived in Laguna by train at midnight on April 19, 1899. Dr. C. E. Lukens, the
Presbyterian missionary to the Indians and a medical doctor, met her at the station, and she

spent her first night in his adobe house. She found it to be large and pleasant, but, surprisingly to her eastern Anglo sensibilities, "not a closet of any kind in which to hang ones clothes."[23] In the following days and weeks, she observed, evaluated, and judged cultural differences between her new life and the one she had known before. Throughout her comments we note the inseparable interrelationship of nature, art, and morality that was characteristic of the nineteenth-century Anglo mindset.

Josephine's artistic background moved her to appreciate her new environment at a level that compensated for her physical needs. The landscape around Laguna was among the things that impressed her immediately, and she wrote enthusiastically about it, nearly all her comments being informed with the eye of an artist. She not only used artist's names for colors (such as sepia, chrome yellow, and Prussian blue) in her descriptions but also compared the "atmospheric effects, lovely greys, blues[,] reds and purples" to paintings in descriptions of the new sights surrounding her.[24] In addition, she was fascinated with the geology of the region, perhaps indicating she had some educational background in the field.[25]

Of the landscape, she wrote, "In my mind's eye I was making pictures, taking photos of this sandy desert scene...."[26] Her descriptions of all she observed often included allusions to pictures, using the vocabulary of a painter—color, value, shadow, texture, and shape. She wrote lyrically about the vivid colors of her surroundings, and most certainly she had pictures to recall, and probably paint, after she left Laguna:[27]

> Surely the beauty of New Mexico is when the sun hides his face[.] I never thought this country beautiful before, but the clouds and sunshine on this peculiarly reddish earth with the black, volcanic hills on one side and yellow sandstone on the other, make such indescribably beautiful values, soft greys and softer hazes that it melts the heart to an unwonted tenderness inexpressibly sweet. Just look! steps, steps, steps, with here a peak and there a peak to break the monotony of the mesas.... Now the greys of the gloaming steal over them, the reds of the sitting [*sic*] sun die out and everything is changed. Only the picture in the mind's eye and heart remain.[28]

Surprisingly, she wrote little about the appearance of Laguna Pueblo, itself, describing it once as "like a yellowish white castle on a hill of rocks of the same color, in many places looking like a ruin"[29] (figure 4).

During Miss Foard's first year at Laguna, her admiration for the Indians grew, and she formed close personal attachments with several of them. They included Laguna people who had experienced the world outside the pueblo and whose lives had been bettered (she believed) as a result. One was Louisa, a girl of nineteen who had attended the Carlisle School, worked for the Presbyterian missionary, and planned to return to Carlisle to be trained as a nurse. It was not uncommon for boarding schools to train girls to be maids, and Miss Foard later hired Lillie Sione, a girl educated at the Santa Fe Indian School, as hers (figure 5). Lillie Menaul (figure 6) and a girl named Zaweta, also worked as her maids.[30]

She also met Lorenzo, whose Indian name, Cheme Chetete, meant Three Stars (figure 7). According to Foard, he was a warrior more than one hundred years old.[31] He paid close personal attention to Miss Foard (sometimes to her extreme discomfort), but she soon developed a personal affection for him.[32]

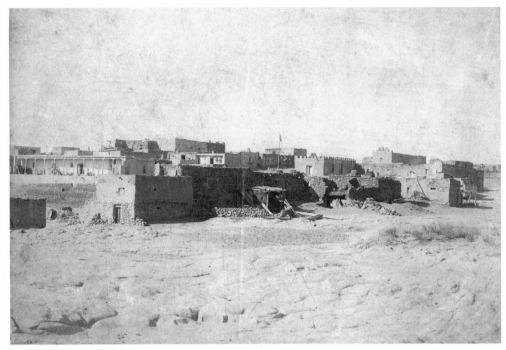

Figure 4. "Laguna Pueblo," ca. 1899. Josephine Foard sent this photograph to her brother-in-law, Rev. Valentine H. Berghaus. She described the scene: "The flag pole is in front of the U.S. Government School building, and the church is some distance back of it. The long building in the foreground is Gov. Paisano's and as clean as it looks in the picture. The long porched [*sic*] is white washed. The whole pueblo is built on an elevated, cream colored, solid sandstone. The old part is in ruins and the whole gives the appearance of a castle of long ago" (letter 26, appendix 1). Photograph courtesy of the School for Advanced Research, Santa Fe, gift of Mrs. Millicent Berghaus.

Miss Foard also recorded her observations about Indian clothing, noting the way women dressed (see figures 5, 6, 8, 11a, 13–18, 20, 22, 23):

> The black duititch which is the characteristic dress of the Pueblo women is worn over a shirt or several shirts made like a man's, generally of light colored calico or muslin. The shirt is very narrow and a little longer than the duititch which comes a little above the knee. This duititch is fastened over the left shoulder and falls under the right arm. [She probably misspoke because the Pueblo dress is typically tied over the right shoulder and under the left arm.] It is a straight piece longer than it is wide and pinned down the whole of the left side with silver pins. It is made of wool woven by men....These black dresses cost from twelve to twenty five dollars. The best ones are made by the Moqui [Hopi] Indians....
>
> On the back over the black frock is worn a large, square, silk handkerchief or muffler, a string or ribbon is attached to the corners of it then it is thrown over the head so

Figure 5.
Photograph of a young woman, "My maid at Laguna N. Mex. / My wash woman." This is probably a photograph of Lillie Sione. She is wearing characteristic Laguna dress: a black native-woven dress tied above the right shoulder and passing under the left arm (the reverse of what Miss Foard says), an underdress, apron, shirt of printed calico, wrapped white deerskin leggings and moccasins, and a necklace with spherical silver beads. Undated photograph, perhaps the one taken by Mrs. Ireland on September 1, 1899 (mentioned in letter 23, appendix 1). Courtesy of the School for Advanced Research, Santa Fe, gift of Mrs. Millicent Berghaus.

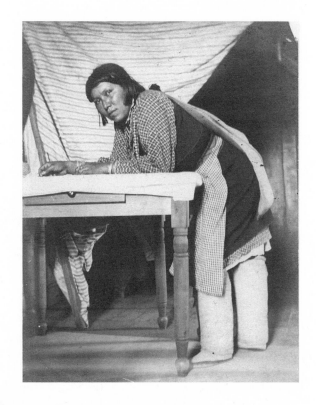

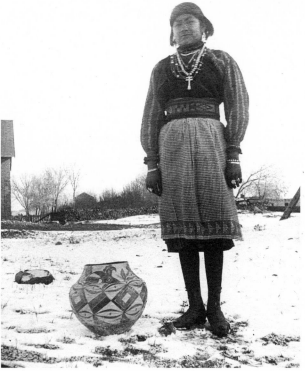

Figure 6.
Photograph of a young woman, "Lillie Menaul / Pueblo of N. Mex. / My little maid." Note that she is wearing high, laced leather shoes, not Pueblo leggings. She is also wearing several necklaces, one with a single pendant cross, and several strands of (probably) coral and silver beads. The large water jar lying on the snow-covered ground is decorated with parrots and geometric designs. We speculate it was made at Ácoma Pueblo, perhaps by Mary Histia, but it may be a Laguna product. Photograph by Josephine Foard, ca. 1902, courtesy of the School for Advanced Research, Santa Fe, gift of Mrs. Millicent Berghaus.

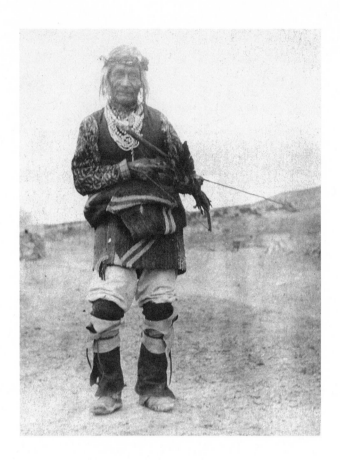

Figure 7.
Cheme Chetete. Photograph by
Josephine Foard, ca. 1902. She
photographed her friend
dressed as a warrior, with short
white leggings and leather
straps tied around his legs
below the knees, a Navajo blan-
ket tied around his waist, a vest
and elaborate printed shirt, and
carrying a bow and arrows.
Courtesy of the School for
Advanced Research, Santa Fe,
gift of Mrs. Millicent Berghaus.

as to let the handkerchief fall loosely over the back. I call it a back apron but the Indian
name is Oeist. But each pueblo has its own language and this would not be the name in
another village.... [The Lagunas, Ácomas, and members of five other pueblos spoke the
same language—Keresan.]

Their moccasins are surmounted by buckskin leggings not made but wound
around the legs to the knee many thicknesses so tightly as to make the legs look clumsy,
and when they sit they cannot bend the knees. The Santa Fē leggings were much nicer,
loose like a boot leg as white as snow. I asked a Tesuque how they kept them so white;
in reply she showed me some white, powdered clay which they rub on the skins
when needed.[33]

Unlike the women, many Laguna men had adopted western dress (figures 8, 11b, 19, 21). Again,
with a discerning eye, she observed the colorful dress of the women and men:

Men were mostly in citizens dress with out [*sic*] coats. Some had gay shirts and a few
had blankets. Some wore belts of large silver disks, larger than the cover of a pint meas-
ure, and large hooped earrings. Many carried in their belts cartriges [*sic*] and revolvers.
The revolvers were handsomely decorated with pearl mountings. Many women sat in

the bottom of the wagons, and the meeting of shawls of all descriptions on their heads, and falling about their bodies made a perfect flower garden. There were plaid shawls, and yellow shawls; blue and purple ones with borders of bright red roses."[34]

Jewelry was almost ever-present on women (figures 5, 6, 8, 18, 20, 23). She wrote to her sister that "you would be surprised to see the trinkets which the Indians wear; beads, bracelets, pins, belts, and buttons made of silver coins—United States and Mexican,—They are made by Indian silversmiths; the Navijos [*sic*] make better than the Pueblos. Tourists search eagerly for them and give good prices especially for the buttons."[35] She added that "to the Indians the Turquois [*sic*] is the most precious of stones because they say that it stole its color from the sky. They call it the spirit stone and it is the emblem of the soul."[36]

In addition to purchasing pottery to send home to her relatives, she acquired examples of blankets and other crafts, commenting that costs were sometimes surprising, "beautiful blankets ranging in price from two dollars to five hundred; the first and last prices being rare."[37] She acquired several blankets, both to use in her Laguna house and to send east:

I have six Navijo [*sic*] blankets, three are beauties; the others are only little saddle blankets.... The blankets with the exception of one are real old fashioned ones made entirely of wool with the real Indian colors, red, black, white, yellow and blue.... I would like very much to have one made of rabbit skins. But they are rare and very expensive. Before sheep were introduced among them they cut rabbit fur into cords, twisted them and then wove them into blankets. It must have required careful work for it is so tender—[38]

Building a House

After boarding for two months at Laguna, Miss Foard decided she would probably stay for some time and declared that "I must build if I remain."[39] There was difficulty in securing land at Laguna, however, so she went to Isleta Pueblo to talk with the Indians about settling there, and the Isletas offered her land upon which to build. She thought Isleta would be preferable as a home because of its nearness to Albuquerque and good food, but after ten days she returned to Laguna, probably because she realized that Isleta potters were not as good as those at Ácoma or Laguna.[40] (A description on an undated stereopticon view of Isleta Pueblo noted that at Isleta, "their clay is not good enough to make pottery for practical use, so they buy for their own requirements, the jars made at Ácoma, and dispose of their own inferior manufacture to the unlucky tourist!"[41]) In addition, Foard said, Laguna was preferable "because Laguna is on the rail-road. [So, however, is Isleta Pueblo.] Besides it is an item to be where there is a doctor."[42]

Miss Foard applied to the Office of Indian Affairs in late April 1899 for permission to build her house and kiln on a thirty-two-acre piece of government property located near the Laguna railroad station that was reserved for future school use.[43] In early June, the Office of Indian Affairs offered to let her build on the property and live there rent-free but also stipulated that the kiln, when completed, would become the property of the government, not the Lagunas (and, by inference, not hers either). The commissioner of Indian Affairs stated that the Lagunas would be permitted to use it without charge, however, "so long as its use by the Indians does not interfere in

any way with the use of the land by the Government for school purposes...." Apparently, she decided not to accept the offer, although that conclusion is not entirely clear.[44]

She also said that she applied to the ATSF to purchase a place on its right-of-way at Laguna but received no answer. So on July 18, 1899, she packed her trunk, said adios to all her friends, and was on her way back to Isleta, when, at the station, she found a message from the railroad asking her for a drawing of the site she wanted. The drawing was sent, but days later, she said "I am still waiting at Laguna."[45]

When she finally received permission from the railroad to build a house on the right-of-way for a rental fee of five dollars per year, she wrote to her sister that "at last it is decided that I shall stay at Laguna and have ordered building material."[46] Shortly afterward she wrote that "last night Lillie [Menaul or Sione] and I were covering our bricks near the railroad where they had been unloaded.... Soon all may be here and the precious house will be up if all goes well."[47]

Building progressed satisfactorily but not without both difficulties and delights. "We began to build on Wed. Sept. 6th...I am so much occupied with building that I have no time for anything else."[48] She complained that the workmen were late to work, slow, could not be depended upon, and had to be urged and watched in order to get things done. And, although she sometimes found it a "most miserable place in which to do anything," she also said that "in truth though, I have a fine lot of men working for me, and this building has been a fine lesson for them.... My men are of the right material when they know what to do."[49] Foard reported that one of her female friends at Laguna said to her "I do not see how you manage, because of all things Indians dislike, it is to be directed by a woman."[50] She thought the situation unusual as well, writing, "Sometimes it strikes me very forcibly that it is the strangest thing in the world for me to be here directing men in building an adobe house; and of all men Indians."[51] Apparently the constraints of gender had been offset by the power of race and class, and probably personality; the notion that women should be submissive to men had been transcended in her mind.[52]

Reflecting the fact that she had a good time with the builders and they with her, she described building the chimney using kiln-fired (that is, not adobe) bricks:

Red bricks are a curiosity here.... [I] showed them how to make the mortar. Satisfaction shown in every line of their faces as they carried off the first two buckets, full of mortar to the roof.

After they turned their backs upon me it was too pretty for description to see them bite their lips to hide the smile of pleasure. They worked away as seriously as two judges on the supreme bench. Their hearts were too happy for expression, and I could have danced with glee. Frank [Sihu] if he had the training would make a fine mechanic.

The funniest part is that I never would have known how to make mortar nor to use it had I not watched the masons put up a small brick building and asked them about proportions and other things.... The boys were so eager to use those bricks, and now are so happy because they are learning something....

Frank and George [Dailey] had never seen a trowel and they used it as though they were buttering a delicate piece of bread for a fashionable lunch; I took it from them and tried to look very professional as I daubed the mortar on more substantially, feeling the ludicrous part extremely, yet not daring to smile. A woman and two Indians on a roof building a chimney! It is well built too.[53]

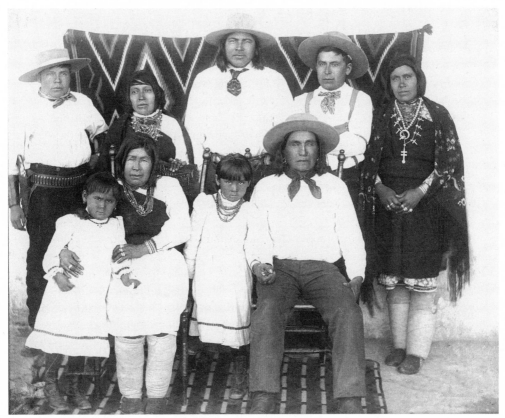

Figure 8. Photograph of Laguna Gov. William Paisano and his family. Photographer unknown, ca. 1899. The governor's wife, Mary, is second from the left. Lorenzo, his son-in-law, is the tallest person in the back row; he is wearing a silver concha belt Miss Foard described in Letter 13 (appendix 1). Mary Paisano is wearing several strands of coral or turquoise and silver beads, as is the woman behind her. The woman at the far right in the back row has two necklaces; one is a Pueblo silver necklace with spherical beads and a crescent *naja*, the other probably has coral beads and pendant crosses. The blanket in the background is probably a Navajo blanket. Miss Foard mentioned this photograph in Letter 26 (appendix 1), when she sent it to her brother-in-law, Rev. Valentine H. Berghaus. Photograph courtesy of the School for Advanced Research, Santa Fe, gift of Mrs. Millicent Berghaus.

Even more surprising to her was to see Laguna Governor Paisano (figure 8) working on the house:

To think that the Gov. should help to build my house after he had nearly pestered the life out of me by throwing difficulties in the way. He proved a good worker and was the cleanest of clean men with his white shirt and new gloves. I have created a sensation! At the store, at the station, every where whites and Indians greet me with "You have the Governor to work for you!"[54]

Finally, Foard was satisfied with her and "her Indian's" [*sic*] building efforts, saying:

> Our house is well built as far as it goes. The whole of this little community are [*sic*] proud of it. It looks a little crooked because the wooden parts are not straight. The masonry is good, firm and solid. George Dailey [figure 21] a full blooded Indian and the boss adobe builder fortunately thought of a corner stone which I did not. He went off with the men and did not explain because he could not speak English. I watched, for George is level headed. Slowly they returned with an enormous stone. I ran for a bottle and paper and soon the names of all concerned, dates, and soforth [*sic*] were sealed up in the bottle thanks to Mr. Miller; and George built it in with the stone. So the names of the Company who sent me here are sealed up in that bottle. I hope that from it may grow, fruits worthy their noble intentions.[55]

By October 18, a second room was under construction. "Some are building the stone foundation of the new room; four are making adobe bricks, one is doing the carpenter work for doors and windows.... I am trying hard to hurry the building of the new room fearing that it may freeze the bricks and put a stop to the whole work. Frozen adobe is good for nothing."[56]

A month later, Foard went to Albuquerque to buy furniture for the new house. She wanted it to be as inexpensive as possible, yet Indian in character, so she bought tenting canvas for carpets and a dull green denim for borders. On this she put Indian blankets for rugs. She bought as little as possible to be comfortable, because she said that things were expensive. She wrote that the Indians were proud of the house, which had only two rooms, with one divided into two with curtains.[57] After returning from another shopping trip to Albuquerque, she balanced her delight with a pungent comment. "It is not so bad after all to ride on a freight train if one could only cork up ones olfactories to keep out the pig odors coming from the front car."[58]

Miss Foard had hoped to be in her house on December 19, 1899, but "every Indian was compelled to work on public works, and that means no work for any one else."[59] She was probably in the house before December 23, when Indian children came to dance for her.[60] She had her first dinner in her house on December 26 and expressed her pleasure in being there, "although I do not like housekeeping."[61] Her only regret with the house was that she did not have a corner fireplace; she had used the corners for closets. (She often expressed her appreciation for nice, neat, clean, tidy, and becoming clothing, and it is clear from the comments in her letters that she so valued fashionable Anglo clothing that she sacrificed a fireplace for closet space.)

Foard photographed the house sometime after it was completed (figure 9).[62] It consisted of a large main block that may have been the space that was divided into two rooms with curtains; there were two additional smaller room blocks, one with a door, and a third tiny room block at the right. There appear to be four chimneys on the house. Miss Foard never says whether the kiln was a separate structure or if it were attached to the back of the house; if attached, the larger of the two square chimneys may have been for the kiln. The kiln was constructed of brick, and a photograph of it (figure 21) indicates that the chimney was also brick. There were also two chimneys with metal pipes on the smaller room blocks; one may have been a stove vent, since she did not have a fireplace.

Baluster-shape jars are visible on three corners of the roof on the main block of the house. Although Pueblo people often made chimneys using old pottery jars with the bottoms knocked

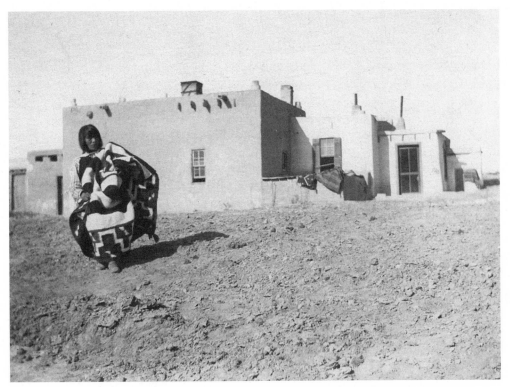

Figure 9. Miss Foard's house at Laguna Pueblo, with an unidentified person wearing a bold
Navajo blanket. The blanket may be one Miss Foard purchased from Cheme Chetete,
which she describes as a "large red one with black and white, square border. . . ." (letter
31, appendix 1). Photograph by Josephine Foard, ca. 1900–1907, courtesy of the School
for Advanced Research, Santa Fe, gift of Mrs. Millicent Berghaus.

out and cemented with adobe clay, one on top of the other, the ones on Miss Foard's house appear
to have been purely decorative, given their locations.[63]

Miss Foard did not mention in her letters what building her house and kiln cost, but it was
probably about fifteen hundred dollars, judging by Indian Comm. Sybil Carter's comments in
1899: "When we had the $1,500 subscribed last year I wrote to this lady [Josephine Foard], who
knows all about putting on glaze, and she responded at once.... The money raised last year is all
gone. It has been spent well. We have a kiln; there are photographs of it here."[64] Following that dis-
cussion, the commissioners raised an additional two thousand dollars for Miss Foard's project.
Whether she had funds in addition to those the Indian commissioners pledged or paid any
expenses from her own pocket is unknown.

Homesickness and Return to the East

Miss Foard felt relieved to be living in her home before Christmas, but as the year-end holidays
approached, she expressed homesickness. It was especially apparent when she wrote about when

the belated [California] Limited [figure 10] came flying by.[65] I ran to see it and stood upon a high rock so as to look down into the carriages and at the passengers at the end of the observation car....

My only idea was to get a glimpse of people looking like home; two thousand miles away off in the east....It was like a gentle breeze with a ray of sunshine and I ran lightly down the slope eastward to my adobe home, while they sped westward: Who knows where? But in their wake there were ripples of light glinting in the sunset rays and I slept well with the pleasure of it.[66]

Later, she returned to the train station to observe that

there were very few on the California Limited to day....I sauntered amid the crowd [of tourists and Indians selling pottery] having a feeling that some familiar face from the far off East might turn up; but never a face appeared and I left humming to my self

> "Then row, row, row, your boat
> Gently down the stream
> For all that is past is gone you know
> And the future's but a dream."

But it was the present after all which was the dream and as I got out of the hearing of the crowd I sang out clearly to myself and was surprised for I had been occupied with others affairs so long that I had not thought to sing.[67]

By April, Miss Foard was preparing to return to her family in the East. On April 3, 1900 she wrote that she was planning to leave Laguna as soon as possible, saying that she was "very nervous" and that her strength was leaving her. She attributed her condition to the lack of nourishing food, although she sometimes went to Albuquerque after she began housekeeping to buy provisions.[68] Indeed, only two months after Foard arrived in the West, she avowed that "nothing would make me flee [this place] but necessity and one necessity is hunger which I actually feel often...."[69] Her letters expressed her regret at having to leave her work "just on the eve of success....But if I become ill it may take a long time to recuperate. I will try to get some one to take my place."[70]

In the penultimate known letter she wrote to her sister from Laguna, Miss Foard reminisced on April 19, 1900:

Just one year ago to night I came to Laguna. Not many minutes have been wasted; and although I am on the verge of nervous prostration I would not part with one of those moments. Something within me is capable of a more thorough, a more intense pleasure than ever before. My eyes are opened to many things and I know to a certainty that there are good Indians who are not dead ones. I know that there are beautiful Indians outside of poetry. Longfellow was more than imaginative, he was true.[71]

A single paragraph, dated April 24, 1900 (included in her last letter from Laguna, on April 22), concludes the known "Letters from Among the Lagunas."[72]

Ill from malnourishment, and with regret at leaving Laguna, Miss Foard returned east, perhaps to Athens, Pennsylvania, to live with her sister Louisa and the Berghaus family.[73] She moved by the end of the year to nearby Waverly, New York, and after regaining her health, tried again to stimulate interest in Indian pottery in New York City and elsewhere at her own expense.[74] Like all artists committed to a vision, nothing could stand in her way for long.

Return to Laguna

An opportunity for publicizing her work and the plight of Pueblo Indian potters came late in 1900, when an assistant commissioner of the Office of Indian Affairs in Washington wrote to Miss Foard, asking whether she might supply examples of her glazed pottery for exhibition at the Pan-American Exposition in Buffalo. She responded enthusiastically, confirming that, although she did not have much to offer herself, she could gather together several pieces she had given to friends and colleagues. A month later, she wrote to say she could send nine small jars and enclosed drawings of two of them.[75] Just a month later, however, she wrote with chagrin that Albert K. Smiley, a member of the "pottery committee" at the IIL in Boston, had vetoed her plan. He had pointed out that he considered it inappropriate to participate because "he thinks that as the pottery at Laguna N. Mex[.] is closed for the present he would rather not have it brought to the notice of the public. He would like us to wait until the work is better developed." In late March 1901, she conceded she would not participate in the exposition.[76] Pueblo Indians did, however, participate. *The Santa Fe New Mexican* reported that "on November 5, 1901, a train carried 14 Pueblo Indians, bound for Laguna, who had been at the Pan-American exposition in Buffalo, N.Y., for the past six months. 'One of them said that Buffalo is a fine town but there are too many people for perfect comfort.... '"[77]

Perhaps the excitement at the idea of showing her pottery to a large, international audience, coupled with the disappointment and frustration of not participating in the exposition, ignited in Miss Foard the idea of reopening the pottery kiln at Laguna. Six weeks later she wrote to Indian Comm. W. A. Jones, asking whether the Office of Indian Affairs would support her efforts financially.[78] She explained the history of the project in detail and told him of the benefits such an endeavor would bring to the Pueblo people. She was, however, concerned about the difficulties she would face, noting she thought it would take three or four years before it would become a "paying business."[79] Perhaps fearing that financial support would not be forthcoming for a project that would take so long to become self-sustaining, she suggested she could also introduce a school of embroidery and fine sewing to Laguna women, thereby providing both work and immediate income. (She was undoubtedly aware that the IIL was supporting a program for teaching lace making to Indians in Oklahoma.)

She also noted she was uniquely positioned to achieve success at Laguna because she already had a home there—which she admitted did not literally belong to her, but to the group that had initially sponsored her first venture at Laguna. In addition, she pointed out she had achieved a position of trust among the people, adding,

> My heart is with the Indians and I am willing to make great sacrifices to their interests. Had I the means I would establish the work among them and then leave it in competent hands. Those who have been educated at the Government schools are the ones especially to be looked after. Many of them have helped wonderfully in improving their

homes but opportunities for remunerative work are extremely few. Money is a great leveler of difficulties, and the older ones would yield more readily to civilizing influences if those coming home from schools could help to lift the burden of poverty from their doors. Schools are all very well, but paying work at home is what they need at once upon going home. They are not half so lazy as represented. Those Indians worked better for me than for any one else. Why? Because they trusted me and because they learned something too.[80]

Her plan was greeted favorably in Washington, and she was invited to take a civil service examination to become a government field matron, with the express purpose of reestablishing her pottery project at Laguna Pueblo. The process of achieving the appointment was not altogether easy, however. A number of contradictory letters were exchanged in which she was alternately encouraged or discouraged; she was especially discouraged when she found she was beyond the age limit for school matrons and the Civil Service Commission had canceled her examination.[81] Even at her lowest point of despair, however, she was undaunted. She proposed several new moneymaking ventures to the Indian commissioner, such as teaching Laguna women to hemstitch fine linen handkerchiefs, make aprons and underwear, raise rabbits, and introduce better breeds of chickens to improve the quality of food at the pueblo.[82] She noted that although the Lagunas had abundant chickens, they were so ill fed they were thin, tasteless, and "revolting as food."[83] She observed that grocers would not buy Indian chickens or eggs because of their poor quality but predicted that improved chickens would lead to improved quality of the eggs, which might then be sold at a profit to grocers.

Conceding defeat at one point, she suggested that a schoolteacher, Miss Margaret Bingham, whom she had met at Laguna and who still lived there, would be able to undertake these projects. In addition, she suggested hiring a Laguna girl she knew to be in charge of introducing better chickens to the pueblo.[84]

Eventually, the confusion of contradictory correspondence was resolved, and Miss Foard was certified as a field matron and assigned to Laguna Pueblo four months after taking the civil service examination in Elmira, New York, about fifteen miles from her home in Waverly. She was informed on October 4, 1902, that she would receive a monthly salary of sixty dollars, but would have to pay her own travel expenses.[85] (That was not an insignificant wage at the time; in 1900, for example, the average salary of a Santa Fe Railroad employee was just under seven hundred dollars annually.[86]) Miss Foard was also informed that the Office of Indian Affairs would cover some costs incidental to restarting the pottery project—which commissioners consistently labeled in correspondence as an "experiment."

Arriving once again in Laguna on October 30, 1902, she immediately began to reestablish her pottery firing and glazing operation. She reported finding the house in "astonishingly good condition, after having been closed for two and a half years." She noted that some repairs were needed, but that "not a thing has been disturbed, not even the bricks and clay that I left outside."[87]

She wrote to the commissioner a week after arriving, listing the supplies she needed for operating the kiln; these lists give us details of the kiln's functioning. For example, she said she needed one cord of wood for every firing and estimated she could fire pottery once or twice a month. She also said she needed a male assistant to do the heavy work. Yamie Leeds, the assistant she eventually hired, later remarked that "he had to watch it [the kiln] for eight to twelve hours" during every firing.[88]

When requesting money to buy dry wood fuel for the kiln, Miss Foard acknowledged that coal would be cheaper and easier to purchase, but she said her kiln would have to be modified to use it. She concluded that wood was far preferable.[89]

Commercial glaze materials were also required, but she noted that since she planned on glazing only the insides of pots, which "will help to strengthen the ware and preserve that dull exterior peculiar to the Indian pottery and is so soft and artistic," little glaze material would be expended on each pot. While admitting that glazing the decorated exteriors of Pueblo pottery adversely changed their appearance (see plates 2, 14, 15), though, she also speculated that "there are many tastes to cater to in [the] market and a wholely [sic] glazed olla may be in demand. In this case the imported paints must be obtained, for the Indian paints will not stand a glaze."[90]

Miss Foard also expressed some of the problems she anticipated having to confront in getting pottery made that could be glazed successfully:

> I learned when here before that the Indians could patch up poor ware very adroitly, but I succeeded in getting two women to make a decided effort for the better.... Two things only shall I insist upon now, first that they make the jars or ollas entirely of green, (or new clay) instead of breaking old jars and mixing it with the green clay. This weakens the ware because one part has already been fired and the other not. Secondly they drag the ware to the open air as soon as it is red hot and while it is red hot which is a serious harm. They of course think that they know better than I. If I can induce them to do better firing in their own improvised kilns it will reduce the kiln work to glazing and this will reduce the expense of firing as I shall then only have to fire for the glazing.[91]

She said every pot would have to be fired three times.[92] (We interpret that statement to mean that Miss Foard, herself, fired pots twice. We speculate that she collected finished, painted, and Indian-fired pottery from the makers; thereafter, she fired them again at a higher temperature to harden them, then applied the glaze material and fired them once more to fuse the glaze.[93])

There is no evidence Foard ever convinced Laguna potters to stop using ground sherds as temper. In fact, potters in several Pueblo tribes, including Ácoma, Laguna, and Zuni, produced stable and highly functional pottery for hundreds of years using ground sherds as temper, often in addition to sand or other ground rock. The Indian potters did, in fact, know more about producing pottery using their raw materials than Miss Foard did. What may have happened at Laguna, which Foard may not have realized, was that the fragility of the pottery resulted from using too much sherd and sand temper or firing the wares at too low temperatures in order to speed production.

Recognizing it would be some time before she could expect to purchase good quality pottery at Laguna in quantities sufficient for her needs, she also asked to be provided a horse so she could visit the outlying Laguna villages of Paraje, Pagaute, and Seama, where, she said, all the best workers had moved because of better farmland. In addition, she noted that "I should go to Ácoma frequently, because the Indians there are by far the best potters."[94] She argued it would cost more to hire transportation to those places than buying and keeping a horse.

The superintendent of the Indian School in Albuquerque, to whom Foard reported, was unsympathetic to this last request, indicating that "I do not think it advisable to furnish her with a horse or horse feed. If it can be made a success at all it will surely be right there in Laguna. It is

surely not practicable to try to have Indian women make pottery at their homes and then try to haul the jars, eight, ten, fifteen and twenty miles in wagons to burn them."[95] There is no record of a decision on any of these requests; nonetheless, she claimed to have visited Ácomita, an Ácoma farming village 11 3/4 miles from Laguna, on numerous occasions in 1903.[96] Furthermore, several glazed Ácoma pots have survived, and contemporary photographs document still more; glazed pottery sent to the Jamestown Exposition in 1907 was all from Ácoma.[97]

At the same time she appealed for additional financial support from the government for her pottery project, she also requested that a bolt of linen be purchased so she could have the Pueblo women begin making hemstitched handkerchiefs, noting that if they are made "neatly enough," she would be able to purchase ongoing linen supplies from the proceeds of sales.[98] She also mentioned she was seeking free scrap leather from eastern shoe manufacturers for Laguna men to make into horse whips.[99] Around the nation, various Indian "industries" were being encouraged financially, including basket making, lace making, silversmithing, weaving, and beadwork—with varying degrees of success.

After working at Laguna for a year, she wrote in October 1903 to A. G. Tonner, the acting commissioner of Indian Affairs, suggesting that examples of her glazed pottery be included in the displays at the Louisiana Purchase Exposition in St. Louis the following year. Tonner greeted the idea enthusiastically, but we have found no evidence that Miss Foard actually sent any pottery. She was also involved in arranging for potters to travel from Ácoma Pueblo to the exposition, but she seems to have been unsuccessful in those efforts.[100]

Despite Foard's enthusiasm for promoting her glazed pottery at the 1904 exposition, all was not well with the project, as is indicated by her request for a thirty-day leave of absence (vacation) after June 1, 1904. Part of the reason, she explained, was difficulty in selling the glazed pottery. Commissioner Tonner summarized the situation: "There is no market for the glazed pottery in the vicinity of the pueblos. The curio seeker either wishes the old native style because it *is* native or is not a judge of pottery and wants only what is cheap."[101] Foard proposed to remedy the situation by moving east to develop the market herself and also suggested that pottery be sent to her for its final glaze-firing in New York "or some other centre where a suitable kiln is to be had and where the cost of firing will be no greater than in Laguna."[102]

The commissioner did not endorse her plan, replying most tactfully that

> the Office was ready to have the experiment tried among the Indians and is cognizant of your faithful work and helpful influence in the pueblo under your appointment as Field Matron. But I do not think it would be justified in continuing you on its Field Matron rolls while you were residing away from the Indians notwithstanding you were devoting yourself to their interests. The working up of such a business as you propose, while I very much wish that it might become a success, belongs rather to philanthropic societies than to the Government.... If, as you say, there is practically little more that you can accomplish by living at Laguna—and I am constrained to believe that that is the fact—I think your services as Government Field Matron should terminate with the close of your vacation. I feel that you have done your best at Laguna and I trust that what you have taught the women there will be of real help to them indirectly, even though the direct results which you anticipated have not been realized. The experiment was worth trying and it may be, as is often the case, its main value will be in its "by-products."[103]

On July 12, 1904, writing from Flushing, Long Island, she acknowledged Commissioner Tonner's decision and resigned as field matron as of June 30, a little more than a year and a half after resuming the project in Laguna.[104] She admitted that nothing else could be done, for although she said the Indians were doing their work and the kiln was firing properly, she had not been able to develop a sufficient market for the pottery in the East.

For two years after that she traveled at her own expense, "telling of the works and finding places where the pottery may be put on sale."[105] Not being salaried, she was probably fund raising continuously for her project as well. She reported to the IIL in Boston that "if I can make sales to keep me out of debt, I shall go on."[106] The IIL's sale of Foard's glazed pottery in its showrooms helped her cash flow, but sales were slow. In 1905, the league's officers noted that they would buy the "Foard pottery because we've had it so long. Miss Foard to set lowest price and maybe the Indian Industries would not charge commission."[107]

Still, she did not give up on the project. Nine months after resigning her field matron's post, Miss Foard wrote to Indian Comm. Francis E. Leupp, reviving her earlier suggestion that Pueblo pottery be sent to her in the East for glazing. She did not seek reinstatement as a field matron but asked if the government would underwrite the cost of packing and shipping pottery to her to glaze and sell.[108]

Seeking to help her defray her personal costs, the commissioner asked whether the government might rent her house in Laguna for other employees stationed there. Ultimately, however, she received word that the house was unsuitable for the needs of a field matron because it "is located on the railroad right of way, within a few feet of a switch, and trains are constantly passing. It is not supplied with water and could not be utilized for the use of the Matron, where water is required for laundering purposes. It possibly could be used for teachers' quarters, but at a rent not to exceed $5 per month."[109] (It is interesting that they thought teachers could be expected to do without running water and tolerate the noise.) Although a plan to ship pottery east for glaze-firing was confirmed in July 1905, there is no evidence anything was ever shipped.[110] By this time, Miss Foard was residing in Harrisburg, Pennsylvania, with the Berghaus family.[111]

While living there, the idea of returning to Laguna to work at the pottery must have come to mind. She wrote to the IIL seeking their advice, and they recommended she petition Commissioner Leupp to reappoint her to the field matron's position.[112] Following that advice, Foard wrote to the Office of Indian Affairs on January 21, 1906, asking to be reinstated as a field matron and returned to Laguna. Displaying the encouragement for which he was noted in developing assistance programs for Indians, Commissioner Leupp greeted her proposal favorably:

> If I understand your plan it is that you return to your Laguna home, superintend the making of the pottery by the Indians; fire it there in your kiln; ship it thence to such eastern dealers as you have interested in Pueblo pottery, train an educated Indian man to glaze and fire and to keep accounts, and trust some women to glaze at their own homes. In seasons when the Indians are absorbed in other work or dancing and will give no attention to their pottery, you propose to travel east and west and try and work up an interest in the pottery which will result in orders.
>
> If, in spite of the meager results thus far obtained, you still feel like returning to the pueblo to resume your personal work at that end of the line, I do not wish to discourage you. I am myself much interested in the preservation and development of

native Indian art and wish that Pueblo pottery, of the best sort, might be put upon a paying basis of manufacture and sale. Whether or not this is practicable does not seem yet to be fully proven, and I am aware that little faith in the scheme exists in the Pueblo country; yet I am ready to give it my cooperation in hope that something worth while may grow out of it.[113]

He offered to reinstate her monthly sixty-dollar salary and also agreed to her request to pay wages of an Indian assistant at twenty-five dollars per month.[114] At the same time, however, Leupp stated the government would only be responsible for the two salaries and would not make any funds available "for buying ollas from the Indians or for the purchase of wood, glazes, gums, brushes, &c. It is to be a *business*, and the capital for starting the business must come from other than Government funds." The IIL, realizing she was receiving no funds for supplies or travel, suggested in 1906 that the "Kentucky Association advance the money [for Miss Foard's expenses to "travel and exhibit the pottery and make a market for it"] either directly to the League or thru the League."[115] The League voted to aid her with a "small gift, bought some of the pottery, and promised her further help should she succeed in establishing the pottery as a business."[116]

Precisely when Miss Foard moved back to Laguna is undocumented, but she was likely there by May 1906. In June 1906 she wrote from Laguna to former Governor Prince, whom she had met when she first arrived in Santa Fe in 1899, saying she thought her project "might work if I only had more money to put in it and some one at this end [Laguna] who was competent to attend to it."[117] The lack of funds was a constant theme in Miss Foard's communications regarding the pottery project for the remainder of her time at Laguna.

In September 1906, she wrote to the superintendent of the Indian School at Keams Canyon, Arizona, seeking to acquire Hopi pottery.[118] The acting Indian Affairs commissioner in Washington, cognizant of Commissioner Leupp's limits on funding, approved the idea of sending Miss Foard what she requested, but added, "If she wants you to buy Hopi pottery for her to experiment on I see no reason why commissions of the sort should not be filled—at her expense. I should like to have her work on Hopi as well as Laguna and Acoma pottery."[119] (A glazed jar that was probably made and decorated by the famous Hopi potter, Nampeyo, is shown in plate 4. Another example of Hopi pottery is illustrated in plate 5; Miss Foard probably bought it in 1906–7 and glazed and sent it to Boston in 1908–9.)

A month later, Miss Foard was again granted a paid leave of absence (her month's vacation) so that she could travel east for "working up an interest in Pueblo pottery."[120] She traveled to Boston, New York City, and Philadelphia between November 29, 1906, and January 5, 1907, where she lectured to local audiences about the Indians and their pottery and organized sales exhibitions at several venues.[121] Reporters from the *New York Herald* and the *New York Tribune* interviewed her, which resulted in the publication of laudatory articles.[122] While there, she also organized a display at the Arts and Crafts Exhibition of the National Society of Craftsmen in New York City,[123] a newspaper reporting that

people who like hand-made things have examined with interest the Indian pottery displayed by Miss Josephine Foard. A "human interest" story which touches on adventure, history, ethnology and philanthropy lies behind those quaint pots and jars. They are said to be the first pieces of glazed Indian pottery made since prehistoric times....[124]

They are also the first bits of Indian pottery made under the auspices of the United States government, for though Miss Foard built the kiln at her own expense the government now pays a salary to her and her helper.[125]

A year later, Foard showed a collection of twenty-eight examples of Navajo and Ácoma silver jewelry at the society's exhibition, but no pottery.[126]

Foard informed the commissioner she was pleased with the coverage because it created "very great interest" but also added that some of those reports were inaccurate and mixed.[127] For example, it was certainly not true that she had built the kiln at her own expense.

In February 1907, the IIL opened a salesroom at 9 Hamilton Place, Boston, "for the Sale of Indian goods, lace, pottery, silver, beadwork, Navajo rugs and other Indian work."[128] The league offered "the Laguna pottery made by the Pueblo Indians under the supervision of Miss Josephine Foard, U.S. Indian Field Matron. This pottery is now produced with interior glaze which much increases its strength and value."[129] The store was moved twice during the following two years to other locations in Boston; the small Hopi and Ácoma jars shown in plates 3 and 5 were offered for sale in 1908–9 at the league's salesroom at 2A Park Street.[130]

A very encouraging and welcome letter awaited Foard's return to Laguna from the East, early in 1907. It was from Acting Indian Commissioner Larrabee, inviting Miss Foard to send examples of her glazed pottery to the Jamestown Exposition. They were to be included in the Indian Office exhibit, which "will show what the Government is doing for Indians."[131] She immediately responded, agreeing to send four glazed and two unglazed Pueblo jars to the exposition. Although she suggested acquiring some examples from Santo Domingo Pueblo "and other makes so as to have a variety," all the examples that were eventually sent were made at Ácoma.[132] Prices for the jars ranged from $3.50 to $8.00 each.

She also submitted a lengthy explanation about her work, to be exhibited with the pottery:

INDIAN POTTERY

The Pueblo Indian pottery, an entirely native industry, made without tools, models or brushes has been thought heretofore so frail that it was not deemed advisable to put it on the market excepting as a curio. In reality it is not so frail as it looks. The Indians have for ages used it for carrying and holding water as well as for cooking purposes. With buckskin cords the spoonas, or canteens, are carried on their backs by the men when going to work, and while they are working the spoonas are buried in the ground in order to keep the water cool.

We buy this pottery directly from the Indians, carefully testing it; rejecting all defective pieces. If deceived once in a while we call them seconds and sell at a lower figure. To preserve the Indian character we glaze them on the inside only and subject them to a hard fire, thus strengthening and adding to the richness of their colors.

Our object is to give the beautiful industry, which is entirely uninstructed, a commercial value in order to preserve it to the Indians as an industry, and to improve it strictly on Indian lines, encouraging them to aim higher and higher[.] To get the clay the women walk miles, then climb a rough trail to the top of a mesa, where they crawl in a small opening to dig out small pieces at a time. This they put in a bag and carry down on their heads.

Yamie Yeyutetacewa Leeds, a graduate of the Carlisle Indian School, is employed to do the kiln and general pottery work after we buy the duonnes from the women who make them.[133] He makes the saggars, and is making artistic tiles for architectural purposes of which we hope to make a success.[134] Other Indians may in time be employed in the pottery so that more than one may understand the management.

Until recently we have confined our efforts to the Acoma and Laguna wares, but are now introducing the Hopi, Santa Clara and Santo Domingo.[135] So far the Acoma duonnes have stood the test of quality better than any others.

We have shipped much pottery to New York City, Philadelphia, Boston, Pittsburgh and to the Harvey Curio department at Albuquerque N. Mex. and we are arranging for new fields.[136]

The reference to architectural tiles in the preceding statement is the first time the new product is mentioned (see plate 14), suggesting that her assistant, Yamie Leeds, began making them, probably in 1906. The introduction of the product may have been prompted by the cost and difficulty of shipping vessels to markets, thus reducing income and profit. Jars and bowls were heavy and fragile and required substantial amounts of packing materials, which were very scarce at Laguna.[137]

Miss Foard continued to receive correspondence from the Office of Indian Affairs until early in 1908, when five of the pieces in the Jamestown Exhibition were returned—not to her, but at her request to the Daedalus Arts and Crafts Club in Philadelphia, where they were probably sold on her account. Miss Foard gave one of the pieces shown at Jamestown, a small, two-handled, glazed jar, to the Office of Indian Affairs in Washington.[138]

No further correspondence between the Office of Indian Affairs and Miss Foard has been located, but the "experiment" continued for about two more years. She proposed that the IIL open an "Indian Tea Room" in Boston in 1909 and sent sugar bowls, creamers, and candlesticks. The tea room never opened, but the league sold the pottery.[139] She was living at Laguna in 1910, when she was enumerated in the federal census as a potter, living as a maid with railroad foreman Morton H. Roseberry and his wife Effie. (Could the idea of Foard's being a maid have been the unsubstantiated assumption of the census enumerator?) Even though the census does not identify her as owning the house, she may nonetheless have been residing with the Roseberrys in the house she had built years before.

The IIL, the primary sales outlet for Foard's pottery, ceased selling Indian crafts in 1910, after sixteen years of selling Indian goods, either in its own stores or through other organizations. That closure probably caused Miss Foard's philanthropic intentions and eleven years of very hard work with the Lagunas to come to an end.[140] On May 5, 1911, Foard wrote the league that she was leaving her work at Laguna.[141]

Although Miss Foard left Laguna for the last time in 1911, her government-paid assistant, Yamie Leeds, may have continued to make and glaze pottery tiles for some time after that and perhaps also fired unglazed pottery for Laguna potters in the kiln. Within a few years, however, the production of all glazed pottery ceased at Laguna, and by 1920 Yamie had turned to farming.[142]

Betty Toulouse, curator of the Laboratory of Anthropology in Santa Fe, years later wrote that

her [Foard's] objective was to produce glazed and unglazed tiles, kiln fired, for sale in the eastern markets. A few Laguna potters participated in this project. Volkmer

[Volkmar] glazes were used but these negated the black and red native Laguna pigments so special commercial pigments were employed when the tiles were to be glazed. If Miss Ford's sole intent was to establish at Laguna a flourishing business in Southwestern Indian-made tiles for eastern sales her efforts were unsuccessful.[143]

CHAPTER THREE

⊹⊱⊰⊹

The Changing
Pueblo World

M iss Foard knew that Indians in the American Southwest, like Indians in other parts of
the country, were experiencing challenging times in the late 1800s. Understanding
why Miss Foard decided to undertake her project at Laguna Pueblo, however, requires
an understanding of what was happening at that time in the Pueblo region, at Laguna, and among
groups in the East supporting Indian causes before she ventured west.

The origins of the problems Pueblo Indians faced in the late 1800s may be traced in part to
when Spanish expeditions first penetrated the Southwest in the 1500s. Fray Marcos de Niza trav-
eled as far as present-day Zuni Pueblo in 1539 and claimed the area north of Mexico for the
Spanish king. His exaggerated tales of wealth in the region led to the 1540–41 expedition of
Francisco Vásquez de Coronado. Coronado's expedition encountered the Zuni people, along with
those of the pueblos of Ácoma, Hopi, and Pecos, as well as numerous other pueblo villages that no
longer exist today in Arizona and New Mexico. The Spaniards made more expeditions later in the
century to pacify, colonize, and bring Christianity to the region, and in 1598 Nuevo México was
declared a missionary province of the Franciscan Order. Its first capital, established at San Gabriel
in 1598, was moved to Santa Fe in 1610.[1]

Native people were forced to submit to the civil authority of the Spanish king, supply food
and clothing as tribute to soldiers and settlers, and sometimes, if captured in war, serve as slaves.
Discontent occasionally led to rebellions, but they were quickly and brutally suppressed. Because
of the lack of mineral wealth in the region, the Spaniards in the 1600s and 1700s focused prima-
rily on implanting the Roman Catholic religion, converting the Indians, and stamping out native
religious practices they considered heathen. Roman Catholic missionaries introduced schools,
new trades, and new crops in an effort to improve the life-styles of the Indians; however, thou-
sands of Indians died from contagious diseases the Spaniards brought to the New World, to
which they had no immunity.[2] Attacks by warrior tribes (Apaches, Utes, and Navajos), along with
severe drought, famine, and intermarriage with settlers further reduced Pueblo populations.
Some sixty pueblos were abandoned between the time that the Spanish first explored the region

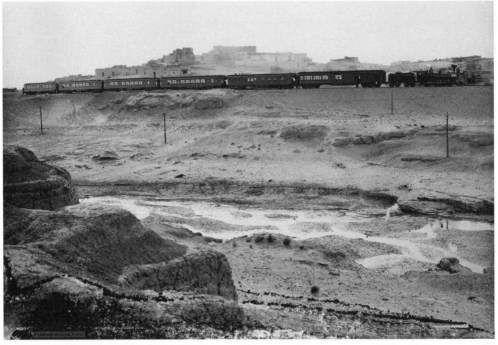

Figure 10. The California Limited of the ATSF Railway passing through Laguna Pueblo.
Photograph by William Henry Jackson, ca. 1893–1900. Courtesy of the Colorado
Historical Society, neg. no. CHS.J4202.

and the mid-1800s. In addition, some pueblo tribal governments were split irreconcilably into
anti- and pro-Spanish factions, leading to numbers of people moving away because of the differ-
ences and even to the destruction of villages.

Pueblo people resisted colonization, forced labor, and the efforts of Spanish priests to eradi-
cate native religions with varying success. Hostilities increased between the Pueblo Indians and
the Spaniards until, in 1680, the natives rose in the Pueblo Revolt, killing or expelling all the
Spaniards and destroying churches and religious objects. When they attempted to return in
1681–82, they were beaten back. They returned again in force in 1692 under don Diego de Vargas.
Some villages acquiesced to Spanish rule peacefully; others that resisted were destroyed and many
people were killed. In 1696 the Spaniards reestablished dominion over the territory.

Rather than accept Spanish domination, some Pueblo people who lived along the Rio Grande
and to the west fled their ancestral villages to find refuge in regions that were outside European
control. Shortly after 1700, some Pueblo people moved to the remote Gobernador Canyon area in
the northwestern corner of present-day New Mexico, where they lived peacefully among their for-
mer enemies, the Navajo and Apache, and to the mountains near present-day Jemez Pueblo, where
they resided as refugees for decades. Bands of Tiwa and Tewa people moved from the Rio Grande
region in 1700 to live among the Hopi, where they built new villages, including the Tewa village of
Hano on Hopi First Mesa in the northeastern area of present-day Arizona, where they remain
today. People from several Rio Grande pueblos also sought refuge at Ácoma during a prolonged

drought in the Rio Grande region at the time of the Pueblo Revolt, and they moved again in 1697 or 1698 to near present-day Laguna Pueblo.[3]

The rights of Indians gradually increased during the years following the return of Spanish control to the region until, in 1812, Pueblo Indians were granted full citizenship, legal equality, and the right to hold local elections for municipal governments.[4] In 1821, Mexico won independence from Spain, and trade was opened between Nuevo México and the United States via the new Santa Fe Trail from Missouri. Trade increased during the following decades, but friction grew between the Spaniards and Americans. American troops entered Nuevo México from Texas in 1841, hoping to gain control of the area east of the Rio Grande. They were defeated, but in 1846 President Polk declared war on Mexico, and American troops under General Kearny captured Santa Fe.

The war ended in 1848, and the Treaty of Guadalupe-Hidalgo ceded the areas of present-day California, Utah, and Nevada, and parts of New Mexico, Arizona, Colorado, and Wyoming, to the United States. The remainder of the present states of Arizona and New Mexico was added in the Compromise of 1850 and the Gadsden Purchase in 1853. The area that now includes Arizona, New Mexico, and parts of Colorado and Nevada was designated the U.S. Territory of New Mexico in 1850. American military troops were stationed throughout the region to protect the settlers and enforce their self-proclaimed right to enter and claim already occupied land. Because the Southwest was generally arid, the incursions were not as severe for Pueblo people as those faced by the tribes who occupied the vast, fertile plains east of the Rocky Mountains and the mineral-rich and coastal regions of the West.

The white population west of the Mississippi grew explosively after 1869, in part facilitated by the completion of the first transcontinental railroad in that year. A decade later there were three competing railroads that offered coast-to-coast service. Building a rail system to California through the Southwest, the Atlantic and Pacific Railroad entered Laguna Pueblo land in 1880 and reached Gallup, New Mexico, in 1881, the route later becoming part of the Atchison, Topeka and Santa Fe Railroad.[5] The first ATSF train from Kansas City to Los Angeles ran through Laguna in August 1883 (figure 10), and the railroad began promoting travel aggressively. Travelers could rest comfortably in Fred Harvey hotels at several railroad stops, enjoy good meals in Harvey dining rooms, and buy Indian objects at Harvey Company curio shops and directly from the makers.[6]

The ATSF facilitated the movement of tourists who were lured in increasing numbers by the promise of adventure amid cultures and landscapes that seemed foreign. It also brought artists, writers, photographers, academics, and aimless adventurers, in addition to settlers who staked out new homesteads in the Southwest, traders who saw opportunities for making money, and people traveling to California—all of whom could reach their destinations in comfort.

Indians and the U.S. Government

During the first half of the nineteenth century, U.S. government policy focused on eliminating the "Indian problem" by moving entire native populations from the eastern part of the country to the Indian Territory, an area designated (temporarily) as permanent Indian lands; it lay west of the Mississippi and was part of the Louisiana Purchase. In the last half of the century, U.S. governmental policy gradually changed from a policy of Indian elimination to one of assimilation of tribal members into regional populations of white society and the eradication of tribal identities. This policy included the natives of the Southwest, as well as to those in the far West.[7]

The U.S. government also attempted to undermine tribal authority over their people by allocating communal reservation lands (including Pueblo reservations) to individuals through the 1887 Dawes Act.[8] The act also made reservation land judged to be surplus available to settlers who were arriving in the West in rapidly increasing numbers. Some settlers also occupied Pueblo Indian lands without legal authority, and natives found little recourse in the courts. At that time, few people thought that the Pueblo way of life, which had existed for hundreds of years, would last much longer. In 1903, the curator of anthropology at the Field Columbian Museum in Chicago observed that "within a comparatively short period certain [Pueblo] Indian villages will cease to exist as such."[9]

The federal government surveyed New Mexico territorial residents in 1850 and found that few could read or write in any language; literacy among Pueblo people was far below the average in the territory.[10] Protestant reformers who came to the Southwest blamed the Indians' illiteracy on the Roman Catholic Church and its priests, saying that "for over two hundred years the Roman Catholic Church has professed to be engaged in the work of educating and christianizing these Indians and the result as shown by the Census of 1870 is that there were 7,683 Pueblo Indians in New Mexico of which only 57 could read and write a very little...."[11] By that time, more than 10 percent of the Indians at Laguna were Protestant; it was reported that the "remaining were Roman Catholic, worshippers of the sun, and necromancers."[12]

In the late 1800s Indians were considered to be wards of the United States, and their education became official U.S. government policy under President Ulysses S. Grant. As part of the government's focus on Indian assimilation through education, the U.S. Bureau of Indian Affairs in 1869 began inviting churches to send missionaries to the pueblos to establish day schools on the reservations. The purpose was to reverse the educational gap and convert the Indians to Anglo ways—which would result in their rapid and total integration into American society.[13]

The Hampton Normal and Agricultural Institute, a boarding school for educating minorities (principally African Americans) that had been established at Hampton, Virginia, in 1868, was the first national school to open its program to Indian students, in 1878.[14] Few Laguna children, to our knowledge, attended the Hampton school; far more important for the Lagunas was the Carlisle School.[15]

Capt. Richard Henry Pratt (1840–1924) founded the national school for Indians, installing it in an abandoned Civil War cavalry barracks in Carlisle, Pennsylvania.[16] The first academic year of the Carlisle Industrial Training School was held in 1879–80; the school attracted 1,040 Indian students for the first class, including several from Laguna Pueblo.[17] Other Indian boarding schools were established at Albuquerque (1881), Lawrence, Kansas (1884), and Santa Fe (1890), among other locations; many, especially Albuquerque, attracted students from Laguna Pueblo.[18] By 1900, there were twenty-five off-reservation boarding schools for Indians in the United States.[19]

At boarding schools, students were taught what administrators deemed would prepare them for everyday life in American society. Boarding school programs included the usual elementary school subjects, including English, arithmetic, geography, and history. Boys also learned blacksmithing, harness making, wagon making, carpentry, tailoring, and farming; girls were taught domestic homemaking skills, including cooking, sewing, and dress making.[20]

The guiding philosophy for all off-reservation boarding schools was the separation of children from "negative influences at home." School leaders believed that "the *best* way to permanently benefit these people is to take their children away from the demoralizing influence of their homes,

surround them with Christian [that is, Protestant] influence, [and] teach them *how* to live."[21] Pratt advocated moving all Indian children into the American civilization, that is, out of their tribal confines, "and it will kindly and speedily end the Indian problem. Continue fitting our civilization to the Indians on their reservations and they will remain an expensive incubus for generations."[22]

In an effort to prove the aptness of this philosophy, some arriving Carlisle students were photographed in their native dress, against a photographer's backdrop of "nature," to demonstrate their "barbarous" state. Three years later the same students were photographed again, with hair cut, dressed in school uniforms, and seated in fashionable Anglo-style chairs, to show how "civilized" they had become. This "transformation" is illustrated by photographs of three Laguna students (figure 11) in about 1880 and 1883.[23]

To reinforce the education they received at Carlisle, many students did not return home during summers but were employed in local homes in the school's "outing" system. Pratt emphasized that this plan was central to his educational goals. "Keep always in mind the truth that whatever brings the Indian into closer touch with whites who are earning their living by hard work, is of prime importance as an educating influence."[24]

In an oration at the Carlisle School on July 4, 1890, James G. Johnson, a lawyer from Randolph, New York, proclaimed that "no one stands in the way of the Indian but the Indian himself.... There is no end to the Indian problem as long as the Indians hang together, separate and apart from the rest of us. They must become individuals, scatter and seek broad opportunities."[25] Three weeks later, Pratt reminded departing Carlisle students that "[you are] not merely going home, [you] are going out to fight a battle.... If you want to pass away and die as a people, cling to the reservation. You must either die as tribes and rise as men, or else die utterly and forever."[26] Pratt's and Johnson's emphasis on the eradication of the tribes was, in fact, the goal of the U.S. government's assimilationist philosophy. "Education for extinction" is what David Adams called it in his book of the same name.[27]

Many people, however, viewed Pratt's and other Indian boarding school proponents' programs skeptically, and their numbers grew in the 1890s. Critics noted that "these institutions [boarding schools] kept Indians in an artificial environment and prevented them from adopting the lessons they learned to their surroundings."[28] More and more people understood that, while these educational programs were undoubtedly well intentioned, Anglo agricultural and household-management techniques were often irrelevant to the people they were endeavoring to help. They also pointed out that students returning home after three or more years in the Carlisle program were often horrified at the living conditions they found and the strangeness of traditional dress, which many were forced to resume wearing. Many became estranged from their own families, because they had been taught to believe they were uneducated and barbarous.[29] They also noted that some returning female students were forced to marry and immediately went "back to the blanket."[30] To Pratt and others, the return to native dress reflected a rejection of white values and represented failures in what the U.S. government and he were determined to accomplish. Margaret Szasz has observed "that the training they had received had little or no application to reservation life.... Their education forced them to choose either the culture of the white man or the culture of the Indian; there was no compromise."[31]

Pratt acknowledged the problems some returning students faced, admitting that "both boys and girls educated and trained at Carlisle to usefulness in civilized life, returning to that young man's tribe, have been cruelly and publicly whipped by the old and ruling Indians because they

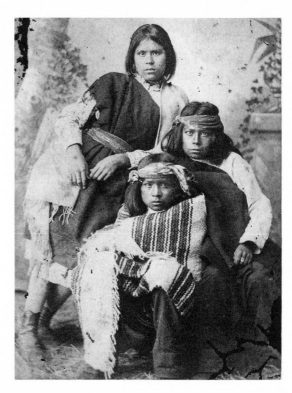

Figure 11a.
Photograph of three Laguna students at the Carlisle Indian School: Mary Perry (Ki-ot-se), Ben Thomas (Wat-ye-eh), and John Chaves (Kowsh-te-ah). The latter was misidentified as John Menaul. Mary Perry later married William Pasiano, who was governor of Laguna when Miss Foard lived there; both are pictured in figure 8. Photograph by J. N. Choate, ca. 1880. Courtesy of Spanish and Indian Trading Company, Santa Fe.

Figure 11b.
Photograph of the same three students, "after three years' training at the Indian School, Carlisle, Pa." Photograph by J. N. Choate, ca. 1883. Courtesy of Spanish and Indian Trading Company, Santa Fe.

insisted on keeping out of the dances and other demoralizing tribal customs."[32] One instance that bolstered Pratt's resolve to continue his practice had a Laguna connection: Ben Thomas (shown in figure 11), a Laguna student who attended Carlisle between 1880 and 1890, returned to New Mexico and taught at the Albuquerque Indian School. He wrote back to Carlisle that one of his Ácoma students, "James [Miller,] says it is true that he was whipped by the Ácoma officers just because he would not give up his citizen's dress, but says he will never give [it] up if they whip him to death." The editor of the Carlisle Indian School paper, in which his letter was published, added, "Three cheers for James!"[33]

The superintendent of the Albuquerque Indian School also advocated a revolution in traditional Pueblo beliefs in 1884, when he proposed that "the most important part of the education of these Indians is to train them to continuous labor, and to inspire them with the ambition to accumulate wealth by their own industry."[34] His words echoed the basic premise of the Dawes Act, which was intended to lead to individual ownership of tribal land and accumulation of wealth. His proposal must have been severely disquieting in Pueblo communities, since the traditional, fundamental belief of Pueblo people is that the contributions of individuals are of greatest value if they benefit all—as opposed to the Anglo focus on individual growth and wealth.

The commissioner of Indian Affairs, Francis Ellington Leupp, a persistent Pratt critic, questioned the simplistic approach to Indian education at Carlisle and championed the opposing plan of sending Indian children to less costly day schools where they would receive practical education preparing them to be farmers, ranchers, and artisans.[35] Thomas Donaldson, identified as an "expert Special Agent," echoed Leupp's questioning of the benefits of boarding school education for Indians, asking, "what is the reservation Indian to do when he gets this higher education? Loaf?"[36]

Critics of government boarding schools identified problems that education fostered in returning students, including at Laguna Pueblo. Donaldson, the compiler of the commentary on the status of Indians in the Southwest that accompanied the 1890 federal census report observed that

> there is a class of chronic grumblers in Laguna, which is largely composed of those
> educated at Carlisle and other government schools. They come back feeling better
> than their fellows and become useless mouths.... The government seems to be engaged
> in contributing to the discontent of the Indians by turning loose on them those
> educated loungers.[37]

The belief that Indians *must* be brought into the "superior" American mainstream gradually changed as a romantic fascination with the "Old West" developed and a will to preserve it grew. Consequently, efforts to preserve Pueblo crafts, such as pottery making, led inevitably to the belief that tribal survival was paramount—witness the programs of the Indian Industries League and the government field matrons, with which Miss Foard was associated, among others.

Perhaps swayed by the arguments of critics of Indian boarding school education, the leaders of associations devoted to the survival of Indians gradually shifted from their sympathetic support of assimilationist goals to one that advocated preserving tribal integrity, including tribal ways of life, through emphasizing and encouraging craft production and sales to whites. By doing so, they thought they could improve the economies of the tribes, which they considered the biggest obstacle to family and tribal stability. They set out to accomplish these goals by encouraging improvements to the native arts they admired, such as pottery and basket making, beadwork, and weaving,

and they also introduced others, such as lace making. In addition, they provided markets for these arts.[38] Miss Foard's work with the potters at Laguna dovetailed perfectly with these altered ambitions, although she remained an assimilationist in terms of religion, language, and education.

Miss Foard's 1899–1900 letters demonstrate she was in the camp of those who approved of sending Indian students to boarding schools to further their education. She came into contact with several Lagunas who had attended the Carlisle School and remarked positively on how that schooling had helped them, mentioning her perception of the benefits of receiving an education at the school.[39] She was also sensitive to the problems that students—and their parents—faced upon their returning home, however. On the one hand, she noted with concern, for example, that returning students sometimes were not treated well, writing that

> there are many Carlisle pupils here and I can tell you that the school training shows for
> good very perceptably [*sic*], even if they do sometimes go back to the old dress and
> customs. When I know that many times they are whipped and persecuted to make
> them assume the Indian dress I am sure that they are not to blame. The force brought
> to bear in this direction is powerful.[40]

On the other, she thought that the students should show more understanding for the parents' points of view, and she even supported a return to Indian clothing in another letter from Laguna:

> She was in a forlorn condition because all of her relations were tormenting her to go
> back to Indian habits and dress. As far as the dress is concerned I see no need of changing
> it as long as they live in a pueblo, because it is modest, pretty and convenient, and
> surely most healthy.... She told her grand parents that she would run away if they
> attempted to force her to wear Indian clothes.... I must confess that I think that they
> showed infinitely more love and consideration for her than she did for them. They
> offered the best they had; she gave nothing in return, not even a kind word.... I would
> not for the world have had her yield but she could have shown some gratitude.[41]

Yet, these examples did not really diminish her belief in Anglo education and Protestant religion in the assimilationist equation.

CHAPTER FOUR

Laguna Pueblo

Miss Foard probably visited Laguna Pueblo in 1898 when she made her reconnaissance tour of the Southwest. A description of the pueblo, a brief history of its founding, the influences of missionaries, and the effects of an internal religious schism help to convey the climate of the place where she moved the following year.

The Spanish name of the pueblo, Laguna, means pool or lake. It is called Ka-waika, meaning lake or lake people, in the Keres language of the native residents. The names allude to a nearby lake (originally a beaver pond) that washed out or was breached by jealous neighboring tribes in 1855.[1] The old village of Laguna (figures 4 and 10) is situated along the Rio San José, a tributary of the Rio Puerco, seventy miles by railroad west of Albuquerque and eighteen miles by road northeast of Ácoma Pueblo. It is in an arid region that sedentary agrarian people inhabited from the late 1200s. According to Laguna tradition, they migrated from the Mesa Verde region during the prolonged great drought that occurred during the last quarter of the thirteenth century and joined other people already living in the region.[2]

There is disagreement among historians about when Laguna Pueblo was founded. Dates between 1697 and 1699 are often cited, but the area was certainly settled much earlier than that, probably by the same group of people who formed Ácoma Pueblo, to which it bears similarities in tribal organization, religious practices, and pottery.[3]

Florence Hawley Ellis argued persuasively that the pueblo existed long before the commonly cited founding dates, noting that the confusion arose from Spanish records that document the building and consecration of the church there in 1699. Both Ellis and Elsie Clews Parsons noted that refugees from La Cieneguilla, Cochiti, and Santo Domingo Pueblos and some Ácomas moved from Ácoma in 1697 or 1698 to a location that was "a cannon shot distant from Laguna," which indicates that Laguna Pueblo already existed.[4] The refugees joined forces with the Lagunas to resist Navajo and Spanish raids, but in 1698 the Lagunas offered to make peace with the Spaniards. In 1699 the Europeans took formal possession of the village (along with Ácoma and Zuni Pueblos) and established the mission church of San José de Laguna in the same year. Later, most of the Cochiti and Santo Domingo refugees returned to their former homes along the Rio Grande.[5] People from other tribes also moved to Laguna during years of famine between 1777 and 1779.[6] In

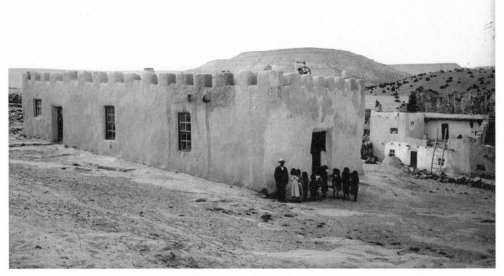

Figure 12. "Pueblo of Laguna old missionary home." Photograph attributed to William Henry
 Jackson, ca. 1890–1900. Courtesy of the Colorado Historical Society, William Henry
 Jackson Collection, acc. no. 86.200.1621; CHS.J1620.

addition to the Indians from other pueblos, Spanish people moved into the Laguna region, per-
haps drawn by the lake and its location along one of the major east-west trade routes.[7] Anglos
arrived in increasing numbers throughout the late 1800s and established villages, ranches, and
farms near Laguna.

Laguna prospered, with dry and irrigation farming and livestock raising the principal activi-
ties. Crops included alfalfa, corn, wheat, chile, and melons; livestock included horses, mules, cat-
tle, and goats, in addition to sheep. In the early 1700s the Spaniards estimated the population at
330 people, and by the early 1800s the population living in Laguna and its several outlying farm-
ing communities surpassed 1,000.[8] According to the 1900 federal census, there were 1,077 people
living in the villages of Laguna Pueblo when Miss Foard resided in Old Laguna.[9]

By the time Miss Foard arrived, six villages made up Laguna Pueblo. In addition to Old / New
Laguna, there are the villages of Paguate (ten miles north), Seama (eight miles west), Encinal (nine
miles northwest), Mesita (five miles east), and Paraje (six miles northwest), and there is also an
enclave of houses at Casa Blanca (six miles west).[10] In the original Spanish land grant, Laguna
Pueblo was allocated 125,225 acres.[11] Today, the villages are located on a reservation of 420,000
acres and have a population exceeding 3,800 people.[12] It is the largest of the Keres-speaking pueb-
los and the third most populous of the pueblos in New Mexico (after Santa Clara and Zuni).[13] In
about 1885–90, the former New Mexico governor, LeBaron Bradford Prince, whom Miss Foard met
in 1899, described the pueblo:

> The bluff on which Laguna stands rises gradually though irregularly from the banks of
> the San José, and is formed of naked buff sandstone without any soil whatever, the
> houses being built directly on the rock. This gives to the town a terraced form, one row

of houses rising above another, and the church standing on the summit like the citidel [*sic*] of a mediaeval city; the whole presenting from the other side of the river a most picturesque appearance. The streets are necessarily irregular, as they have to follow the surface of the rock, and in places they change into a series of steps cut into the solid stone. In at least two places in the town the alleys which run from street to street pass through narrow covered ways, over which the second stories of the adjacent houses extend. These passages are about 5 ft. in width & 10 ft. high, with solid rock floors; but the constant march of human feet, although unshod, through the course of centuries has worn deeply grooved paths from end to end.

This same result of constant travel is also seen in many of the streets of the town where well worn grooves tell of the passing of myriads of feet; and one of the most noticeable "sights" of the place, and really an amazing illustration of the result of constant though imperceptible wear, is on the easterly side of the Pueblo, where the approach is over a vast bed of rock extending up from the river, rough and seamed, through which for almost 500 feet extends a path way worn into the stone by continual passing, to a depth varying from 2 inches to 6 or 8 in the deepest parts. This path is quite narrow, no where exceeding 9 inches in width, demonstrating that even in past ages the inhabitants of Laguna were true to the custom of walking in "Indian file.". . . [14] [see figure 20]

All the buildings are of stone, the flat strata of the sandstone affording a convenient & easily worked building material; and the houses vary from 1 to 3 stories in height. The majority however are of stones, built in the usual terrace form, the second story being set back about 10 feet from the first one, so as to allow the latter to be entered by a latter [*sic*] through the roof. Some of the buildings are plastered on the outside, which gives them the appearance of being built of adobe; but the greater number show the edges of thin blocks of stone of which they are constructed. Originally all the windows were made of selenite, a transparent gypsum nearly resembling mica, pieces of which of great size are still to be found in many of the older houses. More recently however squares of glass have taken the place of the natural transparent stone, and now modern windows are to be found in all directions. The roofs are made of split wood placed transversely over the vigas, and covered with small straight branches usually willow, the whole of course with the usual covering of earth, "puddled" on top, & forming an excellent protection in this climate. [15]

Perhaps because the people of Laguna had a centuries-long tradition of permitting members from other tribes to settle there, the resulting acculturation made the pueblo more cosmopolitan in its treatment and acceptance of outsiders than many of the other pueblos in New Mexico. Among the Indians living in Laguna in 1939 were families traceable to ancestors from the Hopi, Zuni, Jemez, Ácoma, and Navajo. [16] The people of Laguna speak the Keresan language, as do those who live in Ácoma, Zia, Santa Ana, Santo Domingo, San Felipe, and Cochiti Pueblos. In the 1890s, however, Frederick Webb Hodge identified four different language groups at Laguna: Keresan, Tanoan, Shoshonean, and Zunian. [17] Of the nineteen clans at Laguna, five (perhaps six) came originally from Ácoma; four (perhaps five) came from Zuni; one probably came from San Felipe; one came from Zia; another from Oraibi at Hopi; two from Sandia Pueblo; one from Jemez; and two from Mount Taylor (Shoshonean). The origin of one clan was unknown. [18]

Reflecting the long acceptance of settlers from other cultures into their midst, the Lagunas also welcomed Protestant missionaries and other Anglo men into the tribe. Some married Laguna women and became involved in tribal leadership, ultimately wielding significant political power. Their influence helps to explain why Laguna was the first of the pueblos to Americanize.[19]

One of the first missionaries sent to any pueblo went to Laguna. Rev. Henry W. Read, a Baptist missionary from Cincinnati, accompanied the U.S. Army to Laguna in 1849, but his stay was brief.[20] The Baptist Missionary Society sent another, Rev. Samuel C. Gorman, and his wife, Catherine, to Laguna in 1851. He built a store, mission school, and chapel in 1856, remaining there for ten years.[21] The school building, which also served as a meeting house for the tribal council, was described in 1873 as resembling "the battlements of a medieval castle," long and rectangular, with a crenellated parapet (figure 12).[22]

Gorman's influence on the tribe was significant. It was reported in 1857 that

> the Indians have elected him a member of their community, with all the rights and privileges of a full-born Indian. He sits with them in the *estufa* in council when affairs of state are discussed, and preaches to them on the Sabbath in the village church, and, upon the whole, he is exercising a good influence over this simple-minded people.[23]

Surveying and exploration of the West boomed during the late nineteenth century under the aegis of the Geological Survey, the Weather Bureau, and the Coast and Geodetic Survey. Walter Gunn Marmon came to Laguna in 1868 to work on a boundary survey for the pueblo; three years later the secretary of the New Mexico Territory, Maj. William F. N. Arny, appointed Marmon as teacher of English and Spanish, doctor, and minister, receiving both a government salary and one from the Presbyterian Church Board of Missionaries.[24] Arny warned Marmon to avoid questions of religion and asked him to focus on engendering peace, both within the Laguna community and with its neighbors. Gaining students to attend his school regularly was not easy, however; Major Arny noted that Marmon attracted students during the first few weeks by bribing the children with presents but was forced to suspend school for weeks, even months, when few attended thereafter.[25]

Dr. John Menaul became the Presbyterian missionary at Laguna in 1875, succeeding Walter Marmon as teacher when the government withdrew its financial support of teachers on Indian reservations. The Presbyterian Church and the Ladies Union Mission School Association funded Menaul at Laguna from 1875 to 1889.[26] He and his wife, Charity, had previously served as missionaries among the Navajos and the Apaches.[27] Like most of his Protestant contemporaries, Menaul was critical of the Indians' continuing observance of tribal rituals, but he recognized they were important to ongoing Pueblo life and identity. At the same time he understood that those traditions were barriers to their assimilation into the American culture. He was also critical of the Roman Catholic Church and its record of educating the Laguna people, labeling Pueblo Roman Catholicism "baptized heathenism."[28] Nevertheless the Protestant religious services he conducted were held in the Roman Catholic church that was built in 1699.[29] In addition to teaching the 3Rs, Menaul conducted practical courses including agriculture, carpentry, weaving, and sewing.

Recognizing that an ability to communicate in the native language was critical to the success of his missionary and educational efforts, Menaul learned to speak Keres. He also endeavored to transcribe the language and is said to have translated two editions of *McGuffey's First Eclectic*

Reader, the Presbyterian *Shorter Catechism*, sections of the Bible, and annual reports into Keres, printing them on a press he purchased in 1877.[30]

Menaul had a significant impact on the attitudes of Lagunas toward Anglo education. While parents in many pueblos resisted pressure to send their children to school anywhere, some even going so far as to hide them or move to the mountains and assume nomadic lives when agents came to collect students and force them to attend boarding schools, the Lagunas were more prone than most to send their children to day and boarding schools.[31] He eventually succeeded in attracting between thirty and forty-five students to attend his day school during the early years, before boarding schools began attracting them away from the pueblo.

The inspector of Indian schools for the Office of Indian Affairs observed the difference in attitude between the Lagunas and people of many other pueblos in 1884, noting that

> from all the evidence I could obtain the day schools among the Pueblos with the exception of Laguna are total failures.... Day Schools among Indians are, as a rule, decided failures and will be during the present generation, as attendance can hardly be maintained with gifts every morning. Very few attend two days in succession, unless rounded up....[32]

The Lagunas' liberal support of Anglo education had notable effect: the compiler of the commentary on the 1890 federal census at Laguna noted that, of a total population of 1,143 individuals, 167 could speak, read, and write English.[33] Of the 435 children who were of school age (five to eighteen), 307 attended school, an extraordinary number in the pueblos:

- 29 were in Roman Catholic day school.
- 53 were in Presbyterian day school.
- 30 were in government day school.
- 40 attended the Albuquerque government boarding school.
- 48 attended the Albuquerque Presbyterian boarding school.
- 107 attended the Carlisle School.[34]

The Menauls remained at Laguna until 1889, when they moved to Albuquerque (taking the printing press with them) to direct the boarding school for Pueblo children the Presbyterians had founded there in 1881.[35]

In 1892 Laguna was said to be the most prosperous of all the pueblos. It was the only one where significant inroads had been made to convert Indians to Protestant faiths.[36] There were government, Roman Catholic, and Presbyterian teachers at Laguna. The school the Presbyterians ran was the main source of students for the Albuquerque Indian School, however, probably because of the Menauls' fourteen-year influential tenure as missionaries there.[37]

There were other Anglo settlers at Laguna who became influential in the tribe as well. These included Walter Marmon's brother, Robert, who arrived in 1872, working as a surveyor and trader; he established a general merchandise store at Laguna, operated a hostelry for visitors in his home, and conducted tours to nearby Ácoma Pueblo.[38] Marmon cousins Elgin and Kenneth Gunn also later moved to Laguna. Maj. George H. Pradt, a U.S. deputy surveyor, arrived in 1872, lived in Laguna for many years, and helped the Marmons with religious reforms.[39] Furthermore, the

Jewish merchant Solomon Bibo, who had established a mercantile business with his brother Joseph in Bernalillo, operated stores in Laguna and Isleta Pueblos, providing sales outlets for potters' work and supplying them with a source of income.[40] Solomon Bibo served as governor of nearby Ácoma Pueblo for four terms and moved to Laguna in about 1896, operating the store there with his brother Emil.[41]

Walter Marmon, John Gunn, and George Pradt, all Presbyterians, married Laguna women; Marmon's wife was the daughter of a powerful medicine man. Their families formed a bicultural colony on the eastern edge of Old Laguna (where Miss Foard's house and kiln were probably also located).[42] Walter Marmon was elected Laguna Pueblo's first governor in 1872, and his brother Robert was elected to the office in 1880.[43] The brothers drafted a constitution for Laguna based on the U.S. Constitution, the first for any of the pueblos, and they also instituted voting procedures.[44]

The efforts of the aforementioned Presbyterian reformers to remove all aspects of native religion soon led to a bitter dispute between Laguna factions. William F. M. Arny commented that the internal strife at Laguna was the worst among the pueblos, with four factions at Laguna contending for control.[45] One of the factions, the conservatives, was determined to preserve and practice their native religion, while another faction was made up of pro-Anglo progressives.[46] The conservatives were members of important clan societies, including the Koshare, and also included the town chief and the war chief. In late 1878 or 1879 the members of the conservative faction decided to abandon Laguna. Elsie Clews Parsons wrote that

> the withdrawing ceremonialists first took their altars and sacrosanct properties up a mountain [Mount Taylor] to secrete and protect them, and later brought them down to Mesita three miles east of Laguna. Meanwhile the two kivas of Laguna were torn down by the progressives, while Robert G. Marmon was governor, and there was a meeting at which the old women in charge of what was left of sacrosanct things brought them out and gave them up.[47] At Mesita the Kashare [*sic*] and the Town chief continued to live; but about 1880 the Flint, Fire, and Shahaiye Chiefs moved to Isleta, to become affiliated there with the two medicine societies known today as the Town Fathers and the Laguna Fathers.... After the Great Split and the laying of the railroad through the edge of town, there were no Kachina [katsina] dances at Laguna for some time....[48]

When they left Mesita, the conservative Laguna emigrants intended to settle near Sandia Pueblo, but the people of Isleta Pueblo detained them in 1881 and offered them land in exchange for the masked dances that they could perform—because, as Ellis and Parsons reported, Isleta katsina dances had been performed without masks, as was the case with others in their Tanoan language group, the people at Taos and Picuris Pueblos.[49] Eventually, however, many of the displaced Lagunas returned to their former home, but the religious leaders were required to remain at Isleta to guard and serve the katsina masks.[50]

The loss of the conservatives and the ceremonies they could perform brought the Lagunas closer to clans at Zuni and Ácoma, who participated in the partial reconstruction of Laguna ceremonials. Two katsina groups came to Laguna from Zuni around the time of the split, one of them (the Chakwena cult) arrived about 1860 or 1870, before the split occurred. According to Parson's informants, the split was caused, in part, by the introduction and increasing power of that cult.[51]

Close ties have existed with Zuni ever since, and men from Laguna often went there to help in such things as sheep shearing and crop harvesting.[52]

The exodus of the conservative members of the community to Isleta Pueblo and the hiring of Laguna men as Atlantic and Pacific and ATSF railroad workers reduced the population of Laguna over the years, further disrupting pueblo life; moreover the railroad-working émigrés probably included many of the younger men and their families. The agreement to hire Laguna people in perpetuity—considered to be a legal commitment, although it was never recorded in writing—was the price the Indians negotiated to grant the Atlantic and Pacific railroad permission to cross Laguna land in 1880.[53] The salaried jobs with the railroad undoubtedly also decreased the importance to the local economy of producing and selling pottery—although some potters continued to produce good quality pottery until at least about 1920.[54]

Because of the influence of Protestant missionaries, the Bureau of Indian Affairs introduced a series of rulings in 1900 that were intended to wipe out Indian religious ceremonials, which had already been actively suppressed for twenty years. That same year the bureau enacted a Religious Crimes Code making it illegal for an Indian to participate in any ceremonial that could be considered offensive to Christian standards.[55]

Elsie Clews Parsons noted in 1920 that the pueblo was left in "a state of irreligion from which they have never fully recovered" after the exodus of the religious conservatives. Furthermore, she said that "although the kachinas [katsina] cult now flourishes at Laguna, the kivas were never rebuilt, and Laguna is the sole pueblo that is not still controlled by its 'old men.'"[56]

Miss Foard did not mention knowing about the departure of the religious conservatives from Laguna in the 1870s and the destruction of the kivas thereafter, but she was nonetheless aware that ceremonial dancing was diminishing at Laguna, writing that "they do not practice as many of the heathenish dances as formerly."[57] Her view that the dances were "heathenish" reflected her Christian values and the attitudes of the missionaries around her—and among many Eastern supporters of Indians at the time.

CHAPTER FIVE

✦──✦

Laguna Potters and Pottery

S oon after arriving at Laguna on April 19, 1899, Miss Foard turned her attention to learning about the pottery made there. She wanted to experience everything she could about the process, from gathering clay to forming, decorating, and firing. Early in her stay, she was pleased to witness the centuries-old Pueblo method of making and decorating pottery and recorded what she saw in detail:

> We found the work in all of its stages. First, the fire clay modeled entirely by hand, and it surprised me greatly that they can get such good shapes simply by manipulation; not a mould of any kind do they use, neither do they have a model at which to look. They get fine modeling clay from a mountain west of here, and the vein extends eighteen miles I know but how much farther I do not know. After it is modeled they dry it in an oven or under a stove as occasion requires; after which they give it a coat of white clay, like paint using a cloth. After this dries they make brushes of strips of the stiff leaf of the Amole [yucca] plant. It is astonishing that they can do such beautiful work with such rude materials.... It is true that their work is all design and never shaded; geometrical designs but not geometrically applied.... The white clay is gotten on a mountain opposite from that in which the body clay is to be found. Their paints also are found in a different place, in the form of a stone; dull red, yellow, brown, and black are their only available colors. It you find blue or green paint on their pottery you may know that it was put on after the firing.[1] They grind their colors on a stone used as a mortar; they have no pestle; they hold the paint in their fingers and rub it on the stone with a little water until it is of the proper consistancy [sic], then apply it to the ware.[2]

She also noted that "the only tool used in making pottery is a piece of broken gourd and once in a while the bowl of a spoon, and a smooth stone with which to polish. Once I saw [a potter] use her thumbnail. They test the consistency of the clay by tasting it."[3]

Figure 13.
"Dwāyne burning pottery with cow chips." Photograph by Josephine Foard at Laguna Pueblo, ca. 1902, courtesy of the School for Advanced Research, Santa Fe, gift of Mrs. Millicent Berghaus.

Later the same day she saw the firing process that a potter named Guay-oo-ich used, and she critiqued what she saw with amazement:[4]

On a bed of stones she had placed her ware and about it she had piled up old bones and manure, (cow chips). I noticed the whole skull of a horse or cow. The bones served simply to help hold the fuel together, and to keep it loose that it might burn the better. The ware was completely covered with cow chips making a dome shaped kiln. A dense cloud of smoke a rose [sic] until the blue flames came out from all sides. Then gradually all became red; the ware could be seen through spaces where the chips had become exhausted. As soon as it became red hot, the fuel was dragged away and the pottery pulled out to the cool air, while red hot. This hurt my feelings for I knew that it must injure the pottery to some extent....I could not induce them to wait until it had cooled! The chips made a very hot fire....[5]

She also photographed another potter, identified as Dwāyne, firing pottery using the same traditional firing method (figure 13).

To our knowledge, Miss Foard's observation that animal bones and skulls were used in the firing was noted only by one other person at the time. Alexander M. Stephen also observed bones being used in a pottery firing at a Hopi Pueblo in 1892 but stated they were used for whitening it. "Bones of sheep, cattle or deer are sometimes laid in among the dung cakes, this to make the pottery white in the firing; as the bones turn white in burning the[y] impart the quality of whiteness

to the pottery. Bones of horse or burro are not used. These would darken the pottery."[6] While Miss Foard's identification of the skull as possibly being that of a horse may have been in error, she emphasized they served to make the fire burn hotter, which may thereby have whitened the pottery by burning out carbon impurities in the clay.

The pottery she saw being fired was primarily the sort of items meant for tourists, "mostly pipes and cute little cups. I bought a pipe for ten cents. We returned to Minnie's [Sice's] where we saw pipes which were more pretentious with modled [sic] faces and caps a la soldier on the bowls; some had birds perched on them, and one had a dog."[7] Judging by the examples that survive today, pipes with bowls in the forms of human heads and plain bowls decorated with flowers and other motifs were made frequently at both Laguna and Isleta Pueblos. The authors know of no examples with modeled freestanding dogs or birds; being fragile, they would have been easily broken off and then discarded.

The train station at Laguna was the site of most tourist sales. There are several photos of the activity there, which document that potters brought both large and small vessels in addition to trinkets (figures 14–16). In 1884, an observer noted that "sugar bowls and salt cellars were bric-a-brac that would have set Eastern collectors crazy with envy; they were ornamental ware, made by the pueblos of Laguna.... A dozen or so of the Indians were hanging around the door, waiting to sell their wares to the passengers."[8]

Both Laguna and Ácoma people sold their wares at the Laguna station, but it has been asserted—without documentation—that primarily Ácoma pottery was sold there to visiting tourists.[9] In spite of the fact that Ácoma potters had to travel eighteen miles (a three-hour trip by cart) to reach the Laguna railroad station and probably suffered breakage of their wares along the way, the sales they made undoubtedly convinced them that the trouble and loss were worth the effort and risk.[10]

The sale of pottery at the trains was not, however, a simple matter of who had pieces to sell. Foard reported that

> there are certain ones [at Laguna] who, even if they are potters, look with contempt upon those who carry their wares to the trains for sale. For there are superior and inferior potters. Some select their clays carefully and model accordingly; others stick it together as quickly as possible, fire it as carelessly, rush to the trains and sell it for little, and are satisfied to do no better.[11]

She also added that some of the better potters "do not frequent the rail-roads. They scorn the idea of selling pottery on the cars. If they make it they send their brothers or husbands to do the trafficking. There is a decided aristocracy among them...."[12] Miss Foard is the only person, to our knowledge, to document this hierarchy among Laguna potters.

Miss Foard probably did not engage in selling pottery at the train herself, for it is unlikely that tourists would have been keen to buy "Indian" pottery from an Anglo woman, but she probably counseled Laguna women on the sales pitches they should make in order to sell the "improved" wares.

Laguna potters carried their wares from the village to the train station, balancing large jars on their heads. They made the first trip in advance of the arrival of the morning train and waited at a walled enclosure near the station for later trains (figures 14, 16).[13] It was there that Miss Foard

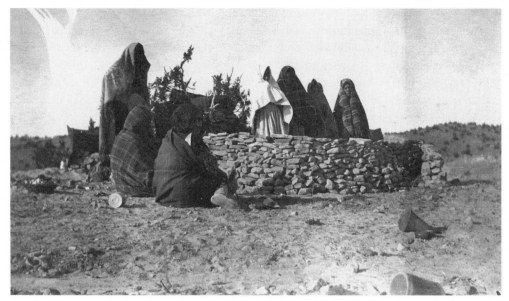

Figure 14. "Potters waiting for the train to sell their ware. Laguna N. Mex.," ca. 1902. Photograph
by Josephine Foard, courtesy of the School for Advanced Research, Santa Fe, gift of
Mrs. Millicent Berghaus.

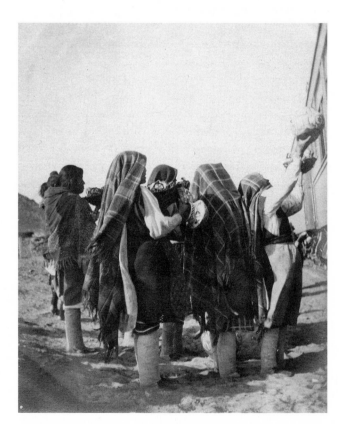

Figure 15.
Potters selling their pottery at
the Laguna Pueblo stop of the
ATSF, ca. 1902. Photograph by
Josephine Foard, courtesy of
the School for Advanced
Research, Santa Fe, gift of
Mrs. Millicent Berghaus.

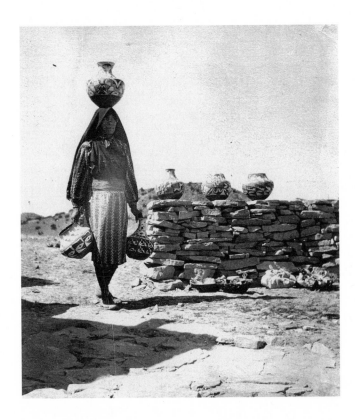

Figure 16.
An unidentified Ácoma or Laguna potter with pottery to sell at the Laguna railroad station. Miss Foard is shown examining some of this pottery in figure 1. Photograph by Josephine Foard, ca. 1902, courtesy of the School for Advanced Research, Santa Fe, gift of Mrs. Millicent Berghaus.

inspected and selected some of the pottery she glazed (figure 1). The wares she saw consisted of large water jars, tall-neck jars, and smaller objects more suitable for tourists.

Even though some Laguna potters, like those at Ácoma, continued to produce refined objects during the early twentieth century, pottery making in most pueblos was declining by the 1920s. Alfred V. Kidder wrote in 1925 that

> no pottery is manufactured at a number of towns. If this condition had come about within the last decade it would have been easy to account for, as tin oil cans for holding water, enameled pots for cooking, and china dishes for serving food have lately been pushing native pottery out of use. But no pottery, other than rough cooking ware, has been made for a long time at Taos, Picuris, San Felipe, Jemez, and Sandia; while the art is practically or wholly extinct at Laguna, Isleta, and Santa Ana.[14]

Ruth Bunzel noted in 1929 at Laguna that

> here we have a dying art, now uttering its last feeble gasps. It has succumbed to commercialism, complicated by the removal of the market when the Santa Fe railroad removed its tracks and built a new station three miles from the pueblo. The women are all hopeless about the state of their art. They would say, "We don't make good pottery here any longer. Why don't you go to Acoma? When we want pottery, we buy it from

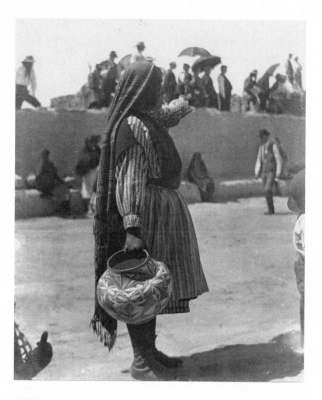

Figures 17 and 18.
Two unidentified Laguna or
Ácoma women carrying large
water jars. The photograph in
figure 17 was taken in the Laguna
Pueblo plaza, and judging by the
number of people sitting and
standing above the wall, the pho-
tograph may have been taken at
a feast day, perhaps the annual
Feast of San José on September 19.
Undated and untitled photographs
by Josephine Foard, ca. 1902,
courtesy of the School for
Advanced Research, Santa Fe,
gift of Mrs. Millicent Berghaus.

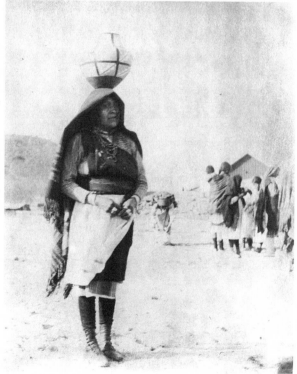

the Acomas." A few women still make small pieces which they peddle on the road, but not only are they inferior in workmanship, but the old style has completely disintegrated, and the products show the wearisome repetition of a few elements without any apparent sense of order or of style.[15]

Few Laguna potters sold their wares at the new station north of Old Laguna.[16] The Ácomas also had new train stations at Ácomita, McCartys, and Anzac, where they sold their pottery.[17] In 1937, the Chicago-to-Los-Angeles highway, U.S. Route 66, was completed, running slightly south of Laguna Pueblo. A few potters sold their wares to tourists on the highway, but by then most Lagunas had stopped making pottery altogether.

Individual Potters at Laguna

No potters were enumerated in the commentary accompanying the 1890 federal census in any of the pueblos, but the author explained that "most of the women are pottery makers where pottery is made...."[18] Miss Foard did not mention how many people were making pottery at Laguna in her 1899–1900 letters, but she did record the names of several female and male potters whose names are otherwise unrecorded today. There are no known documented examples of pottery by any of these potters.[19]

Unfortunately, but unsurprising to us, it has also proven impossible to identify further most of the people she mentioned. Miss Foard spelled the names phonetically, but because she was not fluent in Keres, we may assume she did not record the names accurately. For the same reason, neither are census reports usually very useful for finding or confirming biographical data for individual potters or estimating how many there were. Furthermore, with enumerators changing from year to year, spellings varied widely from census to census. As a result, it is frequently impossible to correlate individual names from census to census or to other records.

As in earlier censuses, no potters were identified as such at Laguna in the 1900 census, although, judging by Miss Foard's comments, several were active then. Perhaps census enumerators did not identify them as potters because few if any of them made pottery full-time. That six Laguna women said they were servants in 1900 does, however, suggest they were asked what they did. Perhaps the women did not enumerate pottery making as their work because potting was simply part of women's duties in the pueblo. For the same reason, it would not have occurred to them to indicate that they were responsible for grinding corn or plastering the walls of their houses with adobe, since those were, among other responsibilities, also considered women's work. In any case, the work of Pueblo women was almost never itemized in the decennial federal censuses in any way other than "household work."[20]

The census taken at Ácoma in 1910 listed seventy-six people who said that they were potters, but only two were listed at Laguna (Yamie Leeds and Miss Foard).[21] Although the startling difference in the number of potters listed at the two pueblos may indicate how precipitously pottery making was declining at Laguna, it may have resulted instead from the lack of interest of the individual census taker at Laguna. In any case, Miss Foard's 1899–1900 letters document that there were several active potters at Laguna in the decade preceding the census of 1910. We speculate that the number of potters decreased continuously at Laguna during the first two decades of the twentieth century, but we also consider it unlikely that all those whom Josephine Foard knew were

Figure 19. Carlisle Indian School official photograph of some of the male students who graduated in 1891. Yamie Leeds is shown at the right, where he is identified as number 16. Other students from Laguna Pueblo include Benjamin J. Thomas (number 7) and Walter Anallo (number 12). Photograph courtesy of Spanish and Indian Trading Company, Santa Fe.

making pottery in 1899–1900 had stopped doing so by 1910. Nonetheless, potting had probably all but ceased at Laguna by the late 1920s.

The federal census for 1910 enumerated only one Laguna person (other than Miss Foard) who listed pottery making as an occupation: Yamie Leeds, Miss Foard's assistant, who was then thirty-nine years old and living at Seama (figure 19).[22] His Indian name, according to Miss Foard, was Yeyutetacewa, but it was not used in censuses.[23] Three photographs of Leeds were taken while he was at the Carlisle School, where he was in the class of 1891.[24]

Miss Foard outlined her requirements for an assistant in 1906. "He must be a man of intelligence, a graduate of one of the Government schools, able to speak English, keep accounts, and learn the practical points of pottery making and baking, that he may carry on the work alone if necessary."[25] She did not record specifically why she chose Leeds, but as a graduate of the Carlisle School, he spoke and wrote English, satisfying at least some of the stated requirements. She did not say whether he knew anything about potting before she hired him, but she did record that he was making tiles for her by 1906 (see plate 14); we do not know if he made pottery vessels. In addition to his other work for her, Leeds hand-printed cards for a display of Ácoma pottery that Foard sent to the Jamestown Exposition in 1907.[26]

Female potters working at Laguna around 1900 who were documented by Josephine Foard in her 1899–1900 letters included:

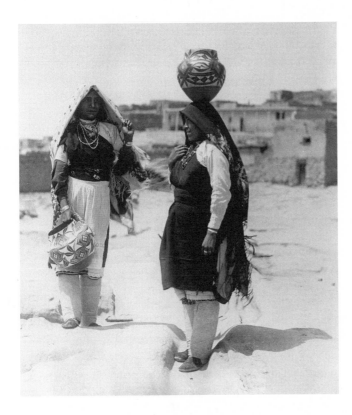

Figure 20.
Minnie Sice (left) and
Louise Beeker, Laguna
Pueblo, ca. 1900.
Photograph by William
Henry Jackson. Courtesy
Colorado Historical
Society, neg. no. WHJ15275.

- Mrs. Billen: Miss Foard mentioned that Mrs. Billen was Minnie Sice's mother and a potter, but said nothing about her or her pottery.[27]
- Dwāyne: Miss Foard observed and photographed Dwāyne firing pottery around 1902 (figure 13), but she did not mention her in her letters or give us any clues about her familial relationships to others or how to recognize her pottery.
- Guay-oo-ich: Miss Foard observed Guay-oo-ich making and firing pottery. She also identified her as Bart (or Bert) Whetmore's mother.[28] Foard saw her firing "pipes and cute little cups." In the 1889 Pueblo Indian Census Roll, Bert Whetmore's mother was identified as "Maria," age forty-three; she and her son were then living at Seama.[29]
- Minnie Billen Sice (Indian name, Tzu-Chey): Miss Foard mentioned Minnie Sice (also spelled Size) several times in her letters (figure 20, left).[30] Foard used a cup made by Minnie Sice the first time she glazed Pueblo pottery at Laguna. She also mentioned seeing pipes that Sice had made.[31]
- Yīes: This potter was mentioned in Miss Foard's letters as "Louisa's grandmother."[32] Her name has not been identified by the authors in Laguna census records.

In addition, photographers recorded the names of two other women who were at Laguna and who may also have been potters around the time that Miss Foard was there. Foard did not, however, mention them in her letters. These included:

- Lottie (or Lotta) Atsye: Lottie Atsye may have been a potter. She is pictured in photographs taken in 1910, along with several pieces of pottery.[33] She attended the Hampton School and was enumerated in the 1904 Pueblo Indian Census Rolls at Laguna when she was age eighteen and living alone. Harriet Atsye, who may have been her mother, is listed after Lottie in that census.[34]
- Louise Beeker (or Beecher; Indian name, Triz-Ray): Triz-Ray (or Louise Beeker / Beecher) is shown in figure 20 (right) with a pottery jar, suggesting she was a potter. She may have been the person identified as Louise Kawakia, who was married to Beecher Kawakia, in the 1904 Pueblo Indian Census Roll (person number 120) at Laguna, when her age was given as thirty-five.

Miss Foard also mentioned an Ácoma potter:

- Annie Miller: Miss Foard referred several times to "James Miller's wife" (without using her first name) and said that "she is handsome and makes fine pottery."[35] There are two pairs of unglazed miniature Pueblo moccasins in the Foard Collection at the University Gallery of the University of Delaware that are documented by attached paper labels inscribed "Toy Moccasins made by Annie Miller Acoma N. Mex. Josephine Foard."[36] Foard said that James Miller attended the Carlisle School; she met him during a trip to Ácoma, so he and his wife may have lived there.[37] Two people named James Miller were listed in Ácoma censuses, but only one had a wife identified as Annie.[38] James was probably the man who said he had been beaten at Ácoma when he refused to return to native dress (see chapter 3).[39]

Male Potters at Laguna

Men who made and decorated pottery were in the minority among Pueblo potters.[40] Foard commented that mainly women made pottery at Laguna, but "sometimes the men model and do it very well...."[41] She also noted that "not every woman is a potter, for a certain talent is required for the work. Occasionally a man will take it up, and a few men will assist their wives with the designs, but this is rare."[42] Three of her assistants, however, were men, and one of them (Yamie Leeds, pictured in figure 19) was listed as a potter in the 1910 federal census. Foard did not mention whether her other male assistants, George Dailey (figure 21) and John Deems, also made pottery.

She did refer to two other men who were potters in her letters, and she noted that both dressed and lived as women. The realization that this life-style existed among Pueblo Indians surprised and flustered her, although Pueblo men who chose to dress and live as women have been documented at several pueblos in the Southwest, including Ácoma, Hopi, Isleta, Laguna, Santa Ana, Santo Domingo, San Felipe, San Juan, Tesuque, and Zuni.[43]

Zuni men who dress and live as women are called *lhamanas*, and at Laguna they are called *kokwimu* (*kok'we'mä*).[44] In Zuni culture, lhamanas are seen as bridging genders, and their role is viewed as a unique personality configuration; sometimes, however, they changed their names from masculine forms to feminine forms when they assumed women's work and dress.[45] Their preference for doing female work was considered to be their key trait—as opposed to the focus of Anglo society on questions of homosexuality. To the Zunis, "the social roles of men and women

were not biologically determined but acquired through life experience and shaped through a series of initiations.... they viewed *lhamanas* as occupying a *third* gender status, one that combined both men's and women's traits...."[46]

Elsie Clews Parsons reported that a boy at Laguna Pueblo could become a man-woman if he merely preferred women's work to men's and said the choice was usually made in childhood.[47] She later noted that "should a man take to women's work, he is expected to wear women's clothes and conform in general to women's ways."[48]

Men who lived and dressed as women have been called men-women, women-men, *amujerados*,[49] transvestites, *berdaches* (a term French explorers originally used to describe a male Indian who did women's work and sometimes formed emotional and sexual relationships with men), and cross-gender roles.[50] Occasionally they have been termed hermaphrodites, but medical doctors who have studied them since the mid-1800s determined that they were anatomically male.[51] Men living as women were not limited to Pueblo society, however; there are references to them among Indian tribes throughout North America.[52] (We use the widely recognized terms, man-woman and men-women, in this book; we also use the masculine pronoun when we discuss men-women and their pottery.)

The physical strength of men-women was an undoubted asset in their roles in a pueblo, including making pottery. In the late 1800s at least four Pueblo men-women in New Mexico were considered to be among the best potters of their tribes. Matilda Coxe Stevenson mentioned in 1904 that there had been five men-women at Zuni in recent times, but that "until about ten years ago there had been but two, these being the finest potters and weavers in the tribe." One of those was We'wha, and because of We'wha's potting skills, Stevenson commissioned him to make pottery for the Bureau of Ethnology.[53] George Wharton James said that We'wha's "pottery fetched twice the price of that of any other maker...."[54] Another reporter noted that "it was the highest compliment if a woman was told that her work was as good as a berdache's."[55]

The two men-women potters Miss Foard mentioned at Laguna were:

- Gayãterre
- Richard (Lillie) Hill: Foard recorded that she met a person selling pottery at the train she thought was a girl. She asked about a piece of pottery she had just bought and discovered the truth, to her dismay. Later, she expressed clearly her gender-roles bias, writing:

there is a peculiar order among them where the men prefer to be called women and assume women's clothes doing their work and receiving woman's wages. They are spoken of as man lady or man woman and as, her, and she. The respectable Indians dislike them and treat them with contempt. Fortunately they are but few. Richard a Carlisle scholar much to his shame calls himself Lillie Hill. Another Gayãterre makes fine pottery[.] Richard's is not so good. It is said that his mother compelled him to take this part as a girl because she wanted a daughter, but I have also been told that it is a sort of religious order not countenanced by the other Indians.

At the train one night I asked some one about a clay bird. As the person of whom I bought it replied in English I asked her name. She gave an Indian name and I said Oh! you speak English, give me your English name. As he did not answer an Indian woman said contemptuously "It is Richard, he is ashamed to tell you." Miserable fellow a well

educated man! Strange notion to want to to [*sic*] pass as a woman! When he went to Carlisle dressed as a little girl, a boy I am told, wrote to Major Pratt "Do not put this girl in the girl's quarters, for this girl is not a girl, this girl is a boy."[56]

No references to Richard/Lillie Hill have been found in Laguna census reports that would enable the authors to identify him or his family further. He may, however, have been the Laguna man-woman named Valentine Queoyoa, a Laguna potter who sold his products at the train station.[57]

The possible correlation of the two names is suggested by a story Elsie Clews Parsons recorded. She wrote about a male student attending school as a girl; it is a story that is similar to Miss Foard's, although it differs in some key details, such as which school was involved. Parsons reported that "Kuyuye…had been at school…at Santa Fe [in Miss Foard's story, he was at Carlisle]….After some time he was found out at school and made to wear boy's clothes and placed with the boys."[58] Parsons called him "a fine potter."[59]

Miss Foard knew about Valentine Queoyoa but never mentioned him by name or said he made pottery. No pottery by him is known. She did, however, record his involvement in a bizarre murder at Laguna.[60]

Gayāterre: As mentioned before, Miss Foard noted that he "makes fine pottery," but there are no known examples of his work, either.

Additional names of Laguna men-women, that is, males the census enumerators identified as dressing as females, have been found in pueblo censuses, but it is unknown whether they made pottery.[61] None of these men-women, however, is the famous Laguna man-woman potter, Arroh-a-och. His is another story, though, and it is discussed in detail, along with that of the Zuni man-woman We'wha, in Dwight Lanmon's published articles.[62]

CHAPTER SIX

Miss Foard's Glazed Pottery

Josephine Foard moved to Laguna Pueblo, because, she said, "the Indians [there] make good pottery, such quantities of it and a great variety of designs in the decorations...."[1] At the same time, however, she observed that the Laguna pottery was often poorly fired and brittle.[2] She had no doubt that she could increase its strength and establish a market for it among easterners, knowing as she did that Anglos appreciated the decorative quality of Pueblo pots. In one letter she noted that

> there is an endless variety of them and people here and at Santa Fē, in fact all over the country have them in their halls and drawing rooms just as Eastern people have handsome jardeniers [sic] standing here, there, and every where. They make beautiful flower pots. I'd like to give an afternoon tea and have my flowers in them.[3]

She realized, however, that the porosity of Pueblo pottery was a significant liability in Anglo homes, thereby limiting its market. She acknowledged that this inherent attribute of Pueblo water jars made them superbly adapted to their original function:

Until recent years these Pueblo Indians never saw a water bucket, but carried water from the springs on their heads in *duonnes* (water jars) made by themselves or their friends. They place them full of water on the floors of their living rooms just as white people do their buckets in their kitchens. It is true that they leave a moist spot, but this evaporation tends to keep the water cool like that fresh from the spring. I knew of some *duonnes* that have been thus used for years and are still perfect.[4]

She also knew, however, that water that permeated the pots would ruin varnished or painted wood surfaces common in eastern households, her intended market for the pottery. She focused, therefore, on making the jars waterproof by glazing their interiors to correct the problem, saying that

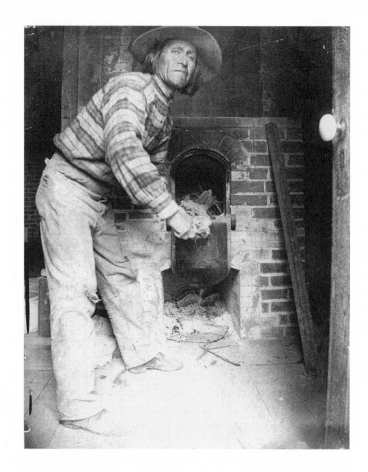

Figure 21.
"George Daily replenishing the kiln with kindling." Photograph by Josephine Foard, ca. 1902, courtesy of the School for Advanced Research, Santa Fe, gift of Mrs. Millicent Berghaus.

she would teach "the Pueblo women to glaze their pottery, strengthen it sufficiently to stand ordinary use, and then market it among handicraft lovers in the East."[5]

Miss Foard initially experienced difficulty persuading the Lagunas to accept her ideas. She showed them a glazed white teacup (perhaps porcelain) shortly after she arrived, saying, "Do you see how nice and shiny this teacup is? Well I am going to teach you to put that shine on your beautiful pottery. And they grunted and said 'Very ugly; all white.'"[6] Undaunted, she decided to glaze some Laguna pottery using the traditional Pueblo outdoor firing method (figure 13). She wrote that she had "been experimenting with pottery, a la Indian, and succeeded in getting a beautiful glaze on a cup, made by Minnie Sice [figure 20, left]. Some of them are in a great state of excitement about it and so am I. I used cow chips too for fuel."[7] She also said that she converted a Pueblo bread oven for her first experiments in firing glazed pottery at Laguna.[8]

Miss Foard's first experiments with glazing provoked a humorous encounter, which she clearly relished telling her sister. The passage deserves quoting in full, because it reveals aspects of her character as well:

Thinking to avoid the heat of the day, in the gloaming I took a little express wagon and gathered chips [cow dung] and loose pieces of coal which I found lying about, hoping

to have enough with which to experiment the next morning in glazing some little pieces of Isleta pottery; nevertheless the next morning I was compelled to go out in the glaring sun and gather more. You cannot buy a particle of coal here[.]

I glanced around furtively, for I did not want even an Indian to see me at my beggarly task. But when one has an idea to carry out especially a philanthropic one, and a grand one, what does the menial part amount to? To stoop is but to rise after all! So I gathered chips with a happy heart. I had arranged my toilet for my work, and was an object to behold. I am happy to say though that I was clean, even though grotesque looking. My gingham gown was of large blue and white plaid which tended to make me look shorter and stouter than I was. I have plenty of flesh as you know, and the southern sun had reddened my face and made me coarse looking as a New Mexican sun knows how to do. But what did all of this matter to me, had I not a high, a grand object in view? I would almost grovel to attain it. On my head I had a large black sun hat pulled down and tied under my big, fat chin a la Gypsy. I held a small shovel and an umbrella in one hand and under the opposite arm I had a small box tucked, in which I had put a few pieces of coal.

I had gotten a splendid fire started and was coming from the rocks where the kiln had been improvised, when a voice from the rail-road startled me by calling out "Are you traveling Aunty, I see you have your camp fire?" I looked about me; no other woman was to be seen; surely the man must be talking to me! Just for one second, a feeling of indignation swept over me at the idea of being spoken to so familliarly [*sic*] as Aunty by that sooty, dirty looking, rail-road employee. Had he been a gentleman though the feeling would have been intensified, but I remembered my attire and occupation knowing that the man saw me only at a distance; and he seeing me in the very act of picking up a piece of coal took me for a veritable tramp. This did not dawn upon me until I had left him; and then, it struck me forcibly as I walked back to the kiln. I laughed and laughed, subsided and broke out afresh; The more I thought of my appearance and viewed the smoking pile of chips the more ludicrous it all appeared. But as I drew near the man, I explained to him what I was doing. Some time after when I had gotten my fire to work satisfactorily and was returning to the house I heard a voice again, and looking up at a passing coal car I saw several pieces of coal, rapidly landing before me, in the distance, from the hands of the man who had mistaken me for a tramp. He smiled as he passed and saw that I understood his kindness. It was a sort of an apology for having placed me so low, in the scale of humanity. I really wanted cow chips not coal, but I had picked up the few scattered pieces to see if they might not help the fire but found that they chilled it.... A camp fire it looked indeed in the shade of those huge volcanic rocks, but to me it was far more, it was full of novelties and romance and wild expectations....[9]

The embarrassment she expressed at being seen and mistaken for a tramp by a railroad worker is a graphic expression of her Victorian sense of propriety, social status, and—probably unconsciously—her own cultural superiority over those she was determined to help. This is especially apparent when she expressed the hope that no Indian would see her gathering fuel. In doing so, she betrayed a separation between herself and the Lagunas: she considered the act of gathering

coal demeaning but never commented about how Laguna potters routinely gathered dried animal dung for fuel to fire their pottery. Her reactions to these experiences also reveal her ambivalence to adjusting to a new life in a new place, one much different from that which she and her family knew. The fact that she described her clothing in such detail, however, may have been intended to convey to her younger sister that she was maintaining cleanliness and had not abandoned the principles of proper eastern decorum.

She showed the glazed pottery to some of the Laguna women, who "were so delighted with the first glazed pieces that they rubbed them against their cheeks, like a child with a kitten."[10] In order to spread the word of what she was attempting, she decided to explain to the Indians how the glazing would expand the marketability of their pottery. The response was disappointing and likely reflected the negligible value the Laguna potters placed on Foard's ideas for improving their pottery:

> After all my visiting and kind invitations yesterday to induce the Indians to come and hear my talk in order to help them in a certain industry only five came.
>
> Hugh Johnson came first and that was well, because he was to interpret for me. [11] He was a Carlisle student and speaks good English. I had explained things to him when the two Marias came.
>
> They seemed empty handed but tucked away in their black, blouse, like waists were three pieces of pottery. After some talk they pulled them out and asked me if I would make them shine as I had Minnie's?[12]

She told the Board of Indian Commissioners that

> the pieces were crude, but the glaze was right. When she [Miss Foard] took out the first cup and showed it to the Indians then something wonderful happened. When the most intelligent young Indian saw the cup and took in what the glaze was, he leaped up into the air and began to scream. "What is the matter?" "Now I know," he cried; "now I understand; Indian make money now; have plenty to eat, have plenty to wear."[13]

The Kiln

Miss Foard's first efforts at glazing Pueblo pottery were done in a converted Pueblo bread oven, but the kiln she eventually built was of significant size. Constructing it was undoubtedly her greatest single expenditure of the more than thirty-five hundred dollars that she eventually spent.[14] It was undoubtedly the first ever used in any of the pueblos in the Southwest, and it must have caused a sensation. It was mentioned in the *Report of the Board of Indian Commissioners* for 1899, and it was still of interest in 1901 when the Zuni missionary-teacher, Mary K. Dissette, mentioned it in a letter.[15] It was featured in the 1906 *New York Times* and the 1907 *New York Tribune* articles on Foard's work at Laguna.

It is not known precisely when Miss Foard began firing pottery in her kiln, but it must have been late in 1899. On August 13, 1899, she recorded receiving a load of bricks from Albuquerque, and she noted there were "white fire bricks" among them.[16] Miss Foard sent a photograph of the kiln to the Board of Indian Commissioners in October 1899; construction of the kiln must have

been more or less complete by then, but she noted it would be much more convenient to live near the kiln.[17] Her house, contiguous to the kiln, was completed in December 1899.[18]

The firebox of the kiln is shown in figure 21. George Daily (or Dailey), whom Foard mentioned several times in her letters, is shown stoking it with fuel. She noted that he is a "full-blooded Indian" and the "boss adobe builder" on her house.[19] Judging by the photograph, the kiln was a large structure, nearly filling the room. The firebox is in front of a large structure, presumably the chimney. There are bricks below the opening that are of a contrasting, lighter color than most of the structure; those were probably some of the "white fire bricks" she mentioned. A drop-down metal door is shown open, and Daily is stoking the chamber with kindling. That the kiln was fired with wood is documented in letters to the commissioner of Indian Affairs.[20]

The back wall of the room, to Daily's left, is faced with red bricks. The remaining fire bricks probably lined a large chamber, which is not visible, where the pots would be placed during firing. Pottery was enclosed in saggars (covered cylindrical ceramic containers) that shielded the pottery from ashes and smoke during firing.[21] Judging by surviving glazed pots, the kiln was large enough to accommodate saggars that held jars at least 13 inches (33.0 cm) in diameter and 10¾ inches (27.3 cm) tall (see plate 7), and perhaps as large as 14½ inches (36.8 cm) in diameter.[22]

In addition to constructing the kiln and using it to fire glazed and unglazed pottery, Foard built her own potter's wheel, also probably the first ever seen or used in any pueblo, since all Pueblo pottery made before that time (and most of it since) had been built by coiling and scraping.[23] We do not know whether Laguna potters ever tried throwing pots on Foard's potter's wheel, but one Indian-decorated bowl she may have thrown and glazed is shown in plate 13.

Foard bought all the pottery she glazed from the potters, saying it was necessary "to buy pots from the Indians because they were too poor to wait for sales."[24] Although she suggested throughout her letters that she glazed Laguna pottery because the focus of her mission was to improve their pottery, none of the known, identified examples are documented as coming from Laguna—although some may be.[25] Three pieces are identified as coming from Ácoma (see plate 3 for one), and the examples she sent to the Jamestown Exposition in 1907 were all from Ácoma.[26] We speculate, therefore, that most of the pottery she fired was from that pueblo, even though her stated intention was to work with the potters and pottery of Laguna Pueblo.

While it is likely the supply of Ácoma and Laguna pottery offered at the train station was adequate for her needs, she did not limit herself to those sources. She glazed Hopi (plates 4 and 5) and Isleta pottery and also indicated she planned to glaze pottery made at Santa Clara and Santo Domingo Pueblos, but no examples of glazed pottery from the latter three pueblos are known.[27]

A newspaper reported Miss Foard's comments on Hopi pottery in 1907:

Of all the Pueblo tribes the Mokis and the Acomas make the best pottery. The Moki or Hopi pottery is the best known of all, like everything else about this tribe, because their strange snake dance has made them known throughout the world. But Miss Foard considers the Acoma superior, and, indeed, believes that the excellence of the Hopi pottery is due to the fact that Nampei [Nampeyo], an Acoma woman, married a Hopi. She is now a very old woman, famous as the best of the Hopi pottery makers and the teacher of the younger women. Acoma is more accessible, being only eighteen miles from the railway. So Miss Foard decided to experiment with the Acoma pottery rather than with the Hopi.[28]

In a 1906 letter, however, she asks to obtain examples of Hopi pottery, and the survival of at least three Hopi jars she glazed indicates that the newspaper article was not accurate (for illustrations of two, see plates 4 and 5).[29] One of those jars is attributable to Nampeyo (plate 4). In addition, her information about Nampeyo's background was incorrect: she was not from Ácoma, but was a Tewa Indian, her ancestors having migrated from the Rio Grande valley around 1700 to the Hopi First Mesa area in northeastern Arizona, where they founded the village of Hano.[30]

In addition to having practical knowledge for constructing a kiln, Miss Foard also possessed some technical knowledge of ceramic chemistry. She prospected for raw materials for glazing and tempering Laguna pottery clay, noting that she drove into the countryside "in search of feldspar and found it. I wanted to experiment with it in potter's clay."[31] Yet we believe that all of the glazes she used were commercial products she obtained from the East. We do not know for certain how many compositions she used. In one letter, Foard noted that she "tested the clays with different glazes and various firings a long time before venturing to put the pottery on the market as improved ware."[32] All the glazes were probably lead-based and fusible at the temperatures obtainable in a kiln heated with wood fuel. Four different glaze colors have been noted by the authors.[33]

Miss Foard's Indian assistant Yamie Leeds mentioned that she used a "Volkmar" glaze on tiles (plate 14). That glaze was undoubtedly purchased from Charles Volkmar (1841–1914), whose pottery studio, Volkmar Kilns, was located in Metuchen, New Jersey, between 1903 and 1911. Furthermore, Foard and Volkmar were probably acquainted because Volkmar was a director of the National Society of Craftsmen and a member of the exhibition committee of the National Arts Club / National Society of Craftsmen, where he exhibited examples of his glazed pottery and Miss Foard exhibited glazed Indian pottery and silver jewelry in 1906 and 1907.[34]

Hiring an assistant to help operate the kiln was a priority. The assistants who worked with her during her decade at Laguna included George Daily (figure 21), who worked for her during her first year at Laguna and helped her build her house and kiln; he may also have worked with her when she returned to Laguna in 1902. Yamie Leeds (figure 19) and John Deems were paid assistants after 1906.[35] Regarding Leeds, she wrote to the Carlisle School in 1910 that he "is looked up to by the whole Indian community with respect and is appealed on most occasions as a man of good education and judgment. He never fails to respond to a call for help if he can do it. He is doing good work in developing the pottery industry, and in most ways shows the fine training that he got at Carlisle."[36] She also said that John Deems, who was "educated at the Carlisle School.... is reliable, and an excellent helper.... When I was coming away, I left my kiln and workshop open to him, and gave him to understand he was responsible for the safety of my goods. I shall find everything secure and in good order when I get back."[37]

Ultimately, Foard intended that Pueblo potters would have "small individual kilns made, building them like the Indians women's bread oven... but without a top" (figure 22).[38] One newspaper reporter stated that "Miss Foard is now experimenting with small, cheap kilns, such as the Indians can build for themselves without trouble or expense. When she finds just the thing, she will encourage the Indians to build their own kilns and fire their own wares."[39] It is not known whether she ever achieved that goal, but a photograph of a bread oven was included in a *New York Times* article on April 29, 1906, where it was captioned "Pueblo bread oven to be utilized as a pottery kiln."

Surviving specimens of Josephine Foard's glazed pottery attest to the fact that she was successful in glazing pottery, but some of the examples also document she experienced technical

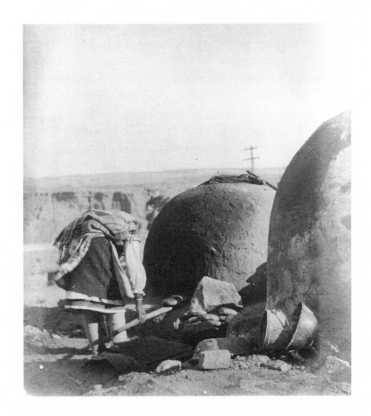

Figure 22.
Photograph of a woman
baking bread in a native
oven. Miss Foard said she
hoped to convert bread
ovens like these to make
them suitable for glazing
pottery. Photograph by
Josephine Foard, ca. 1902,
courtesy of the School
for Advanced Research,
Santa Fe, gift of Mrs.
Millicent Berghaus.

problems (plate 1). At first, she said she tried glazing the decorated exteriors of the pottery, but she immediately realized her error in doing so, noting that "the dull exterior so peculiar to Indian pottery disappears when it is glazed on the outside. So it is glazed on the inside only, because that strengthens the ware and gives it a commercial value which it would otherwise not have."[40] It seems surprising she had not anticipated that the appearance of decorated pottery would be changed dramatically by the glaze or that the pigments would react with the molten glaze; apparently her ceramics knowledge did not extend to the chemistry of firing native pigments under glazes. Later, she requested commercial pigments that would withstand glazing, but on the only examples of Pueblo pottery that she glazed over the decoration (plates 2, 14, 15), the pigments ran into the glaze, indicating she did not use commercial underglaze pigments on them.[41]

Foard said she tried whenever possible to identify the makers of the pottery she bought and wrote their names and a number on the pottery she glazed. The number, she said, would be recorded in a book she kept.[42] Her book has not been found, but eleven glazed pieces have been located that were inscribed with names before they were fired: K Juwateaya, Ocēcēta, Queaustea, Cookone, Wa-Ki, and Marie Iteye (plates 7–13). Several of the signed jars and bowls are also inscribed with numbers in fired pigments on the bottom (plates 9, 11, 13), and three have incised letters (not illustrated). Five jars have paper labels from the Indian Industries League in Boston (see plates 3 and 5 for two).

This recognition of individual Indian craftspeople was probably required by the Indian Industries League, one of the few institutions to emphasize the identification of individual native

craftspeople at the time. (One of its objectives was "to open individual opportunities of work to *individual* Indians." [emphasis added][43] Constance Goddard du Bois had promoted attention to the individual Indian, in both literature and the arts, as early as 1899, and she and the Indian Industries League both argued that recording personal identities encouraged a more complex perception of Indian culture and encouraged individual creativity.[44] The philosophy behind the recognition of the individual, however, was not altogether altruistic. It was instead a fundamental basis of a plan supporters of Indian assimilation advanced—including the Indian Industries League—whereby identification and promotion of the individual would ultimately weaken tribal loyalty and authority and lead to the independence of the individual.

There is no evidence that anthropologists, museum curators, or scholars at the time either supported or decried this subversive philosophy, but it is interesting to note they rarely recorded the names of the makers of objects they collected from the 1870s to the 1930s. Although that attitude is now viewed as demeaning, the identity of individual makers seems simply to have been of no interest to those making artifact collections.[45] Indeed, many scholars and institutions (such as the leaders of the BAE) thought that the imminent collapse of the Indian way of life and the deaths of tribes and tribal customs were foregone conclusions. As a result, they only collected artifacts and recorded native customs and beliefs while they were still available; most of them remained aloof from the efforts to preserve the native cultures.

In their own self-interest, however, some curio dealers realized they could market Indian crafts more profitably by promoting individual Indian craftspeople's identities. Prominent among them were Abram and Amy Cohn, owners of the Emporium Company in Carson City, Nevada, who began selling Washoe basketry in the 1890s. They contracted to buy all the magnificent baskets Louisa Keyser (Dat-so-la-lee) made and sold them and the work of other leading Washoe basket makers in their summer store at Lake Tahoe, starting in 1906. They numbered the baskets, documented the makers' names, and cataloged the details of each basket on certificates that accompanied the baskets.[46]

A slightly different philosophy was at the root of efforts by people like Kenneth Chapman and the organizers of the Santa Fe Indian Fairs who tried to have Pueblo potters begin signing their wares in the 1920s. Theirs was not related to the effort to subvert tribal loyalties through recognition of individuals, but an attempt to reverse the decline in the quality and quantity of Pueblo crafts by giving recognition to superior individual artisans and objects exhibiting superior workmanship. There was a financial angle as well, but it was directed toward the benefit of the individual craftsperson as opposed to a dealer. The organizers speculated that signatures would attract "art" collectors to buy Pueblo pottery and would ultimately contribute to increasing prices—and, they also strongly believed, to improving its quality. María and Julián Martínez of San Ildefonso Pueblo received many prizes at the Santa Fe Indian Fairs and began signing their pottery about 1923, but they remained a distinct minority until the 1950s.[47] Judging by the significant prices that signed "María" pottery brings today, the organizers were very perceptive in their mission.

Examples of Miss Foard's Glazed Pottery

Large groups of Miss Foard's glazed pottery are in the Josephine Foard Collection in the University Gallery of the University of Delaware, the Science Museum of Minnesota in St. Paul, and the Indian Arts Research Center of the School for Advanced Research (SAR) in Santa Fe. There are

thirty-seven pieces of Pueblo pottery in the Delaware collection, and eight of them are glazed. The glazed pottery includes a large jar decorated with birds and five small jars and a creamer bearing geometric and naturalistic decoration (plates 1 and 6). All the vessels have defective glazes, which is probably why Miss Foard retained them.[48]

There are fourteen glazed vessels in the collection in the Science Museum of Minnesota, including jars, bowls (or jardinières), a canteen, a cup, and two pouring vessels; most are identifiable as Ácoma or Laguna products (plates 7, 8, 11, 12, 15), but there are two jars that were made at Hano on First Mesa of Hopi (see plate 4 for one).

There are four glazed vessels and two architectural tiles in the Indian Arts Research Center (SAR) that are associated with Miss Foard. The tiles were donated by Miss Foard's assistant, Yamie Leeds. One of the vessels, a jar, was sent to an unidentified exhibition and bears a label like the one on the jar illustrated in plate 8.

The pottery in these three collections and in several private collections provides a snapshot of what was being produced at Ácoma, Laguna, or both pueblos around 1900 and helps us understand and date pieces that are not otherwise documented. The unglazed pieces in Delaware include the sorts of wares being produced for tourists—a small pitcher and miniature pottery boots, moccasins, animals, and canteens—in addition to four large water jars (not illustrated). The collection in the Science Museum of Minnesota also includes three unglazed pottery figurines and two unglazed jars.

The decoration on the glazed water jar from the Josephine Foard Collection in Delaware, shown in plate 1, consists of an elaborate design of birds above and below a continuous two-color rainbow band. It is a design usually associated with Ácoma pottery, but similar jars were also made at Laguna. The jar is well formed, thin-walled, and competently painted, but serious problems occurred during the glaze-firing. The glaze penetrated the body, dripped down the outside, and discolored the red-and-yellow rainbow bands and the yellow bodies of the birds. The molten glaze also seeped through the bottom of the jar, adhering it to the saggar, and part of the bottom of the jar was broken out when it was removed.

The bowl in plate 2 may be one of Miss Foard's early experiments, for the glaze has caused the manganese/iron decoration to run uncontrollably and the glaze to pool in the bottom. Family history relates it was a gift to the Pradt family of Laguna and they gave it to Dr. Elder, an Indian Service doctor at Laguna and ancestor of the person who sold it to Kenneth Chapman, who was at that time a director of the Indian Arts Fund.[49]

Two glazed jars bearing printed labels indicating they were sold by the Indian Industries League in Boston are shown in plates 3 and 5. The small jar in plate 3 is unusual for the allover red slip and the raised white decoration. The interior glaze is clear and almost colorless, but it is granular and bumpy. It has two paper labels on the bottom, one handwritten with the inscription "[1?]6 Ziwite K / Acoma / 50¢." The second label is printed like the one in plate 5; it is inscribed in ink "Laguna Kiln / New Mex. / Made by Ziwitze." The potter was possibly the person who was identified in the 1906 and 1907 censuses at Ácoma as Tsieweita Stevan; in 1906 her age was listed as twenty-one, yet in the following year it was given as twenty-eight.[50] It is unknown whether Miss Foard used the term "Laguna Kiln" as an official name, or whether the Indian Industries League's shop added it simply to identify the source.

The label on the other jar with an Indian Industries League label (plate 5) is inscribed with the phrase "Hopi skill" and a name that is difficult to decipher, perhaps Konike, Kowike, or

Komike. The authors know nothing more about the potter or about any other pieces she may have made. The glaze on the interior is thick and glossy, unlike the darkened, bubbly glazes on the pieces shown in plates 1 and 6. It is one of three examples of Hopi pottery known to the authors that Miss Foard glazed, probably in 1906–7.[51]

The jar shown in plate 4 is from the village of Hano on First Mesa of the Hopi pueblos; it is inscribed on the bottom, "Hopi." Although the jar is not inscribed with the name of the maker, we attribute it to the famous Hopi potter, Nampeyo, who introduced the Sikyatki-revival style of decoration—seen here—derived from sixteenth-century Hopi pottery, Sikyatki Polychrome. The decoration consists of a design motif Nampeyo used frequently: curved eagle-tail motifs at either side of cross-hatchured squares.[52] The decoration is mostly in black; the only red in the design is in two small curve-sided triangles below the neck.

The five small jars and creamer in plate 6 are all from the Josephine Foard Collection in Delaware. They are likely of both Laguna and Ácoma origin and have dark yellow-amber glazes that have pooled in the bottoms. The small creamer is decorated along the lower part in a wave-like pattern traditionally associated with Laguna pottery. It is glazed on the inside and on the handle, but the glaze is yellowish, rough, and speckled. Miss Foard sent creamers, sugar bowls, and candlesticks to the Indian Industries League in 1909 for an "Indian Tea Room" in Boston, which never materialized; they were instead sold in the league's store.[53]

The jar shown in plate 7 is the largest of Miss Foard's glazed vessels we have seen. It is decorated with parrots of unusual and distinctive form (note how the birds' crests and wings are detached from the bodies), placed within hatchured oval panels, and with bands of split rectangles above and below. It is signed in script on the bottom K Juwateaya, a name that has so far eluded identification in Ácoma or Laguna censuses. It is the only example of a name inscribed before firing on a piece of Foard's glazed pottery that is not in block letters.

The jar shown in plate 8 bears a paper label that is inscribed by hand, "Name of Article *Duonnē or olla* / Name of designer *Ocēcēta* / Name of maker *Ocēcēta* / Name and address of Exhibitor / *J. Ford; Laguna / New Mex.* / List No. 2 / Selling Price [erased]."[54] The label indicates the jar was sent to an exhibition (the location and dates are lacking), perhaps at the Indian Industries League in Boston or the National Society of Craftsmen in New York City, where she organized an exhibition in 1907, or the Jamestown Exposition in the same year.[55] The potter, Ocēcēta, is probably one of two women named María Josecito, who were enumerated in Ácoma and McCartys censuses.[56]

The jar and the bowl shown in plates 9 and 11 are inscribed with the name "Queaustea" and the number "18" on the bottom. We have seen five vessels inscribed with this name, the most of any inscribed pieces.[57] The name is that of the potter, and the number "18" is likely the identifying number in Miss Foard's book. "Queaustea" has not been identified with certainty in any of the federal or Pueblo censuses taken at Ácoma or Laguna between 1900 and 1910, but an Indian Industries League label on a jar (not illustrated) inscribed with the same name identifies the maker as being from Ácoma.[58] The person may have been identified in the 1904 Pueblo Census at Ácoma as Cayashtie, age forty-one, a woman with no husband enumerated but with two children.[59]

The jar shown in plate 9 is elaborately and competently decorated in geometric designs, and the wall of the jar is relatively thin. The glaze inside is a uniform, light yellowish color and has no apparent technical flaws—one of the few flawless examples we have seen. The owner of the jar remembers that his grandfather purchased the vessel while living in Winslow, Arizona, and

working for the ATSF.[60] He may have purchased it at Laguna or at one of the Fred Harvey stores (to whom Miss Foard sold glazed pottery), perhaps the store at the railroad stop in Winslow, the tourist gateway to the Grand Canyon.[61]

In addition to glazing traditional pottery forms from Ácoma, Laguna, and Hopi (and perhaps other pueblos), Foard also said she designed new forms she thought would sell well in the East.[62] These included "water pitchers [plate 15] and jardinières [plates 10–13], and … architectural tiles [plate 14]."[63] After the potters made some of the new forms, she wrote that she "wondered why they did not bring them to me, and when I inquired for them, they told me that they had made fifteen and sold them on the train."[64]

Pueblo potters were making flowerpots for tourists before Miss Foard arrived at Laguna, but they typically had holes in the bottoms to permit water to drain. The bowls shown in plates 10–13 may be examples of Foard's jardinière designs. That the bottoms are not pierced for drainage would permit their use as plant or flower containers that could be placed on finished wood surfaces without fear of water damage. Their deep shapes were probably derived from Pueblo food-bowl forms.

The bowl illustrated in plate 10 is inscribed with the name "Cookone." It is the only known glazed piece that we associate with Miss Foard bearing that name, and it may be the name of a Laguna Pueblo family living at Paraje. The 1899 Pueblo census listed José María Coo ka nish, who was living with his son of the same name; in the 1904 Pueblo census, José María (with no last name), his wife Juana Marie, and son Lorenzo were listed as living together, preceding the listing for José Marie Kukanish.[65]

Comparing the form of the backward-slanting capital letter "E" on the inscription, we speculate that the name was written by the same person (probably Miss Foard) who inscribed the pottery with the names of Queaustea and Marie Iteye.[66] The name "Cookone" may be a misunderstanding of the spelling of the name "Coo ka nish," and it may identify Juana Marie as the potter. The bowl has a speckled, dark yellowish-amber glaze inside.

The bowl shown in plate 11 is inscribed "Queaustea / 18." The same name and number are also inscribed on the jar in plate 9. The bowl is decorated in black and yellow-orange with a stylized floral design, and the rim is scalloped; the bottom is red. Before glazing, the interior may have been covered with red slip or there may have been a red band at the top; if there were, the glaze has dissolved the slip, leaving only small remnants that look like imperfections in the glaze.

The bowl shown in plate 12 is inscribed on the bottom "Wa-Ki," probably the name of the potter who formed and decorated it.[67] The decoration includes unusual small birds with curled topknots and multiple wings and tail feathers, perched on stems with foliage and berries. The bowl is shown in a photograph captioned "Work and a worker in Miss Foard's pottery," which illustrates an article written by the commissioner of Indian Affairs, Frances E. Leupp, in 1910.[68]

The bowl in plate 13 is about the size of a Pueblo food bowl; there are slight ridges inside that look almost like turning marks. In Pueblo pottery, ridges like these would have been smoothed by scraping before the object was coated with slip and decorated, which suggests to us that it was probably not a Pueblo Indian potter who made it. The bowl has a quality of execution that is more like eastern Arts and Crafts pottery, where turning ridges were considered to be aesthetic hallmarks of handmade pottery. Because of this feature, we speculate that Miss Foard herself may have thrown the bowl on her potter's wheel. She definitely made pottery at Laguna, as is documented by a note from the potter Minnie Sice, who asked Foard to pay her for "making the clay for you."[69]

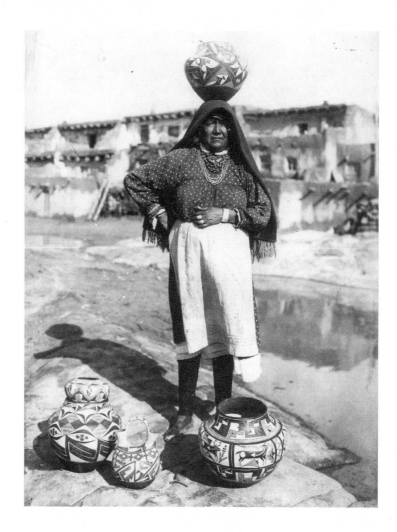

Figure 23.
Photograph of an
unidentified woman
at Ácoma Pueblo.
Unknown photog-
rapher, ca. 1920.
Collection of
Robert Bauver.

Another indication that a Pueblo potter did not make it using local materials is the very light col-
ored body that is much whiter than is found on Ácoma pottery vessels. Therefore, it appears to
have been made with commercial clays that Miss Foard either brought with her or imported from
the East. The glaze is nearly colorless, also suggesting it was different from that used on most of
her other glazed pottery, which typically fired to a speckled pale to dark yellow color.

Although Josephine Foard may have made the bowl illustrated in plate 13, we believe that an
Ácoma potter decorated it. The bowl bears a name and number on the bottom, "Marie Iteye /
#6."[70] She is listed in three censuses taken at Ácoma. In the Pueblo Census Rolls for 1904, she is
listed as Marie Iytie, age twenty-one.[71] Again, the number "6," inscribed below the signature, was
presumably cross-referenced with the maker's name in Foard's record book.

Distinctive deer are prominent in the decoration. While deer were rarely depicted on Ácoma
or Laguna pottery vessels around 1900, there is a photograph of an unidentified woman at Ácoma
Pueblo who stands alongside a jar decorated with similar deer (figure 23). That woman may be the
same potter, Marie Iteye, or perhaps her mother.

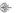

Decorative glazed tiles were a part of the Aesthetic movement of the 1870s and 1880s and the Arts and Crafts movement of the 1880s through the 1920s. In 1877 several major American architects and artists, including J. Alden Weir, Stanford White, William Merritt Chase, Elihu Vedder, and Winslow Homer, founded the Tile Club in New York City. An exhibition of tiles, which the club sponsored, was shown at the Century Club in New York City in 1881.[72] The exhibitions and publicity of the Tile Club may have given Foard the idea of making decorative architectural tiles at Laguna. She was probably also influenced by Charles Volkmar, one of whose specialties was architectural tiles.

Foard began to experiment with tiles as early as 1906, preceding the production of tiles (nontraditional forms for Pueblo Indians) that were being made in considerable numbers—starting around 1920—for the Anglo market in several pueblos, including Ácoma, Laguna, and Zia.[73] Rectangular, flat pottery tablets, decorated on one side, were collected at "Moqui" (Hopi) for the Bureau of Ethnology in 1883, but they are smaller than Miss Foard's, being slightly larger than playing-card size and do not have grooved backs (which Miss Foard's tiles have) for architectural application.[74]

Foard's assistant, Yamie Leeds (figure 19), donated the tile shown in plate 14 to the Indian Arts Fund in 1930. He said he made it under Foard's direction and used special pigments and a Volkmar glaze.[75] The pigment of the decoration, however, has bled into the glaze.

The vessel in plate 15 may be an example of the pitchers Miss Foard designed. It is related in form to pouring vessels made at both Santo Domingo and Cochiti Pueblos, but those typically have animal heads modeled on the spouts.[76] The walls seem rather thick, but we speculate the vessel was likely made by an Acoma or Laguna potter. The paste is slightly yellowish-pink, but if it were made at Santo Domingo or Cochiti, the clay would be reddish. The decoration on the outside is a pattern of repeated red and black triangles, but the red pigment was mostly dissolved by the glaze, and the black pigment has bled and turned slightly greenish. There is no remaining evidence whether the interior was coated with red slip; if it were, the glaze has dissolved the pigment.

Judging by the amount of Miss Foard's glazed pottery that is found today, her output was fairly large, but we have no means for estimating her total production. Even though her kiln functioned satisfactorily, Miss Foard complained she did not achieve as much as she had hoped. She could not persuade potters to change their firing methods or convince them that glazing was an economically sound idea, and neither could she induce "every Indian pottery maker to build a kiln and decorate his pottery after any new style." (It is interesting that Miss Foard used the male pronoun, since almost all Pueblo potters were female.) In frustration at their unwillingness to change their firing methods, she commented petulantly that "they of course think that they know better than I."[77]

Assistant Indian Commissioner Tonner noted in 1904 that "the experiment was worth trying and it may be, as is often the case, its main value will be in its 'by-products.'"[78] In 1907, Josephine Foard summarized her mission at Laguna, saying,

> my work consists largely in educating my Indian assistant in modern, easier and
> cheaper ways of building, and firing, and decorating the pottery while still retaining
> the original character of the work. He will carry on the work here after I have left it,
> and teach his countrymen. The Pueblos around my home still make pottery after their
> old style and in a way that was handed down to them from prehistoric times. Here

and there I have succeeded in making slight changes, such as substituting a paint brush for a twig, and many of the workers now bring me their jars to glaze after they have finished them. Some bring them to me to bake, and many I can help by advice or suggestion.[79]

We do not know whether anyone used the kiln to fire or glaze pottery after Miss Foard departed Laguna in 1911. Yamie Leeds, her assistant, moved with her to Colorado (see chapter 7) and by 1920 had turned to farming at Laguna Pueblo.[80]

Writing years after Foard left Laguna, Betty Toulouse and Elizabeth Willis DeHuff found nothing of lasting merit in her work.[81] DeHuff declared Josephine's project to have been a failure.[82] Perhaps because her comments were written so much later, her facts—about Miss Foard's intent, duration of stay, and age—were highly inaccurate, but her unflattering comments resonate today because they shed light, perhaps biased, on the often-suppressed attitudes of Pueblo Indians toward well-intentioned "helpers" from the East:

> Still another young woman, who had studied ceramics in the east, came to the Pueblo country. She was distressed to find that the Indian pots, so symmetrical in shape, graceful in design and beautifully decorated, would not hold water without seepage. She decided that by all means they should be glazed to stop the capillary action, to keep them from dampening furniture upon which they might be set when full of water, by those who bought them, and to make them "more valuable to the Indians themselves." Making the necessary arrangement, she went and spent a summer in one of the Indian villages, where they have the best pottery clay. All summer she gathered together the chief potters of the pueblo and taught them patiently to glaze their pots. The Indian women watched, followed instructions and made the glazed pottery. When her vacation was over, with a sigh of satisfaction for her successful philanthropy, the young ceramic artist regretfully went on her way. She had scarcely gotten out of sight, when the Indian women—one and all—walked to the edge of the mesa and, with a chuckle of disgust, hurled all of the glazed pots that they had made over the precipice, breaking them to bits. "Pots that are not slightly porous make water turn stale! Who wants such pots? Besides what harm can a tiny damp spot do to a hard-packed clay floor or to anything else? Glazed pots were not pretty on their own!" The women of the pueblo continue to make pots as of old.[83]

Miss Foard's introduction of a turntable for throwing pots on a wheel instead of coiling and the use of brushes instead of yucca fiber for painting them never caught on. Her introduction of kiln firing at Laguna in 1899 was a "first," however, and the technology is now widely used in Laguna and Ácoma—although the kilns are now heated with either electricity or gas.

Josephine Foard's passion was to help bring economic self-sufficiency to the Indians. She wrote, "to buy it and help create a market for these really useful wares, this is the truest missionary work one can do for the Indian."[84] Considering herself a missionary in this regard is perhaps why her family remembers her as "Aunt Joe, the painter and missionary."[85]

CHAPTER SEVEN

After Laguna

Around 1912, the *New York Press* reported that Miss Foard had been exhibiting watercolor and oil paintings in local galleries.[1] The article went on to say that, at almost seventy years of age, "she has purchased and taken possession of an undeveloped farm of 160 acres in Colorado, which she has determined to devote to the raising of broom corn, despite the fact that she has had no experience in this kind of work." Moreover, according to the article, Foard had never visited Colorado and knew little about agricultural conditions there.[2] She said she had been discouraged from taking up her new venture and was advised it would be impossible to get an adequate water supply without great expense. With her inimitable resourcefulness, however, she imported a water witch (a dowser for water) from a nearby county, who within half an hour identified a piece of ground under which he said water could be found. With the small amount of her remaining capital, she hired drillers who found water of excellent quality twenty-six feet below the surface.[3]

Miss Foard described her farm in a letter of September 6, 1914, to her nephew Charles Berghaus.[4] It was near Sheridan Lake, the county seat of Kiowa County, in southeastern Colorado. The land was flat with no hills, "just rolling planes [*sic*] and ridges....nothing to be seen but an expanse of prairie grass or snow...." After a rain, she wrote, the "rivers of water are as placid as glass." The air was clear. There were no houses nearer than two miles, and an army barracks was at the same distance. She had horses, a donkey, barns, and stables. Yamie Leeds, the Laguna man whom she hired as an assistant in 1906, worked for her in Colorado as well; she also had a young Pueblo Indian boy, Kysfeeya, living with her.[5]

Perhaps finding the farm too much for a single woman in her seventies to manage, Miss Foard returned to the East in 1917 and resided with her now-widowed sister, Louisa, in Ridgefield Park, New Jersey. A few months later, Foard broke her hip in a fall on icy pavement and after a brief illness died of pneumonia in the Hackensack, New Jersey, hospital, at age seventy-five, on March 17, 1918.[6] Her nephew, Charles Berghaus, conducted funeral services in the Ridgefield Park Episcopal Church, and she was buried in Hackensack Cemetery.[7] Miss Foard died intestate. Her sister Louisa, acting as the executrix of her estate, maintained there was nothing in the way of personal property other than letters and photographs, many of which are published in this volume.[8]

An obituary written about Miss Foard reflected her commitment to Pueblo Indian pottery and her personal interest in ceramics and painting.[9] It also recorded that she was involved with a number of local art guilds or leagues and was elected a member of the Royal Society of Arts in London in recognition of her pottery work with the Pueblo Indians.[10]

In Conclusion

Miss Foard arrived at Laguna Pueblo, having studied the ceramic arts and developed an interest in American Indian culture. She also had a vision and dedication to contribute her talents for the benefit of the Pueblo Indians. Her religion, language, and education influenced her life among the Lagunas, but did not define it—because she believed her mission was neither assimilationist nor reformist. Yet, it truly was reformist. Her idea that an ancient handicraft, pottery making, could not only be preserved but also improved upon by introducing industrial processes and materials imported from the East was itself contradictory. She believed her firing methods were superior to the Indians' and stronger pots, necessary for transporting them to distant markets, would result. She also saw her role as that of a marketer to a consumer society and adapted the native pottery to its requirements by introducing the foreign idea of glazing the interiors of jars and bowls and creating forms unknown to Indian culture, yet useful to Anglos.

Foard was a leader in trying to develop ways for Indians to gain self-sustaining economies, but she was not a crusader with a following that would lead to a mass movement to sell "improved" Indian arts. Although she was an active player in the early years of a growing movement, there were numerous government field matrons helping to develop native arts industries before and at the same time as Foard—yet none of them had her specialized art training.[11] Before 1900, the Indian Industries League was selling Indian arts in its Boston store (offering Miss Foard's pottery there by 1904, if not before), and by 1905 several organizations were praising Indian arts.[12] After 1910 many literary and visual artists were defending American Indians and shaping governmental policy regarding them. In 1911, the first pan-Indian organization, the Society of the American Indian, was formed, which placed emphasis on the recognition of the virtues of the "old life" of Indians.[13]

A project with intentions similar to Foard's—but unlike it in emphasizing improving the quality of existing native pottery types rather than modifying them by using foreign technologies—was begun in 1917, the year Foard made her final return to the East. Californians Verra von Blumenthal and Rose Dougan aimed to help the Indians at San Ildefonso Pueblo improve the quality of their pottery. After spending three summers in the Southwest, but with little result, they turned their project over to the Museum of New Mexico, along with a two-hundred-dollar annual subsidy. Success was eventually achieved, with María and Julián Martínez and Tonita Roybal being notable beneficiaries of the project, and sales at high prices for top-quality pottery resulted.[14]

The movement among Anglo women to revive and preserve Indian crafts and develop profitable markets for Indians gained further momentum after the First World War. These women were a generation younger than Miss Foard and had greater wealth at their disposal; they were painters, writers, photographers, collectors, and philanthropists, and they worked actively to preserve and promote Indian arts and crafts.[15] Like Foard, many of these women aided in developing an art market that would profit the Indians by their patronage, by educating the public regarding the value of Indian arts, and by promoting markets in order to attract new customers. In 1922, the

Southwest Indian Fair was established in Santa Fe and continues (as the Santa Fe Indian Market) to be an economically and artistically successful market for Indian arts and crafts, as are a number of other exhibition-sales venues in New Mexico and elsewhere.

In the 1920s, several new organizations working on behalf of the rights and conditions of Indians were established: the Eastern Association on Indian Affairs, the New Mexico Association on Indian Affairs, the American Indian Defense Association, the General Federation of Women's Clubs, and the Indian Welfare Committee.[16]

Santa Fe philanthropists Mary Cabot Wheelwright and the White sisters, Elizabeth and Martha, established shops in Boston and New York City in the early twenties, which marketed American Indian art and flourished until the forties. In 1923 in Chicago, the Grand Council Fire of American Indians was organized to revive Indian traditions.[17] That same year, concerned Santa Feans formed the Indian Arts Fund (which started as the Pueblo Pottery Fund) to preserve Indian arts by purchasing superior examples.[18] In the early 1930s the activities of these individuals, institutions, and organizations would culminate in the founding of the National Association on Indian Affairs and the federal Indian Arts and Crafts Board, which Comm. of Indian Affairs John Collier established.

These organizations, along with Indian arts and crafts sales-exhibitions, such as the Santa Fe Indian Market, have helped stimulate widespread interest in Pueblo pottery, among other indigenous crafts. As a result, more and more people have turned to producing pottery as full-time work. Today, Pueblo potters are carrying on the traditions of their ancestors, but nearly everything made is destined for the collector and art markets; little is made now for use in Pueblo homes (other than as displays). Potters are now producing impressive objects at many of the pueblos, and they are receiving national recognition and honors for their work.

Josephine Foard's mission to develop markets for Pueblo pottery that extended beyond the realm of ethnographic curiosities has occurred, and technologies have changed. Some Pueblo potters refuse to produce wares using anything but traditional coiling and scraping methods and fire their wares outdoors. At the same time, other Pueblo potters fire their wares in kilns and use potter's wheels, commercial materials, industrial techniques (such as slip casting), and make more and more ceramics in styles that reflect contemporary non-Indian art and crafts movements. The definition of "what is Indian?" is changing. In some ways, it is as if Indian assimilation continues—while, simultaneously, conservative movements to preserve Indian life-styles and languages multiply and grow at the pueblos.

Pueblo pottery often reaches levels of quality that equal and occasionally surpass the work of ancestors, but the future of pottery making at the pueblos is not entirely sanguine. Young people continue to learn pottery making from their elders and at schools, but the attraction of earning wages often distracts them from devoting the time necessary to mastering the required skills. Pottery making is presently in a period of resurgence at many pueblos, but how long that period will last is uncertain.

APPENDIX ONE

"Letters from Among the Lagunas" by Miss Josephine Foard

Letter 1

Santa Fē New Mexico
April 9th 1899

Dear L. [her sister, Louisa Berghaus]

I have a beautiful room at the Claire Hotel but I take my meals at a restaurant as the Claire dining room is being repaired. My room is very large and faces the plaza. Just now the plaza presents a gala scene, for every Sunday afternoon the band discourses delightfully at three o'clock, and the whole town turns out to enjoy it, sitting or promenading as pleasure dictates.

Many are in carriages on ther [*sic*] side of the streets listening to the music. I can see and hear it all as I sit here.

The plaza is simply a square such as Philadelphia and New York have with a pavilion in the centre in which the band plays. When the music ceases I write for I cannot do it and listen to music. It plays well. Before me are picturesque groups of Americans, Indians, Mexicans, Neg[roes], and all sorts of foreignors [*sic*] chatting in as many languages; English the smallest part of it.

The Government School wagon drawn by six horses just passed and stopped opposite the Palace. The blue uniforms of the girls like those of the Carlisle School are very neat and becoming to them as they climb in and out of the great wagon. Children try to dance but it is only a jargon of motion. The Claire I am told is a stronghold for gamblers and I just saw a prominent one passing. In this territory gambling is lawful.

This is a strange climate, both warm and cold at the same time. In the mornings and evenings we have the steam heat turned on and are glad to wear heavy coats, but from eleven o'clock in the

81

morning until about four in the afternoon it is very warm in the sun. At the same time many hold on to their fur capes and coats for if they happen to come under a shady roof or walk, they become suddenly chilled. All the day long during the sunshine invalids and Mexicans may be seen sitting on the seats in the plaza, looking energyless as though life were but a dream, and that they had no part in it outside of that little plot of green. To the consumptive it means a renewed life unless he is too far spent before he reaches this sunny clime. But to the Mexicans it means only indolence and ease. Time is nothing to him.

The mountains hover all around, the highest point being covered with snow. It is called Baldy and it is well named, for it does look like a bald headed old giant glistening in the sunshine. It is more than twelve thousand feet above the level of the sea and five thousand above Santa Fē. Charley would be interested in the little burros; ugly little things, as lifeless looking as the lounging Mexicans but far more interesting, as they carry their many burdens with a touching patience. They are driven through the streets by the Mexicans in droves, often with no loads at all but also singly with semicircular loads of wood looking like raised saddles; in other words just as you see them in pictures representing Bible times. They are the same long eared, little things of which we read in the Bible and it is easy to imagine ourselves in that far off land and time watching the virgin and Holy Child as they took their flight into Egypt.

I said that they were ugly little things, indeed I take that back because they have a stolid, peculiar beauty of their own. As one goes by with a tall Mexican mounted on his back, the Mexican urging the clumsy little burro to a trot, his arms and legs flying as though every joint were loose, he presents such a rediculous [sic] figure that I am convulsed with laughter; he has a club in one hand, while both arms fly up in the air and both legs fly out from the donkey, both arms and legs come back again; the legs making a bow about the little burro's body and the feet almost touching under the little beast; up and back, up and back they go many times, the Mexican urging as violently with his voice as with legs and arms. At its very best the little burro can only get up a sort of clumsy jog and is not traveling half as fast as the Mexican. I wonder that he does not get off, and help the burro along. It would not be near as hard work. I am glad to see that the club does not once descend to the donkey's back. It is simply used to urge, and as a guide instead of a bridle. I never shall forget that Mexican's legs and arms; surely he outdoes the Flying Dutchman. When he is not exerting himself his feet nearly touch the ground.

Mexican women walk about bonnetless with long, black shawls thrown over their heads. It struck me that they were in continual mourning, for their dresses are black also. One day I saw a funeral, all women walking in the middle of the street. Oh, but the most striking, the most beautiful, the most picturesque part of it all in this City of Holy Faith is the Pueblo Indians, stalking about in their native costumes; tall and stately and dignified, looking like the very Lords of Creation. Most of the men are bare headed, but occasionally a gay handkerchief is artistically tied almost turbin [sic] like about his head, the knot coming to the left. The long black hair is tied often with a woven band of wool, red in color, or black, or blue, as fancy dictates. Sometimes these colors are all in one band. Their blankets are as varied as their figures, gay blankets and sombre blankets worn as gracefully and as effectively as a Roman toga in the ages gone by. Every place, in houses and stores we see Indian blankets and pottery. Such a great variety of them, the pottery is as varied and beautiful as the blankets and ladies use it for parlor plants.

The mud houses are odd looking affairs but frequently so boarded up and painted that one does not suspect them to be adobe houses. El Palacio is of Adobe. It was the palace first of the

Pueblos, afterwards of the old Spanish viceroys and Mexicans and is now the residence of our own U. S. Territorial Governors and Secretary and has been ever since it became a territory of the U.S. It has stood sieges and been held alternately between white men and red.

Santa Fē was, long before the Spaniards came an Indian stronghold and the Capitol and centre of the Pueblos. The Palace is older than the old St. Augustine Fort in Florida consequently the oldest building in the U.S. It is full of exciting history. Much is hidden but much could be told also, first of the gentle Pueblo reign centuries before the ruthless, cruel Spaniards came. Four hundred years ago they drove out the peaceful, unoffending Indians, naming the pueblo Santa Fē—Holy Faith—.

I arrived here at midnight Apl. 7th. Of course I saw nothing of the town, But Oh! Oh! Oh! when I looked from my window in the morning, from the third floor, down into the plaza, into the streets and far away off upon the distant mountains, and the nearer, bare waste of creamy sand and rocks, my wonder grew. On all sides were adobe houses, one storied; conspicuous among them was the Palace, a low, long building with a roofed porch running its full length, the whole front extending from block to block opposite the plaza diagonally from the hotel. It never struck me for an instant that this was the much talked of Palace. Indians, Mexicans, Americans, burros and modern, eastern looking conveyances with smaller horses than I had been accustomed to seeing, met my view in this out of the United States sort of town. All in such strange contrast to any thing that I had ever seen that I began to wonder if in some way or other I had not come, unwittingly, into possession of an Aladdin's Lamp, or ring which I had been unconsciously rubbing with the jolting of the car ever since I had left Kansas; for it was then that the strange foreign appearances began. But they were in the distance, this was all about me and I as strange as any thing, for I knew not a human being; I stood alone, was alone and even this enhanced the charm of it. To all appearances I was in a foreign land. Groups of men stood about talking in a strange tongue. But even in this short space of time I have grown somewhat accustomed to it. This part of the town though has modern stores and frame houses interspersed with the adobe here and there.

Even at this early date I have met some charming, cultivated ladies. Mrs ____ [probably named Wallace] wife of the Hon. Sec. of the Territory who was formerly Minister to Australia called. When Gen. Lew Wallace wrote *Ben Hur* he was Gov. of N. Mex. and lived in this palace.[1] I could not help wondering if the present secretary was of the same family as the author, but Mrs ____ told me that he was not. She took me into Gen. Lew Wallaces room and showed me the wide window sill (painted blue) on which Gen. Wallace wrote much of *Ben Hur*; while standing there she read a letter written by Gen. Wallace telling her what part of *Ben Hur* had been written in that room. It seems that there had been a dispute about the book having been written there, and Mrs [Wallace] had written to the author asking as to the truth. Parties had said that it had been written elsewhere. The letter confirmed the fact that part of the book had been written in the Palace and on that window sill. I never saw such a sill. It was as large as the floor of a small closet. Mrs [Wallace] is very charming and I doubt if any one ever presided at the Palace more gracefully.

The Hon. B. L. Prince ex Governor of the Territory kindly gave me many points of interest in regard to the Indians, and his wife was kind and courteous.[2] The Rev. Mr. Gay is a dear, courtly old Irishman nearly ninety years old; he has a beautiful wife who is an invalid. Both are interesting and lovely. He is rector of the Episcopal Church and on Sunday preached a fine sermon, sitting. He read the service standing and knelt but once, but it was a great effort for him to rise again. Notwithstanding his age he enjoys perfect health and insists upon showing me the sights, and introduces me to many nice people. I have been to the Palace many times and it is very curious. In Ben

Hur's room as it is called there is a quaint old fire place made of adobe. It is across the corner of the room and is in as perfect condition as it was three hundred years ago. I have an idea that the altitude here is a little too great for me but every thing is so very interesting that I would hate to leave. Many of the Mexicans speak to me as I pass. Their courtesy in this is like that of the Maryland negroes as they were once. Burro is pronounced with the accent on the first syllable and is boor'o. I am told that Spanish is the easiest language to learn as no letter has two sounds. But of course it is not so in the Castilian. I must tell you of my travels en route to Santa Fē. I had the oddest experiance [*sic*]. As usual some old codger thought that I must entertain him. He was seventy eight years old, an intelligent old German who opened conversation by offering me a paper. He told me his whole history. He saved money and got to America when he was fourteen years old, slept on the counter of a grocery mans store who employed him; eventually became a partner of another grocer; became wealthy and is now on his way to California to see his wife. When he was a boy he used to lie awake at night and weep because he had no better education, but as he grew older he studied at night.

On the same train a party from Cuba had a private pullman. In passing to the dining car my way was obstructed by a woman surrounded by a little group of men and women. She was telling something in a very elocutionary style. I could but listen and found that she was at the head of some American relief society in Cuba and that they had with them a son of a noted Cuban and a little orphan Cuban girl. I learned this afterwards.

The cause of the excitement was that the son of _____ while in the dining car over heard some conversation about Cuba and a certain enemy of his father. It seems that this name always excited his anger. In addition to this he was jealous of any attention that Mrs _____ paid the little orphan child; with it all he gave vent to his rage in the dining car and wanted to kill some one. When I saw him he had quieted down and was sorry for what he had done. He looked like a boy of eighteen years.

When the passage was cleared I passed on and said to some one I would like to hear Mrs _____ talk about Cuba. She replied "Ask her, she will be glad to do it." I supposed that she belonged to some hospital corps who had lately returned. I did ask her, not knowing of the private car or the relief party nor of the son of _____. I only knew that they were from Cuba and I hoped to hear something real and fresh from the field. It was soon learned throughout the several Pullman cars that a lady was to tell us something of Cuba, and the beautiful observation car was filled up quickly. Then for the first time I heard that it was a party going to a convention, calling themselves "The Confederation of Brotherly Love," or something of that sort. Before she began to talk Mrs _____ asked me if I would like her to speak on Cuba or Agnostics? I nearly whistled with surprise and said, Cuba, but if afterwards you choose to give us an idea of Agnostics I would like to hear it. But I consulted others of the party who were to hear it and they decided as I had. I was getting myself into rather a conspicuous position which I did not like. I had only thought to have her in the seat with me and one or two others for a quiet talk.

Well! she made her speech, a short enough one; kindly, and nicely she spoke, but it was not about Cuba, it was simply what the "Confederation of Brotherly Love," had done.

When she had finished she asked to be allowed to introduce their President. I began to suspect that every one about me belonged to this party. "Might the President be allowed to speak?" she asked modestly. We were all glad to hear him; but my thick perception did not grasp the least idea as to what it was all leading until the President began to talk of evolution. He meant his whole speech for me, and I had not pleased him, evidently, for he spoke with fire and he looked fire

directly into my eyes. I began to feel fire all over, but I listened and I learned. No use to repeat what he said in full for everyone knows the substance. He wound up by saying that every man was a god within himself and that their Society of Brotherly Love would in the course of time be the only religion in the world. I was nearly boiling, but at the close of his talk I asked him where in all of this evolution he placed God? He fiercely asked "Who?" I replied Our Supreme Being, The Creator of the Universe, The God above us all? Again his answer was "There is none." Again I coolly said then I cannot endorse what you have said and believe; you think that you have no superior, no one above your self. Again he ventured not so fiercely "You have a spirit in you which is a god." All that I said to this was Yes, I hope that I have God's spirit in me, around me and above me, He who is the one God of us all and above us all. Not an expression in the whole crowd showed that one person was with me. All were silent. I felt that we were pigmies posing as giants. When I awoke the next morning I felt sure of only one person on whom I could depend as a Christian. I expected to be ostracized by the whole Pullman crowd; on the contrary the first person whom I met smiled and remarked, "I could not understand what that man meant last night by his speech." She soon found out, and it was quite plain that the Convention people were not in the ascendancy after all.

The old German who was a real American at heart asked me how I slept? Not very well I was compelled to admit. With a twinkle in his eye he ventured "Too much speaking last night, how do you like Agnostics?" I shook my head at him, as two of the Brotherly Love women were behind me.

I bought at the curio store for Charley [Miss Foard's nephew, Charles Canning] two arrowheads, one of flint and the other of obsidian; shape of darts about one half inch in size.

Tomorrow I start out to visit the Indian villages and this is the crowning interest to me.

"Good night."

Letter 2

Indian Pueblos

Dear ____

The day after I arrived at Santa Fē I called to see the Rev. J. L. Gay our church clergyman. It was he who had engaged my room at the Claire for me, and was so very kind and polite in introducing me to many nice people. He told me interesting things of Santa Fē and took me to the Historical rooms which are also in the spacious Palace. All sorts of Indian curios and pottery can be seen there much of which belongs to the Hon. B. L. Prince. Gov. Prince called to see me the following day and told me more than any one else could have done about Indians, their customs and their pottery. He gave me a letter of introduction to Col. Bergman Supt. of the Penitentiary. The Rev. Mr. Gay went with me to call upon Col. Bergman on Apl. 12th. We found him most courteous and kind. He showed us the Penitentiary and surely he deserves great credit for its management. Gov. Prince also gave me a card to Gen. Hobart who invited me to see his invalid wife, which I did returning from the Penitentiary. She was very pleasant, and, like all of the best people here interested in the Indians. All with one voice proclaim them superior to the Mexicans of the same station in life. She gave me a piece of prehistoric pottery from the ruins of the Pecos palace of Montezuma. At half past six of the same day I dined at the Palace invited by the wife of the Hon. Secretary of the Territory, and there I first met the Hon. Secretary. By the by I never was in a territory before; it is needless to say that I had a most enjoyable evening. It was my first meal

in a palace, and of all strange things, an Adobe Palace, and stranger still to meet so much refinement in a mud house. I could not help the thought that after all it was not the Palace that set the heart and brain throbbing with pleasure but the cultured hospitality that opened the door to the stranger. In the drawing room almost the first thing that attracted my attention was the pictures of thatched houses and a people who could not possibly belong to New Mexico. I knew even before our hostess told us, that they must be Australian pictures. At table I met pleasant people, from Chicago and Santa Fē and the U. S. Indian Agent.

After dinner the women withdrew to the drawing room while the men remained to smoke. From this table of luxuries with its charming mistress and noble master my thoughts would wander. The Palace is more than four hundred years old. I wonder what the first meal was and how served? I think that we can tell in a measure. Dusky forms seated on the floor around a common bowl filled with something seasoned with chilli [*sic*]; and maybe corn roasted on the cob, with slices of dried venison, or quite likely it was fresh from the hunt, juicy and luscious. Buckskins, and blankets made of cotton or woven rabbit skins, would have made a contrast amazingly great compared, with the gowns and coats we wore on that charming day of April 12th 1899. Then imagine a dinner when the Spanish Viceroys held high carnival [*sic*]! What was it with no Atchison, Topeka & Santa Fē or Denver R.R. to bring dainties to their feasts? It must have been very much like the Indian feast in quality.

On my way to Gen. Hobart's office at the Federal Building, a fine stone structure, is a substantial monument which attracted my attention, I examined the inscriptions and it seems like a novel when on the four different sides I read

"Kit Carson—Died May 23rd 1868"
"Age 50 yrs."
"Held the Way."
"Pioneer Pathfinder—Soldier."
"Erected by Command of the G.A.R."

I had not thought of being in the land of Kit Carson; if I had I would have thought it much farther back. Shows how much my history was at fault!

Letter 3

Española and En Route
Apl. 13th 1899.

Dear L[ouisa]

As the Indians of Santa Clara, San Juan and San Ildefonso are said to make the best pottery in this neighborhood, I thought the thing to do was to visit these places via Española. But alas! when at midday I arrived at Española I was told that there was one case of small pox in each pueblo. This put an end to the longed for visit, and you must know how great my disappointment was. Gov. Prince had given me letters to some of the white people, but nothing was left but to return on the next train to Santa Fē, and from there, go to Laguna where I was told there was no small pox as it had ravaged the place, the winter before and had been disinfected. Here I was

though at Española, a place less than a village and it was afternoon. Nothing to do but think and dot down my thoughts, which I will give you the benefit of, in a small way while there and on the cars to and from Santa Fē. It strikes me that the valley here is very similar in formation outwardly to that around Chambersburg, Pa. that is if you rob Cumberland Valley of its verdure; for here not a spray of grass is to be seen or scarcely a tree. Yellow sand and rock predominate. A little shower springs up in the sunshine and ceases almost before I have time to be surprised. The town with its scattered houses looks like a few brown beans, in a dish of pale soup, such as soldiers joke about. In the middle of the day when the Indians are about with their picturesque costumes, it looks like the same soup with a few small, red peppers and Mexican beans interspersed. But en route is the charm. Oh! the beautiful cañon through which the blue mountains are seen enhance the whole thing! Oh! wonderful nature and strange! White Rock Cañon is its name; what great variety of color, light, and shade the clouds lend! I am so very glad that there are floating clouds, otherwise this intolerable, creamy white would be every where. The piñon trees seen through the vista en route to the saw mill give me the first knowledge of those nut bearing pines. The purples, yellows, blues, browns and blacks of the rocks and the creamy earth enriched by the clouds suggest yellow ochre and burnt sienna.

Had I the brush of an artist what a tale I might tell! Verily it is a feast of good things, both to the eye and brain, in fact it sinks way down to the heart.

Now we go over the Horse Shoe Loop! Talk of blue mountains! These are they, painted by a day of unusual cloud effect deeper than any I ever saw among the Blue Ridge Mountains of Pennsylvania. Now Round Mountain, and there is Gen. Hobart's fine fruit farm! These now are the Rio Grande River Mountains, fourteen hundred feet lower than the Santa Fē; elevation above the sea 5600 feet. Yellows, dotted with piñon on the left, are in strong contrast to the dark blue on the right, and yellow sandstone opposed to the foliage of piñon make so deep a green that it is almost black in the distance.

The rocks look like old forts and castles of creamy stones. We near the Buckman Saw Mills, and the rushing waters with the deep shade of the tree covered rocks, causes a feeling of happy, cool content to creep over me, and a sort of respect is awakened for Buckman and his mill: surely he must be something of a poet to have selected such a spot on which to build his mill.

Purple madder now to the left! I laugh at the first view of the Rio Grande, but I laughed more at the Santa Fē for it was only a river bed, dry, with but a thread of water so slender that I asked where the river was, as I looked down upon it. At this the Rev. Mr. Gay laughed more heartily than I. Arroyos I learned to call them; this is the Spanish for rivulet but in New Mexico the dry river beds are called Arroyos, and a very pretty name I think. Cotton wood trees are almost the only trees I see aside from the stunted growth of evergreens. Were it not for its strong, rushing, rollicking current the Rio Grande would suggest only a canal. Yonder is a huge rock, so formed that it reminds me of Fingal's Cave, and piñons are there too, to give a show of life to the deep solitude.

With so much dark rock where does the white sand come from? See the crowns, and peaks, and castles, covered with snow! Poor Indians! of how much we have robbed them; at the same time, not so much down here as in the north.

Old Baldy Mountain is over there looking very different from the Santa Fē view. We are going down grade now. This barren waste of hills, rocks and vale remind me of a horrid dream I had years ago. Why does its hideousness obtrude itself here amid all of this charm? At last I know why at intervals a feeling comes over me that I have been here before as it did on the A. T. & S. Fe road? Little sister used to say that she was afraid of my dreams for they come true, but I am glad that

only part of this one proves true! Yet true it is and I am glad that it is true; you do not know to what I refer because I never told any one of it I think.

The greys that predominate it all are the soul of this wonderful day's ride. But Oh dear! I am glad that I was not born here, nor doomed to end my days here if they are to be many. Oh: nature and nature's God how surpassingly wonderful are all thy works and ways and what midgets we are in the midst of them! I forget that I am writing a letter and ramble on as though it were for no one but myself; but you know that you are to keep these letters and return them to me when I come home because they are my only notes of travel.

So many places look like nature's forts and strongholds, and I have no doubt they were so to the poor Pueblos; yet how they crumble and fall! I like the altitude of Española better than that of Santa Fē. I wonder what curious life awaits me here and if it may be long? I shall make the most of it let it be long or short.

Irrigation is very new to me, and interesting, but I am thankful that we do not have to depend upon it at home. These people love this queer country and I do not blame them. It is indeed, just now, at five o'clock in the afternoon like a dream; so quiet, so sleepy, so lifeless. Yonder is an Indian on his little horse, his red blanket sets him off well. As I left the train near noon the Indians made a striking picture, though not a pretty one; they lounged around in blankets of reds, pinks, blues, browns, greys and greens. Some were thrown over their heads and some only about their bodies. Men, women and children wore white buckskin moccasins and leggings. They looked as though they might swelter in such heavy, woolen goods and skins on such a warm day.

At the station was an Indian measuring a boy's foot; right there he cut a pair of moccasins and proceeded to make them. I called to see Dr. Lee Granson who is much interested in the Indians and their pottery. There goes another Indian with a very handsome blanket wrapped about him. It is striped, red, grey, blue and black and is not at all gaudy. He is a large, tall fellow and the blanket nearly covers him. His wife has a grey blue one on.

The Santa Clara pottery is a terra cotta color generally, but often it is solid black, a few are light and decorated. Now see that Indian with a plain, bright red blanket while that of his wife is a dull, striped one and prettier. Another woman has a light, grey blue and still another a deep blue. Most of the horses and cows are rough, ragged looking and bony. Poor things food is scarce for them! Cows are expensive, costing from thirty five to sixty dollars, while horses and burros are cheap. Horses sell from two to five dollars and up. I priced some at fifteen. An Indian told me that he would sell his best horse for fifteen dollars. Eggs are selling at fifteen cents but they are more likely to sell at twenty cents and more. The Rio Grande and Denver cars coming back to Santa Fē are shockingly slow; we will get back at half past eleven o'clock instead of at eight P.M. as we should have done.

Letter 4

April 16th

Dear ____

The Tesuque Pueblo is about nine miles from Santa Fē in an opposite direction from those other pueblos and not on the rail-road, consequently I had to get a carriage and driver.

April 15th

On the road I saw many arroyos. Sage brush grows every where and I was much interested in it and the arroyos. Some sage grew very high. A land mark called the Divide is quite an elevation and separates Santa Fē from a Mexican village; and further on is a German ranch; quite a thriving looking place and the first ranch I ever saw.

We forded the Tesuque river which was no great accomplishment. We met Indians walking by their loaded burros and were politely greeted with "Bueno dias"—Good Day—

Gramma grass, scrub grass and Buffalo grass helped out the monotony of the Sage all along the road. Their grey green effect is very similar and the whole surface in the distance looks bare because there is so little difference in the color of the ground and it.

Santa Fē Mountain to the right on the road to Tesuque is covered with snow. This shows that the altitude is greater than it appears. Old Baldy has mica deposits.

The Tesuque pueblo is the only village here which has no case of small pox; but it is not worth while to spend much time upon their pottery as it is the least desirable. They are not a good set of Indians; rather tricky I am told; because of their nearness to Civilization, which is not what it should be in its dealings with the Indians.

As my guide and I drove into the pueblo it became so very warm that I loosened my little cape and let it fall behind me carefully secured, as I supposed. When I alighted from the carriage I did not think of my cape and went immediately to one of the adobe houses and tried to talk to the Indian women; but I got no answers. Almost the instant that I stepped into the room, a girl from the opposite side came forward holding up my cape. I was thunder struck for it seemed not more than ten minutes since I had loosened it. She soon gave me to understand that she wanted twenty five cents for restoring it. I gave her ten. Soon another girl came and made me understand that she had found the cape in the patio and wanted money. I scolded the other girl but gave the last claimant ten cents. By this time my guide and driver came in, and we climbed a ladder to the house above in order to see some pottery.

The family below could have no communication with those above unless they went outside and mounted a ladder. I did this with some trepidation, sending my guide Lowitzky who is a Jew, up first. He was on good terms with the Indians and a fine interpreter.

While up there I bought a newly made idol; it is a clay doll and has its mouth open like a cat fishes [see figure 3]. It is out of all proportion, its head being about four times larger than it should be. The hideous thing sets me laughing every time I see it. In the first place I was surprised to learn that they worship red idols. When we came down the ladder we were accosted by an old woman, who told Lowitzky that her daughter, wanted twenty five cents for finding the cape. At this I spoke sharply and she did not get twenty five cents. The truth of the matter was she had stolen the cape from the carriage as we drove slowly across the patio. This girl had been to school and it is the general opinion that the schools demoralize them. I'll look into this and tell you more of its truth. I'd like to doubt it. One thing is certain, and that is, the Tesuque houses are clean and spacious and the Indians were clean when I saw them. As I was talking to them and trying to get information without getting an English word in reply suddenly I turned and asked if that building, to which I pointed, were a church. One girl forgot and called out "Yes!" quite eagerly, and as quickly she covered her face with her shawl. I tried to shame her for telling me what was false, as she had told me she could not speak English, but could get no more English until I gave her a nickle [*sic*]. The

Pueblos do not have a chief but a governor elected by the people, a new one each year. As we were leaving, the present governor came in from ploughing [*sic*]. He was in his shirt sleeves and although he did not look like a governor he was a fine specimen of an honest laboring man. The Tesuques told me that the black pottery was made so by smoking it and so did D^r Lee Granson but others said that it turned black in the firing just as some burn red or white. I am sure that this is not the case. Later I will find out all about it and tell you. Upon leaving the pueblo I turned and said Adios! which brought forth a whole shower of adios. Farther back from the stations they are more honest I am told.

One day I passed Fort Marcy, Head Quarters. There was a school in the enclosure and little Mexican children stared at me just as English speaking children do. A large enclosure to the left with adobe walls I suspected to be a corral, and I asked some urchins what it was. They all stared and looked blank until I got a safe distance from them, when one little fellow, modestly drawled out "coor'–räll." I had no time to visit the old part of the town until to day Apl. 17th and very hurriedly then. Well: I found it a jumble of adobe houses with mere alleys for streets. The old historic church San Meguel [*sic*] is the attraction. It looks from the front like an ancient mausoleum more than any thing that I can recall. I hope that I can get a good picture of it. I had a hard time to get in and an amusing one after I was in. We must pay a quarter to do it and be shown around by a consequential, grey bearded, old sexton. A rope is attached to a large bell from the outside near an old sort of cloister. I rang, rang, rang until I began to be provoked; at last a nice looking priest came out and asked politely if I wished to see the church. He said that the sexton would soon open the door, which he did. The church was built in 1580, (some say 1548[)]. At the uprising of the Pueblos in 1680 the roof was burned. In 1692 another roof was built. Inside there is a good deal of rude carving and mural painting. The carving was done with the stone implements made by the Pueblos. Over the Altar is a picture which was painted in the 13th century, brought from Spain; another is five hundred fifty years old. Near the front door is a picture of the Virgin Mary painted in Mexico three hundred years ago, after the Virgin had appeared to an Indian. I can recall one more only just now—it is of Christ before Pilot which is two hundred years old. The old bell was brought from Spain and was made in the year 1356; it weighs 780 pounds. I hope that my figures may not clash with other people's! If they do the portly old sexton is to blame. He told me much that I cannot recall. In some way or other I excited his ire, and the more he fumed the more I enjoyed it. The curious looking, rude carving on the gallery with its same quality of painting, attracted my attention and as the sexton passed it I asked if he were not going to take me up there? To this he gave a decided "No!" I innocently asked if it were not safe to mount those old steps. "O, Yes!" said he "but if we took people up there every thing would be stolen." I wondered what precious things could possibly be kept in such a forlorn, unkempt place; and to my expression of surprise he remarked "All Americans are thieves." All of this and more was kept up in an unaccountable tone of anger on his part, I turning it all into a joke. Finally I said Are you a Mexican? This was the climax to his wrath and in hot tones he said "No!" I am an American, as much an American as you are." My amusement was growing stronger every moment but without a smile I said, why you just said that "All Americans are thieves."

He cooled down very perceptibly and was almost pleasant. I went off, gaily reciting my adventure to others whom I met and chuckling over the funny time I had had in the antiquated church. I was told that the sexton was noted for his idiosyncracies [*sic*] and garrulous tongue, and that he was a Mexican.

I recall as I write, the "Ghost of San Meguel," [*sic*] Santa Fē. Many years ago the Indians killed a priest; he was buried in the San Meguel Church and at certain seasons his ghost appeared; but fourty [*sic*] five years elapsed and he did not appear again until last year, eighteen hundred ninety eight.

I have learned a great deal about the Indians and am picking up a little Spanish which is the language of Santa Fē.

Tuesday
Apr. 18th 1899

Dear ____

I must leave here soon, there was a grand army parade and I enjoyed seeing some of the brave, Rough Riders of New Mexico. Do not write again until you hear from me. I have decided to go to Laguna. I shall probably go tomorrow night. I wish that I could send one of these little burros home. I will buy one if I stay long. I will say adios to Santa Fē with many regrets; her charming hospitality will be remembered with grateful pleasure by me longer than any one here will remember me. I hope that I may return. I cannot leave until I get a letter from Dr. [Lukens] at Laguna telling me that he has secured a room for me and that he will meet me at the train. I cannot drop down in an Indian village at midnight alone. Laguna will be very different from Santa Fē. I have met lovely people, Gov. and Mrs Prince, Mrs Wallace, Mrs Whitemann, Mrs Palan[,] Mr. & Mrs Gay and their daughter.
Bueno Noche

Letter 5

Laguna N. Mex.
Thursday April 20th 1899

Dear ____

I arrived last night Wednesday at midnight. D^r [Lukens] the Presbyterian missionary to the Indians met me at the train. A half a night in an adobe house! I cannot recall any peculiar dreams. So there are none to come true after my first night in a strange house. Every room is large and pleasant though there is not a closet of any kind in which to hang ones clothes. The house has but one story and is flat roofed as all adobe houses are. The inevitable ladder is back of the house upon which to mount to the roof. I will not mail this but continue it another day when I have seen more. Many of my letters will have different dates.

Since I wrote the above I have been to Pahaute Sunday Apl. 23rd to attend a Christian, Indian meeting. D^r [Lukens] kindly took me with his family, distance twelve miles; with his wife and son was their cook a neat Indian girl of nineteen years. She is having a summer at home after twelve years absence at the Carlisle Gov. School. In September she will return to Carlisle and Major Pratt will have her trained as a nurse in some hospital. Louisa shows the fine training she has had at Carlisle; she has a natural gift for nursing. On our way to Pahaute we saw some cute little prairie dogs. As they kicked up their heels and darted down into their holes in the ground I could but recall Washington Irving's "Prarie [*sic*] Dog-Village." In all directions

green little spots or tufts of the yucca plant were to be seen and now it is of greater interest than before, because I know that the Indians and Mexicans call it Amole or soap root. It is well named for the Pueblos dry the root in the oven, after which they crush it and make a foaming suds of it and wash woolen good [*sic*], and best of all they wash their thick long hair with it once a week, until it shines with cleanliness. San Mateo off in the distance is snow capped on several of its peaks and is thirteen hundred feet high. They tell me here that it is the highest mountain in New Mexico.

We passed large flocks of sheep, prettier and whiter than any I ever saw; with them were hundreds and hundreds of little lambs as white as snow. "Lucy's Little Lambs" herded by Indians and their poor, starved looking dogs. I no longer think that Lucy's Lambs are a myth for these really were white and clean looking. I suppose that it is because the sand is so white. On a hill was a queer, little, stone house looking like a square box. It was built by a man who is guarding and attending his young trees; a veritable fairy grove with hues and shades of lovely spring reds, browns and greens; against the yellow background it is rich. It is near a small stream and irrigating ditches are all about it. An odd dinner we took in the Government school teacher's house [Miss Bingham's]; the meal was cold because we carried it with us. Indian children dressed in all colors and garbs were peeping in at the windows. One Indian was pointed out to me as a Lente Indian, that is a descendent of an Indian and a Mexican. I may not have spelled it correctly but it sounded like that. A swift little stream ran through the pueblo: some very small children were playing in it and others were washing clothes. We came upon them so suddenly as to nearly run over them, but in their scamper they did not forget to help a very little tot out of danger's way. Water is so rare a thing that we can but remember this incident. I spoke to many of the Pueblo girls; among them Lillie Sionie [*sic*; later her name was consistently spelled "Sione"], a bright, pretty girl who had been educated at one of the Santa Fē schools. The poor girl is lame but an energetic worker and a Christian. I will find out more about her after a while if I stay here long enough. I was amused at an Indian doll which was a narrow piece of board, perfectly flat. The crown of the head was white, face green, eyes black and the body pink; a blue band was under the chin. The dress was of evergreens; peacock feathers adorned the back of the head. Ribbons tied the greens on. These dolls are used as idols at devotional dances after which they are given to the children. Often they are handed down from generation to generation.

The most curious thing that I saw was Indian corn bread; it resembles in color and texture a hornet's nest. They call it metsene or paper bread and it is to the Pueblos what cake is to us. [Crossed out: Only the old women can make it because when put on the hot stone to bake it, it must be spread very quickly to prevent burning the hands. It is made of blue corn which accounts for the color.] John Nori was interpreter at this meeting.[3] He is a most conscientious convert; was formerly a very bad man in every way. Now he comes twenty miles to the religious services and observes Sundays devoutly, reading his Bible when ever he has an opportunity. He had lived with a woman as his wife many years but as soon as he became a Christian he married her and gave up all of his evil habits. He and others are fine examples to many who have had greater advantages of Christian teachings.

Yesterday I bought some arrow heads of Lorenzo the Indian warrior.[4] His Indian name is Cheme Chetete meaning three stars; he is nearly if not quite a hundred years old and one of the few old warriors left who fought with our Government against the Navijo [*sic*] and Apaches. He cannot speak a word of English.

Letter 6

April 29

My Dear ____

 I hoped that you had gotten my letter ere this but I fear not as H ____ sent his to Santa Fē. The last few days have been such hard and busy ones that I have hardly had time to think. On Thursday the twenty seventh the doctor went with the Government school inspector Mr. Burton, to be gone all day. About noon some one came for the doctor saying that the cars had run over a Mexican. We gathered necessary things and hurried to the station. Mrs [Lukens] and I taking the Indian girl with us. When we reached there we found the poor man with his foot looking like a mere stump; he was cut and bruised all over and internally hurt. Some one had had the good sense to tie above the wound to prevent bleeding; his wife was bathing his head, and a crowd who knew nothing, looking on. He was lying in the broiling sun and wind on Mr. [Emil] Bibo's store porch he and his clerks and nice little Mrs Bibo did what they could, but really we were a helpless set with no doctor at hand. Mrs Lukens was the most efficient person among us. She had brought deodorizers and after we had bathed the sand from the foot she used them freely. We could get no information regarding the man's home because we could not understand Mexicano; no one would take him in, indeed no one had a place in which to put him. At last, Mrs [Lukens] suggested taking him to my office, which we did. A bright eyed Mexican (Frank), who could speak English, and a night worker on some trains went with us and were treasures, and so was Louisa the Indian cook. The men got the sick man on a cot which Mr. Bibo loaned us and they carried him to the room. That was a dreadful journey in the sun, and causing jolts which could not be avoided. Mrs L[ukens] had dispatched a man on horse back for the doctor. He went by trail; fortunately the doctor had started home by the carriage road and reached here by four o'clock. We had every thing ready of which we could think, hot water &c. and the doctor amputated the leg beneath the knee.

 Louisa assisted him, she sat or stood at the doctor's side throughout that long and trying opperation [*sic*] almost anticipating the doctor's wants, he had not the necessary tools and this prolonged the work. Frank and the railroad man helped also and a missionary from a neighboring town happened to come in, much to the relief of the doctor. It was night before he was done but he sat beside his patient all night. There we were with a dying man to nurse, three women and one man to do it. A new work for me, indeed for all of us probably. We took turns in sitting up at night and by Saturday we were nearly worn out. Not a man or woman came to offer help, excepting Miss Bingham who sat with me one night even though she had to teach school. The Mexicans are such worthless people as a rule that no one cared whether he lived or died, suffered or not. The Indians hate them, but we did think that for the sake of humanity, some one might have come to enquire for him and ask if we needed help. Poor Joe ____ was a brave sufferer and a grateful one! The doctor said that it would be a miracle if he lived. His wife nor any of his friends came near him after that first day. I made it my duty to bathe his face and hands every morning; his great brown eyes spoke volumes of gratitude for it. Once he looked up and said "Is this your house?" I told him no, that it was the doctor's house and that I was helping to take care of him. Both lips and eyes then said "Thank you, señora." Poor soul: none of us until then knew that he could speak English. After this he was very anxious to have some clean clothes. At times he suffered such agony that he would forget every ones presence and cry out

Iya! Iya! Iya! Iya Dios! Iya Dios! I shall never forget it; his Oh! Oh! Oh God! for that is its equiv-
alent. On Saturday morning I began to think that it was impossible for me to endure another
night of nursing, I could scarcely hold myself up and the others were nearly as badly off. Even
Louisa looked pale. As the doctor must of necessity have his Missionary meeting on Sunday I
told him if he would sit up until twelve I would take his place until morning and Louisa and Mrs
Lukens then might be fresh for the day's nursing. I awoke between twelve and one and heard the
doctor in his room; I wondered that he did not call me and was shocked that he had left poor
Joe alone. At breakfast he told us that Joe died at fifteen minutes of twelve o'clock Saturday
night April 28th. We had not nursed him quite three days, yet it seemed three weeks and we were
almost ill our selves. Peace! peace! peace! poor man. We could have stood it no longer and his
death was a release to us; but in our hearts we were glad that we had opened our doors and taken
him in. The doctor had sent word to his wife that she must come and take care of him, bring-
ing clean clothes and a man to help her. She had on Saturday sent him a jug of milk. Early on
Sunday the doctor went to his Sunday meeting at Pahuate. In this climate with no ice the dead
must be buried soon, so Mrs Lukens and I started out to look for an Indian to carry the news to
Joe's wife. When half way to the pueblo we saw a Mexican wagon well loaded coming, and soon
discovered that it was Joe's wife coming to take care of him. She was not really his wife. She had
a bed, clean clothes and other necessary things. She did wail very piteously when she found him
dead. She drew her black shawl over her face and the men delicately withdrew until her grief
found some relief in quiet. They then came in and wound the bed clothes around the remains,
pinning them and carrying it all out as though it were a log; and the wagon went back as it had
come, but heavier.

To do a little justice to the woman and her friends I must tell you that she, her little girl and
others stayed about the house on the day he was hurt until we feared that they might stay all night.
And as they were much in our way and useless we asked the priest to tell them that they had bet-
ter go home; but we never thought for an instant that they would not come back again.

We learned that Joe was a Penitente, a very prominent one—and that at midnight of that
same day he was buried with great ceremony, lighted torches making the scene wierd [*sic*] and
spectral. There are several villages of these Penitentes, of whom I may write another time. Joe's leg
healed beautifully and if it had not been for his internal injuries he could have lived.

There is very much that is interesting to tell of all this country historically, both politically
and physically, and of the inhabitants but of all the forsaken places in which to live I think it
exceeds. The sand storms are horrid and there is no vegetation excepting where irrigation is pos-
sible. Every thing is expensive; yet every one raves over the beautiful, healthy country, excepting
those who are compelled to live here. I for my part would not miss seeing it for a great deal. Every
place we turn we see the effects of volcanic action. There are all sorts of things of which to be
afraid if one depends upon what he reads, but when here, all dangers seem far off.

For instance away off on the mountains are bears, wolves, lions, hoyotes [*sic*], but smaller and
nearer dangers are rattle snakes, tarantulas centipedes, and a small grey spider all of which are poi-
sonous. A queer little thing called child of the earth is said to be very poisonous. They are rarely
seen though.

Mrs ____ had been here but a few weeks when she captured in her house a centipede, a taran-
tula, and a child of the earth and all of them she has in alcohol. Another woman lived here for sev-
eral years and never saw any of these dreadful things. It is very odd to hear the wind blow, it

actually howls, and see the sand fly, but feel never a quiver of the house. I have almost decided to stay here because the Indians make good pottery, such quantities of it and a great variety of designs in the decorations, also because Laguna is on the rail-road. Besides it is an item to be where there is a doctor.

I like to run to the door and see the women carrying their ollas or water jugs on their heads with such ease. Their characteristic, native dress is varied, yet of a sameness too. The babies on their backs are held with gay and sombre [*sic*] colored shawls drawn tightly about them so as to form a seat for the little ones. Their little heads dangle and bob about, and the poor baby eyes turned up to the sun are often doomed to be sore or blind. It is surprising to see some, very, small children carry babies on their backs as though the weight were nothing.

The pueblo of Laguna is like a yellowish white castle on a hill of rocks of the same color, in many places looking like a ruin. Many of the adobe houses are neat and pretty inside. They do not call the women squaws, nor the babies papooses.

They elect a governor each year unless they choose to elect the same one again. His rule is supreme almost. When a man marries he leaves his own home and goes to that of the bride and is subject to the parents of the bride as completely as though he were a child and their own son. If he wishes to go from home or spend money or engage in any business he must ask them, and if they refuse he must obey. If he dies his children belong to his wife's family. With all of this stringent authority there is little quarreling and the greatest defference [*sic*] is paid to the old and to parents. Inheritance is always through the daughter not a son.

There are many Carlisle pupils here and I can tell you that the school training shows for good very perceptably [*sic*], even if they do sometimes go back to the old dress and customs. When I know that many times they are whipped and persecuted to make them assume the Indian dress I am sure that they are not to blame. The force brought to bear in this direction is powerful.

This very Louisa has gone through an experience that would make you or me yield under the same pressure. When I arrived here the family with whom I board kept no girl; the next day they sent for Louisa who was glad to come. She was in a forlorn condition because all of her relations were tormenting her to go back to Indian habits and dress. As far as the dress is concerned I see no need of changing it as long as they live in a pueblo, because it is modest, pretty and convenient, and surely most healthy. It was a great relief to the poor girl when the doctor and his wife rescued her. Her one great ambition is to be a trained nurse. She told her grand parents that she would run away if they attempted to force her to wear Indian clothes. When she came to this house she told no one and this frightened her relatives very much because they thought that she had indeed run away. My coming saved her because it was on my account that a girl was needed. When she came from Carlisle she was given a house; she had also about fourty [*sic*] cattle and other things which I cannot mention. When I left she had one cow. If a child inherits any thing, it matters not where she goes or how long she stays that property is held in her or his name until she claims it. They used every inducement with Louisa to get her to live with her father and keep house for him or to live in her own house as she pleased and I must confess that I think that they showed infinitely more love and consideration for her than she did for them. They offered the best they had; she gave nothing in return, not even a kind word. She is educated, they are heathens. I would not for the world have had her yield but she could have shown some gratitude. Lillie Sione went back to her home and made it a lovable place and is helping her parent to civilization and Christianity.[5]

We had a hail storm to day in opposition to the sand storm which we are still having.

It is both cold and warm. If you had such a sun at home you could not endure the heat but here if you are in the house or in the shade,—even only that of an umbrella—it really is delightful, summer weather. Driving in the broiling sun even is enjoyable if under an umbrella.

You would be surprised to see the trinkets which the Indians wear; beads, bracelets, pins, belts, and buttons made of silver coins—United States and Mexican—They are made by Indian silversmiths; the Navijos make better than the Pueblos. Tourists search eagerly for them and give good prices especially for the buttons.

Letter 7

Thursday—May 4th

To day we, the whole family, visited Mr. B[ibo?] in his car. He said that he had many curios and I did not want to miss any thing seeable. The first thing he showed us was a human skull which he found in one of the cliff dwellings near Winona, Arizona. He thinks that he was the first to visit that particular cave. After examining it carefully and laying it aside to look at something else I went back to the skull and said, rather timidly, as though I were asking a thing very great, Mr. B[ibo?] if you find any more skulls I wish that you would give one to me if you do not want it yourself. "You can have that one," came so quickly from his lips, that I fairly jumped at it and asked if he really meant it. It was too good to be true! I hugged it up in my arms and carried it off in glee. He showed us Indian, arrow heads which were beauties; transparent black ones which they call black topaz, (but are really obsidian or lava glass,) red flint ones curiously shaped, and light ones more curious still. He has a water crystal which I do not understand. I must be looking up my Dana.[6] He also showed us his refrigerator car, tools, and other things and gave us magazines. I almost felt like a beggar; but we were isolated enough to want any thing belonging to the civilized world. He seemed to be a man of much practical knowledge, so I asked him if he had any feldspar; Immediately he produced a fine specimen and pointed out a place where I might get some and fossils also. My brain and heart went pit a pat for I was among things for which I had yearned many years.

The purplish, brown hills back of our adobe house he told us contained cobalt, lithium lithographic stone, zinc, copper, silicon, and a red stone of which paint could be made. My very finger tips tingles with delight. The dark, porous rocks opposite us, paralel [*sic*] with the force pump, are of volcanic action and called malapie [*sic*]. I was so sure that there could be no such word, for search as I would I could not find it; but at last we found that it was a corruption of malopais [*sic*] meaning bad country.[7] And it is this very bad country which relieves the sameness of the white rocks and sand and helps to give richness to the wonderful cloud effects in nature's pictures.

POTTERY
Friday May 12th

Dear ____

Louisa and I went to the pueblo after dinner. It proved to be a most interesting visit. We were hoping to see Indians at their pottery work and were not disappointed. We found the work in all of its stages. First, the fire clay modeled entirely by hand, and it surprised me greatly that they can

get such good shapes simply by manipulation; not a mould of any kind do they use, neither do they have a model at which to look. They get fine modeling clay from a mountain west of here, and the vein extends eighteen miles I know but how much farther I do not know. After it is modeled they dry it in an oven or under a stove as occasion requires; after which they give it a coat of white clay, like paint using a cloth. After this dries they make brushes of strips of the stiff leaf of the Amole plant. It is astonishing that they can do such beautiful work with such rude materials, while we when I took lesson [sic] in pottery in Philadelphia many years since were so very particular about our brushes. It is true that their work is all design and never shaded; geometrical designs but not geometrically applied. These designs would put many a fair maid to the blush if her china were placed side by side with the designs of the Pueblos. And they did just such work years before they ever saw a white man. The white clay is gotten out of a mountain opposite from that in which the body clay is to be found. Their paints also are found in a different place, in the form of a stone; dull red, yellow, brown, and black are their only available colors. It you find blue or green paint on their pottery you may know that it was put on after the firing. They grind their colors on a stone used as a mortar; they have no pestle; they hold the paint in their fingers and rub it against the stone with a little water until it is the proper consistancy [sic], then apply it to the ware. Could any thing be more simple or crude? Primitive indeed! And as various in designs as the number of their ollas or tinajas, for you never see two jugs painted exactly alike. I know now for a certainty that the black ollas are smoked black. My thoughts go away, way back to the ancient Egyptians and imagine I can see them at some such work; and later to the Greeks. But where are they the Greeks? Aye: they are in our hearts, our brains, our finger tips, for are they not our masters and are we not at their feet striving to follow, and will we not strive and still follow?

If they arose to such heights with no incentive but the talents which God gave them, why have these Pueblos during all their generations living near to Civilization and Art remained just where they began, and why are they willing to remain where they began? No: not where they began for they are degenerating. Tis said that their ancestors did better work. But I do not believe that they ever did to any appreciable extent. It is that Spain ground out of them all that could elevate, and crushed every hope and ambition? It cannot be that altogether, because the Indians of the North have not advanced one step more in Civilization nor are they as near it as the Pueblos, and have not the art in them; but that may be on account of the difference in their environments.

Well; to come back, Louisa and I visited first her grandmother; found her working at her clay, seated on the floor with three children beside her. Louisa got the key to her own house and it proved to be a spacious room, large enough to make three or four. Then we went to Minnie Billen Sice's home and found her pretty sister Lillie ill from nervous prostration caused by the recent murder near them. We saw smoke in the distance and went further, to see if it came from burning pottery and to our satisfaction found that it did. The old woman (guay-oo-ich) went back with us and we sat with Minnie and her mother while they modeled. I tried it also a la Indian until the old guay-oo-ich took us to see her burning pottery. This was a supreme moment to me because I had been told, and school books teach us, that Indian pottery is sun burned—please note this fact–. On a bed of stones she had placed her ware and about it she had piled up old bones and manure, (cow chips). I noticed the whole skull of a horse or cow. The bones served simply to help hold the fuel together, and to keep it loose that it might burn the better. The ware was completely covered with cow chips making a dome shaped kiln. A dense cloud of smoke arose until the blue flames came out from all sides. Then gradually all became red; the ware could be seen through spaces where the chips had

become exhausted. As soon as it became red hot, the fuel was dragged away and the pottery pulled out to the cool air, while red hot. This hurt my feelings for I knew that it must injure the pottery to some extent. Now what becomes of sun burned pottery? I could not induce them to wait until it had cooled! The chips made a very hot fire and with a long stick we helped the woman, Bart Whetmore's mother pull away the chips and gather up the ware which was mostly pipes and cute little cups.[8] I bought a pipe for ten cents. We returned to Minnie's [Minnie Sice] where we saw pipes which were more pretentious with modeled faces and caps a la soldier on the bowls; some had birds perched on them, and one had a dog. Not the least interesting part of our visit was to see the women and girls grinding flour and meal. It must have been the Bible time way of doing it. At the side of an inclined stone worn by ages of grinding, and forming a mortar, with a small one for a pestle (oblong in shape) were a kneeling woman and child swaying back and forth grasping the pestles and reducing the wheat or corn to powder. I should have said that there were three stones in a wooden trough on the floor. They sang a dull tune to keep time to the motion. I am told that sometimes a man beats time on a primitive drum, while five or six women in a row grind and sing.

All of this forms a picture for an artist well worth reproducing if we consider the gay, native dress, bedecked with beads, shells, ornaments of silver, and beautiful necklaces of coral. Most of the babies are round, fat faced little things often not one bit pretty because their eyes look weak and they need handkerchiefs. They are mostly seen on the backs of old men or small girls or boys. I had a taste of the Gala bread metsene. I have read of clay eaters and am surprised to learn that I am among them to a small extent, because the paper bread has a very little clay in it. As it is very tender I think that they put it in to hold it together. Louisa's grandmother's name is Yīes. She is old and cannot speak English, but is a good worker though not very clean and orderly about her house. The only tool used in making pottery is a broken gourd and once in a while the bowl of a spoon, and a smooth stone with which to polish. Once I saw [her] use her thumbnail. They test the consistency of the clay by tasting it. In going to the pueblo we took pleasure in following the trail. No danger of loosing [*sic*] it because it is a path worn in the rocks by the constant tread of moccasins for ages, generation after generation. It is deep, and so very narrow that it is hard for me to keep step in it. I do not see how it was possible to form and keep so narrow a path. A great gloom hangs over the pueblo since a frightful murder of an Indian the other day. His wife and her accomplices, killed the poor man and carried his body to the rail-road to make it appear that he had been killed by the cars. They placed his body so that the train cut off his head and legs. But the crime was not hidden and the three are in jail. The poor things feel it dreadfully. No white community could be more shocked. I am told that this is the first murder at Laguna with the recollection of the oldest Indians of the pueblo. The oldest man is one hundred and twenty five years old. (Most decidedly these Indians do not deserve the name of dirty Indians. I have seen but three dirty houses among them as yet. It is the orderly, cleanly ones which surprise me.) Adios!

I am sleepy——

Letter 8

May 13th

All of us took a long walk after supper far up the rail-road to the north, where the train turns last: we climbed the rocks and sat there in the gloaming. The charm of a summer night in New

Mexico, still and calm and beautiful is great. The gloaming though is short for when the sun drops down, darkness follows quickly; but the stars come out one by one in unusual brilliance to atone as it were for the fleeting twilight and the moon is [*sic*; missing phrase]. The doctor [Lukens] tried to set fire to a stunted cedar tree, but it was stubborn and refused to burn much to my comfort for I felt that not a twig was to be spared where there were so few. Trees are as scarce as water. One large reservoir near the pueblo attracted my attention last night. I could not tell what it could be as it was enclosed by walls of stone and the bed of the enclosure was nothing but solid rock with deep holes, evidently of nature's making, very uneven in depth but smooth. It was about a half acre in size. When told that it was a reservoir I could not believe it for it was a dry as an arroyo. In fact it never has water in it excepting after a big rain; then it is a treasure as the many cavities hold water.

When it rains every hole in the rocks holds water until it is used or evaporates. They form small laundries, and dotted about here and there may be seen groups of women and children washing their clothes. With the children it is only play. All other water is so filled with alkali, lime and other minerals that it is hard either for man or beast to quench his thirst or to bathe himself. A spring of fresh water is valued so that it is kept nearly empty by constant use. There is a walled up one near us and Indians get up at midnight or even sit up all night near it to get the first flowing in of the water during the night. Great and varied are the resources of an arid country, and how much I am learning in a breath's time as it were. All is so new to me and out of the United States sort of thing that I wonder almost who I am. Reading is a great thing but it is not like living and seeing. On our way back we passed a cave and that brought forth the story of another not far off. In this cave a lion dwelt and the Indians held it in great reverence and worshiped it as a God taking it food and other offerings. One day a young man met the lion at the entrance of the cave. The man had been hunting but had had no success as a sportsman, in fact he never did have, in consequence of which he had to endure the ridicule of the whole pueblo. The lion obstructed the entrance to the cave and told the Indian that if he would go home and make him a corn cake in a certain way, and bring it to him he would show him a hunting ground of great value, and teach him the secret of success. Off ran the Indian and in due time returned with the cake. The lion true to his word led the way, a great distance off until they came to the lake at the right of us. The lion stepped into an opening in the water and bad the man follow; at first he refused, but the lion ordered him to do so and soon they were beneath the lake in spacious apartments. Through these they emerged to a most wonderful hunting ground. No body knows what he did or what he saw; but it is known that he returned to his friends loaded with game. After their subteranean [*sic*] visit the lion and he parted never to meet again. He told of his adventure and was laughed at more than ever; but as he became the most famous hunter of the Pueblos they were awed into belief of the Lion, and his cave is pointed out to this day.

There are three layers of lava formation here showing that there have been three volcanic eruptions, and it was after the third or up to that period only that the Pueblos date their history. Many were destroyed but their legends tell of fire with water and a resinous thickness which filled the atmosphere.

The Pueblos are older than the Navijos but neither have any legends far enough back to give any clue to the more ancient cliff dwellers, and mound builders, nor the more civilized agricultural and architectural people. The ruins of buildings large and wonderful are said to be in Socorro and Valencia Counties; though what I learn in this verbal way must be very superficial of course and I only write what I hear. I will look it up more thoroughly when I have opportunity.

Letter 9

May 17th

My Dear ____

So many pardons for not writing sooner and to Dear Canning also for not acknowledging his beautiful Easter greeting. Your letter came just as I was packing to leave Pennsylvania. I shall in my haste write you a forlorn letter. I can scarcely spell a word correctly because I have gotten Spanish, Indian and English in a conglomerate state in my poor brain. I get the sounds of a, e, j, and h, all Spanish and find myself sticking them indiscriminately into my native tongue. If I only had the gift of a linguist I would fare better in this barren wilderness. I do not see how man or beast lives on these rocks sandy plains; but the wealth of history and natural science which confront us at every turn compensate for the sand storms and other privations. If I did not love geology and the picturesque part of these native Americans and adobe homes, combined with the greater interest I have in the object of my sojourn I would not stay one minute. At every turn one sees strange formations and upheavals.

I killed my first tarantula in Albuquerque, a young one and the only one I have seen here. They are rarely seen in town. But wait: it just strikes me that maybe I did not kill him after all for I put an old tomato can over him. I forgot that the thing can bore its self out through the ground. I came to Laguna because it is a most desirable place to study Indians and their pottery. This is the one absorbing subject to me. People may talk as they please of dirty and dishonest Indians, of course they exist but here they are clean and honest as a rule. A white man in authority told me that when he could not account for a thing to his company he always said "Those damned Indians must have taken it." He did not hesitate to tell me this and gave me to understand that he knew what white people had done the theft. This he thinks a joke with which to cover his own short-comings and lay at the door of the Indian, a thing which many could and would not perpetrate. It strikes me forcibly, upon entering some of their homes that their lives are a strange mixture of the civilized and the heathen, as they have furniture, stoves, and even sewing machines such as we have. You would be charmed with the large rooms; but often the whole family or two or three families sleep in one room, on the floor mostly, wrapped in their blankets; beautiful blankets ranging in price from two dollars to five hundred; the first and last prices being rare.

I enclose an arrow head for Canning. Tell him that I bought it from Cheme Chetete the old warrior.

I think that I shall remain here sometime but cannot tell, as there is some difficulty in securing land and I must build if I remain.

Bueno noche

Happy dreams.

Letter 10[9]

Monday May 22nd

I am too tired to write but after such a climb, ride and eat I must. There is no pleasure without alloy.

The alloy here is first hunger, second dust. I smell dust, I taste it, I eat it, I chew it, I carry it about in my hair and clothes; I shake it from my clothes and fill the air with it and when I have done they are worse than when I began.

Our long talked of picnic is a thing of memory and reflected pleasure. The doctor rode Dewey the rest of us rode in the large carriage; we started about four o'clock in search of feldspar and found it. I wanted to experiment with it in potter's clay. After gathering sufficient for testing purposes we started for the hill top. No height ever looked so tempting to me nor so unattainable. It was near if not four hundred feet to the summit and to that summit we must mount. I had to rest several times before I got far, for the action of my heart in this altitude is too great. Laguna is six thousand feet above sea level. I wished very much that I might always have a geologist at my call. I want to know the nature of every layer of rock and every pebble. I feel sure that that blue, powdered, rock substance must be lava. All is of volcanic action in certain directions. Almost at the start there was a very pretty, interestingly steep rock formation of chrome yellow. The doctor ascended with little trouble. His wife and son followed and Louisa brought up the rear. Miss B[ingham] demurred, I tried it and backed out. It was too dangerously smooth and steep. Then Miss [Bingham] was persuaded and only I was left. I never did like to be out done so forward I went, the doctor and Louisa extending their hands at different stages. At last we all stood together only at the beginning of the difficulties. All the way up I was always the last one; but that gave me the advantage of seeing the rest, one by one as they trailed along the winding way, making a most beautiful and striking picture as each one gained different heights at great distances apart. Miss [Bingham] was the first to reach the summit. The others soon followed excepting the doctor who kindly lingered to see if I needed assistance.

I seated myself on a bank which I called lava ashes. I had to breathe rather than rest. How we ever got up that dangerous height I'm sure I cannot tell; but I know that all of us were on our hands and knees some of the time and that we would slide back, laugh, and cling to rocks or roots at times. We called aloud and shouted to one another and listened to the echo. No other sounds were to be heard. It was too fascinating for any thing but the wild charm of the moment.

As I neared the top all alone, amid steep and rugged rocks with torn clothes and scratched shoes I thought "Around the rugged rock the ragged rascal ran." My merriment was changed into surprise for I was sure that I saw prints of cow hoofs but I could not believe it possible for how could such a clumsy beast as a cow get there? But at last there was no mistaking it for there were cow chips to be seen also.

We sat on the summit and enjoyed the grand panorama, all glad to rest and I to breathe at my leasure [*sic*]. Not far from us on a ledge of rocks was an immense boulder and on it a small rock of sandstone. Miss B[ingham,] Louisa and the doctor threw stones to dislodge it. I could not look at them as it excited every nerve in my body, fearing that they might accidentally throw themselves off, for we were very near the edge of a steep rock.

The beautiful calm of that great height was charming and soothing. The different mesas to [the] east reflected the sitting [*sic*] sun, giving the yellow sand rocks a ruddy glow which reminded me of a picture that I had seen roughly painted of the early spring hills at the water works near Athens, Pa. Our horses and carriage below, looked like toys and a train of cars farther off looked like the little iron one with which children play. The air was pure and lovely but we had to go down; how was the question, for I knew that that would be worse than the climbing. I thought that the easiest way might be to roll down; [Crossed out: and wake up to oblivion]. The cow tracks were a comfort for I reasoned that I was not worth much if I could not climb where a cow might lead. Little Charles said

pitteously [*sic*] "How are we going to get down?" His father reconnoitered and called to us and the result proved good. We found a part of the cow trail and went joyfully down even though we did have to slip and slide and pick our way carefully. Near the base of the hill we found some odd and pretty sandstone formations. They look like drippings of sand and water, with wavy circles, dark outside and light when broken open. Some had assumed the shapes of watches, cocoanuts, terrapins and other things. Tired we were when we reached the carriage and sat down on the blankets to eat our cold supper in almost dark New Mexico. On the creamy sand we spread our tent surrounded by historic rocks, caves and mountains, and mesas in solemn mases [*sic*] huge and grand. What idiot was it who said that America had no history? I remember it from my childhood. Why these rocks, mountains and valleys have written on them the histories of eons upon eons and we cannot unravel them. Each year a new story of the rocks is read to us, and still we study and read, and still are but babes in the stone lore. They laugh us to scorn so little do we know, and people, the wise ones as it were, turn their backs upon us and cross the deep in search of knowledge, and leaving their spendings on a foreign shore return no richer, to their own land of hidden treasures and Oh! for the story of the rocks; the buried cities; the human tales that are untold, the story of the great Creator in this wonderful land of our [*sic*; missing word]! On our way home a happy unsung song filled our hearts. The doctor led the way on Dewey. Dewey has the prettiest gate of any horse I know. The doctor sat him well and he cantered on as though he too felt the spirit of the occasion. We left all of the wonders behind us to sleep the sleep of the tired and happy. I know that I shall sleep well.

Letter 11

May 23–

Yesterday's expedition is in direct contrast to one on Saturday May 20th, for Charles and I started out in this direction to look for arrow heads. We had gotten only beyond the cave when old Lorenzo Three Stars suddenly made his appearance [see figure 7]. I cannot imagine how he got there for I heard nothing, saw nothing until he offered his hand. I asked him where he was going. "Pahaute" he said. We sat down to rest; so did he. He laughed at the stones I had gathered and pointed in a teasing way to me as though he did not think much of my selection. We started out again and he started too. I did not fancy this but I tried my best not to show it. I soon found out that the dear old man had a feeling of protection and thought that he must take care of us. The sand was very deep and walking was not easy. If we do not have rocks upon which to walk it must be sand. To keep my gown from the sand I held it up. Immediately old Lorenzo took hold of it walking behind me; thus I had this dusky old warrior Cheme Chetete for my page. In all of that long walk he never released his hold excepting when it was necessary to help Charles or me over a bad place. It was very pretty in the childish, old man and I was almost ashamed that I felt inclined to be merry at the comical part of it. In my mind's eye I was making pictures, taking photos of this sandy desert scene, and telling it in glowing term [*sic*], and fits of laughter, to my friends far away. Imagine it if you can my dear: A fat woman under a big hat and umbrella trudging through the sand in the broiling sun, carrying a small, black bag. A small boy is beside her; the old Indian though is the picture of the scene with his blue over-alls and red shirt. His blanket forms a girdle as he lets it fall about his waist. He has a tin can for water, and a gunny sack in which to put his gleanings of stones to sell on the cars. To crown it all is an old straw hat adorned with egle [*sic*] feathers sticking straight

out, not up from the side. This is the picture of which I wish I had a snap shot. Could any one fail to enjoy it? His gallantry was pretty even if it were a trifle tiresome to me. We came to an arroyo whose banks were very steep and he offered to assist me as politely as any New York Society man could have done, extending his hand, but I pointed to Charles telling him to help the boy. I had scarcely time to turn before Charles was on the other side and Lorenzo back to help me. We trudged on until we came to quite a knoll covered with bright colored stones such as arrow heads are made of; we sank down to rest under a piñon tree. This evidently had been a spot where arrow heads had been manufactured in past years and here it was where Lorenzo sought and found many of his. We searched and searched and found never a head; but Lorenzo gave me all of the pretty stones which he found as did little Charles. But at last he showed too much admiration for me and I thought I'd better come away, he patted my arm, admired and felt the quality of my sacque and dress even my shoes did not escape. I wondered if he would not leave soon; but leave he did not until we were back to the spot where he had overtaken us. Here he seemed to think that we were safe, said adios, crossed the arroyo, sat down, took off his shoes and started off on a run towards Pahaute. I verily believe that he thought Charles and I needed his protection in our lonely walk. That he gave me some of his pretty stones I am surprised because he likes money; he often comes around with arrows and arrow heads and turquoise for sell [*sic*]. He is very industrious and works hard.

The oddest thing to be seen is his peach orchard. The poor old soul carries water about a quarter of a mile with which to water his trees. His fence, the kind peculiar to this country he adorned with all sorts of cast off clothing, red, black, blue or any thing that he can find; all sorts of sticks are dressed up in some manner for scare-crows. Tin cans and old pieces of tin, iron and any thing available are tied on these stick fences and trees to scare the birds away. Where he expects the birds to come from, and what kind they are I cannot tell for I never saw so few in my life. In a stiff breeze it is exceedingly amusing to hear these tin thing [*sic*] clang and clash. Instead of a peach orchard one would think of an orchard of tins and rags. It is pathetic to see his devoted industry. Many times he may be seen with his grand child in a blanket on his back going to see that all is well with his trees, but this year there will be no fruit, as the frost has killed the blossoms. Once when he gave me a stone, scalping knife I wiped it; he immediately took it back and wiped it clean on his trousers. The goat in our family is an item of interest. When she arrived it was amusing to see the whole family go out to receive her, and the first milking was an event. The doctor held her while Louisa milked but Mrs Goat raised her heels and Louisa raised herself and fled midst peals of laughter. After this, one held the goat's head, another her heels, and the milking proceeded until after several such scenes with unproved methods, the man [Frank] Sihu could milk her alone.[10] I am sorry to say that poor Nannie one morning got a brutal kicking from some one. Poor, inoffensive, tied up, little Nannie!

Letter 12

May 31st

Dear ____

With this I send a box of metsene and a string of coral beads. Mary Paisano [wife of Governor William Paisano] gave me the bread and I bought the corals from her.[11] I engaged another string of corals from her but a certain man to whom I told it went immediately to her and bought them. She told me of it in some disappointment because he was a white man of whom she expected better

things. The metsene or paper bread is made of Indian corn meal and is their bread for state occasions; it is made very thin, thin as a wafer, and spread on the hand, then laid quickly on a very hot, smooth stone; the hand must be withdrawn almost in a flash or it must of necessity be burned. Only the old, experienced women can do it. Layer after layer of this paper is made and laid together until a thick sheet is formed and as I told you before it looks like a hornet's nest in texture and color. If you examine it you can discover the width of the fingers on it as it is spread on the stone. In the first place the men raise the corn, and the women grind it between two stones. In warm weather the Indians put some of this corn bread in water, let it dissolve and it makes a cooling as well as nourishing drink. They make metsene of the blue colored corn. This accounts for the grey color of the bread.

The ollas or water jugs are porous and used as water coolers without ice. There is no denying that they keep the water cool. There is an endless variety of them and people here and at Santa Fē, in fact all over the country have them in their halls and drawing rooms just as Eastern people have handsome jardeniers [*sic*] standing here, there, and every where. They make beautiful flower pots. I'd like to give an afternoon tea and have my flowers in them. It is supper time and I must go. Do not be afraid to eat the bread for it is quite as clean as baker's bread.

Letter 13

June 1st

Dear P____

I have not written you nor heard from you since I bade you good bye in New York. On the seventh I will have been here two months. This is a climate for consumptives. I cannot see why, for the natives themselves are subject to it. It is the custom for people here to ask strangers if they are lungers; that is if they are seeking health on account of weak lungs. For the heart the Altitude is too great. I climb the mountains and pant and gasp for breath. Sand and sand storms are the rule and not the exception here. My mode of living is primitive enough for all economical purposes but it is expensive enough for better living. The Indians are exceedingly interesting, gentle, and courteous but very tenacious in regard to their old customs and traditions. They have a governor and not a chief and his law is absolute unless decided otherwise in council. The have regular political meetings and vote. Sometimes there is a good deal of spirit about it too.

There is much that is very admirable in their government and it is stringent.

I made some drawings of new shapes of pottery and gave them to some women to make for me. I wondered why they did not bring them to me, and when I inquired for them, they told me that they had made fifteen and sold them on the train. Your birthday will soon come and I want to send you a trifle peculiar to this country; an Indian cup or jar. It is very hard to get any thing with which to pack here and expressage is expensive. No grass is to be had and boxes are scarce.

Sunday June 11th

A Visit to Päräje

We all took an early visit to Paraje and Seami, in order to attend the missionary meeting for the Indians. It was a ride of eight miles one way. In the doctor's big carriage with two horses it was

an enjoyable drive, more so I think than the one to Pahaute because irrigating is more common, consequently there are more green spots like oases to be seen. At Paraje the meeting was held in the Government School room as at all other places. I was seated near the door in a rocking chair which Miss Dennis the nice little teacher gave me. There was such a crowd of Indians around me that I nearly suffocated. Dogs, the inevitable, among Indians began to quarrel and Louisa got up and gave one a kick but he stayed and growled on. Afterwards while his interpreter was talking Dr [Lukens] tried to put two or three out, but as one dog snapped at him he retired to his desk and continued his sermon.

A sense of the rediculous [sic] almost overpowered me but I looked as stolid as any Indian there; there are internal smiles that can be continued at more convenient seasons. At noon we hurried to Seami for the afternoon meeting. We formed quite a procession, looking strange and interesting enough and I gazed eagerly about. I hope that I can give you some idea of it. Two prairie schooners and three lumber wagons well loaded led, while four men on horseback followed irregularly.

One man with a baby on his back and some women were walking near us. Others were farther off. All were gayly [sic] dressed more or less, and formed a picture against the back ground of colored rocks and sand with occasional green spots that was pleasing. Men were mostly in citizens dress with out coats. Some had gay shirts and a few had blankets. Some wore belts of large silver disks, larger than the cover of a pint measure, and large looped earrings. Many carried in their belts cartridges and revolvers. The revolvers were handsomely decorated with pearl mountings. Many women sat in the bottom of the wagons, and the meeting of shawls of all descriptions on their heads, and falling about their bodies made a perfect flower garden. There were plaid shawls, and yellow shawls; blue and purple ones with borders of bright red roses. Black ones with umbrellas relieved this gaudy array. They have adopted these colors from the Mexican weave; the real Pueblo draperies are far prettier and more tasty; some do not adopt the gaudy styles, or if they do it is always toned by some thing sombre [sic]. We drove up to the village without knowing where we were to eat our lunch, but Mrs Ross Louisa's Aunt called us to her nice clean house and we spread our lunch. The Indians waited modestly until we evacuated. In this house hanging on the wall was a set of harness belonging to William Paisano; it was mounted with silver.[12] Of all this silver there is no sham; it is made of United States and Mexican coins, dollars, fifty cent pieces &c. Lorenzo a son in law of Gov. Paisano had on a belt of silver disks that cost seventeen dollars without counting the cost of the work [see figure 8]. He is a very handsome Indian both in form and face and is as good as he is handsome. I often think that were he a man of society he might make some hearts grow tender. It was a warm day but the women sat all through the meeting wrapped in those heavy shawls until the perspiration ran down their faces. Mexican women do the same. Just before leaving, Barbara invited us to lunch. Her house and table were as nice as one could wish. She had been a cook in a good family at Albuquerque but a miserable white man had betrayed her, and ruined her life. She refused to resume the Indian dress and her father sustained her in it.

We drove back to Laguna feeling that the day had been well spent; but I was very tired.

Little, civilized surprises turn up once in a while. For instance opera glasses in an Indian house; one too, where English is not spoken; not cheap glasses either, large, fine ones. When I saw Minnie's father take his and look far away into the distance to see if his horses had strayed from the pasture, I understood better why they had them. I see very few chairs. The Indians, most of

them, work sitting or kneeling on the floor, or on a very low stool. They kneel to make bread, grind flour or meal, wash clothes and model Metye [Metsene] or clay. I cannot understand how they can kneel or sit so long. I was pleased to see that in dipping water from the tinajas to drink, a separate cup was often kept with which to drink. I wish that some white people might do as well; but I must add that only some Indians were so genteel. Hair washing is an important affair in the family. When it is dry it is gathered in a roll and turned up and tightly bound with a red woolen band, until it looks like a horse's tail tied up to keep it from the mud. All have shockingly long bangs which are slightly twisted and tucked behind the ear.

KICK THE STICK RACE

Mr. Walpole the U. S. Indian Agent has just been among the Zuñis and Comanches, and told us of some interesting customs among them. By the by he was very polite to me while I was at Santa Fē. These Indians are noted as fast runners. The Comanches are the fastest runners in America. With some of them no horses can compete. On June 7th 1899 in their Kick the Stick Race they ran thirty miles in less than two hours. They have delicate little sticks about five or six inches long. These they put on their toes and as they run they kick the stick forward. If a man looses [sic] this stick in the sand another, who is their referee gives him the first available things he finds; a stone, a stick, a snake or any thing and on he of Kick the Stick Race goes without halting to the goal. The referee of course must be swift of foot to follow up the races. In some of their races they hunt rabbits and are very expert.

One Indian, a Comanche, was told to go in haste for a doctor. He was a runner and was told to take a horse, "No! me kill horse," he said and off he went. In nine and a half hours he ran fourty [sic] miles to the doctor and fourty [sic] miles back. At another time a man started at half past three P.M. and at five o'clock he had run fourty [sic] miles.

Often while selling pottery on the trains the Indians are carried off, and Robert, who works for the doctor, once made this mistake. The first station was Isleta, over fifty miles from Laguna and the train reached there about ten P.M. Robert arrived at the doctors the next morning at breakfast time, having run over fifty miles in about nine hours. He is an English speaking, Laguna Indian.

Letter 14

June 15th

Did Charles get his arrow heads and the scalping stones? Tell him that the Medicine men use these stones for performing opperations [sic]. The days of scalping have gone by! On the fourth of July we are to have an Indian foot race, and a race on horse back. I hope that the Mestene was not broken.

I have so many pans in the fire that I do not know which one to take out first. I wrote you a hasty note about reading matter for Annie Lockwood.[13] She came home the same day that I came to Laguna. She has been teaching in the Government School at Albuquerque. She has consumption and cannot speak above a whisper. She was a Carlisle student and is a communicant of our church, the only Episcopalian here. Her mother is very poor and cannot speak English. Annie does not get nourishing food. We went to see her and all of us took her something to eat. When I bade her good

bye she said "It is so nice to see a little of Civilization." The poor girl has forgotten her native tongue and no one at Seami can speak English. She will be glad to get some church papers; please send me some. She is a full blooded Indian and a fine girl but must die soon. See if you can get me some of those five cent booklets like "Titus." I can lend them to advantage to those who can read.

To night the Indians are having one of their devotional dances. It is called the Doll Dance. Each child who goes receives a doll such as I described to you. I wish that you could see one, Sister would laugh until she cried if she saw one. I have since I wrote you, seen some that are of round wood instead of flat. The Christian or Protestant Indians do not go and indeed many others. No white person is admitted or I surely would have been there, even though it is considered the most heathenish of all their dances.

I have been experimenting with pottery, a la Indian, and succeeded in getting a beautiful glaze on a cup, made by Minnie Sice. Some of them are in a great state of excitement about it and so am I. I used cow chips too for fuel. Think of it! It is uncertain sort of work though! A famine among the Indians this coming winter is feared because of no rain.

After all my visiting and kind invitations yesterday to induce the Indians to come and hear my talk in order to help them in a certain industry only five came.

Hugh Johnson came first and that was well, because he was to interpret for me.[14] He was a Carlisle student and speaks good English. I had explained things to him when the two Marias came.

They seemed empty handed but tucked away in their black, blouse, like waists were three pieces of pottery. After some talk they pulled them out and asked me if I would make them shine as I had Minnie's? Hugh interpreted most clearly and well all that I had told him. One Maria went to sleep near the last, and the other pinched Hugh and in her mischievous eyes showed her appreciation of the situation. It is useless to say that I did also.

After all this was done and they were gone, in walked Minnie Sice and her mother Mrs Billen. I felt tired and annoyed, but remembering that I was dealing with a peculiar people whose advantages had been only those of the heathen, I went over the whole thing again.

Minnie is a nice, industrious young married woman, always polite and kind. She is well educated in English and from Carlisle as most of the best educated ones are. Her mother Mrs Billen is unusually gentle and sweet in her disposition. She comes from a long line of Governors. Her father was governor several times and the family are among the most respected Pueblos. Minnie told me with pride that her grand father was buried like white people in a box which was brought from Albuquerque. You know that they are usually wrapped in blankets. Minnie's father is also an Indian who commands respect. I was many times in their spacious house. Lillie Billen an unmarried daughter is very pretty and modest and although she speaks fairly good English she is afraid to do so. Many Indians suffer from this timidity.

I am perfectly infatuated with the idea of experimenting with Indian pottery, and thinking to avoid the heat of the day, in the gloaming I took a little express wagon and gathered chips and loose piece of coal which I found lying about, hoping to have enough with which to experiment the next morning in glazing some little pieces of Isleta pottery; nevertheless the next morning I was compelled to go out in the glaring sun and gather more. You cannot buy a particle of coal here.

I glanced around furtively, for I did not want even an Indian to see me at my beggarly task. But when one has an idea to carry out especially a philanthropic one, and a grand one, what does the menial part amount to? To stoop is but to rise after all! So I gathered chips with a happy heart. I had arranged my toilet for my work, and was an object to behold. I am happy to say though that

I was clean, even though grotesque looking. My gingham gown was of large blue and white plaid which tended to make me look shorter and stouter than I was. I have plenty of flesh as you know, and the southern sun had reddened my face and made me coarse looking as a New Mexican sun knows how to do. But what did all of this matter to me, had I not a high, a grand object in view? I would almost grovel to attain it. On my head I had a large black sun hat pulled down and tied under my big, fat chin a la Gypsy. I held a small shovel and an umbrella in one hand and under the opposite arm I had a small box tucked, in which I had put a few pieces of coal.

I had gotten a splendid fire started and was coming from the rocks where the kiln had been improvised, when a voice from the rail-road startled me by calling out "Are you traveling Aunty, I see you have your camp fire?" I looked about me; no other woman was to be seen; surely the man must be talking to me! Just for one second, a feeling of indignation swept over me at the idea of being spoken to so familliarly [*sic*] as Aunty by that sooty, dirty looking, rail-road employee. Had he been a gentleman though the feeling would have been intensified, but I remembered my attire and occupation knowing that the man saw me only at a distance; and he seeing me in the very act of picking up a piece of coal took me for a veritable tramp. This did not dawn upon me until I had left him; and then, it struck me forcibly as I walked back to the kiln. I laughed and laughed, subsided and broke out afresh; The more I thought of my appearance and viewed the smoking pile of chips the more ludicrous it all appeared. But as I drew near the man, I explained to him what I was doing. Some time after when I had gotten my fire to working satisfactorily and was returning to the house I heard a voice again, and looking up at a passing coal car I saw several pieces of coal, rapidly landing before me, in the distance, from the hands of the man who had mistaken me for a tramp. He smiled as he passed and saw that I understood his kindness. It was a sort of an apology for having placed me so low, in the scale of humanity. I really wanted cow chips not coal, but I had picked up the few scattered pieces to see if they might not help the fire but found that they chilled it.

Afterwards in switching I saw the man again: he was telling me of the Moqui Snake dance which he saw two years ago but his engine came, he swung himself on and I saw him no more. In my mind I can still see his round, soot besmeared face and pearly white teeth and kindly eyes; and imagine the tender, pitying heart that prompted him to greet so pleasantly a poor old woman tramp.

A camp fire it looked indeed in the shade of those huge volcanic rocks, but to me it was far more, it was full of novelties and romance and wild expectations, for it held my precious experimental clays and glazes. Sitting there beside the smoking pile I read an article from the "Heral [*sic*] and Presbyterian["] on the Penitentes.

The Los Hermanos Penitente or some of them live not far from Cubera which is about eight miles from here. The poor Mexican Joe whom we nursed was one of them but he lived at Al Rito. This society were New Mexican Conquistadors and is a brotherhood which was organized within the folds of the Roman Catholic church and its adherents are to be found exclusively among the Mexicans of that church, although the Roman church does not approve of their customs and barbarous lacerations. Yearly they crucify one of their number. Now they tie, instead of nail them to the cross. It has been ten years since they actually nailed one to the cross. Burial alive is the penalty if one divulges the secrets of the Morada.

Their principal practices are during Lent. At other seasons they meet only at midnight to bury the dead or to punish offenders, a cross marks their resting places en route to the spot of burial. Many of them are seen away off in desolate looking places, often they are planted in a pile of stone to make them firm. I have seen many of them, but the place of burial is secret. Near Lent they

gather from fifty to a hundred miles to the place of their Morada or rendezvous and on the first Friday begin the flagellations. At dead of night the procession forms and on the mountain side led by the pito,—a shrill reed pipe—they march, beating their backs with cactus flails and other whips until the blood flows on the rocks where they walk with bare feet. On Good Friday Mrs ____ told me that she saw one of their processions. The leader carried an image, others carried crosses which they planted and knelt to at different stations. Not long since, about two weeks, two men were fighting and the younger stabbed the elder with a knife. He was imprisoned in a room in which was a bed of cacti and another of Amole the leaves of which are like needles at the tip. He was compelled to lie upon these beds in a nude condition. One of our women was in the village at the time and attempted to look in the window, but was told that she would be treated in like manner if she did. One can imagine that our laws might surprise those horrible Penitentes should they practice their tricks upon our people. Is it not time to interfere with them?

Indians cannot be compared to them in their brutal worship. When this young man was released, crosses were cut over his back causing the blood to stream.

I have heard more of the dance of June 15th. It is more heethenish [sic] than I thought. Some say that it was the Ghost Dance, others that it was the Doll Dance and others still that it was both. It was a night dance and secret, and what ever it was, they had it and they had dolls. Men were dressed in white clothes trimmed with evergreens; and this, I admire as I do the dolls, if it were only that. Only the best dancers were allowed to dance. One girl is trained to dance around and around constantly for a long time with her hands straight above her head. Only a few can do it. Minnie Sice was in training for it but it made her ill and she had to give it up. A converted Indian told us that the practices at this dance are so vile that they would not dare to admit white people. They are masked, and no wonder if they are so beastly. Many of the better Indians will not go near them and I am glad that Minnie could not endure it. This is the only dance of which I have heard as immodest.

The black duititch which is the characteristic dress of the Pueblo women is worn over a shirt or several shirts made like a man's, generally of light colored calico or muslin. The shirt is very narrow and a little longer than the duititch which comes a little above the knee. This duititch is fastened over the left shoulder and falls under the right arm. It is a straight piece longer than it is wide and pinned down the whole of the left side with silver pins. It is made of wool woven by men. I have read some place that the women do the weaving but I saw two men weaving and I never saw a woman do it. The women told me that they do not weave. These black dresses cost from twelve to twenty five dollars. The best ones are made by the Moqui Indians. The women make pottery; that is strictly their work but once in a while a man will help them.

On the back over the black frock is worn a large, square, silk handkerchief or muffler, a string or ribbon is attached to the corners of it then it is thrown over the head so as to let the handkerchief fall loosely over the back. I call it a back apron but the Indian name is Oeist. But each pueblo has its own language and this would not be the name in another village. Many of them are handsome but sometimes we see one of calico.

Their moccasins are surmounted by buckskin leggings not made but wound around the legs to the knee many thicknesses so tightly as to make the legs look clumsy, and when they sit they cannot bend the knees. The Santa Fē leggings were much nicer, loose like a boot leg as white as snow. I asked a Tesuque how they kept them so white; in reply she showed me some white, powdered clay which they rub on the skins when needed.

—Adios—

Letter 15

A MEXICAN VILLAGE AND SHRINE

On Monday June 19th the doctor kindly took me to Sebolletto. A Mexican woman drilled me to say Sa-vo-yet'-to, and for Mocino—Mokeno. Sebolletto is a Mexican town more than one hundred years old. As we were crossing a causeway I saw my first Coyote. This same woman taught me to say Co yo' te. Well! This one was a pretty, graceful, wild looking dog with large, extended ears. The doctor shot but missed hitting him. On the way home we either saw it or another one. They must have been hungry because they are not usually out in the day time. I was pleased too, to see threshing floors. They are staked off, circular enclosures with smooth, hard, clay floors in which horses tread out the wheat. As we drew near Sebolletto the three cupolas of the Mexican church shone in the sunlight like square doll houses; they are of wood; the church is of adobe. On one house were cute little pigeon houses. The church is one hundred and fifteen years old. An old painting of San Antonio in this church is greatly prized and was brought from Old Mexico. Every one in this part of the country calls Mexico "Old Mexico." An image of the crucified Christ, life size, lies in a glass case near one side of the chancel. It was dreadful! The floor of the church is a grave yard and is of clay. It is divided into three parts. The first is near the door and to be buried there you must pay twenty dollars; for the middle division you must pay thirty dollars; for the third or nearest the Altar you must pay fourty [*sic*] dollars.

The woman who showed it said "Malo," meaning that it made people sick. Every time there is a new interment bones are dug up and thrown away to make room. This is done in other places also. We went to see Maria Maveas who is ill with consumption and has a baby twenty days old. This poor baby will die and is fed on goat's milk. The mother goat is brought in and the baby held under it to get its meal just as the kids get theirs. She was brought in while we were there and the motherly beast looked anxiously for the baby; not finding it she went to the bed. I wondered if the babe might be a Romulus or a Remus. Augustina a pretty Mexican came in to interpret for the doctor; her baby—three months old—wore delicate earrings of Mexican filigree. This mother nursed the new baby as did all the other mothers there. Poor babe three mothers and a goat. During the wars between the Mexicans and Indians there was much fighting at this place. The wars were fierce and bloody because the mesa almost surrounding the town made strong places of defence [*sic*] for either party. On these hills are lions, bears, wild cats, coyotes and other wild beasts, but they usually do not come near enough to molest the town as in the immediate vicinity [*sic*] there is neither grass not earth, being solid sandstone mostly.

The town, unlike Indian pueblos, is regularly laid out in streets. They were bonito,—pretty good—. We were invited to dine in their best room. The women did not join excepting Augustina, as she did our talking. The father—Marcas—and son arranged the table and stood one at either end, serving us most deferentially. When we had eaten they removed the dishes to the kitchen where the women were. I had learned enough Spanish to say "Gracias por comida," thanks for dinner or meal.

The Mexicans are so very gentle and polite that it is hard to believe them anything else than lovely. The instant we arrive at a door they say entrar—enter—.

The woman who gave me Spanish lessons begged me to stay two weeks with her saying that she would teach me Mexicano and I, teach her English. She was comfortable and at ease in chemise and skirt only. Augustina told us of a cave or porch to which they had carried the Blessed Virgin in order to pray for rain. This portalis [*sic*] or porch was more than a mile from town. The

Virgin leading, they formed a procession of all the villagers, and carried her to a shrine ready made to receive her.

Different parties take turns in staying there at night to protect the image. One woman is housekeeper and remains the whole time, nine days. On Sunday—18th—fifteen people stayed all night. I asked what they did to pass the time? "Sing songs," said Augustina. It must have been wierd [*sic*] and inspiring, for that portalis of rock is of nature's own forming. It is a cave of immense proportions, rock bound on all sides, excepting one which is uncovered letting in the glad sunlight. The floor is elevated, far above the hall way, from which the roof must be twenty or thirty feet. The dust was kept down by sprinkling the floor; canvas and rugs were scattered about and near the walls were cushions for reclining. There were three springs of cloudy, cool water in refreshing abundance and it contained no alkali.

I drank from a cup in which,—the doctor told me—a Mexican had washed his hands just before. Beastly thing! At one end was an adobe fire place which was in what they called the kitchen.

The Altar above which the Virgin was enthroned, is also of adobe and as white as Snow. It extended almost to the ceiling, her alcove filling the highest place in the centre. The steps leading to this were carpeted in the centre with red swiss; the sides of the altar were decorated with branches of trees. The virgin herself was an ordinary paste doll about three feet tall, dressed in the latest style; she wore a sailor hat, a white gown trimmed with red flowers and pink ribbons, a tule [*sic*] veil covering the whole. There was a canopy of white swiss and red ribbon, also red, blue and green artificial flowers in abundance. On the right of the Virgin stood an image [of] Joseph with the infant Christ in his arms; to the left was San Antonio. These simple folks were content to pray to and worship a common paste doll and thought that her intercessions could bring rain. Can we wonder that it is a difficult thing to govern Cubans or to bring order among the Philipinos?

Portalis is a horse shoe shaped porch; the passage or hall way to it is covered with grass, with a little rivulet gurgling by.

Trees and arch way with refreshing breezes made us wish to linger for the moonlight. A fish hawk's nest up hundreds of feet in the rocks reminded us of eagles eyries and the doctor shot at them: the pistol kicked him for his pains, causing the blood to run down his face. The hawks only chattered in derision and we went on our winding way looking back upon what we might have thought a Gypsy camp. My thoughts went back in pleasant dreams to Dear [*sic*] Park in Illinois which we visited long years ago and I thought it was a great event in my life; do you remember it? Well this surpasses it! As we wended our way, Indian trail like, the Mexicanos led the way.

An old grisly, gray headed man sat on a little burro, his feet almost touching the ground; a child in front of him and one behind made a load for the burro, larger than himself. An old woman followed with six of us in her wake. Two Mexicans had babies but not on their backs. On we went in the burning sun and sand by the side of the irrigating ditches with clear rushing waters in which I longed to plunge and lap my tongue, dog like. This think you might have outdone the "Aunty Tramp?" Never mind! I did not do it; but such refreshing streams are rare in New Mexico, and Alkali water never quenches thirst. Can you imagine yourself being thirsty from morning until night with plenty of water to drink? I eat lemons, and fruit I can get, and go to the store in desperation and buy a bottle of sparkling hoyote water at twenty five cents; this quenches the burning thirst only a short time and it is the same old story over again.

We sought shelter and rest for a time beneath lovely overhanging rocks and huge hills; finally we left the old man and the burro with its followers there, while we went from the shade and

coolness into the sun and dust and sand, back into the town to take a look at the old church Doloros to which the Virgin would return on June 24th. Those Mexicans have the mild tones and the gentle hospitality proverbial among the Spaniards. It is beautiful, soothing and deceptable [*sic*] and I would not have felt afraid to abide with them for a time excepting for their utter lack of modesty in regard to the calls of nature. This trouble is great among the Indians also although they are not half so bold and immodest about it. This is a thing that the Indian Agents should look to in their work of civilization.

One house in Sebolletto is almost handsome and belongs to a much respected Mexican. We stopped there and took the little Garcia girl with us to meet her father who was attending to his irrigation. We rode far but did not find him. We turned to take the dear child back, when we were all, without ceremony deposited on the ground. Something had broken! The little girl fell directly between the wheels and I caught her arm as I alighted. She cried plaintively, "Oh!" that was all and I held her in my arms all unhurt. She is a beautiful child; her eyes, dark and tender such as to go to ones heart. Two Mexicans came to the rescue but could do nothing until one fine fellow ran across the plains for wire; we had a rope.

It took a long time to get the carriage in going condition. The child stood, looking occasionally up into my eyes with the most loving, confiding smile. She could speak only Mexicano. At length the doctor gave the man a quarter and told him to take her home. I felt very anxious about having her go alone with a stranger.

The doctor said that if we broke down again he would put the seat on the front wheels and we could ride home in that way; we had a bout [*sic*] fourteen miles still to go. Driving up in such a manner I am sure that we would have astonished even these natives. Fortunately we had a nice lunch with us and arrived late without startling our neighbors.

I hope that you may not tire of the details of my long letters. I am selfish enough to write more than I otherwise would because I keep no notes and I expect to cull reminiscences, when I get home, from what I write you and others. I fear that sometimes I forget that I am writing letters and go on as though I were simply writing for myself and it seems so far short of what I want to say because there is so much that strikes me so intensely that it is beyond retaining or expression, and often one shrinks from putting on paper what seems only for ones self. It is all here in this strange land which attracts while it repels, fascinates while we would flee from it. Yet nothing would make me flee but necessity and one necessity is hunger which I actually feel often; the food I get is not nourishing and human nature cries out against it when one knows that it should not be so.

Letter 16

Frid[ay]—June 23rd
Albuquerque N. Mex

I have been here since Wednesday night. We are having what is called a big storm but there is not a drop of water, just wind and sand. It would be very pleasant to have a little rain. There has not been more than a half hours rain here at one time for six months. The people are shipping their stock to Kansas and other places to keep them from starving. Lambs have died by the thousands. I mean this more about Laguna and other place [*sic*] rather than Albuquerque. Where irrigation is possible it is better, but to irrigate even is becoming difficult because the

miserable little rivers are nearly or quite dry, excepting during the rainy season and sometime after. These rivers are said to have no mouths; I should say that they have throats instead for the water leaves in a marvelously short time, it disappears altogether in some places and unexpectedly springs up in others. They have an underground stream which modestly hides itself from suffering humanity. Every body is now interested in Las Vegas—as the Rough Riders are to be there.

On Tuesday June 20th I went to Isleta by freight to see the Indians. At the station I was politely received by the ticket agent and his wife Mrs Kille [?]. Her mother is housekeeper and she opened her kind heart and allowed me to board with them. Every thing was delightfully clean and the table fine. I slept in the parlor on a lounge bed. Mr. Hovey a U. S. Government School teacher and polite Mexican took me next morning to see some Indians but the two Governors were absent at their work. After supper we went again and both were kind and polite and interested in what I had to say. They said that if I wanted to live among them they would give me land upon which to build. As Indians are vacilating [*sic*], white people advised me to build on rail-road land. Isleta would be preferable by far as a home because of its nearness to Albuquerque and good food, but the Lagunas make better pottery and are better Indians.

–GIO [*sic*; GALLO] RACE–
Sat. June 24th

I am back at Isleta to see the Rooster Race. It is San Juan's day on which the Isleta Pueblos always have a fiesta dance. Emily, a bright eyed Pueblo invited us to the house of her brother Juan Lente. On the house top we are waiting. It is tiresome to wait the gathering but interesting also. It is quite amusing to see two Indians on one horse. I have a pencil and paper on which to dot down what I see and will give it to you as I write it. The church bells ring to call them together. Some Mexicans come and two Navijo; one Navijo woman is drunk and the Isletas do not like to receive her; she has a boy with her and is loud and silly in her attentions to him. They are not as respectable looking as the Pueblos. The men are mounted on horses and now they carry banners or flags of red, white or blue and shoot pistols. Now they circle about the plaza, and with yells fly off to the young corn fields; how they dash by and how quickly they reach the distant fields and scatter, pulling the growing corn up by the roots and back they come again with never a halt! It is very exciting! How gracefully they fall to the sides of the running horses and pull the corn. They carry the corn to the church as an offering to San Juan and with the flags place it on and near the shrine. Now they mount again and go in search of a rooster. Each one whose name is Juan or Juanita is visited and greeted with "Gio" and he Juan or Juanita if he has no rooster gives a cake, pie or something to eat. How long it takes! See the pies and cakes fly in the air! Sometimes they miss their aim and go beyond the outstretched arms for whom they are intended, but another catches them. There goes a man loaded, to his home; he must have gotten more than his share. The horses stand still through all this shower of bread! This takes a very long time and grows monotonous.

Father ____ is on the roof of the church with his friends, looking on. 'Tis said that his teachings and example are not of the best. I enquired of Juan what would be done to him if he refused to provide a Gio (or rooster)? "Get a beating" said Juan.

I counted eighty mounted Indians but there may be more.

The house tops present a pretty panorama dotted as they are with Indians of all ages and sizes in all varieties of pueblo garb. They improvise tepees or canvas tents of black, black and white, and white alone to protect themselves from the sun. Suppose that we should all cave in? I do wish that I had a Kodak!

We as I said, are the guests of Juan Lente and are on the roof of his house sheltered from the sun by a white canvas. His grandfather, who is Governor, is here also. Now Juan mounts the ladder with a bag in his hand, he takes from it a huge Plymoth Rock rooster. The Governor calls and two horsemen come and one receives Juan's Gio. He has to reach his utmost to get it, and the Governor too, to give it. The Indian who receives it removes his hat, reverently bows his head and utters a short prayer in Indian. Now he joins the contestants who circle the plaza once, halt, bury the rooster (whose legs have been tied) in the loose earth, leaving his head above ground.

Now all is ready and I pity the poor rooster. As those in the race dart off they give little short yells with now and then a pistol shot.

Each one running at full speed without the slightest halt must reach from his horse and try to get the gio. The poor thing dodges and dips his head to avoid those awful hands. One man twice gets him but must give up his prize for it was not fairly won. At last one succeeds in getting it; several dash after him to recover it, and the one who does, get hold of it, is getting well beaten over the head or any place with the dying Gio. Cruel! Cruel! Oh! I can scarcely endure it! But he is soon dead, someone whispers to me for I have covered my eyes.

Another Gio is planted; I want to leave but he is soon rescued and the victor dashes off with him to his home before he can be caught. That was bravely done! The Gio is safe because no one dares pursue further.

Now a bottle of whisky is buried and is soon recovered; there is a big chase. I am hoping that it may break and all be spilled. Once in a while there is a slight quarrel but the Governor and others call out "Don't get angry it is only play!"

One man while in full tilt dropped a slender, little stick to the ground; he leaned from his horse and with perfect ease picked it up, not halting in the slightest. We must leave now, for the race will be kept up until sundown and this is only a repetition.

The Gala dress of the women is almost the same as that at their daily occupations, excepting that they make themselves more tidy and don more necklaces of beads, silver, turquoises, rings and other Jewelry, with ribbons Aprons etc. The men at Isleta have the fronts of their shirts of pretty drawn work done by the women. Emily had a new oeist for this occasion and men, women and children had an extra bath and hair wash with Amole root.

The pueblo of Isleta is said to be five hundred years old, and the church three hundred. The Rooster Race recalls to my mind those entertaining tournaments in Delaware in the days of our youth. The old church is of Spanish origin I think. The enclosure is a grave yard.

A boy not long since was buried in this yard and as it may be a fair specimen of an Indian funeral I will tell it you as an eye witness told one. His body was wrapped in white, no box was used and he was literally covered with flowers. All stood about the grave and had a constitutional wail or howl. The priest threw some earth on the body, then the women did the same, after which some water was poured on, then it was pounded with a great, huge stump of a tree. More earth and water were added and more pounding until the grave was level with the ground: After this it was covered with flowers. The flower custom though cannot be conformed to in some pueblos because there are none to be had. Isleta is a much lower altitude than Laguna and a fertile little

spot with plenty of water. The Indians have beautiful vineyards and make good wine which is the cause of drunkenness among them not found elsewhere in pueblos.

This evening while resting in a patent swing after supper and waiting for the A. T. & Santa Fē car, a train of negro troops came in on the El Paso road en Route to the Philipines [*sic*]. I talked with one fine looking fellow. He was very confident that the negro soldiers would be a match for the climate as well as for the insurgents.

As the train moved off I held up a tablet on which was a paper flag, our own, dear, old flag. Such a cheering as went up from those Negroes with hats off, you never heard excelled and they kept it up until out of sight.

Letter 17

THE PICNIC
July 1st

I am back again at Laguna and received your letter. You should take one of those round trip excursions to California. Dr Dean and Mr. Gregory of Columbia College were through here the other day en route. If you ever take such a trip be sure to provide good lunches. There is no place in which to get any thing to eat, and travelers nearly starve if they stop here. They come here and beg for a meal. Yesterday two men ate their lunch in the yard, and others were glad to get a breakfast of eggs, bread and butter. Dr Dean suggested that there was a great deal of nourishment in dried beef. These two had sat up all night at the station and were glad to be taken in by the doctor and Mrs Lukens. She keeps a supply of dried beef otherwise I do not know what might happen. I suffer for lack of fresh meat; in winter it will keep any length of time. Ice we cannot get here. On June 29th I went to the Indian, School picnic. Miss Bingham is the U.S. Government Schoolteacher and greatly interested in her work and has improved the school very much since she came.[15]

We went in prairie schooners if you know what they are. I wanted very much to ride in one of those white covered wagons, but never dreamed of riding behind such poor, forlorn horses. They were so bony and small, and weak that at times I feared they might fall; one had a saddle sore. There were two loads and I felt ashamed that I had added my hundred and thirty five pounds to their burden. When we came to rough places or an arroyo, I climbed out and walked and eventually induced the children to do so. They thought it fine fun. I had tears in my heart and tears in my eyes for those poor brutes. The Indians cannot help their having so little to eat; they have little themselves.

At last we reached a succession of caves in rocks of white sandstone just in sight of San Mateo that highest mountain of New Mexico, a sight of which with its snow capped peaks we were always glad.

I took a small sketch of it. The Governor sent us there on account of a fine spring of water. En route a boy needed a handkerchief; I called out does any one understand English? Tell that boy to wipe his nose. I turned my head and feared to look for a long time; At last I did look, and low and behold I had been understood and his face was clean. Old Lorenzo was there; and Jefferson who drove could speak English.

We ate our lunch and started back earlier than I had thought we would. Again to relieve the horses I walked. At one place they rested awhile and the children gathered reeds and ate them. I

walked on leaving them far behind. It was a lovely walk and invigorating. My whole heart went up in an earnest prayer to our Heavenly Father to hasten and prosper the civilization and Christianizing of these people.

Distances are so great and the atmosphere so refined that the eye is deceived and the bodily endurance greater than at home. We think that objects are much nearer than they actually are.

My eye caught a glimpse of broken pottery; I examined it and found it, to my joy,—some of the old, extinct work of "Our fore fathers" as the Indians said. Treasures they are to me! I walked on studying Ant hills and the whole of the silent earth before me, and the firmament which is so Italian like in its eternal blue.

The schooner came up, I climbed in and rode to the next hill where we all jumped out and rode no more until we reached Laguna. There had been nothing to mar our pleasure excepting the starved looking horses.

During the whole day not a jar or an ugly word or look had passed among that little group of children.

We overtook Dr L[ukens] and the University men who had breakfasted with him en route to the Enchanted Mesa.[16] I had not met them much to my regret, but at supper we were all there, tired, yet all enthusiasts. Dr Dean is a professor of Columbia University and Mr. Gregory a student and both naturalists. You can imagine my pleasure. Nothing was too small to awaken their interest and I drank in all of their superior knowledge gladly. But I did not appreciate it at all when Dr D[ean] tried to protect a young tarantula that was speeding across my office floor. He relieved our anxiety about the child of the earth assuring us, that it was not poisonous at all but the harmless little ground cricket. I suppose it gets its name from its head, which looks like a bald headed baby's head in shape. Mr. Gregory warned me that my health would fail because of my intense interest in every thing in so rare a climate, where self denials are a necessity. We will see!

They are gone and so is Miss Bingham for her summer vacation.

I made a turn table of plaster of Paris and a drying pan consequently I am tired.

Letter 18

THE CLAY PIT

Yesterday a little girl came with her grandmother to see me. The child interpreted for the Grandmother. They brought me some stones, clay and paint as a present but asked for money.

They promised to take me to the clay pit, saying that if we did not take some dishes and leave something to eat on them in the cave we would die. She continued that many years ago—twenty-three ladies—Indians—went there for clay and failed to leave things for the spirits to eat, in consequence of which a big stone rolled on them and they were killed.

As they did not return at night searching parties went out to look for them and their bodies were recovered. This part is really true; others were with them in an unconscious condition and recovered after the opening had been made.

After the rescue the pit was filled up and no Indian can be induced to get clay from that spot. Another opening farther away has been made. The little girl said that no one must build houses of the pottery clay for if she did she would surely die, that one woman did and she died soon after. They cautioned one to tell no one because Indians do not like white people to

know these things. I would like to give their names but will not in case it might in some way injure them. The grandfather taught a woman to weave one of the black dresses and she thought that she was married to him and insisted upon prepairing [*sic*] her home for him to live with her.

The groom always goes to live with the bride's family. Sons and daughters are subject to their parents as long as they live no matter how long. At their meals a dish is placed on the floor with food in it. All sit around it in a circle, each dipping his fingers in to help himself, but those whom I saw each had a cup to drink from. I say all, there are exceptions even with those who have not been to school and we find them eating in a more civilized way. Some who have been to the Government schools live astonishingly well. But even some of these go back to the old customs of sleeping and eating. They in many or most instances cannot help themselves. One alone among a houseful cannot regulate the many or control his own habits.

It is strange that most of the men assume citizens dress, while the women return to the wild dress. It is pretty and modish enough to call forth no objections; but they are compelled to do so in self defense or be persecuted by the old ones. What can be expected of them when they are even whipped into obedience? Some stubbornly hold out until their clothes are all gone and nothing remains but to don the wild attire. They have not one cent with which to buy any thing else.

Barborba [*sic*] says that she is very careful of hers because when they are gone she knows not where she can get more.

I am very much pleased with Mary Paisano. When I first saw her she wore the wild dress and it is very becoming to her; but William, her husband wore the civilian clothes and neat and clean he always was. But they belong to a fine family; his father and mother are irreproachable and are rich, all Christians.

One day I asked Mary why it was that the men and not the women dressed in citizens dress after coming from school? In a very low, modest voice she replied "I don't know." The next time I saw her, she was making dresses like ours. I helped her make some skirts and Louisa helped her make a shirt waist. She looks very neat and nice and her husband is proud of her. He sent to Chicago for a pretty, ready made black gown for her and a dozen pairs of corsets. Think of a dozen. She dresses herself as we do now altogether. They have white enamel, brass knobbed bed steads [*sic*] and most things accordingly; a tapestry carpet also. No Indians live as well as the Paisanos. They are the aristocrats from the father down or rather I should say on both sides of the house. Charley Kie has a well furnished house and a pretty wife.[17] Most of the Indians have beds along two sides of the room which are nothing more nor less than divans. Covered with Navijo blankets they are attractive looking—some have bedsteads and these divans too. I supposed that they slept on the divans and wondered how they could keep from rolling off of such narrow affairs but have learned that they only hold the bedding which is removed to the floor at night. The Indians are coming up in the civilized world thanks to the schools, Carlisle in the lead.

I hate to see the dear little babies strapped to their board cradles, though they look cute like bright eyed, round faced little mummies almost; always clean. The semi rotunda shaped top holds the heavy shawls from the face, at the same time I cannot understand how they can breathe with so little air space. I intend buying one of the woolen hair bands with which men and women tie their hair, or a garter which is the same but longer.

Letter 19

–THE FLOUR WEDDING–
July 9th

As there were to be Indian races both foot and horse and fire works on the fourth, I thought it well to practice some National Airs and tell the Indians what the Fourth of July meant. We drummed up a crowd. Mrs Miller played the organ and we tried to practice the Star Spangled Banner—America, and The Red, White and Blue. This was in the afternoon and the time was too short. It was perfectly dreadful! The organ was out of tune; our voices did not accord, the time and every thing were wrong. Mr. [Emil] Bibo put a flattering squib in the paper about it, but! but!

The fire works and races were good though owing to Mr. Bibo's exertions. He threw candy for which the children scrambled and were happy. I could not help wishing that it had been given in a better way as he was so generous.

A few days since there was a Flour Wedding at Pahaute among the relatives of nice little Mrs Marmon.[18] They are grand occasions. A certain little woman wanted to go badly, but I notice that whatever she wants to do or wherever she wants to go the foot of the better half is put down most determinedly, but if he wants to go he goes. Heathenish! To this Flour Wedding all of the friends go, not to the home of the bride, but to that of the husband's father and mother just one year from the time of his marriage. When a man married he leaves the home of his childhood and owes his parents allegiance no more. It is considered that his wife's family has gained a son and that his own parents have lost one. Consequently when a year has passed the Flour Wedding takes place in the home of his childhood.

Friends and neighbors gather from near and from far carrying with them bags of flour, clothing and all sorts of obtainable eatables, and household effects. At this one mentioned more flour, clothing and food were brought than the old people could consume, consequently the near relatives and friends were presented with the excess. Mrs Robert Marmon received a new dress.

The home of the groom's parents has been so enriched that they are supposed to have been remunerated in a measure for the loss of a son.

All sorts of surprises come to me here. Yesterday a drove of cattle went by. An Indian was mounted on a poor forlorn looking heifer with a rope for a bridle and a boy was on a good sized calf without any bridle. After a few steps the beast refused to go; the boy dashed his legs about the calf like grappling irons many times to no effect; as a last resort he grabbed the tail of the poor beast and gave it a twist or two as though he were winding a clock, when off started the calf on a good trot which did not last long. I wonder if any one other than an Indian could ride thus?

The Laguna Indians are different from the Isleta Indians in that they do not become intoxicated as frequently. This may be because whiskey is not so easily gotten.

They do not practice as many of the heathenish dances as formerly. As far as I am able to judge the Pueblo men are industrious and do their share of the work and the women are not expected to bear the burden of the day. In fact many of the men do women's work. The wool is carded by men and all of the out door work is done by them. Of course occasionally a woman may be seen doing out door work. Carrying water is strictly a woman's work and she carries wood but men do both too. I am learning to think that much of the talk we hear of the lazy, the filthy, dishonest Indian is exaggerated, for I find them much as I find white people. A few are lazy, a few

dirty but the adobe houses of many Pueblos are so much cleaner and much more tidy than the majority of lowly whites that these Indians could put them to the blush. When we call them lazy we must consider that in most instances it is impossible for them to obtain work any other than is in his own small sphere. They are not so surrounded by paying communities.

The women make pottery almost exclusively; but there is a peculiar order among them where the men prefer to be called women and assume women's clothes doing their work and receiving women's wages. They are spoken of as man lady or man woman and as, her, and she. The respectable Indians dislike them and treat them with contempt. Fortunately they are but few. Richard a Carlisle scholar much to his shame calls himself Lillie Hill. Another Gayāterre makes fine pottery. Richard's is not so good. It is said that his mother compelled him to take this part as a girl because she wanted a daughter, but I have also been told that it is a sort of religious order not countenanced by the other Indians.

At the train one night I asked some one about a clay bird. As the person of whom I bought it replied in English I asked her name. She gave an Indian name and I said Oh! You speak English, give me your English name. As he did not answer an Indian woman said contemptuously "It is Richard, he is ashamed to tell you." Miserable fellow a well educated man! Strange notion to want to pass as a woman! When he went to Carlisle dressed as a little girl, a boy I am told, wrote to Major Pratt "Do not put this girl in the girl's quarters, for this girl is not a girl, this girl is a boy."

How people can write such glowing descriptions of this sandy, rock bound wilderness I cannot tell! They speak of its wonderful fertility and fine, abundant fruits. They had better say a country of yellow desolation, dotted here and there with green spots; a sight so refreshing to the eye as to make one feel that he have [sic] reached an oasis on the Great Desert. We feel like lingering on the site fearing it may vanish in a twinkling, because it is so rare that a few whiffs of the breath looses it to our view and it is gone. Where are all of the luscious fruits and green grass? Little lizards called swifts dart about and are well named. Try to catch one and it is even hard to see it excepting at a glance. The little horned toads are more curious but easier to catch. These with the Prairie dogs (which are more like squirrels) and coyotes are more numerous than green spots. Amole is green enough in little prickly tufts, but with its threads and needles one is inclined to stand off and admire. The ugly snaky looking cactus is actually repulsive looking. I ate a piece of the fruit and I never want another. I did not know how to skin it, and a thousand prickly things revenged themselves upon my tongue and lips.

Now I am amused at this inconsistent speech for I myself rave over this fascinating country; but then that is because of its wonderful strangeness, its Geological formations, its Atmospheric effects, lovely greys, blues[,] reds and purples; though this is only when the sun is not too bright and one raves thus when he forgets the privations and thirst; but I must not forget that others see with eyes even better than mine.

While en route to Isleta a man told me of Chaco Cañon, seventy miles north of Gallup. Near Holbrook are old prehistoric ruins; dwellings of which there are even no traditional records. There are stones twenty feet high in places and the building is five hundred feet square; the rooms, sixty feet square. The mason work is as fine as that of to day. The ceilings are of willow work. All is wonderful, telling of a civilization that has been lost. While telling me this we crossed the Rio Puerco—dirty river—, now a dry arroyo; but in the rainy season it is a rushing, muddy stream. There were clouds all about us as the train sped on and I thought how can those sand, colored hills look so like Prussian blue? But of course it was the over shadowing clouds on the Malapais, those hills of dark, porous, volcanic rocks, the hardest, and blackest rocks, scattered among the chrome hills.

The sage green of the plains enhanced its values. Glimpses of objects as the train flew by were unsatisfactory but very beautiful.

What a shame that I have not seen Acoma the mesa village, and the mesa Encantado, so near each other; so near me, and yet so tormentingly far. The Indians of these different pueblos speak an entirely different language. Most of them though speak Spanish. At Laguna the black dress is duititch but at Isleta it is Monte [*sic*; Manta].

[Several lines were cut off the page here]

I must make some drawings of pottery. Some persons profess to read traditions of Indians from the designs on their pottery. 'Tis said that they never paint an unbroken circle, that they must leave an opening for spirits to escape. I fear that this is a mistake for I can show many unbroken circles.

In fact I think that the Indian, like Shakespeare, has much more laid at his door than belongs to him. Take Hamlet for instance; Why! We can get more arguments out of it than Shakespeare ever thought of or cared for, I firmly believe.

Letter 20

July 18th

Dear ____

I do not know what I have written lately; in this case I may repeat. I thought that I had said good bye to Laguna. I could not get land from the Indians because it belongs to them in common and all have to consent. All of the best Indians want to give me land but the majority rule. Have tried every devise and argument and all that they do is to keep me waiting until the next meeting. Pretty Lillie Sione said "You have spent a great deal of money to help the Indians and now they do not want you to have the land to build a house on." She is a wise little Indian. At last I applied to the R.R.Co. and had received no answer. The Isleta Indians had gladly consented to let me have land but I wanted to stay at Laguna. I had decided though to go to Isleta and I and my trunk were on the way to the station and my adios had been said to all of my friends.

At the station I found a message asking me for a drawing of the site I wanted. The drawing was sent and I am still waiting at Laguna.

There are some strange women here for a time. One is a thorn in my flesh. She pounces down upon me like a thousand of brick if I do not visit her two or three times a day; when I leave she pounces down again because I do not stay longer. She declares that the next time she spends the summer any place she will go where people are not always busy. Once I made up my mind that I would stay long enough to satisfy her and I was convinced that she was glad to see me leave. For [Charles's?] birthday I have a silver cross made and worn by an Indian; if you attach a ribbon to it he can use it for a book mark.

Wed. July 19th 1899

We have actually had a rain. It began on Sunday July 15th and the first, real, good rain since I came to New Mexico. There had been several showers for only a few moments but this began and rained steadily for three days. Before the rain came the clouds were beautiful. It poured all night and most of Monday and Tuesday it came in perfect torrents. Peoples houses leaked—Mrs [Emil] Bibo was

compelled to move out and live in the back of the store. This one I am happy to say leaked only a lit-
tle because the roof had been thoroughly repaired in the spring, but the adobe washes off easily and
the dirty streams from the roof are very disagreeable. The roads and yards were a flowing stream. We
could do nothing but watch the steady, heavy rain falls, more like hogs-heads of water than rain drops.
The railroad was submerged and men had to wade before the engine and find the track for the train
to pass. After it had ceased to rain for a short time the water ran off in an astonishingly short time.
We went out in order to see the San Jose river. I supposed that the white sand would be pleasant, solid,
like that of the sea shore to walk upon; instead of that we waded in the most sticky mud. The San Jose
was like yellow rapids, swollen a good deal but even then it looked only like a ditch.

A prairie schooner was stranded on the opposite bank and the poor men had to remain there
all night. It is amusing to notice the prints of bare feet, first that of a great man and then those of
a tiny boy which were very cute and pretty. I met Cheme Chetete with a baby on his back and a bare
footed little tot beside him. The old warrior kindly called me to a better path. Yesterday (Tuesday)
there was a landslide on this side of the San Jose, a portion of the bank as large as the station went
down into the stream with a great thug. Only a few days since we had stood on that very spot.

It rained last night and we feared it might to day as the clouds were heavy this morning. But
the sun shone brightly most of the day. To night as I came in from the office the clouds were
stretched so evenly and gently across the sky without a hill among them that it suggested a prairie
turned upside down above us and dark hills around us looked in the moonlight like clouds. The
sky had taken the place of the earth and the earth that of the sky. The effect was strange and fas-
cinating in the clear, and brilliant moonlight for the moon had space enough just as the plains
have although we have hills every where. In the midst of the storm a bare footed man in loose
white pajamas ran easily and gracefully by with a spade over his shoulder. When I say a man or
woman or child I mean Indian of course mostly. This one was going to hunt prairie dogs which
the water might force from their burrows. Being like squirrels the Indians eat them.

This evening has been a novel one among novelties, because it was not a native novelty. We
spent the evening at Col. Marmon's. His four children are at home from school. Their mother is a
full blooded Indian. They have a piano and the four children are musical and well educated. We
had the four parts and the son played the violin. Bessie recited "Lasca a Cow Boy" a poem of the
Rio Grande—Texas—most beautifully. These children do not look like half breeds and the father
is so gentlemanly that one wonders how he could have given his children such an inheritance as
that of their mother; because she does not represent a good type of Bueblo [sic]. Bessie recited also
the famine scene from Hiawatha. Coming from an Indian it was doubly interesting. Such an enjoy-
able evening in the home of an Indian was scarcely to have been anticipated. Was I dreaming?

Letter 21

INDIAN BABY
Friday July 21st

To day I heard something about the land lease and I almost danced myself back to my room
because I knew that I'd get the land.

In the evening I went to see Minnie Sice's baby, just fifteen days old! It was strapped to its
board cradle looking very pretty, excepting that its face had white clay on it. This the Indians use

instead of the powder for babies. The little bodies are painted in the same way. Louisa and I named it Margaret for a little girl in St. Paul. Attached to the buckskin string which strapped it to the board was an Indian arrow head used as a charm "To keep things away,"—Minnie said—spirits she meant. There is also a little package of corn tied in a rag about the neck. This is to propitiate any spirits that may be hungry and evilily [*sic*] inclined toward the baby just as food is left under trees and in the clay cave to ward off evil. Little by little new things crop out revealing the deeply rooted superstitions of the Pueblos. The Roman teachings help to intensify those of the Indians.

Sunday July 23rd

On the rocks I found some Indian beads. I searched for them on the ant hills and the vicious little things made war on me from which I was glad to flee after I had gotten many bites. They hurt me until bed time. I have the beads though! Some Indians and even white people think that the ants make these beads, but the thing is evident if you study them at their work. They go great distances to collect small stones for their homes in the ground and come back with all sorts; even precious stones in the rough are found on ant hills. The Indians lose their beads and the ants gather them. I noticed that among their workers was a master builder and if an ant came with a stone which was not needed he was ordered back to deposit is near the hole; consequently there was a circle of beautiful stones about two yards in diameter around the hole. The ants are large and fierce.

Since I wrote you I have bought some Mexican opals, not mounted. I have the blood opal, and the fire opal. [Crossed out: I got them from M^r Hernandez a Congregational Missionary from Mexico. He and his wife are very nice.] I never saw a blood opal before. I am told that they correspond in value to the others. May be I will send them to you to keep for me. Yes! I will write a letter to the Library Club. As they do not meet until October I still have plenty of time. I have a silver bracelet made by the Governor of the celebrated cliff pueblo, Acoma. The large, round silver beads and buttons are odd and pretty. I want to get some if I can.

Aug—1st

At last it is decided that I shall stay at Laguna and have ordered building material. I have worked hard to gain this point. Tomorrow the whole family leave for Mexico, they may be gone a month or two. I shall have the house to myself with Lillie Sione for housekeeper and maid of all work. I would like it were it not for my spicy neighbor. I sneak around corners to avoid her but she always catches me as a spider catches a fly.

Friday Aug—4th

Well; I am alone with nice, bright eyed, conscientious, little Lillie [Sione], as clean and industrious as she is good.

Aug—5th or 6th

To day we organized our Bible class. Two of those whom I invited were ill and the baby of another, so that cut us down to six. This is something for a beginning. This is not for the Indians

but the few white people here. We need it as there is no church to attend. The missionary has meeting for the Indians only, and here at Laguna very seldom.

Aug—8th

I have failed to see any immodestly dressed Indian. A few times near their houses and while bathing I have seen very small naked children. To day on the bank of the San Jose I saw one little tot entirely nude excepting that he had on his grandfather's hat. He had an abundance of hair as black as blue black hair could be. I did not think of a nude boy but of a head and a hat. He evidently was too small to plunge into the river with the other boys and he did the next best thing, undressed and looked on wistfully.

As his back was turned toward me I took a hasty sketch as he stood solitary and alone. Further in were women washing clothes on the rocks, and one little two year old tot was as seriously at work as any one. She was Charley Kies little girl.

Sunday Aug. 13th

Our second Bible class met to day, instead of six we had seventeen, six Indians. Louise's Grandfather wandered in at the last and looked happy to join the singing. He could not sing the words but he soon caught the time and his venerable old fact was pleasant to see.

Last night Lillie and I were covering our bricks near the railroad where they had been unloaded; as we returned we heard the kitten crying piteously. We suspected some wild animal and ran in for a revolver. We had lingered in our walk and the night was as dark as pitch being cloudy. I shot four times at random under the cool house, where the cat was in her last agonies we feared. During the flashes from the revolver we saw the bushy tail of a koyote [*sic*] fly around the corner of the house, then we heard it running up hill among the stones. We both felt very much excited at the idea of shooting but went to bed and slept until we were awakened by a koyote [*sic*] concert under our windows. There seemed so many I feared they might break into the chicken house. As this was my first experience with wild beasts I was somewhat disturbed and poor Lillie could not go to sleep again. With me it was but a part of the wild life I was leading and helped to make up its compliment of pleasures.

The next day Mr. Marmon told me that he had heard them and they were not as near as we supposed and that when they made that peculiar yap! yap! yap! noise they were training their young and two or three could sound like a dozen. Those may have been far or near but it is common for them to come into the yards and take thirty and forty chickens in one night if the hen house doors are left open.

All the day before our bricks were being unloaded. The pile of white, fire bricks look very pretty over there. Soon all may be here and the precious house will be up if all goes well. Prof. Hodge and suite from the Smithsonian Institute have been at Laguna since Friday; to day they are at Acoma. They are out on an Archeological and ethnological research. I find that Lillie the gazelle eyed maiden allows herself to indulge in uncomfortable jealousies and can be impertinent when under their influence. To day I gave some medicine to a baby who is very ill. Lillie angrily reminded me that I had not given her little cousin any medicine. After it was all over she was quite penitent.

Sept. 10th

Cheme Chetete haunts me like a satellite. He follows me with a bag and picks up the stones and chips for me and I give him a little money as occasion requires. The boys birth days excaped [*sic*] me altogether. I will send some opals and they can take their choice after you select one for yourself. Keep the others for me until I come home. I am so much occupied with building that I have no time for anything else. This is the most miserable place in which to do anything. People are so slow and cannot be depended upon. I have to watch the workmen all the time to get things done. I did not know that Miss ____ had joined the Salvation Army. She is so beautiful and refined that I am amazed. I have lost in weight ten pounds and I do not like it.

Letter 22

BUILDING
Oct. 9th

I have not time to answer your letters regularly nor to read them over. I only write to say what is necessary. I hope to have the Club letter ready for the 24th[.] I scarcely have time to think so it will not be more than a letter written at break neck speed. The building absorbs every moment, even of thought. I wish that I could be with you on All Saint's day. Write me all about your memorial font to dear little Sister. What is it like? Get some flowers for me and have them placed on the Altar. One room of the house is nearly built[.] I'll send a picture of it. Keep all of the pictures that I send for me; they may be helpful to you when you read the Club letter[.]

One is of a dance. Had I time I might tell you interesting and amusing things of the building work. I have a time planing [*sic*] and keeping the men at work. I am told that I get more good work from the Indians than any one else here.

The ticket agent Mr. J. M. Miller is a great help to me, always accommodating and polite. To day he said to me "I often laugh at you," I enquired why, "Oh! because you have so much grit; I never knew that a woman could have so much grit as you have." Well! to live out here requires grit! My men, like all Indians, thought that they could come and go to work just when they pleased and get a full day's wages, until I cut down their pay a few times when they came late. It is very funny as well as annoying. If they work one hour in the morning they want a half day's pay; but they do not get it. It is very hard to make them understand. They act as though I were defrauding them. It tires me until every nerve in my body is on edge.

The roof may go on tomorrow[.] It would have been on before if the rain had not stopped us. Sometimes it strikes me very forcibly that it is the strangest thing in the world for me to be here directing men in building an adobe house; and of all men Indians. Six months or a little more I had not seen one. Mrs ____ said to day "I do not see how you manage, because of all things Indians dislike, it is to be directed by a woman." As it is they flock to me for work. I suppose it matters very much who the woman is and what the recompense. It is no joke to them to be discharged. One afternoon one man went off and worked for some one else. The next morning he came back and started to work; upon which I told him to leave that I had gotten some one to do his work. Every time one is discharged the others work very industriously for a day or two. In truth though, I have a fine lot of men working for me, and this building has been a fine

lesson for them. It is a prodigious work to undertake among such people and at a place where there are so many disadvantages.

There is not a stick, or a piece of board, or kindling, a brick or any thing to be picked up. Stones there are in abundance but I must go on my knees almost to get them. All has to be sent by freight from Albuquerque. Nails here are ten cents per pound.

The rule is to cheat, and every man nearly thinks that all he lives for is to get every cent out of his neighbor that he can honestly or otherwise. When I say rule, I must add the exception also, because there are some here who are the soul of honor with me, and I can depend upon them.

The Indians are comparatively more honest but they want big prices for things and labor. But who can blame him: the Indian is a much misrepresented article. What a bad white man wants to hide is laid at the door of the Indian, as I have said before. Oh! I can tell tales which may open the eyes of those who want the truth. If some who have dealings with the Indians do not burn in this world they will in the next. In many stores it is the custom to charge Indians a much higher price than they charge the white man. For instance an Indian girl Juanita bought some insertion at thirty cents a yard; I got the same at ten cents. Clerks are taught to press down the scales with their hands or feet while weighing for Indians, or Mexicans, or any one who is not on the alert. The Indians know this and think that most people dealing with them are trying to do the same. I am trying to gain their confidence and show that it is the part of honor to deal justly.

A few days since I needed some beams. From Albuquerque I could not get them for several day [*sic*] and I needed them at once. There were some old ties on the rail-road such as are usually burned but are not allowed to be given away—I secured several of them and telegraphed to the R.R. company asking if I might have them. In the meantime I explained to my Indians that they must not cut or put adobe on one of those beams until I received an answer to my telegram. I told them that we were Christians and that every thing about the house must be done honestly. They understood it and cheerfully worked on another part of the building. A white man who did not know the circumstances, forgetting that he helped himself to such ties whenever he wanted them began to call attention to those about him reminding them that I was cheeky. At noon I received an answer from the company saying that I might have the ties. When the white man heard it he turned so pale that he looked green, because he likes to make every one appear as bad as himself and he knew that he had misrepresented me.

When I went to the building and told the men that we could have the ties I wish that you could have seen how quickly they threw down their tools and went to work on the ties with the happy expression their faces of men who liked to do what was right. My men are of the right material when they know what to do.

Letter 23

—TO THE LIBRARY CLUB GREETING—

On Sept. 1st Mrs Ireland of Santa Fē took Lillie Sione's photo [possibly the photograph shown in figure 5]. One with me and one alone. Lillie objected to bare feet as she always wears shoes and stockings. The better class of Indians always do. After we were ready for bed that night we went out to drive a pretty little burro from under my window, but he had fled, knocking over some boxes and

a ladder in his flight. I had just gotten ready for bed again when back he came. At four o'clock the next morning the alarm clock awoke me. I dressed in haste and arrived at Bibo's store to join the Acoma party, Mrs Ireland, Miss Atkinson from Santa Fē, and Mrs Cannon from Oklahoma. As we were the guests of Mr. Emil Bibo he sent his clerk Mr. Reardon who was very polite in his attentions to us. It was a great novelty to ride in a prairie schooner but Mrs Ireland insisted that she could not ride without a back to the seat, and a chair was provided which was strapped to the back of the schooner in case of need. We have the joke upon her that she never again thought of the chair until at night when we arrived at Bibo's store and saw it tied up just as when we started. The Prairie Schooner is a lumber wagon covered with white canvas such as immigrants use. Quarte a noted Mexican was our guide and was provided with relay horses. He is a very interesting character, has done many bold and desperate things, and is perfectly fearless. At one time he and a gambler were slaughtering a bull at Grants; the gambler became angry and attacked Quarte who ran into Bibo's store, as he ran he slipped a butcher's knife up his sleeve, and turning stood up with his arms down, after having bared his breast, and said "shoot." He is so cat like in his movements that all fear him and had the gambler moved, the knife up the sleeve would undoubtedly have dealt a deadly blow. Quarte's son appeared upon the scene and by a motion from a clerk he understood the situation and was ready to arrest the arm of the gambler had he attempted to shoot. As usual Quarte was unharmed. He is one of the finest wrestlers in New Mexico.

Valencia County is noted for desperate deeds I am told which will not bear the search light of Justice. Sometimes tricks to test Quarte's bravery are played by the many clerks at the store and he never fails to respond, but these parties never dare tell him that he has been hoaxed. Though he is brave I fear that his bravery is not always exerted in what is right. At the same time he has always proved faithful to his master, and has been in Bibo's employment for fourty [*sic*] years.

At six oclock instead of five we started off on a gay trot with many a bump and peal of laughter. As we journeyed, for miles we kept in sight of the Poco Grande—Little Giant an eroded mesa, looking like an Egyptian pyramid. The Mesa Encantado or Enchanted Mesa table is of all things the point of interest to tourists from all parts of the United States. But in my opinion it is nothing compared with the pueblo of Acoma. En route to the Mesa Encantado different rocks loom up in the distance in curious grandeur; one especially suggesting the ruins of a gigantic cathedral, the carvings of nature standing out in artistic beauty and one might wonder whom the Architect and whose the chisel did he not know that the Divine Artist alone had worked these wonders in all of this beautiful, cream colored masonry, so near white that it is called Blanco. It is more than four hundred feet high and called Table Window on account of an opening in the rocks looking like a window[.]

As we drew near the Enchanted Mesa it was very interesting to notice the gatherings from near and from far, they came from all directions. Indians, Mexicans and white people were going to the grand fiesta in wagons & on horseback. Once in a while a little burro came trudging by with an Indian on his back her husband walking beside her giving the long eared little beast a poke with his stick occassionally [*sic*] to urge him on.

This should be called the Creamy Land for the sun gleaming upon the sandy rocks and plains in every direction makes them almost white excepting where the shadows of a Mesa or a cloud falls upon the plains or another mesa[.]

You never saw such a gathering. The distances and spaces were so great between the mesas that all seemed space, yet the mesas appeared as extended as the plains. To me every thing looked new,

yet truly it was very Ancient. One absorbing thought with us all was the Enchanted Mesa. When would we see it? Would we know it if we did see it? At last a gigantic rock loomed up in the distance, grand and peculiar but not gloomy. What was it? Our mounted Mexican guide with many gesticulations tried to tell us that it was the Mesa Blanco—or white table the Mesa of all Mesas.

The Mesa Encantado is called the Enchanted Mesa because it is supposed to be haunted by the spirits of three old women who perished there by starvation many hundreds of years ago.

The story is only traditional but firmly believed by many people. The Mesa was used as a village fortification against the warlike Navijos and Apaches. The Pueblos or Village Indians were a peaceful people consisting of nineteen villages, and to protect themselves against the nomadic tribes built their pueblos on the mesas, or table rocks. The Enchanted Mesa and Acoma are each from four to five hundred feet high, and inaccessible excepting the one by scaling the walls on one corner, the other Acoma by steep and difficult trails and mostly dangerous excepting to Indians.

The three old women whose spirits haunt the Mesa Encantado were left there one bright day by all of the men who had gone to cultivate the land in the plains below. While they were gone an immense rock became detached from the main rock and went crashing down to the ground below, carrying with it the only trail by which it was possible to ascend or decend [*sic*]. At night the men returned to see the ruins and the poor women above mutely appealing to them. But nothing could be done. The science of scaling with rope and ladder had not reached them. Day after day with heavy hearts they could only watch and wait until grim death robbed the rock of its only life, and silence has reigned there ever since; no vegetation, no water, nothing but barren, yellow rocks.

For ages it stood. Thus no human voice disturbed it until a few years since Prof. Libbey of Princeton succeeded in gaining its heights by means of a rope and stone. Others since have scaled it. Prof Hodge of the Smithsonian Institute has two or three times ascended it by means of Smithsonian Ladders. This summer I met one of his party of Dr ____ an ex surgeon of the Navy.

I cannot vouch for the spirits that haunt the place, but this I know, Mrs Ireland attempted to take a photograph of the mesa and the plate was spoiled; and one of the relay horses balked three times in sight of the Mesa and three times Quarte had to replace him. When we started off again one of the seats broke and down came Mrs Ireland and Miss Atkinson on a bag of oats. Were the spirits resenting the picture taking? Be that as it may, the real Indians do resent it.

Off in the distance was our objective point, Acoma. Of all the feasts that of Acoma is the centre of attraction. It is the Grand fiesta of all the pueblos excepting the Snake Dance of the Moquis; and Acoma is vastly superior to the Enchanted Mesa if we exclude the spirits. The weird always rivits [*sic*] our attention. But Acoma has thousands of traditional stories against the one of the three women, and as many facts of history. Each of the many trails which are harder to climb than Jacob's Ladder has its own story as well as history. The one which we climbed for four hundred feet or more would allow of only one person at a time in many places. When we were able to get a foothold we would find corresponding little notches in the stone on either side, in which to put our fingers to help the climbing. It was very fascinating and exciting, as well as alarming; the more so on account of the little feeling that one might lose a footing and go rolling down. My comfort was, that I'd go bump up against some sure footed Indian behind me. We would not have missed it for the world even though our hearts beat so rapidly that it was hard to breathe.

I declared that I never could go back that way and was relieved to learn that there was a horse trail. Montezuma's Trail was the most difficult and most dangerous looking, though I doubt if he

were ever there. When pursued by the Spaniards he fled down this trail,- so our Indian interpreter Juan Garcia told us—and escaped to the lowlands far in the distance before he was captured. The spot was pointed out to us from the top of the trail.

Years later when the Spaniards after hard fighting had conquered the Acomas, they tried to convert the gentle Pueblos to their religion.

A priest went to Acoma to work among them and was so fiercely pursued that he fled to one of the corners of the rock and sprang over, thinking, that death preferable to the tortures of the Indians. He held a hoisted umbrella and wore his priestly robes.

To the amazement of all, he escaped with little injury, owing to the umbrella and robes, which broke the force of the fall. An Indian maid escaped something, in the same way. The Indians considered that the priest had been preserved through some enchantment, and received him in their midst, accepting his faith as far as outward form is concerned. He lived among them fourty [*sic*] years. One cannot help thinking that it might have been better for the Acomas if the priest had perished, for Spanish teachings and superstitions, combined with his heathen practices have held the Pueblos in thrall and prevented their receiving better things. The rock from which the priest sprang is known as "The Priest's Rock."

There are still living Indians who have been whipped for not attending the church of the Mexicans. Acoma is said to have six community houses containing many hundred rooms and seven hundred inhabitants. I did not count them but imagine this to be about correct from what I remember of the place.

The clay, stones, and timber of which the buildings are made were carried up these different trails on the backs of the Indians.

There is not a spray of grass there, nor a green thing of any kind, and water is only to be had by rare rain falls collected in the deep cavities of the rocks, forming immense cisterns. In the smaller ones they wash their clothes and persons, which in time becomes filthy until finally the water dries up and no more comes until the next rainy season, which is usually every nine months. The larger cisterns holding thousands of gallons of water remain clean and pretty a long time and water is only dipped from them. When these fail, water is carried up the trails from below on the heads of the women mostly in the beautiful Ollas made and decorated by these same women.

Horses were there by the hundreds and some one asked if they too were carried up. But we found their trail also and wondered that any beast could climb it.

San Stevano's day comes on Sept. 2nd always and the Acomas have their Grand fiesta or Harvest Feast on that day. The Pueblo Indians never fail to give thanks for the yearly blessings.

We arrived just in time to see the procession from the church. The image of San Stevano the patron saint of Acoma, led by the Mexican priest, headed the procession and his canopy followed him. A very important part of it all was the spirit of San Diego—St James—the first saint who entered Spain and Acoma.

Every four years he returns to Acoma in order to give thanks for the harvest and his fourth year happened to be this 1899, on San Stevano's day, according to Indian calendars. It is really five years of our time.

He came on a hobby horse made of white canton flannel; he was made to appear as though he were riding this horse. The horse was divided in the back so as to fit around a standing man, making his body seem to be sitting on the horse, the saddle cloth covering the horse's body to the ground, also the man's legs.

The man kept time to the music causing the horse to have the appearance of prancing at times. His shaking head and body were not very substantial looking. San Diego wore a green veil for a mask. Two mounted Mexicans with black masks acted as policemen to guard the spirit of St. James from harm; they carried whips with long lashes and every one kept out of the range of them. The image of San Stevano with much ceremony was placed under a canopy.

This canopy or shrine was made of green corn stalks and leaves pulled up by the roots. It was quite pretty. All day at different intervals devotees knelt at this shrine and brought offerings of bread, fruits and clothing in baskets which were made by the Navijo. All who knelt in devotion helped themselves freely to these eatables and after it had been blessed by the priest much of it was tossed into the air, falling among the crowd of dancers in front of the shrine; they eagerly caught it and when a man got as much as he could carry he left.

The dancing did not begin until after dinner and was much more interesting than the procession. The morning exercises were those of the Roman church and was as much Mexican as Indian. Although the dancing is as much a devotion, it is strictly Indian in the afternoon. At night the Mexicans have their distinctive dance and the Indians are not in it. A violin, drum and guitar constitute the music; the violinist is a blind Mexican who has played at these fiestas for fifteen years; but at the Indian dances nothing but a drum with its thum, thum, thum is heard. With slight changes the dancing is almost the same step all of the time but the figures change. One is similar to our Virginia real [*sic*]. About two dozen men led. They gesticulated with their arms and hands, casting their eyes up and about as the special prayers required. One could plainly see that they were invoking something. With the feet there is very little action.

One could not help admitting that their dances have more significance than those of our own civilized people. This particular one was the Harvest Feast dance and a part of the Sun Dance. Behind the men came the lads, maidens and matrons dressed artistically. The banners, worn on the heads of the women are of boards about a foot and a half in height, painted green, with yellow, and black bands in which are cut the sun, moon, and stars.

The young men are nude to the waist but so painted in white lace patterns that they look like pretty chintz shirts, skin tight. The bare arms have on them bracelets or armlets above the elbows of evergreens gracefully moving during the dance. From the waist they have skirts of linen embroidered with red, yellow, and black, extending to the knees. The trousers or moccasins with leggings are headed with garters made of Germantown wool tied in great tassels of red and black. Often from the back were hanging skins of animals such as fox or hoyote [*sic*]. On their heads were scarfs [*sic*] of red and others [*sic*] colors. In their hands they carried either gourd rattles or bunches of evergreens. The drums are made of hollow tree trunks with skins stretched over the ends. They look very old. It would be difficult and tiresome to attempt to describe the figures of the dance. Suffice it to say that the women have as little action in the dance as they do in the daily labor which belong to men.

When we read and hear that Indians compel all of the hard work to be done by the women we must remember that it does not apply to all Indians. There are as many varieties of customs and dispositions among them as among whites. Here at Laguna they are comparatively clean, industrious and honest and few drunkards. At Isleta they are not so honest. One day some one suggested the propriety of leaving something out of doors for it might be stolen. An Indian looked surprised and said "Why! there are no white people around." At the same time I notice that Indians are as careful as any one to close and lock their doors. It is a fact though that the most dishonest part of the community is the white part. Tramps are numerous.

In all of these pueblos the churches are a point of interest. The one at Acoma was built or rebuilt in 1802. The stones, adobe and sand were carried up these four hundred feet trails on the backs of the Indians, and the water in jugs on the heads of women[.] It requires an immense quantity of water to build an adobe house. It is a fort as well as a church.

It is 40ft wide, 150ft long and 60ft high inside. The logs and beams are so long that one wonders where they got them and how it was possible for them to get them up there when we know that the walls of the trails are so narrow that our shoulders would nearly touch on either side in many places. The gallery has a railing rudely carved with stone hatchets. The choir is gone but there is a large altar platform. There are no nails and the hinges of the doors are perhaps the most curious thing in it—for they are of wood. At Laguna they are the same not a nail in the whole structure. The great corridors and balconies and the patio have stood many sieges, and were the only places in which the poor Acomas found safety and fresh air in extremities of war. At times the whole pueblo found shelter in the church. The ceiling is a curious, inlaid willow affair; the willows being laid in zig-zag or angular lines, and each willow is painted, red, yellow, black or white, but dull enough not to be gaudy. In front of this fortified church looking like an ordinary yard is the cemetery. For generations Indians have been buried there, some to the depth of sixty feet, one on top of an other. It must originally have been one of those great sisterns [sic] because they could never have dug graves to the depth of sixty feet in solid rock. It is all level and no trace of a grave is to be seen. On the gate posts are little clay figures, or heads of human beings more suggestive of beasts and most grotesque looking.

Many wonder that the Indians still inhabit this strange cliff town with all of its inconveniences and labor producing trials. Many of the young ones when they marry do want to go down to the plains but the old ones have great authority and refuse to allow them, because they fear that the spirits of departed ones may return and do them some harm for abandoning the old place.

The adobe houses of Acoma are three stories high forming straight, up and down terraces. Formerly the older ones had no doors on the first floor and some remain so. This was because they were forts as well as dwellings. They ascended to the first roof by means of ladders, and drawing the ladder up descended to the first floor. During wars with nomadic tribes and the Mexicans they hid in the caves of the cliff and in the dry cisterns from which they shot arrows at their enemies. We can see the smoked stones now where they had their fires.

The Spaniards besieged them and tried to starve them out; but the wily Indians slipped down the trails at night and gathered reeds from the distant ponds miles away and in the day time threw them over the cliffs to make their enemies think that they had plenty of vegetation. This led the Spaniards to think that the Acomas had an ever flowing spring of water and plenty to eat.

I was very much surprised when I learned why Indians seldom have beards. It is because they pull it out one hair at a time. They have no idea of relatives and dates. Jose Garcia said that he would take us to his mother's house. When we got there we knew that it was not his mother's at all. When we questioned him he laughed and said "it's my Aunt's, we call our aunts mother too," and our cousins we call brothers." The Pueblos are more moral than the Navijo; they have but one wife by law but the Navijo have one or more. Many Navijo were at this fiesta and one who was pointed out to me wanted to marry the younger daughter of a widow. In order to do so, he married first the mother, then the elder daughter, after which he married the choice of his heart. Another one offered Mr. Dural one hundred horses for his Mexican wife. Mr. Dural refused to sell his wife. Miss ____ professes to have discovered a cliff dwelling at Acoma and

showed it to us the day of the fiesta, but she is laughed at for her knowledge, for there are no cliff dwellings there excepting that the place itself is a cliff. Under it is a long tunnel and Mt. Taylor is opposite. On it there is an Altar to which the Indians go yearly with offerings,—to their patron saint,—of feathers, fruits bread and vegetables. The peculiar dress of the Pueblo women is artistic, pretty, modest and expensive. They are fond of coral beads and turquoises especially. Silver is indulged in freely.

They pin their dresses with pins made of United States and Mexican coins, they button their moccasins made [*sic*] of them.

The day at Acoma was nearly spent and we must leave. Oh! how much we had learned and seen, I can never tell it all. We were tired thirsty and hungry, so down the horse trail we wearily went, wanting to stay though where we were at the foot of Acoma we threw ourselves down on the rock to rest and wait for Quarte. We thought that he would never come. We talked of every thing, of how nearly starved we had been for weeks and of the money we had to pay to be able to starve, when a cry of, "Here comes Quarte" rejoiced us, and we watched him and several horses coming down the horse trail; one fell over and rolled down a steep place, others looked as though they might turn summersaults and we then understood the wonders of the horse trail better. Our little party will never cease to be grateful for the pleasures given us to day by Mr Emil Bibo.

"Adios."

Oh, I must not forget to tell you how generous these Indians are at these fiestas. Their houses are thrown open and every thing eatable which they possess is offered most freely and kindly. White people generally give them a coin but they do not ask it, and if they accept their hospitality it is perfectly correct that they should do so[.] It is said that the poor things suffer afterwards for their generosity.

—Adios—

Letter 24

BUILDING AN ADOBE HOUSE

We began to build on Wed. Sept. 6th. Our house is well built as far as it goes. The whole of this little community are [*sic*] proud of it. It looks a little crooked because the wooden parts are not straight. The masonry is good, firm and solid. George Dailey a full blooded Indian and the boss adobe builder fortunately thought of a corner stone which I did not.[19] He went off with the men and did not explain because he could not speak English. I watched, for George is level headed. Slowly they returned with an enormous stone. I ran for a bottle and paper and soon the names of all concerned, dates, and soforth [*sic*] were sealed up in the bottle thanks to Mr. Miller; and George built it in with the stone. So the names of the Company who sent me here are sealed up in that bottle. I hope that from it may grow, fruits worthy their noble intentions.

The Indians flocked to me for work. I offered one dollar per day but they asked a dollar and a quarter because they board themselves. I had to give it because they get it on the rail-road. I tried to make a contract with them for a certain time, or a number of adobes but, they could not understand and struck stolidly for so much per day. I follow them and urge them to work and tell them that I will not give them a full days wages unless they are on time. It is hard work. The white people say that it is remarkable that I get them to work so well but the truth is I have fine men. Some

days they made 350 bricks—390 once and 300 once. At last I got them to make over 400 per day but that was only on the last two days. The bricks are 18x9x4 inches. Three men worked all of the time and one man carried water. This was the best I could do. The water was some distance off and I got an old man or some girls for less money when I could, but at last I was compelled to have the fourth man to do it, and carry straw. Every morning I go at seven o'clock to see that all are on time. Then I go to my breakfast and return until noon. I hurry back after dinner to see all started again and there I stay until six o'clock. I rejoice many times that the house is on rail-road land and I am sure that any one connected with it will be also when I recount the many trifling things with which the Indians consider it their duty to meddle. We can scarcely blame them when we consider how they have been dealt with in regard to their land.

They have a stringent government and a petty one, in some instances, but mostly it is to be admired[.] Many men are afraid to turn around without asking the Governor's permission. I mean the Indian Governor of the pueblo. When I supposed that I was to have U.S. Government land I had some sand hauled while I was sure that I could get it. I engaged Ulyses Paisano a Christian Indian who is very conscientious and very favorable to the house building.[20] He had hauled two small loads,—Indian loads are always small because their horses are not strong—when, he told me that the governor had ordered him to stop, because the sand was for my house. D^r Lukens kindly interfered, as the sand was put in his yard, he had a right to do it. And Ulyses went on with the hauling. After I secured the land I anticipated trouble again, but got the next sand without it, because, there happened to be no one to tattle; also because the officers and majority of the Indians had decided in my favor, since they could no longer control the land question. The sand did not belong to them. But I needed clay at once. It belongs to the Indians. If I sent to Albuquerque for it I must keep the masons waiting[.]

On Friday Sept. 8th I asked William Paisano to get some for me. I offered him the prodigious sum of five dollar [*sic*] for two barrels. He said "I must ask the Governor, my father"—The Gov. said that he must ask the officers; two were consulted; they said "We must ask the other officers."

At last all were consulted at a public meeting. On Saturday I saw William; he said "I think it is all right." Well William: will you get a man to go for the clay at once? "I must see the Governor" said he again. The Governor was from home but he promised faithfully that he would see him, and get a man early on Monday Monday [*sic*]. Well: William did you send a man for clay? "I am sorry but I forgot it. I can not see the Governor again until night." Again he forgot it. On Tuesday he said "I saw the Governor and the officers, they say that you can have all the clay you want, but there is a hole where the clay broke in, and it is dangerous to go. The officers will send a man from each pueblo and they will dig out the dangerous place and then you get clay." In the mean time I got white clay from a neighboring hill and tested it. It proved to be good fire clay and I engaged Lorenzo to carry some for me in bags. It was not on Indian land and I had a right to it. Annie and Lillie Menaul carried enough to start us.[21] The next day I was told that Lorenzo had been brought up before court and was to be fined for getting dirt without having asked the Governor. I began to wish that the Governor had his best suit of clothes on, at the bottom of the sea with Meginty.

I went immediately to him and plead for poor old Cheme Chetete saying that it was a shame to punish an old man like that for trying to make a little money. Afterwards I had a long interview with the Gov. Lieut. Gov. and the interpreter all sitting on a log in front of the new house; during which all my wants were granted. I took the opportunity to ask for the men, to be allowed to get

clay, stones, wood and other things. But each time that the men get any thing they must ask permission for that special occasion.

The Governor wound up by asking for a present of money for himself and the Lieutenant Governor. I would like to have cowhided him for his littleness, and after I get all that I need for the building he will find out that I can do without him entirely. If it were not all for the benefit of the Indians it would be different. Had the house been on Indian land I must have had a much more serious time. They promised that old Lorenzo should not be fined or punished and he carried clay several times for me until we had enough. He is a good, willing worker, far better than younger ones but too old to do much. [Crossed out: The Governor said that there was danger of a cave in at the clay pit and the men from each pueblo should be sent to clear away the dangerous part then I can have all the clay I want. Of course this means I pay for it.]

On Sept. 13th a troop of Negro soldiers from Arizona en route to the Albuquerque Street Fair encamped in front of the station. It was as if by magic they appeared on the high ridge, by the pueblo, looking like a straight line between earth and sky. They looked as though they were almost floating in the air. It created quite a commotion among us as they filed in and pitched their tents. A fine looking set of men! They had been in the battle of San Juan, Porto-Rico [*sic*] and were proud of it. It is pleasant to see the clouds but I hope it may leave a dry spot around our building until it is complete.

Sept. 26th Mr Miller took a picture of the house as much as is up. Mary Paisano came by, and we wanted her to be in the group with us and the workmen, but she would not. Mr. Miller pretended to take her picture, at which she dropped down on the rail-road so suddenly, out of sight that we all laughed and she joined in. She is a very fine woman. Robert, George Dailey's brother told me to day that his brother "He got some plenty of money."

Letter 25

Oct. 11th

The men annoyed me by being late this morning and then by not working. I came from breakfast and found five Mexicans talking to George Kowice and Frank Sihu; the two Georges not working at all.[22] I said sharply, George Kowice go to work and don't talk. "Yes mam" said George and went to work with a vim. The Mexicans took the cue and walked off. The past few days have been slow work. The Indians have only periods of good, working inclinations. I have to urge and watch. Later in the day I asked George who those Mexicans were? He replied very meekly "I do not know you told me to work and not talk." I got out of the way to have a good smile[.] Suppressed laughter is a thing in which I am becoming an expert.

Monday Oct. 16th

Red bricks are a curiosity here. I ordered some with the building materials. The men were anxious to slip them in among the adobe bricks but I would not allow it. There were not many workers to day only George Kowice, Frank [Sihu] and Shiosee.[23] I put Frank and George at the chimney. I can almost roll with [crossed out: merriment] to think that I am teaching them to build a brick chimney with mortar. Frank and George asked if they could use the bricks and I refused until I saw

that they could not carry out the dimentions [*sic*] with stones and adobe. I was determined not to have a smoky chimney. I called them down and showed them how to make the mortar. Satisfaction shown in every line of their faces as they carried off the first two buckets, full of mortar to the roof.

After they turned their backs upon me it was too pretty for description to see them bite their lips to hide the smile of pleasure. They worked away as seriously as two judges on the supreme bench. Their hearts were too happy for expression, and I could have danced with glee. Frank if he had the training would make a fine mechanic.

The funniest part is that I never would have known how to make mortar nor to use it had I not watched the masons put up a small brick building and asked them about proportions and other things. How a grand idea in one direction teaches us to grasp the smaller ones and their importance is showing itself every day. The boys were so eager to use those bricks, and now are so happy because they are learning something. They feel the force of a new impulse. With my whole heart I love to help them to better things.

Frank and George had never seen a trowel and they used it as though they were buttering a delicate piece of bread for a fashionable lunch; I took it from them and tried to look very professional as I daubed the mortar on more substantially, feeling the ludicrous part extremely, yet not daring to smile. A woman and two Indians on a roof building a chimney! It is well built too.

Oct. 18th

Yesterday I told George to get a man to haul stones and to be sure to ask the Governor's permission. This morning he told me that he had gotten the man. I asked who? His answer sounded like "Gum." I put the men to work and went to breakfast wishing that Gum were not so late. When I returned I saw the team there and my astonishment grew when I discovered Governor Paisano unloading stones. Convulsions of unuttered laughter and amusement took possession of me when I got far enough away not to be seen. To think that the Gov. should help to build my house after he had nearly pestered the life out of me by throwing difficulties in the way. He proved a good worker and was the cleanest of clean men with his white shirt and new gloves. I have created a sensation! At the store, at the station, every where whites and Indians greet me with "You have the Governor to work for you!" Some said "Why Gov. Paisano never works." But in that they are mistaken for he works on his ranch[.]

The beauty of it all is, that my men feel his presence; they neither talk nor idle, nor do they stop to look at each passing car.

They work with a will with the eye of the Governor upon them. George Kowice had asked "What you pay a man with his team?" Three dollars per day; if he works less than a day he gets less money. "That is what I told him," said George. You can feel a little of my surprise when I learned that I had been bargaining with the Governor who feels his dignity very much. He is said to be worth about twenty five thousand dollars, and is a good man. One day Miss [Bingham] who is Inspector of U.S. Government Schools sent for him to come see her on School business. He sent word to her that he would not come because she had not called to see him. She immediately went and he then called with the Court Secretary and Interpreter George Hiowa. At all meetings he takes his seat in a prominent place as by right of his dignity.

Everyone upholds him in his rights and no one dares disobey him, no one says slanderous things of him. We are building an additional room and my Indians are glad to get the work. The

women are plastering inside and out. I will send a picture of them working. The cold days have passed for a time and the sun is warm.

Frank called from the roof "He is come!" I asked who? "Lorenzo." Old Lorenzo had been herding sheep far away. They all know that I have great respect for the old warrior, childish as he is. Although nearly a hundred years old he loves to work. I was so angry at one of the store keepers yesterday that I could have thrashed him.

Some time ago George Kowice asked me for four dollars with which to pay on a set of harness. He was told that he could have the harness if he paid so much and the balance when he could. I gave him the money and supposed that he was using the harness; but he told me that the store keeper took the money and refused to let him have the harness until he paid the whole, at the same time he refused to return the four dollars. Fearing that George might loose [*sic*] his money I borrowed ten dollars of Dr [Lukens] and gave it to George. His face was a picture of pleasure when he got the ten dollars.

Medicine men are magicians, the most important men of the Pueblos and Religious Officers. James told me that once a year they meet in the school house for three days to recount and perpetuate the traditions of the Pueblos. They select three or four of the most intelligent young men with good memories to whom they tell all that is important so that they can hand it down to the next generation.

Old Lorenzo is a sort of one but not in reality. I told him one day that I was malo [*sic*] touching my head. He gravely stooped and laid his arrows and bow on the floor. I knew that something was coming and felt a little serious. He took my head between his two hands and pressed it several times looking very solemn [crossed out: so was I]; then my shoulders in the same way. Lastly he laid his ear on me as a doctor would to sound ones lungs; picked up his bow and arrows, shook his head in a confident, satisfied way, and left without a word. I was glad to see him go. I think that he must have pow-wowed me. I did feel better soon, at least I thought so.

Indians and Mexicans believe in witches. Mrs Pinos is the delicate wife of a rich Mexican. She has been an invalid for many years. Just before her ill health began she had a quarrel with her neighbor. She declares that this neighbor bewitched her and caused her to be lame. Shooting stars are witches flying to their nightly meeting. The rain bow is a bow of the Gods, the lightning their arrows, thunder their drum, the sun their shield. The cross or crosses are emblems of the morning or evening star.

Letter 26

BUILDING AN ADOBE HOUSE.
Oct. 15th

I will send the pictures as soon as I have time to wrap them. I wrote the Club letter in haste without thought or preparation at night and fear it may not be interesting. Every minute is occupied with the building[.] The roof is half on one room. It is very cold, and a very penetrating cold, too much so for out door work yet I must be here all the time. One of the men is Louis and is called Louise.

Nov. [should be Oct.] 25th

I am sitting in the shade of the house wrapped in a heavy coat with a big hat on watching the men work. There is ice around the water tanks. Some are building the stone foundation

of the new room; four are making adobe bricks, one is doing the carpenter work for doors and windows.

It occured [*sic*] to me that I might keep some writing materials here and send off some of the many letters which I owe. I am trying hard to hurry the building of the new room fearing that it may freeze the bricks and put a stop to the whole work. Frozen adobe is good for nothing.

Nov. 14th

To day we sang at the funeral of Col. [Walter] Marmon. He was the gentleman of the place.

Nov. 21st

I am returning from Albuquerque after having bought stores and other things for the house. Surely the beauty of New Mexico is when the sun hides his face[.] I never thought this country beautiful before, but the clouds and sunshine on this peculiarly reddish earth with the black, volcanic hills on one side and yellow sandstone on the other, make such indescribably beautiful values, soft greys and softer hazes that it melts the heart to an unwonted tenderness inexpressibly sweet. Just look! steps, steps, steps, with here a peak and there a peak to break the monotony of the mesas.

The wide expanse of low lands covered with the blue grey, sage and green amole make the hills look far away, while the mellow atmosphere brings them so near that I think I can reach them in ten minutes walk, when lo and behold! I am told that they are thirty five or fourty [*sic*] miles away. Not hills though, mesas all of them. Now the greys of the gloaming steal over them, the reds of the sitting [*sic*] sun die out and every thing is changed. Only the picture in the mind's eye and heart remain. It is not so bad after all to ride on a freight train if one could only cork up ones olfactories to keep out the pig odors coming from the front car.

Albuquerque N. Mex.
Nov. 30th

I am buying furniture for the new house. It is to be as inexpensive as possible and Indian in character. I bought tenting canvas for carpets with a dull green denim for borders. It costs only twelve and fifteen cents per yard. On this I will put Indian blankets for rugs.—They are heavier than rugs generally. These blankets I will keep to bring home with me. Indians frequently use canvas for carpets. I am getting as little as possible to be comfortable. Things as I told you are expensive. The Indians are proud of the house. It has only two rooms but I divide one into two with curtains. This is Thanksgiving day I must go to church and return to Laguna to night.

Dec. 19th

I will send a few trinkets peculiar to this country for Xmas.—The petrified cedar is from the Petrified Forest of Arizona, the agate from Mexico. I wanted to send pottery but packing is a serious thing. Thank H__ for the pamphlet. I enjoyed the article by Mr. James on Indians: he is quite an authority. I will send some large and fine pictures of Gov. Paisano and his family [figure 8];

one also of Laguna [figure 4]. They give a good idea of the characteristic dress and mud houses. The flag pole is in front of the U. S. Government school building, and the church is some distance back of it. The long building in the foreground is Gov. Paisano's and as clean as it looks in the picture. The long porched [*sic*] is white washed. The whole pueblo is built on an elevated, cream colored, solid sandstone[.] The old part is in ruins and the whole gives the appearance of a castle of long ago.

The picture of high rocks is a corner of Acoma carved into those shapes by erosion. To the right is the Path of the Fathers, and the only trail over which burros or horses can reach the pueblo; it was made for this purpose by the Indians: no wagon can get over it or to the village.

You will recognize the old church in another picture. I had hoped to have been in my house to night but every Indian man was compelled to work on public works, and that means no work for any one else[.]

Love and a Merry Xmas. Let me know the length of the bow string. I think it can be made.

James says that they used to make them of the sinews from the backs of horses, but now from those of cows. He will make them as soon as he knows the length.

Letter 27

Dec. 20th

I will mail with this a picture of some Indian children with babies on their backs. It is a poor thing but it may interest Canning. Tell him that the houses in the back ground are made of mud mixed with straw. He will notice a ladder upon which the Indians get into their second and third story houses. They have no stair ways, but climb up the outside on ladders. Men women and children carry babies on their backs, always bare headed, they have no hats: their hair is so thick that it protects them from the ordinary cold.

I suppose that Mrs M ____ has returned from Europe before this. Give her much love from me. I would like to see her and hear her tell of her travels. But tell her that I think she has found nothing more novel or foreign than this New Mexico, with its prehistoric homes and its present, wonders, and traditions, strange people, languages and every thing pertaining to it. Think of my building an adobe house. I soon learned how good work was done and it was amusing to myself when I ordered experienced workmen in the place of poor ones. I showed Frank how to make a cement pavement and he did it well.

Dec. 26th

Dear Canning:

I thank you for the beautiful calendar. It is soft and refined in its pretty blue and white. It hangs by my dressing table with a lovely piece of mistletoe from Texas over it. I must tell you of my strange and interesting Christmas. At this time the Indians have long devotional dances lasting about two weeks beginning on Christmas eve. They begin to clean the houses and town and prepare generally for it a week before. The children have their fun out of it which is innocent but not devotional. Little boys go from house to house and dance, and the

people give them something to eat, which they carry away with them. They told Juanita that they would like to go to the white lady's house but were afraid she might not like it. I sent word that I would be glad to have them come; I was more than glad. On Saturday night Dec. 23rd a timid knock announced them. There were four small boys about your size who danced and one other who beat the drum, while a fifth droned out a monotonous tune. Two who danced were perfectly nude excepting that they wore stumps [?] and shoes, with stockings rolled to the shoe tops leaving the legs bare. It was a bitterly cold night too. In addition to horse hair, one had a yellow handkerchief carelessly tied on his head. Their naked bodies were painted with white clay and their faces and the upper lips with black to imitate moustaches. The other two dancers wore red blouses of calico, white trousers, moccasins and caps; their faces were painted also. All carried bows without arrows. They imitated a Navijo war dance and danced with more spirit than the grown Indians. They brought a bottle of cold coffee pretending it was whisky. When they rested in the dance they passed the bottle around and drank freely, after which they acted silly as though they were drunk, keeping time with the drum. Juana, her mother and some older boys were with them. Much to my sorrow, I gave them candy, for ever since on all occasions I have been pestered with them and other little savages, knocking at my door asking for con'-da or calling in the distance con'-da[.] I must say though that they were never rude. Hearing the noise outside other Indians came to the door but we did not let them in.

On Saturday night I was fortunate enough to see the Comanches coming. It was the most exciting thing to hear and see those mounted Indians in their wild dress. A whole troop rode into the pueblo. I heard them whoop and yell as they were crossing the San Jose and opened the door to see what it meant. It was a sight to be remembered. Just before the red had left the twilight sky they formed in line in front of my door. The eagle feathers on their heads formed a semicircle from the forehead running back instead of from side to side: They sang to keep time for marching with occasional whoops. On Christmas day they danced in the same garb. Really though they were not Comanches but Pueblos imitating them as they came and danced in the years gone by. They danced much more vigorously than in their devotional dances. The imitation dances are mere fun but the real Pueblo dance is their way of worshiping God and thanking him for his goodness to them and of asking for blessings.

I really think that those of us here who are Christians are more heathen than they, for they in their blind way were trying to worship their maker while we stayed at home, ate good dinners, received presents and went to no place of worship to show the world that we acknowledged God as the Giver of All Good Things. The Indians as is their ancient custom have more than a week of Thanksgiving and prayer, but in addition they have their Roman Catholic services and pray to the one God, the Father, Son, and Holy Ghost, to the best of their knowledge. In this last of course there is no dancing. There are no seats in their churches excepting a very few near the door, because they do not need them and they could not dance if they had them. If they had no idols and worshiped God alone it would be very beautiful and touching and surely no harm in the dance. I wanted to send you a bow and arrow made by an old warrior but he did not bring it. Much love to you with earnest wishes for a Happy New Year.

Affectionately
Aunty Dodo.

Letter 28

XMAS
CHRISTMAS
Dec. 26th 1899

My Dear _____

The box with all of the pretty and delicious contents came on Sunday morning or rather at midnight before. I am so near the station that I sent for it at once, opened it and dined off Turkey, Turkey cooked in Pennsylvania, sweet, tender, and exceedingly palatable. Miss Bingham came in and I invited her to stay. She is a Maryland girl and was pleased to write home that she dined upon turkey cooked in Pennsylvania. It was enough to make every one envious; that roasted turkey had traveled more than two thousand miles. It is a thing to be appreciated, and I thank you all for my charming Xmas box. This was my first dinner in my own house, and I was glad to be there although I do not like housekeeping. The kettle is pretty and will be exceeding useful. The home made ginger snaps, fruit cake, and plum pudding are a luxury for they may keep for an emergency; but the turkey was best of all. It is so difficult to get meat here and some people spoil it by parboiling it before roasting it which makes it such tasteless stuff. The pickols [*sic*] and olives look tempting in the bottles but I am reserving them until the perishable things are devoured. The celery was fresh and nice and the cloth still wet. Thank H _____ and the boys for me. As soon as I can find time I will write and thank them separately for all the pretty things which they sent me for this joyous season.

This whole week is one grand festival with the Indians. For days before Xmas their friends gather, gather from all directions, near and far and every thing is made clean and bountiful to receive them. They bake in clay and stone ovens, something like the Pennsylvania Dutch ovens. When they are hot enough for use they wash them out with a long mop before putting the bread in. At a little after eleven o'clock on Sunday night (Xmas eve) the devotions in the church began and lasted until twelve o'clock on Xmas morning. I will send you with my collections some pictures of the dances if I can get them. To day Tues. 26th they had another dance and on Thursday will be the last until the New Year, and Governors inaugural dances. The old church which you can see in the picture of Laguna is much more interesting than I thought. I had never been in it until Xmas eve, and I find it much richer in coloring and paintings than others I have seen.

During the Roman Catholic services they kneel all the time of their devotions instead of dancing.

Letter 29

Laguna N. Mex.
Jan 2nd 1900–

PLAYING THE LOBBYIST—
How almost impossible it is for me to be ready for a special occasion. For instance this evening I had planned to get myself and sitting room up in the most attractive manner to entertain the new Governor, Shosemi.[24] In fact I had determined to play the lobbyist. All my efforts to get the clay for which I had bargained had failed unless I gave an untold price. To this I rebelled and I wanted

to try some experiments. The new Governor was supposed to be a man with whom it might be hard to deal unless one should happen to please him. Knowing that man's heart is often reached by catering to his appetite and as frequently to his vanity I invited the Governor to see me to have a talk. After all of my pretty plans I was so occupied all day that I had no time to attire myself in a gorgeous tea gown and have a dainty table arranged before to my dismay in walked Gov. Shosemi before dark with his interpreter James Hiowa. I gave the Governor the best chair and as coolly as possible proceeded to get down my pretty kettle and spirit lamp. I knew that they would be interested in this novelty. I said nothing of business but made tea and passed Ginger nuts. I told them that this was the way ladie's [*sic*] entertained white Governors when they called. This tickled his vanity and added to his importance. I was enjoying the situation immensely, the more so that I knew those two men were enjoying an innocent pleasure never tasted before and feeling that I in my inmost heart had no object excepting for their good. Soon Shosemi said to me "You are kind to me and I will be your friend and ask God to help you." I seemed to be prospering in the work of lobbyist and produced milk and crackers, and in time a few Brazil nuts and as the friendship warmed almonds and raisins.

At last the appetited [*sic*] having been gratified I began to talk business, and lastly clay. I told him that it was a shame for the Governor to allow the woman [*sic*] to get clay in a dangerous place; that it was his duty to have the dangerous part cleared away and the hole made large enough so that they would not have to go in on hands and knees to get clay and that a good Governor always worked for the interest of his people. I told him to sell his clay at a reasonable price that there would be clay there hundreds of years after all of these Indians were dead. I ended by saying let me help you when ever I can, and have time to make this Pueblo a good, industrious, God fearing people? A Governor cannot do a nobler thing than to establish a good business for them and help them to a noble life and civilization. If you do this God will look down on you and bless you and the other officers in your good and wise work. His eyes grew bright and enthusiastic and his cheeks as red as though he had been taking wine instead of tea. We parted good friends and he promised to help me in every way and to have the clay pit cleared of all danger.

We have had some cold weather, though I am told that this is an unusually mild winter.— There is a strange inconsistency about these people. Some of them old and young go bare footed during the bitterly cold weather and some, in fact nearly all the women swelter with heavy shawls about them and on their heads in the scorching sun during the summer.

I dislike very much to write 1900. It seems altogether wrong. I send you some Arizona rubies and metsene. The rubies came from near Holbrook. I also send some lead and silver ore from Mexico. At the end of the house I have some flint sand and one day when the men were working I told them not to disturb it "Yes" said Robert "my brother George says that that dirt is very much valuable[.]" Another said "That is little, much good." James did something wrong and I said James you did that carelessly. "Carelessly! What does that mean?" I explained it and later in the day I mislaid [*sic*] something and was looking for it when he called out "now Miss Foard you are carelessly!"

I have a wretched cough[.] People come here to get well yet it is a land of pneumonia and consumptives; Indians are a prey to it. One cannot walk out here without seeing something of which to write or talk. This morning I got a grand view of Mt Taylor, fourty [*sic*] or fifty miles away, with its deep, rich blues and purples. A Mexican on horse back made the nearer picture complete and brought to mind an Arab on his steed: he is tall and slender even with his great blanket of greys, and dull reds worn so gracefully that I longed to have a sketch of him.

So dark and swarthy was he, that one could have pictured him an Othello. Had his horse been one of mettle and grace to correspond with his rider I could have imagined myself among the ancient Moors or Arabs, but he was small, and bony and ungroomed.

"Had I the pen of a ready writer" I would set men's heads and hearts on fire, with the beautiful, strange wonders of this stranger land. Yet!—they would be disappointed, because, the beauties are not all on the surface. To the visible eye only, often, 'tis but a barren waste. Ones soul must have a touch of something that is not always there; and ones brain, some knowledge more than is on the surface to be able to take in the real beauty. There is something in those clouds, and the stiff, cold wind that makes that swarthy Mexican look something he is not, against that creamy, back ground of rocks and sand: and Mt Taylor would not be the Mt. Taylor of this moment were the Mexican away and the glaring sunshine here.

Yes! the glaring sunshine tells a tale; just look at my hands! No poetry in them; regular clod hoppers, rasping, tools. Lime and Alkali are no respecters of persons[.]

Doing a great work in a country of few resources, among a primitive people is not all poetry by any means. Yet! there is a great deal of poetry in roughing it, and there is a tear also, a great, big unshed tear sometimes, and a heart ache.

Cheme Chetete says that your bow cord is too long. Indians in battle used them only four feet long. I will send your string soon. I just bought a turquois [*sic*] from Juanita a Navijo. She is to bring me a blanket. Lately I have seen the man who took me for a tramp; he looks quite embarrassed since he knows I am not a tramp and no more coal comes flying through the air.

Bueno Noche

To the Indians the Turquois [*sic*] is the most precious of stones because they say that it stole its color from the sky. They call it the spirit stone and it is the emblem of the soul.

Letter 30

MEDICINE DANCE
Jan 10th

It is past bed time but I must tell you of the dance. It was the last of the New Year's festivities and of the Governor's inaugural also a medicine dance or a prayer for the sick. I have just returned from it. It is the strangest thing of which you ever heard but really beautiful, graceful and dignified. These were all men. The dress is indeed picturesque and very similar to that at the fiesta of Acoma. As robes they wore deer skins (dressed), and from the centre of their belts in the back suspended were skins of coyotes &c. They did not look nude at all for the net work of paint looked like a covering of lace. [Crossed out: Their legs were covered and each carried in one hand a gourd rattle and in the other his bow and arrows[.] These are made expressive with gesticulations.] If there are sick persons they go from house to house to pray for their recovery.

I had asked Mr and Mrs Miller to accompany me. Gov. Shosemi had promised that I should come and that he would notify me when, but he took care not to do it and I started out to compel him to keep his word. We went to John Riley's house where we supposed it to be, but Mary said that she would not allow them to come there.[25] We went to another and found a man whom I knew; he took us to the house where a boy was ill and we heard drums and dancing. The Governor,

and the Lieut. Gov. Charley Kie who could speak English fortunately were there. Charley brought the Gov. out and we were told that he feared we might not like it, but he was willing for us to come. He said that they the dancers were naked. This appalled us and I asked if it were worse than the Acoma dance? Charley said "No"! I decided that I must see the dance.

Then another man came out and said if we went and did not talk in an ugly way or ridicule them they would let us go to others: that that was their way of praying to God and they did not wish to be talked about unkindly. We assured them that we came with no other than kind, friendly feelings and would respect their wishes. As soon as we were admitted to the large room (not where the invalids were) I saw several women whom I knew and one offered me a seat on her blanket which was spread on the floor. Mr. and Mrs Miller stood near the entrance, and soon the dancers filed in, keeping time to the thum, thum thum of their drums, which is the only music they ever have. [Crossed out: They are curious in the extreme made of hollow tree trunks with deer skin stretched over each end.] When they had gone through certain prayers they danced themselves out in order to visit more invalids. I wish that we could have gotten a picture of them. Wild enough they looked in dress but their faces were as grave as their dress was wild. Their prayers are not addressed to the great and living God but to the sun, moon, stars, sky, air, water or constilations [*sic*] generally.

Above the elbows were armlets of evergreens, a sort of Norway fir, some had heavy buckskins thrown over the left shoulder and bead necklaces about their necks.

On their heads some had evergreen wreaths or silk handkerchiefs, feathers &c. All carried bows and arrows trimmed with greens with which they gesticulated alternately with the gourds which they carried in the opposite hand. Gay and somber moccasins, fringed wool garters and fringed cords from their waists, skins of wild animals from their backs and many other garments and ornaments which I cannot recall helped to complete their dress. Indeed they were very much dressed, more dressed than nude. Many false things as well as true are said of the Indian. In every day dress the Pueblos are very modest and I see none of the shocking undress of which we read and hear. That feature belongs to another set. Really no objection can honestly be made to that dance excepting that they were not praying to the real God but to many Gods. These dances are gradually dying out; the educated Indians do not join them and there is a talk of abandoning them altogether. There is no doubt that within a few years, when the old Indians lie in their graves there may be no more feast dances.

Those who become Christians will not go near them; [crossed out: neither do the educated ones to any great extent.] As we passed William Paisano's house we heard him playing a hymn on his accordion. A strange contrast to the heathen dance in the next house! I would not have missed seeing this secret dance for a great deal. I say secret because no white person as a rule is allowed to see it. They came in in single file and formed in line around the end & side of the room. The clay floor was wet for about four feet from the wall to prevent dust. I could not help having some feeling of respect for them as they were earnest and true to their convictions.

Laguna N. Mex.
Tuesday—Jan. 16th 1900

Dear Em ___

To day I have again been to the ever interesting Cliff pueblo of Acoma. This wonderful mesa village had new charms under the shades of winter clouds. The rocks looked more beautifully

chiseled into odd shapes than before. I saw an immense hen on her nest and the turtle looked more a turtle and the upturned moccasined foot more decidedly a giant's foot of rock, and numbers more of strange, unique carvings. Of course all of this great carving is done by *erosion* but what ages it must have taken even as soft as they are for those rocks to have taken such shapes hundreds of feet way up in the air on slender pedistals [*sic*] as it were compared with the surrounding rocks, one a perfect head and face which suggested to me only a Diana. As we passed what I called Cathedral Rock which is really Window Mesa I tried to imagine what it might be like if it were three or four hundred years back and the gentle Pueblos were streaming all over those plains and climbing those seemingly inaccessable [*sic*] rocks. It was not hard to imagine it after the many feast dances I had seen especially the last one at night on January 10th. We had hard work to gain admittance to that dance. Gov. Shosemi had promised to let me go and so had Charlie Kie the Lieut. Governor.[26]

But I must get back to my Acoma trip. As we drew near the Enchanted Mesa the mud became so sticky that I feared we must stop. It was clay and made the wheels of the buggy look like huge waggon [*sic*] wheels such as no one sees in civilized countries.

But the Mesa Encantado absorbed our attention and we let the horse rest. Dr Lukens took me and I paid him the modest sum of five dollars for the trip. I saw for a certainty the spot where Prof. Libbey shot the rope with a stone at the end of it over the corner of a rock so as to enable him to scale the walls where no white man had been before and no Indian since the fatal rock became detached. After reaching the top he came to a halt because of a great opening of fifteen or twenty feet in the rocks. He sent to Acoma for a ladder which he extended across and on it 450 ft above the level he reached the other side. Dr Lukens was once with a party who ascended and he showed me the spot. But Acoma has a history too. It is real. It breathes and speaks and moves. Coronado the first Caucasian Soldier who entered New Mexico saw Acoma the City in the Sky in 1540 when the village was old. Now it has about six hundred inhabitants. As we drew near it the Enchanted Mesa fell into insignificance; arriving there we left our horse and buggy in charge of Juan the brother of the Ex Governor.

My heart during the ascent beat so violently that I was compelled to take frequent rests before we reached the narrow trail which is just wide enough to admit one person, and once more I climbed to Acoma. The Indians had helped the difficulty of climbing by making steps of stout twigs in places. The charm of that climb is indescribable. I longed for a shorter gown and the wind took my fur lined cape like a flag and wrapped it about my head blinding me in one of the most difficult footings; Fortunately I had my fingers firmly in one of the little notches of the rock.

James Miller a Carlisle Indian and his wife were with us each with a large bag on his head. Bright fine looking Indians they are. She is handsome and makes fine pottery.

They climbed with as much ease as I did with difficulty.

When we parted Leo Garcia another English speaking Indian joined us and took us to the Governor. Leo was an Albuquerque pupil. The Acoma women make the best pottery of all of the Pueblos excepting it may be the Moquis who are said to excel.—The Lagunas are very generous about this superiority of the Acomas and tell of it proudly.

I wanted to see Valerios Rock or Leap as it is often called, but had no time.[27] While the Spaniard [*sic*] were at war with the Acomas they were very hard pressed one day and a party of them wished to reach their comrades who were in sore need of reinforcement but, there was a chasm of about twelve feet between them. They succeeded in extending a log over it and some passed over, but one man in his excitement after he reached the other side forgetful of twelve who

were to follow pulled the log after him. There was no replacing it and the others were left to their peril. Valerio with wonderful dexterity made a marvelous leap back to their rescue. This is why it is so named. The Indians point out these spots with evident pride.

It was more profitable to travel with an English speaking companion who knew something of the country and habits of the people than it was when I went in the glare of the summer sun with the noted Mexican Quarta [*sic*] who was eager to tell us what we could not understand though it was infinitely more fascinating then and novel.

The sight of the great pillars of rock and the Enchanted Mesa recal [*sic*] the fact that in the old and dangerous times each one of the highest points was a sentinel's station. An Indian was stationed on each one and although the distances between were great the slightest cause of alarm was signaled from one to the other until it sped like a flash almost to the distant village. Many think that the sentinals [*sic*] were the only inhabitants that the Mesa Encantada ever had and that explains the presence of old pieces of pottery up there without a trace of habitation. I for my part accept the sentinal [*sic*] theory, but I am not a *wise acre*. How weird and monotonous it must have been to the poor sentinal [*sic*] four or five hundred feet above every body always watchful always on the alert to give the signal of the coming enemy. The news was carried on from mesa to mesa by these messages given so rapidly that the Acomas were on the defensive so soon that one can scarcely believe it until we are reminded that there are Indians now living about here who can run faster than their fastest horses. I wrote you in one of my letters that the Zuñis are the swiftest runners but I was mistaken for it is the Comanches- Then we must remember that objects could be seen at greater distances and a signal given more effectually in consequence. Good night

Bueno noche
I am tired.

Letter 31

Feb. 11th

I have six Navijo blankets, three are beauties; the others are only little saddle blankets. I have a lot of pottery packed in boxes and some silver beads and buttons. Some are made by the Pueblos but there are more silversmiths among the Navijo. I think I shall send them to you for should I die here there would be no one who would know what are mine. The blankets with the exception of one are real old fashioned ones made entirely of wool with the real Indian colors, red, black, white, yellow and blue. But way, way back there were nothing but white and black ones. They raise the sheep, shear them, card the wool and weave it into blankets on the crudest, most simply constructed looms. It is said that it takes them six months to make one blanket, but that depends upon many things. The little saw teeth beauty is of Germantown wool. I bought it because it represents the carvings on some of their medicine sticks which I found on the mountains. Thus far it is characteristic but in colors and wool not. I prefer the altogether Indian work and they are the most valuable. The large red one with black and white, square border I bought of Cheme Chetete the old warrior who wore it a year at least. [It is possibly the blanket shown being worn in figure 9.] It is a fine all Indian blanket. I would like very much to have one made of rabbit skins. But they are rare and very expensive. Before sheep were introduced among them they cut rabbit fur into cords, twisted them and then wove them into blankets. It must have required careful work for it is so tender—

Feb 26th 1900

The Governor interrupted my dinner and left hurriedly to look for an interpreter and has not returned. I hope he may not but if he does I will deliver your message which will delight him. Miserable fellow! A short time since he sent word to me that I must pay seventy five cents for a certain piece of work for which I had been paying fifty. My anger told pretty quickly what I would do, and I sent a message to him through his interpreter which was not stinted in the least. I told him that he had nothing to do with that; that I and no one else would regulate my prices: that I lived on rail-road land and the Indians had nothing to do with it, and if they did not cease troubling me I might sell the house to some store keeper and go away. I knew that they would hate this. They as a rule try to fleece me out of all the money they can; but white people set them the example. A woman never gets more than fifty cents per day. This is enough for usually they come late and seldom do a day's work. I employed a child about fourteen year's old doing some work for several day [*sic*], a few hours each day. She was very slow and I gave her twenty five cents per day. She was, nice, quiet and happy at her task. Her mother came one day and said "You do not pay her enough." I simply replied, she need not come again. In a few days the mother told me that she would like me to give Marie work again; but I did not. I served the men in the same manner. I mean those who needed it, for many are fine men and do their work as honorably as any man. I am learning to be tricky too, but I make sure that my tricks are just and honest. George Dailey and Frank Sihu are as fine men as can be found in this world and there are other good Indians. I wish that they could speak English! Frank is learning; he goes to a night school and I am told that he was a drinking man before he became a Christian. I must enclose a letter he wrote me. No! I will copy it.

"Seami N. Mex. Feb. 11th 1900

Miss Foard.

My Dear Friend as you wound think any thing what I am thinking about by this time as you said to me before I left the work down there you said to me you may need me any time you are ready for the dishes. yet still I never have forgoted what you have said to us. this is what I want to know because I am waiting to hear something from you and so is George Dailey is waiting to. As you know we wound promise if we arent sure we must not say so. but we must be sure what we say at first. but I am always willing to do for you any thing. what you want me to do fore you, and so just let me know it soon because it is long time I never hear from you any words. please let me know it if there is a work for me. This is all I want to say to you God be with you where ever you are. My best regards to you.

I am your friend
Frank S."

"P.S. Excuse me any word that I may have mistake."

Frank's wife really wrote the above because he cannot. I will copy one which Lillie Sione wrote she was at school five years I think.

"*Pahaute*"

"Dear friend Miss J. Foard[:]

 I am going to write to you just a few lines this morning. We are all well and hope you are the same. I wount to ask you to Please get me some lemons in the store or on the train this evening 15cts worth and if you can get it at the store sent it by this uncle that gives you this letter. An if not sent it by some one you see at the store from here an sent it by some one before Saturday that is if you get it in the Passenger to night it is cheaper in train I will thank you.

I am your true friend
Lillie."

 The following is from Lillie [*sic*; should say Minnie] Sice who has had greater advantages at Carlisle Pa.

"Miss Foard—Laguna N. Mex.

 Please will you pay me for carrying out that pottery and for making the clay for you. You promised to pay me when I do some little work for you again, but I don't come down often because I am sick. I was very sick Sunday and have been in bed till yesterday. I am a little better to day. I have to keep Etta for that reason she took care of little Margaret. I heard you are buying some pottery do you want to buy any of ours? My mother wants to no [*sic*] she making a lot.

Yours Minnie Sice."

The penmanship of these letters is beautiful. They are very anxious to learn and James Hiowa often brings letters and books asking me to explain them. He said that he could not come to work one day because he had to do publican works. What do you mean James I asked "Why! ditches, roads and such things." I explained public to him; he asked me to spell it but poor James still says publican works but said with delight "I learn something new every day." Frank and George Tyria speak their pleasure with their great, expressive, brown eyes and smiling lips as they know no English. Some times when a great pleasure carried them away they have a peculiar expression which sounds like "Chee-chee-che, tete-getete" away up in the key of G. Nothing can describe it on paper. Living among the Indians is very different from visiting them. We soon learn that they can be merry and give vent to their pleasures as freely as we, but at the same time their self control is wonderful. I wound up my Alarm clock one day and placed it on a table near Frank. I know that he had never heard one. When it went off I started, but he never moved a muscel [*sic*]. I was watching him; he did not even move his eye lids.

 Gov. Paisano's family are very polite and generous to me. Mary often gives me a loaf of bread and melons, and the wife of Ulyses sent me some nice meat. This is to be appreciated I assure you. The Church Mission House in New York kindly snds [*sic*; sends] me some illustrated monthlies. I keep them as a sort of Circulating Library. The Indians like them greatly, even those who cannot read. Martin Luther and his wife and many others show the good training which they got at the U. S. Government School at Carlisle and other places.[28] It shows throughout the whole Pueblo

country. Martin patronizes the Circulating Library. One day he returned the books he had and said, smiling, "My wife she say get another because she say she like to read them, she say, because get more." "We sit up at night and read them." Martin has a good position as Section Boss of the A. T. St. Fe R.R. at Cubera.

March came in like a lamb. We Mrs Miller and I went to see the pretty pueblo bride Lillie Kie. Fred and she were married some days ago. She blushed all sorts of colors, smiled and looked prettier than ever. One would imagine it scarcely possible to see the blushes of so dusky a bride but we did. We stopped en route to see an old woman fire her pottery. 'Tis a pity that they drag it out to the cool air while it is still red hot.

Mrs Miller hurried home to her tea, leaving me to see the ending, when the belated Limited came flying by. I ran to see it and stood upon a high rock so as to look down into the carriages and at the passengers at the end of the observation car.

All were looking for Indians among the ruins of the old, castle like town; instead they saw amid the strange surroundings a lone woman wrapped in a fur lined cape looking like a diminutive Liberty, or may be, a "pigmy perched on Alps—" My only idea was to get a glimpse of people looking like home; two thousand miles away off in the east. Suddenly from the end of the observation car a hat was lifter [*sic*], then another, and another, and another, until at last as they rounded the curve, hands, hats, and handkerchiefs of men and women were waving me a farewell. It was like a gentle breeze with a ray of sunshine and I ran lightly down the slope eastward to my adobe home, while they, sped westward: Who knows where? But in their wake there were ripples of light glinting in the sunset rays and I slept well with the pleasure of it.

INDIAN LETTERS
Mar. 24th 1900

Miss Foard.
Dear Friend your letter was handed to me just this evening. I am very sorry for it came very lately as it should to be. tomorrow is Sunday. well do not be disappointed for that but I will any time and so let me know it again. what day I will bring wood because I said to you before I am always willing for it any thing what you please. well I will take this letter to you by myself, because I am not tell you with my lips as you know I cannot talk English very well, but I understand a little. well this is all I can say good by. God be with you always.

Frank S[ihu].

Mar. 25th

My Dear Friend
Last night I heard that you want to bring some wood. I didn't hear soon that you wanted But I shall bring day after tomorrow.

I am your friend
George Tyria

April 1st

Indians have energy enough if you get them started. Friday night James Hiowa worked all night and I was up too of course. I shall not do that again. If I had not done so our work must have waited some days because James said "I and all the men must work on publican works." He did not get sleepy once but of course he was busy. I carried a revolver with me every time I went from my room to the work shop. I showed it to James and he pointed to his own which was on the table saying "So many bad peoples round," adding "when Mexicans or bad peoples steal Indians' horses or cows, Indians go very quiet in one house, tell it, come out, go in another house, come out quietly until he been in all houses. No body hear any thing, no body make any noise, all quiet.

After while a door open, then another, and another, a great many doors, no body speak, but one man go off, hide behind stones, another hide farther off until there will be an Indian here, and an Indian there, great many Indians scattered all about hiding. After while the man steal horse come, then Indians make no noise but catch the man." The inference was plain; that thief was never seen again. 'Tis the only redress for the poor Indian. Who blames him?

Letter 32

April 3rd 1900

I am planning to leave here as soon as possible. I am very nervous and my strength seems to be leaving me. Every one says that it is the altitude and all the white people complain just now saying that no one can stand the Altitude long; but I think that is on account of the lack of nourishing food. No ice is to be had and in warm weather it is difficult to get or keep meat, in cold weather it can be kept a long time. The great trouble is people are grasping and will not go to the expense of sending to Albuquerque. I have done so since I began housekeeping and found it not near so expensive as boarding. I hate to leave the work just on the eve of success, and after I have gained the confidence of the good Indians and every point of importance excepting the price of clay and wood which are unnecessarily expensive. But if I become ill it may take a long time to recuperate. I will try to get some one to take my place. I shall not leave for three or four weeks. Miss B[ingham] has invited me to sup with her on chicken. I have a nice little Indian maid to work for me. I would like to bring her home with me. If her grandmother should die she and her sister would have no one upon whom to depend although the Indians always care for those in need. Their father is the man whom their step mother murdered very soon after I arrived here. They look like twins. Annie would like to go home with me but her grandmother will not even allow her to go to the Carlisle school. She is a widow and Annie is her main stay. As there is no man in the family the cousins and nearest relatives bring wood and other necessary articles when needed without their asking for them. It is a matter of course.

The weather is now almost as warm as though it were August, but August here is not as warm as in New York. We never suffer from heat unless in the sun.

Saturday, Aprl. 7th

There were very few on the California Limited to day. The Indians filed down with their tinajas and smaller pottery, old Cheme Chetete bringing up the rear with his tawdry bows and arrows and

a bag full of arrow heads and turquoises. His grandchild was on his back held closely by his blanket, drawn up so as to form a pouch. His old straw hat with eagle feathers made his wrinkled face just a little more noticeable than it otherwise would have been. Some persons on the train threw pennies from the windows and the children scrambled for them as though they were treasures; in reality they care not for a copper unless it serves to make a trinket; a nickel thrown was a treasure. I sauntered amid the crowd having a feeling that some familiar face from the far off East might turn up; but never a face appeared and I left humming to my self

"Then row, row, row, your boat

Gently down the stream

For all that is past is gone you know

And the future's but a dream.["]

But it was the present after all which was the dream and as I got out of the hearing of the crowd I sang out clearly to myself and was surprised for I had been occupied with others affairs so long that I had not thought to sing. At lunch time a man from Seami brought a load of wood and I gave him a dish of wine jelly with custard over it. I took a mischievous pleasure in making it look as dainty as possible. Placing a silver spoon on it I carried it out and sat it on a log calling his attention to it. He could understand no English but most Indians know a little Spanish. His whole face beamed with pleasure and he said "Mucho *Gracias*" so sincerely that it made me glad.

Spanish is the language every where. It is even the language of roosters, they come out boldly and clearly with "Poco Bueno." It is a positive fact that the Plymouth Rocks which are brought here from the east do not say poco bueno. It means little good or not worth much and when something about our work is not doing well it is rather discouraging to hear poco-bueno almost in the very doorway. And often from there it will be carried, one by one, a way off in the distance. Poco bueno, poco bueno, poco bueno, poco bueno—poco bueno until it dies like a whisper. and you feel it is no use, even the chickens say so, then you will wish that those miserable roosters would crow in English instead of Mexicano.

One day the men were all at work on the roof and George came down for some clay. I said, George that rooster says poco bueno. He smiled and mounted the ladder. At the top I heard him telling the others and it was followed by peals of laughter. Since that I frequently hear a man calling poco bueno when he hears a rooster crow.

L.

Letter 33

Palm Sunday Aprl. 8th

I was told weeks before that children would carry leaves into the church to day. They seemed to have no idea that it was Palm Sunday or why the leaves were carried there, so I made it my pleasure to tell James and every one whom I met about Christs [*sic*] triumphal entry into Jerusalem. They liked the story and were pleased that they were doing a thing that was in the Bible and that of which I approved. Even Gov. Shosemi looked happy, at the same time he knew all about it. He always does if you mention the Bible. I also know how perverted all of their ideas are. The mere fact that I did not come as a missionary seems to rivit [*sic*] their attentions a little more readily than it otherwise would.[29]

On Friday Mar. 30th while we were working, as usual there were some loafers. This always annoyed me but I tried to make the best of it and had James [Hiowa] read Bible stories while I explained them. John Riley was one of the loafers and he became greatly interested: his eyes were an inspiration as they grew tender with sympathy.

This morning I attended the Indian (Roman Catholic) services. As soon as I got fairly into the pueblo I saw two small boys carrying branches of trees on which were tied paper flowers of yellow and blue. The smaller boy looked remarkably cute and interesting as he walked beside his brother both wrapped in Navijo blankets of the gayest weave. I was hoping that the whole church full might be as picturesquely attired; but shawls of all hues were there. Two little girls wrapped in jet black shawls were an odd contrast to the gayer ones. Gov. Shosemi met us at the door and gave each one branches of Norway fur [*sic*] from Pahaute. He looked rather sheepishly at me and hesitatingly offered a branch. I took it with a smile and a thank you which reassured him. He has a winning, childlike expression when pleased.

Two white men gave me a seat near the door and were earnestly interested when I told what the branches meant. While I sat there looking at them as they filed in, sometimes singly, sometimes in groups I noted as I had done before the Altar and mural decorations. About twenty candles were lighted and they enhanced the richness of the chancel and altar colorings. Each Sunday the women who are expected to bring candles are notified by the Chief man who acts as a priest when the real priest is not there. He is there only once or twice each year. The ceiling and walls of the chancel are richly painted on buck skins. The painting was done before it was mounted and was as smoothly hung as paper on our drawing rooms. It is all Indian work excepting the figures which were the work of Spaniards and Mexicans. One is the figure of Christ with the Cross on the way to the Crucifiction [*sic*]—This was a reredos. The Virgin and Joseph with the Infant Christ in his arms were on either side of the Altar. San Jose is the patron Saint of Laguna and their feast dance comes in September[.]

There is much wood carving rudely done with stone hatchets. All of the coloring is done in rich, dark reds, blues, black, and white. The walls are painted with a sort of dado, each painting representing something. For instance water, clouds, rainbows, steps, birds with branches or leaves about them. The colors are always the same dull ones repeated, which they get from the mountains. The Pueblo Indian has in his native mode of lifeing [*sic*] literally no expense that is he can live without money or the aid of white man if he consents to live as he did five hundred years ago; a heathen. They never fail to tell you that certain things cost so many horses or cows, sheep or skins. The Laguna Indian's name for buckskin is denna. As I studied the church architecture the church itself was being filled. Women carried white cloths or large handkerchiefs and carefully spread them on the floor upon which to kneel. Some of the men did also for the floor is of earth. The women occupied the left and the men the right of the place. A group of men knelt near the chancel, all wrapped in gay blankets. They did the chanting and responses. The principal or chief man soon came, and went straight to the chancel. He was in his shirt sleeves and had a blanket wrapped about his waist.

All of the children carried branches variously decorated; pictures cut from papers, many were advertisements. One I noticed was a biscuit advertisement. Some suggested valentines. I tried my best to sketch a little tot about six years old with his Navijo blanket, but he stood still about two seconds at a time and I gave it up. The chief man spoke in a sing song sort of way, like a gig song. Part of the time a woman was beside him who wore a black shawl. Gov. Shosemi looked very unofficial as he stalked about driving out dogs and distributing branches, looking happy and not important.

One man looked ancient and artistic in leggings of orange color, and fringed garters of red to set them off, not forgetting his handkerchief of red silk put on like a wreath, though many men wear these. His Navijo blanket helped to make him look like a figure of the long ago of which we read.

Just above me was a swallow's nest of mud which helped to attract ones attention to the ceiling of angular layers of round sticks painted in the usual colors. Edith Paisano a little Protestant spied me and like a dart she slipped to my side and sat here with such a satisfied air that I drew my fur cape about her. She glanced up to my face with winning confidence and I soon took her little hand and led her home. I was hoping to have a quiet time to dine and rest before the evening Missionary meeting which I always attended when there was one at three o'clock; but as dinner was nearly ready a knock came which was unmistakably Indian, gentle but decided. It proved to be Frank Sihu and his friend from Seami who had come in order to attend the meeting. These visits are very trying, long and tiresome even though they are fine men.

My little Annie Menaul [her maid; she also calls her "Lillie Menaul"; see figure 6] always wants to go to the meeting with me and I took her to day. There is a nice feeling between me and my little maid. At the close of the meeting the Missionary asked that any one who would like to become a Christian would hold up his hand while we sang a hymn. I looked around and saw that in the back part of the room a great strong, young fellow was holding up his hand. There was no doubt about that; it was up as high as he could get it, straight up in the air and his eyes were wide open, earnest with hovering tears. It had taken an effort one could see. He was invited forward and all in the room came up to welcome him to the fold.

This was a little too much for him and he half hid his face with his blanket and dared not look. When he reached the platform the tears came. They gave him a solemn welcome, some embraced him, even the young men did this. When it was all over and the meeting dismissed I went to him again and saw that the tears were gone and that a glad light had taken their place. I came home hoping that I might now have a time of rest, but just as I was nearly done with my supper one of those dreaded knocks came. The Governor and James were there. I tell them so distinctly that I do not want Sunday company. If they do come I make them listen to a Bible teaching, so the Gov. had to listen also. He said that he liked it and told me some of his views. He startled me by saying that the grave of Christ was in front of the church here, and that on Easter morning he burst open the grave and came into the church. I was so shocked that I said nothing, fearing that I may have misunderstood. They also think that Wednesday in some way takes the place of Good Friday.

One little maid said "The day an Indian dies, the family bake bread and the next day they feed the corpse." She innocently added "I don't know why Indians do that," just as though she were not an Indian. She had been away to school and had learned differently. I have some interesting medicine sticks which we found on the mountain. At certain seasons bread crumbs and bread made to represent human beings, and other animals are placed in secluded places on the hills and in the cemetery in order that the spirits may feast. Sometimes they are placed in nice large jars made by the Indians[.] Others are placed in an enclosure made by sticks cut in different shapes and often feathers tied with them- These are medicine sticks. I was fortunate enough to find some and will bring them home with me. In Arizona there is a Sacred Lake. Souls of departed Indians appear there. Four days the doors of graves are open, the spirits rise and float above the lake, voices are heard. Friends communicate and talk with fathers, mothers and other relatives. After having left food for the spirits on their journeys they go away satisfied. This is the custom of the Moqui-Indians.

[Crossed out: One little educated Pueblo was very much persecuted because she became a Christian. Her chickens were killed and thrown near her house.] During the fall and winter of 1898 small pox raged among the Pueblos. A child died and was buried near the corner of its mother's home. One little, educated maid objected because her small cousins must pass the grave on their way to school. There were hot words the mother declaring that the child was on its first stage of its travel to the spirit world, and after the fourth day she would reach the end of her Journey consequently she could do no harm as she would not be there. Weeks after the mother complained to the little maid that her cousin's ran over the grave of her child. Our maiden retorted "Why, you said that she had gone to the spirit world on the fourth day. What harm can it do if she is not in the grave."

Aprl. 15th

Your letter and the delicious Candy came at the same time. Very many thanks! To day is Easter and I have been eating Pennsylvania candy all day and have enjoyed it hugely. Yesterday I dyed ninety eggs. Last night and to day I have been distributing them to old and young Indians, explaining their significance. All were the more pleased that they represented the resurrection. I have another Indian blanket at wholesale. A man from Chicago ordered eight hundred. I needed wood badly and told men to bring it, They would say "Yes this week," but none came for a month when four loads came at once,—yesterday. I am actually coming home. I am very tired but dislike to give up this work. On the table is a lovely white rose from California and some orange blossoms. I have not seen a rose until to day for one year. Mrs Miller sent it me. I fear that I cannot get a blanket for you at your price unless I get a saddle blanket which is nice used as a small rug. [Crossed out: I am glad to say that there is not much drunkenness among the Indians here. Whiskey is not allowed to be sold.] The Indians wash blankets beautifully. Minnie Sice washed mine. She says that they always wash new blankets as soon as they get them. I bought from the Indians some turquoises in the rough. I shall have them dressed with the matrix left in. I like the idea. Tiffany's mine is between here and Santa Fē. Turquoises are expensive because they are difficult to get from the mines.

Thurs. Aprl. 19th 1900

Just one year ago to night I came to Laguna. Not many minutes have been wasted; and although I am on the verge of nervous prostration I would not part with one of those moments. Something within me is capable of a more thorough, a more intense pleasure than ever before. My eyes are opened to many things and I know to a certainty that there are good Indians who are not dead ones. I know that there are beautiful Indians outside of poetry. Longfellow was more than imaginative, he was true. Among these gentle Pueblos I can show you handsome men and beautiful women, and I can show you one woman who is both handsome and beautiful with a dignity that is Queenly. She is the sister of pretty little Lillie Sione. One day I said, Lillie Your sister is very pretty; very much pleased she added "Every body says that." But these beauties do not frequent the rail-roads. They scorn the idea of selling pottery on the cars. If they make it they send their brothers or husbands to do the trafficking. There is a decided aristocracy among them and they are as proud of their ancestors and their good deeds as you and I are of ours.

Letter 34

April
Sunday—22—1900

There are a few minutes before going to the missionary meeting at the school house and this may be the last time I shall write you from Laguna. I secured a beautiful saddle blanket for you.

–Evening–

I have returned. A young man was baptized and taken into the body of Christians. The odd part is that all his friends, even the heathens, went up to welcome him as a Christian. I was astonished at being called upon to make a farewell speech. I did it, ending with advising them not to sell pottery on Sunday. In March we had warm weather, now it is cold. In the box I will send some piñon nuts. This sort of nut is small but rich and has saved the lives of Indians during times of famine.

Could you get a glimpse of my busy, strange life you would not wonder that I do not find time to write. I have caught up a little lately with my correspondence but there are many interruptions with which to contend I can scarcely write intelligibly. For instance just now I have dismissed a troop of boy dancers. A knock came; being night I asked who is there? A little voice answered "Indians." The broken English was pleasant to hear. They were painted so grotesquely that I pretended to be afraid, but the poor, little fellows did not understand, looking so serious that I desisted. Although it is Sunday night I permitted them to dance. There was quite a crowd, but only six danced. After it was over I called an interpreter from outside and told them that they must not come again on Sunday. They can scarcely understand this because their dances are devotional. If they are ill or want rain they dance; their thanks giving is a dance. Since I wrote the above there has been another interruption. Notwithstanding I tell the Indians and every one that they must not come on Sundays they make every excuse to do so. Just now it was James and the Governor. Their excuse was that Shosemi had a letter which the interpreter (James) could not read correctly. I explained it and to my comfort off they went. My house is too convenient, but I like to help them when I can.

James has a very inquiring mind and will come every day if I would permit him. I have turned him away many times. One Sunday before dark he knocked and when I opened the door he did not hesitate but entered with an air of, I am doing the right thing now. Before I could protest he said "This is Sunday and I brought my Bible to learn God's word." He is not a Christian but he knew that I would never refuse that. I knew well enough that it was only a ruse of his to gain an entrance. He knew also that there was a Missionary here for that very purpose.

Mr. and Mrs Miller and I took a twilight walk through the pueblo and we could not help remarking that the Indians have some, urgent, secret, meetings of late. They frequent a certain white man's house. I suggested that it might be on account of the threats of another man to bring soldiers here if he were molested. On the other hand it may be on account of the murder at Acoma. This murder occured [sic] a few days ago.

Tuesday Apr. [24th]

I have heard since that the secret meetings were [on] account of the sick Mexican across the way. [The] Pueblos do not like to have them there fearing that they may have some contagious disease. It is said that they were incited by a white man who hates the doctor whose patients they are. Miserable frauds! They would do nothing to prevent the spread of the small pox and now make a fuss about a poor nervous woman whom they may see walking about any day.

Letter 35

[Letter from Josephine Foard to her nephew, Charles Berghaus,
in possession of Mrs. Millicent Berghaus]
Sheridan Lake
Colo
Sept. 6th 1914

My Dear Charlie:
 [A portion of the letter has been cut away at this point]
 Little Kysfeeya is much interested and asks all sorts of questions. I spoke to him to day of a Minister's being a Servant of God. Immediately he asked "if Mr. Charlie was his servant?" I replied Yes—And his countenance fell—because of the word servant. One day I was throwing rags in a pile and he said "I am afraid of Consfanious [sic] Combustion. Is your church rich?" Little Kysfeeya's mother is poor and she wants him to go home. You probably do not know that an Acoma Indian shot Kysfeeya's father last winter, this leaves his mother with no one to help her and the children need clothes and many things. She has land plenty but must depend upon her relatives to cultivate it. And that costs money. She has a son about 14 years old who can earn some money but not much. Kysfeeya could not earn money and if he went home it means that he must give up school and forget all that I have taught him as no white people live near him so I am hoping that I can induce some white people to send me some money so that the poor woman can clothe the children & feed them while Albert can herd sheep &c and earn something. Then Kysfeeya could stay here and go on with his studies being no expense to his mother. Four or five dollars a month would be enough as she has her house and some grain each year. She grinds her own wheat for flour when wheat grows. Last year she had none as there was a drouth [sic]. Her husband was a good worker. She is a good woman and has 7 children but only four at home. Two at a Government School and Kysfeeya here. Albert was at a Government school but had to go home to help his mother when his father was shot. If your people could & would give a little toward helping I will try elsewhere to get enough to be sure of one year at 4 or 5.00 a month. Then I might get a box of old clothes sent. The oldest child at home must be about ten years old and three younger. Indian women are not lazy. Poor Albert had only two years at school and Kysfeeya can read & write better I think. He could help his mother with the work at home but if she were relieved of the anxiety of money she would do without him and I want to keep him. He is bright and learns well. I will write her tomorrow that I will send her money trusting that I may get it. When I told him that his mother wanted him to go home he began to cry and said "I wish that my mother would not say to me come home." He is a funny little fellow. A year ago he heard that a

woman was married the second time. He said "Why Mr. Cuffee has a second hand wife?" I explained about the clouds. He thought a little while then said "The clouds are pumps—they pump water up and they pump the water down." You want a good old fashioned letter. That would be canoing [*sic*] on the Susquehanna river or climbing hills looking for bird's nests, sketching & painting a Cooks [?] nest or going at dawn to see the birds rise over a swamp but the new is such a contrast—for instance to day I went with little Kysfeeya to the field to get corn and fodder for the horses. After he had tied two sacks of corn on old Sol—*the Burro* (alias donkey) I told him to go for the cows while I took the burro home. Such a picture out does Mand Müller raking hay. I put the rope on my shoulder and led him home and longed for a camera for Sol is a pretty fellow.

There are no hills here just rolling planes [*sic*] & ridges. One day or part of one nothing to be seen but an expanse of level prairie grass or snow covered. Not a drop of water even in a gutter. We go to town in the morning seeing nothing but grass—we come back in a few hours and rivers of water are as placid as glass. The horse, barns, stables every thing reflected in this water. When I go to bed at night there is not a house to be seen nearer than near two miles and never has been but in the early morning at times right on my own ground and in my own field a house has sprung up in the night. I turn to look back of me and wonder at the Army barracks two miles away—there were none there the night before then I turn back to look at my field and low behold it is empty. The house has disappeared and nothing but the grass or bare ground to be seen. At other times great lakes are as enticingly distant that one longs for wings to reach it; in a few hours it is gone as are a forest of trees which prove to be a herd of horses. Such are the wonderful mirages of this strange prairie. Even more wonderful things are to be seen. Thank your mother for the check. This is an expensive time and I appreciate her kindness.

This morning a great river took houses away that I had never seen before and in 15 minutes nothing was to be seen but my green field of grain nearly ready to cut. But of all the healthy places that I ever heard of this exceeds—the air is pure and distances are great to the eye. I hope that some time after you are married you and your wife may come and enjoy it. Love to your mother & you.

Affectionately
Aunt Joe
J. Foard

I never thanked you for the photo of the church (Easter) it is beautiful and I was glad to get it.

Letter 36

[Letter to Former Gov. Le Baron Bradford Prince
(New Mexico State Library, Santa Fe, LeBaron Bradford Prince Papers,
Accession no. 1959–74, Box 14020, folder 16, "Notes on Pueblos, 1906–18")]
June 8th 1906

Dear Gov. Prince:

I thank you very much for your reply to my inquiries about the Congressional District. I would have acknowledged your kindness earlier had I not waited to make inquiries about the

school books of which you asked. Mr. Pradt who knows all about Laguna says that there were more printed, that D[r] Menaul had a song book for the church meetings printed and a catechism also in the same binding but that he himself nor any one could translate it. The only way D[r] Menaul could read it was because the English was on the opposite page. In fact it was not Indian at all but a corrupt Spanish. He preached to the Indians in the same language and the poor Indians did not understand a word of it. This Mr. Pradt says was the only book printed here. I wish that it were otherwise. I do hope that you may get to Laguna some day soon. It will give me great pleasure to show you the sights. The Indians gave me a warm, gentle welcome. No attempt at kissing I am happy to say, but many took me in their arm and put their heads on my shoulder. You know that after I left here I was trying in New York and else where to awaken an interest in Indian pottery. This I did at my own expense and at last it looked as though it might work if I only had more money to put in it and some one at this end who was competent to attend to it but I could not afford to run it alone and appealed to Commissioner Leupp.[30] The result is I am here under more favorable circumstances than before because I will be permitted to leave when I see a necessity, both to visit other Pueblos and get a greater variety of pottery and go east and west to establish sales; then I may select an Indian man whom I will instruct to glaze and carry on the business when I am absent. This is a big work for me with much self denial but I am in it with all my heart. Mr. Leupp was here a few days since and I like his way of looking at Indian industries—When you come I hope that you may help me with ideas of things and suggestions. Remember me kindly to Mrs Prince, please.

Yours again with thanks
Josephine Foard
Laguna
New Mex.

APPENDIX TWO

Foard Correspondence with the Office of Indian Affairs

Letters 1a and 1b

LETTER 1a
Department of the Interior,
U. S. Indian Service,
Pueblo and Jicarilla Agency,
Santa Fe, N. M.,
May 31, 1899.

Miss Josephine Foard,
Laguna, N. M.

Madam:

Referring to your communication of the 30th instant, you are informed that all the land in the immediate neighborhood of Laguna is the property of the Indians as stated in the letter from the Hon. Commissioner of Indian Affairs except:

"Beginning at a point 72 feet westwardly from the center of the main line of the Santa Fe Pacific Railroad, and 75 feet northwardly from Robert G. Marmon's north fence: thence N 32 15' E., on a line paralell [*sic*] to the railroad, 21 chains 47 links, to the northeast corner which is a mound of stones; thence N. 57 45 W., 15 chains to the northwest corner which is a point; thence S. 32 15' W., 21 chains 47 links, to the southwest corner, which is a point; thence S. 57 45' E., 15 chains to the southeast corner and place of beginning, containing 32.20 acres, more or less."

The above described tract was reserved from confirmation and is therefore Government land. The remainder of the land described by the Hon. Commissioner is the property of the Indians and this office cannot give authority outside of the land above described. My information is that your location is on the Government land, but it may be erroneous.

I have written to the Governor of Laguna advising him to offer no further obstruction to your work.

Very respectfully,
N. S. Walpole
U. S. Indian Agent.

LETTER 1b
Laguna N. M.
June 2nd 1899

The Hon. A. C. Tonner,
Dept. of the Interior
Washington D.C.

Dear Sir:

I thank you for your kind reply to my inquiries in regard to the land on which to build our kiln for improving the Indian pottery. I immediately wrote Mr. N. S. Walpole and enclose his reply. Will you please return it to me at an early date as it may prove useful to me? He is correct in stating that the site I selected is on the Government land. Col. Marmon, and Robert G. Marmon and Major Pradt who assisted in the survey in 1898 all said and do still say that this rock opposite the station is a part of the Government reservation. If the Government will give me permission to build there I shall be safe from trouble[.] At the same time I want the Indians to be willing to have it there. They are a courteous law abiding people with many peculiarities and when to day I went among them and met the Governor and read them part of your letter I was touched with their gentleness. The Governor said he would call a meeting soon and put the matter before the whole Pueblo. I then showed them a piece of their own clay which I had glazed and told them that I wished to show them how to do it.[2] They showed their pleasure in their eyes and the Governor asked me to allow him to show it to his people[.] I gladly gave it him and came away feeling that your communication and the glaze had gained a great point in favor of the pottery. All I want is a right to the land a legal right. Some one said "Go on and build your kiln and make the Indians think it is all right." That I will not do. They have had tricks enough and every thing I do must be honorable and straight forward. If I make mistakes it will be my misfortune not my will. If I still find any real obstacle to the building of the kiln I will simply instruct them in improving their on [sic; own] primitive methods and go to some other Indians with my kiln and visit these again at intervals. But I feel that things will go smoothly now and that the kiln may be built. Will you please let me know that I have a right to build there as it is Government land?

Yours very Respectfully
Josephine Foard
Laguna, New Mexico

cc Rev. C. E. Lukens

Letter 2[3]

Department of the Interior,
U. S. Indian Service,
Pueblo and Jicarilla Agency,
Santa Fe, N. M.,
June 5, 1899.

Commissioner of Indian Affairs,
Washington, D.C.

Sir:

Referring to Office Letter of May 25, 1899, Land 23138–1899, I have the honor to state that Miss Josephine Foard desires to build her kiln on a portion of the land reserved for school purposes and which does not belong to the Indians. When I was at Laguna about a month ago I looked over the location and authorized Miss Foard to build her kiln on the spot designated, but with the distinct understanding that the kiln when completed and put into operation should become the property of the Indians. I also explained to the Indians the advantages to them of the new industry, substantially as contained in above mentioned Office Letter.

Since receipt of said letter I have again written to the Governor of Laguna setting forth the advantages and asking him to offer no farther objections.

Very respectfully,
N. S. Walpole
U. S. Indian Agent.

Letter 3[4]

June 14, 1899.
N. S. Walpole, Esq.,
U. S. Indian Agent,
Pueblo and Jicarilla Agency,
Santa Fe, New Mexico.

Sir:

Enclosed herewith please find a communication dated the 2nd instant from Miss Josephine Foard, of Laguna, New Mexico, who makes application to have a certain tract of land reserved to her on which to build a kiln for the purpose of improving the Indian pottery.

I shall be glad to have you look into the matter and advise this office of your views and recommendations in the premises, returning the correspondence with your report.

Very respectfully,
G. Tonner
Acting Commissioner

Letter 4[5]

July 13, 1899.
N. S. Walpole, Esq.,
U. S. Indian Agent,
Pueblo and Jicarilla Agency,
Santa Fe, New Mexico.

Sir:

The office is in receipt of your letter dated June 30, 1899, returning a letter by Miss Josephine Foard, dated June 2, 1899, which had been sent to you for report. You say that you have several times given Miss Foard permission to build her kiln on the Government land described in your letter to her, which she enclosed with hers to this office, but with distinct understanding that the kiln, when completed, should be the property of the Pueblo Laguna. You recommend that permission be given her to build her kiln upon this land under the conditions and with the understanding just mentioned.

It now appears to be quite definitely settled that the rock elevation near the depot at Laguna, which Miss Foard desires as a site for a kiln in which to fire Pueblo pottery is within the 32-acre tract which was reserved by the decree of the land court referred to in office letter of May 25, 1899, to you and given to the Government for school purposes. Although advised by you that she might use the ground referred to, Miss Foard seems to desire authority from this office. From your reports, it seems that there can be no objection to the use of said ground for the purpose indicated, and in view of your recommendation, I have to direct that you advise Miss Foard that she may erect a kiln thereon for the uses above mentioned, but with the distinct understanding, however, that no rights are to be acquired to the ground and that the privilege conferred may be revoked at any time when the office may deem it desirable.

Regarding your statement to Miss Foard that the kiln, when completed, should become the property of the Laguna Indians, I would state that if the ground is the property of the United States as you say, the kiln, when completed, would also be its property and not the property of the Laguna Indians. I deem it desirable to note this point in order that the Indians may not acquire an erroneous impression as to their rights within the reserved tract referred to. You will advise Miss Foard and the Indians accordingly. Of course, the kiln itself is of no use to the Government and so long as its use by the Indians does not interfere in any way with the use of the land by the Government for school purposes, there will, of course, be no objection to its use by the Indians in firing their pottery.

Very respectfully,
W. A. Jones
Commissioner.

Letter 5[6]

Waverly N.Y.
Dec. 22nd 1900
Dept. of the Interior
Office of Indian Affairs
A. G. Tonner, Asst. Com.

Dear Sir:

In reply to yours of Dec. 18th I scarcely know what to say. I have very little pottery that was made under my supervision. I gave the best of it away. Although our kiln worked beautifully we had not accomplished much when my health failed and no one could take up the work. The Indian pottery was so imperfect in most instances that it was hard to glaze. As we did not want to change the Indian character of the ware I only attempted to get them to make it stronger and glaze it on the inside, leaving on the exterior that artistic, dull effect peculiar to the Pueblo Indian pottery. I was succeeding slowly in getting better work. Those gentle Pueblos have more sturdy worth than is given credit to them. When they once grasp an idea and are convinced that it is right they can as a rule be depended upon if dealt with fairly, but very few of them had learned that they must change their method of clay work. That required time and I am hoping that we may reopen our pottery next winter as my health is quite restored. I would very much like to have an exhibit myself and be in Buffalo to draw attention to its merits and demerits. I could make a very attractive thing of it. I would have a few Pueblos there making pottery and a room ah la Indian [*sic*]; blankets and all. No one understands the merits of their tinajas as well as I and no one appreciates the wonderfully artistic beauty of the Pueblo pottery decorations more than I. But to make it attractive I would be compelled to add some of the ware with which I had nothing to do. I have just returned from New York City and was surprised to see while there so little of this beautiful pottery even in the museums. I have some beauties and can get more of it, but I do not trust to others packing it. I feel that every house should have a piece of it[.]

P.S. Miss Sybil Carter who is one of our Pottery Committee will I am sure let me have two small pieces which I gave her only a few weeks since. Have you one of the huge bread tinajas? They are to me the most curious of all their pottery because of their size. I have none but you might be able to get one excepting that I do not know a person capable of packing it safely. I could do it I think if I were there. You would have to pay two or three dollars may be [*sic*] more. I know of but one person who has one; much too large to go in a large barrel, in circumference I mean. J. Foard

[page missing?] because in the not very far future it must grow scarce. I would like to have the exhibit at Buffalo simply to bring the work to the notice of the public, but the few insignificent [*sic*] pieces which I may be able to collect from those to whom I gave them will make no showing unless I were there to bring them to the front. But I fear that the expense of it may be more than I can manage. Under the circumstances if I can collect enough to answer your purpose and you think it worth taking I will do my best to forward it. I wrote to Mr. Albert K. Smiley our Secretary and Treasurer [of the Indian Industries League, Boston] and the originator of the idea of the Pottery plant and asked him if he would lend me the pieces of pottery which I sent him. All of the pieces are small. If I send them I suppose that you will allow my name and our pottery to be placed on the collection? I am pleased that you intend to ship directly to Buffalo. I am good at packing and do not like the idea of any one else handling my precious pottery. How much time will you give me before I answer definitely? Would it be too late early in February? I may be able to do so sooner. I will as soon as possible either describe it or make a drawing or photograph and send you[.]

Yours Truly
Josephine Foard
437 Park Ave.
Waverly N.Y.

Letter 6[7]

Waverly N. Y.
Jan. 21st 1901
Hon. A. G. Tonner
Washington D.C.

Dear Sir:

I must beg pardon for not replying earlier to your last communication in regard to the pottery. I defered [*sic*] it hoping that I might receive some of the pottery for which I wrote. I fear that I shall not get it and must depend upon the small pieces that I have here and none of them are as finely glazed nor as large. I enclose a list of the pieces with their sizes and colors. All of these reds are dull of course. And they are mostly larger in diameter than in height. It may be that I need not send all of them as they are similar and I may yet get the others. If I do I will substitute them for some on the list. If you would rather have five or six instead of the nine please advise me. I will within a day or two draw one or two to give you the shapes and coloring. There are no two alike in design or shape nor really in coloring although the Indian paints are confined to brown, black, orange and red. When the other colors appear they are those applied after the firing is done.

Yours respectfully
Josephine Foard
437 Park Ave.
Waverly N.Y.

ATTACHMENT

Pieces of pottery made by the Pueblo Indians of Acoma and Laguna New Mexico.
 And the very first ever glazed.

 9 pieces
 No. 1
 5-1/2 x 5-3/4 inches Color = red, brown & cream-
 No. 2
 5-3/4 x 8 inches Color = black & cream-
 No. 3
 5-1/4 x 5-3/4 *in.* Color = red, black, cream-
 No. 4
 3-3/4 x 4–7/8 inches Color = red, black & cream.
 No. 5
 5-1/4 x 6-3/4 inches Color = red, brown, cream
 No. 6
 4-1/2 x 5–7/8 inches Color = orange, brown, cream.
 No. 7
 4 x 5–1/8 in. Color = orange, brown, cream.

No. 8

 2-3/4 x 5–5/8 in. Color = Brown, orange & cream.

No. 9

 2-1/2 x 5 in. Color = gray glaze—no paint.

Letter 7[8]

Waverly N. Y.

Jan. 22nd 1901

Hon. A. G[.] Tonner:

Washington D.C.

Dear Sir:

I enclose with this two miniature drawings of pottery to give you an idea of size shape and coloring of those I purpose [sic] sending to Buffalo—The drawings make no pretentions [sic] whatever to art work. They simply convey an idea. The others are similar in shape and size and coloring although no two are really alike in any of these respects and the designs are entirely different. I will prepair [sic] a card for them when you tell me what to do with them. If you have any suggestions in regard to the card I will be glad to have them. I hope that there may be no doubt about my getting them back again. I would like to have some idea how they are to be surrounded or placed. Is there to be any special color effect?

Yours Respectfully

Josephine Foard

437 Park Ave.

Waverly N. Y.

Letter 8[9]

Waverly N. Y.

Feb. 20th 1901

Hon. W. A. Jones

Office of Ind. Aff_

Washington D.C.

Dear Sir:

I enclose specimen of the card which I would like placed on the pottery. If I were expert in making letters I would illumine them but I simply cannot form them. If I had some idea how you label those which you intend sending I might manage to do better. I would like very much to sketch a little Indian maid with a tinaja on her head in the corner of the label.

If you will kindly advise me I will be glad.

I think that I can substitute a large tinaja for one other of the small ones as you requested. There is not any time much variety in the coloring of the Indian pottery but I will do my best to send them as different in color as possible. I gave them away thoughtlessly I think now. I hope that

I can get just one large one. I have variety enough in shapes not glazed but I had nothing to do with them excepting to buy them of the Indians. I hope that none may be broken but that is a risk one must run.

Yours Respectfully
Josephine Foard
437 Park Ave.
Waverly N. Y.

Letter 9[10]

Waverly N. Y.
Feb. 23rd 1901
Hon. W. A. Jones:
Washington D.C.

Dear Sir:

I have received a letter to day [*sic*] from one of our committee [Albert K. Smiley, secretary and treasurer of the Indian Industries League, Boston] who objects to my sending pottery to Buffalo. He thinks that as the pottery at Laguna N. Mex[.] is closed for the present he would rather not have it brought to the notice of the public. He would like to wait until the work is better developed. I wrote to him nearly three months ago telling him of my intention and asking his advice. As he did not reply and had never objected to any thing that I proposed I took it for granted that he either approved or was indifferent. He apologizes for not having replied earlier, saying that his eyes had been injured. Of course he is correct as far as the undeveloped work is concerned, and the specimens which I have on hand are very insignificant as I wrote you formerly. Lately I have felt that really no one could see the glaze (being on the inside) unless he were close enough to look into the jar. At the same time I feel very much annoyed about it, simply because I have promised you the ware and you have allowed space for it. Will you please tell me at once if it is too late for me to withdraw? If it is of no consequence I will be pleased but on the other hand I will surely send the pottery if you are put to inconvenience or annoyance by my not doing so; but by no means must the label which I sent to be copied be attached to it. Under the circumstances I would not have my name nor any ones of the pottery nor the pottery itself mentioned. But if you simply want to enlarge the Gov. collection without reference to the glaze I will gladly send them as my own private affair to be considered your collection. I most humbly beg your pardon for this blunder of mine. Had Mr. ___ [Smiley] replied two months ago as he should have done I would not have put you to this trouble nor myself to this mortification. Miss Sybil Carter who is also one of our committee advised me to do as I did. Whatever is done please destroy the sample card which I sent.

Yours Respectfully
with regrets
Josephine Foard
437 Park Ave.
Waverly N. Y.

P.S. If I send any how shall I mark them that they may be returned to me instead of to Washington and if they are not to represent the pottery and only to add to the Government collection had I not better select different ones to represent the most attractive colors? J. Foard

Letter 10[11]

Waverly N. Y.
Mar. 28th 1901
Hon. A. G. Tonner
Washington D.C.

Dear Sir:

As soon as your last communication came I wanted to write and thank you for the kind manner in which you took the pottery affair: but we had measles in the house and I did not wish to send them by mail to Washington. Now that the danger of the disease is past I thank you most cordially for your courtesy.

Yours Truly
Josephine Foard
437 Park Ave.

Letter 11[12]

May 13th 1902
The Hon. W. A. Jones
Commissioner of Ind. Affairs
Washington D. C.

Dear Sir:

I am very much interested in a newspaper article of some months ago which stated that you were to visit Lincoln Institute, a school for Indian boys and girls in Philadelphia that you might study the methods of instruction there which are radically different from those of other government schools. I spent one year among some Pueblo Indians of New Mexico, hoping to improve their pottery and help to establish a pottery on a good business basis. I had just gotten things on a good footing for a beginning when my health failed, because of many privations, poor food especially. After I built a house I fared better but it was too late and I was compelled to leave at once in order to recuperate. No one could be found to take my place and the business is still waiting for me or some one. I was there long enough to learn many things. I bent my whole energies to the interests of the Indians and gained their confidence and respect, for I dealt fairly and squarely with them, paying them good wages for work that was well done and utterly refusing to pay for poor work or short time. I found most of them willing and glad to work for money and am convinced that what they need most of all things is, honest labor. I agree with Mrs. M. McHenry Cox in, that what they need is to be taught the plain, practical lessons of life whereby they may be able to support themselves. Since I have recovered my health I wish that I

had not been so hasty in relinquishing the work. One thousand dollars of the money given me for the work I did not use, but it has since been appropriated to another good cause. Were it not so I would like to continue my work among the Pueblos. But I would change my plans somewhat. I would introduce other industries, so that the pottery would not be the primary object. It of necessity must require three or four years of careful work to establish a paying business. The Indians do very artistic, pretty work, but it is frail, because of their imperfect methods. This is hard to correct because of their tenacity to old habits. At the same time I succeeded in that short time in getting a very few of them to improve their work a little. If I returned I would introduce a school of sewing and embroidery. Good plain work at first, afterwards fine work. They can do it. It is in them. Then I would have it sold every where. People had better buy their work than send them money or clothing. This should sell more readily than lace because not so expensive and it would be an industry which in the course of time would not need a constant teacher as lace work does. Only the wealthy can buy lace to any great extent but plain clothing is always in demand.

Miss Sybil Carter is a personal friend of mine and I know what a fine work she has done with her lace, but lace is for the few; the many need employment. I wish that I could have a personal talk with you on this subject. My house is there in New Mexico waiting for some good work to be done in it. My heart is with the Indians and I am willing to make great sacrifices to their interests. Had I the means I would establish the work among them and then leave it in competent hands. Those who have been educated at the Government schools are the ones especially to be looked after. Many of them have helped wonderfully in improving their homes but opportunities for remunerative work are extremely few. Money is a great leveler of difficulties, and the older ones would yield more readily to civilizing influences if those coming home from schools could help to lift the burden of poverty from their doors. Schools are all very well, but paying work at home is what they need at once upon going home. They are not half so lazy as represented. Those Indians worked better for me than for any one else. Why? Because they trusted me and because they learned something too. I said that my house was there. It really belongs to those who sent me there—but it is mine practically. I have the keys here with me. I built it and am sure that I can have the use of it. Some Jews [presumably the Bibos, who had a trading post at Laguna] write me frequently, asking to buy or rent it. I have steadfastly refused, because I am hoping that it may yet be turned to good account for the Indians[.] Cannot you help me in some way to keep that house and establish an industry for them? I have a letter now awaiting an answer to rent or sell. Either the one or the other means for the house to be used only to cheat the Indians and keep them farther from the path of good citizens. I thought that God sent me there to build that house for the good of his Indians and to his glory. I do not want to be considered a missionary. I simply want to do good work, a business. God's work can be taught in that way even better than in schools or as a missionary if the right person is at the helm. Mrs[.] Cox is quite right in getting homes and employment for those who have done with school, but employment in their own homes is quite as important I think. Every child cannot be torn from it[s] parents never to return, and many who never leave home need work.

Yours Respectfully
Josephine Foard
437 Park Ave.
Waverly N. York

Letter 12[13]

May 23, 1902.
Miss Josephine Foard
437 Park Ave., Waverly, New York.

Madam:-

Yours of the 13th instant is at hand and has been read with much interest. I have this day asked the Civil Service Commission to send you blanks for an application for a position as matron in an Indian school. The Office has made a preliminary application in your behalf, otherwise, under their rules, there would not be time enough left prior to the examination for your application to be accepted.

The Office would be very glad to have you resume your pottery work among the Pueblos and it can give you assistance by offering you the position of field matron at a salary of $60.00 per month. Some small additional sum for equipment may be assigned you during the year. If you care to receive such an appointment as that, the way to do it will be through this examination as school matron, for when you are once on the eligible list of school matrons you will be transferable to the position of field matron. In your application to the commission for examination you should give some statement as to what your pottery work among the Pueblos has been. As I said before, I should be very glad to see you become eligible through the Civil Service examination and I trust that you may be inclined to take the one which is set for June. Please give this matter your very earliest attention and send your papers in to the Commission, if at all, just as soon as possible.

Very respectfully,
A. G. Tonner
Acting Commissioner.

Letter 13[14]

May 28th 1902
Hon. A. G. Tonner.
Washington D.C.
Indian Affairs.

Dear Sir:

Just after my last letter of the 26th I received the Application papers for Matron and other papers (Manual of Examination). When I had partly made out the Application I found that I was past the limit age for matron and concluded it was useless to send it in, but finally continued it and returned it to Washington. With these papers was a card telling me to go to Elmira N. Y. June 3rd for an examination. I suppose if I do not hear from the department again it will not be worth while for me to go to Elmira as I will be rejected on account of my age. I am 58 years and the limit is 55. I am quite disappointed for I know that I could do much good either with the pottery or other industries. My motives are not selfish because my home is beautiful and I am not compelled to leave it. At any rate I hope that something I have suggested in my writings to the Office of Indian Affairs may in some, even small way, be of benefit to the Indians.

There is one good woman of whom I would like to speak now as I may not have occasion to write again and she is Miss Margaret Bingham, the government Indian teacher at Laguna N. Mex. I never heard of her before I saw her there. She was teaching a very unruly school, found it so when she took it. In the course of the year while I was working at the pottery she made a wonderful change in it for good. The Indians saw and acknowledged it. Miss Bingham was faithful and true to her school and respected by all good people who knew her. It must have been a sore trial to her to have been removed for I know that she loved her work. Pardon me if I have spoken of what I should not.

Respectfully.
Josephine Foard
437 Park Ave.
Waverly, N. York

Letter 14[15]

May 29th 1902.
Miss Josephine Foard,
437 Park Ave.,
Waverly, N. Y.

Sir:-

Replying to yours of the 26th instant I have to say that I am glad that you will undertake the examination for the position of Indian school matron. I do not anticipate that you will have any difficulty in passing it. I suppose among the papers sent you by the Civil Service Commission there was something which will give you an idea of the scope and character of the examination.

Poultry raising, sewing, embroidery, anything that will help the Indians, especially the women, to support themselves will come within your domain as field matron.

Very respectfully,
A. G. Tonner
Acting Commissioner.

Letter 15[16]

May 29th 1902
Hon. A. G. Tonner
Washington D. C.

Sir:

Yours of May 28th is just received in which you state that I neglected to state the site of the pottery building. After your communication I thought of that omission. I did in my application for matron speak of it but of course you may not see that. It is at Laguna N. Mex. I went there April 1899 and closed it April 1900. I wrote you yesterday that I had sent to Washington the

Application, as directed by you, for the position of matron, I also wrote you that I had discovered in the Manual of Examination that I was beyond the eligible age for matron. Under these circumstances I suppose that it is useless for me to make any further effort in regard to the position of matron or any industrial work in connection with the government. I wish that I knew of some one who could do the work which I had hoped to do but good potters command large salaries and are few.

Thanking you for your kind interest and communications I am Yours

Respectfully
Josephine Foard
437 Park Ave.
Waverly, N. York

Letter 16 (manuscript of telegram)[17]

May 31, 1902
Josephine Foard.
437 Park Ave.
Waverly, N. Y.

You will be allowed to take examination at Elmira. Matter of age will be adjusted afterward. Letter Monday.

A. G. Tonner
Acting Commissioner

Letter 17[18]

June 2, 1902
Miss Josephine Foard,
437 Park Ave., Waverly, N. Y.

Madam:-

On receipt of your letters of the 28th and 29th ult. the Civil Service Commission was consulted as to whether any arrangement could be made for giving you an examination as matron, despite the age limit. You are to take the school matron examination with the purpose of being appointed as field matron. For field matron there is no age limit and the Commission agrees that you will be allowed to take the school matron examination with the understanding that you will be eligible only for the position of field matron. Therefore, you were telegraphed on the 31st ult. to take the examination, which I trust you will be able to do.

Very respectfully,
A. G. Tonner
Acting Commissioner.

Letter 18[19]

June 4th 1902
Hon. A. G. Tonner:
Dept. of the Interior
Washington D. C.

Dear Sir:

I thank you for your telegram stating that I would be allowed to take the examination for matron, also the Civil Service Commission for its kind interest in it. I received your communication of June 2nd, explaining the telegram (last night, June 3rd), when I returned from Elmira where I had taken the examination. I was surprised that it was so very easy and simple, and astonished at myself that I was so stupid. To me usually I have little difficulty in expressing myself on paper, but yesterday I seemed not to have an idea, my thoughts were as sluggish as the day was warm and trying. All the time since I have been contemplating this position I have planned in my mind as to the best methods to be employed at first to secure the interest of the Indians and give the best practical instruction. But at the examination I had not one to put on paper. I had thought that I would begin with compelling them to keep their own accounts as far as possible and buy and sell like business men. I would select some of the brightest and give them the management of certain industries, and try to train some educated boy or girl to fill my place when I leave; let them feel that they are on a level with good, working people. I, before going to them would consult business people in the cities as to the best means of selling the Indian work, and what would be most salable, plainest kind of work at first. I am planning the greatest amount of work for myself, more than I can do, but I am hoping that the Indians may learn to do most of it in time. It may be very slow work, it must of necessity. For some of the girls I have thought it well to let them make a specialty of certain sewing, for instance hem stitched handkerchiefs and nice aprons and underware [*sic*], after they learn to do good hand work. The pottery must wait awhile until I get something started that is more likely to bring in money soon. Private parties in our large cities must be interested to buy. That I must do personally. I may need much advice from the Commission at Washington but I hope that things may not be too complicated. The simplest means possible I think the best and least confusing. In case I have failed to pass the examination and may not go to the Indians at all, I would like to suggest to the Commission that all Indian homes should be compelled to have outside closets [toilets]; this for morals and health. I do not remember seeing any at Laguna. I notice by yours of the 29th that the scope of a Field Matron is large, for which I am glad, because if one industry fails another may succeed. I feel that I am taking a great responsibility, but if I go I will do my utmost. I have written this long letter because I failed to express my view at all well at the examination. Of course I know that this counts nothing. I gave the name and address of Miss Sybil Carter, but since then I am reminded that she contemplated going to Europe this spring, and a communication would be long in reaching her if she went.

Yours Respectfully
Josephine Foard
437 Park Ave.
Waverly, N. York.

Letter 19[20]

Aug. 23rd 1902
Dept. Interior
Indian Affairs
Washington D. C.
Hon. A. G. Tonner

Dear Sir:

In May 1902 I had some correspondence with the Government at Washington about the pottery work at Laguna N. Mexico. I was advised to apply for the position of Field Matron. I did so and went to Elmira N. Y. June 3rd and was examined. I was notified that same week from Washington that my examination was canceled because of my being beyond the age limit as appointed by the President. On August 6th this month I received from Washington a certificate of Examination, the average being only 88.50. I was greatly surprised to get a certificate at all as I had been notified that the examination had been canceled on account of my age. Of course I know by this that there is not the slightest possibility of my doing any thing for the Indians as far as the Government is concerned, and I cannot on my own account because the expense is beyond my income. But I have the interest in the Pueblo Indians in my thoughts and heart and cannot entirely yield the idea of business of some kind being established among them. As far as the pottery is concerned it is hopeless, for potters are scarce for such places. Some other industry may be managed and I am hoping that our house at Laguna may yet be utilized for the good of the Indians. For instance, some one may be found to accomplish the work which I had hoped to do, excluding the pottery. Chickens, rabbits and sewing surely might be made a good business in time. Rabbits are used as food for Indians but they have no idea of cultivating them. I thought it might prove well for themselves, for they need meat. As I cannot hope to go to New Mexico myself I have thought that I might interest myself in finding some one to go as Field Matron, if the Government approves. I have a project on hand in which I hope to be able to instruct an Indian to raise *Chickens* and then return to her own home and introduce it as an industry to her people. I am making arrangements now to go on a chicken farm in New Jersey where I may be a partner in the business. If I do not find it too expensive and my partners are willing I will take an Indian girl or boy and give her at once the hatching of a small incubator and see what she can make of it letting her sell her own chickens and eggs, buy food &c. In the mean time she must be employed in the work of the house, cooking &c. I would rather take two or three at once but could not afford the expense of it. I know a girl in New Mexico twenty three years old who would be the person to do the thing well, but the distance is too great, and the expense, to bring her here. I must get one from one of the schools. Supposing that I should succeed in training a girl to the work, the management, raising, buying and selling would it be possible for the Government to give her a position, or rather set her up in the business at her own home so that she might establish a business among her own people? One successful Indian, man or woman might soon interest others, and in New Mexico there is a wide field and demand for eggs and chickens. In Albuquerque N. Mex. a grocer told me that they would not buy Indian eggs and chickens because they were so poor. They sent to Kansas City mostly for them. He was perfectly correct because Indians do not have a good breed of chickens and they are not well fed. On our farm in N. Jersey we will pay special attention to fine

poultry and if I can manage to teach one or more Indians, men or women, and send them back to New Mexico or elsewhere I shall be glad and hopeful of good results.

Josephine Foard
437 Park Ave.
Waverly New York

Letter 20[21]

Sept. 5 1902
Miss Josephine Foard.
Waverly, N. Y.

Dear Madam:-

Yours of the 23rd ult. is at hand in regard to the cancellation of your examination for the position of matron on account of your age. The age limit *does* apply to the position of school matron, whose examination you took, but not to that of field matron, the position to which the Office wishes to appoint you. I have explained the matter to the Civil Service Commission and I understand that your examination will be allowed to stand, and you be made eligible for appointment. In a few days therefore I will call for certification to a field matron position and trust that your name will be among those certified.

I write you this *now* lest you may make plans for the winter which it will be inconvenient for you to change should the position as field matron at Santa Fe be offered you, which now seems quite probable. I hope to write you again on this matter in a few days.

Yours respectfully,
W. A. Jones
Commissioner

Letter 21[22]

Waverly N. Y.
Sept. 15th 1902
U. S. Civil Service.
The Hon. W. A. Jones
Washington D. C.

Dear Sir:

I have just returned from visiting Chicken farms in New Jersey. I had almost committed myself to a permanent partnership on a chicken farm, but fortunately defered [*sic*] it until my return home where I found your letter of the 5th advising me in regard to the position of Field Matron in New Mexico. I shall now go to the farm and devote myself to the study of chickens best adapted to New Mexico for the benefit of the Indians. I do very much hope that the Civil Service may appoint me to Laguna, because that is decidedly the most favorable

place of which I know in which to introduce an industry, especially that of chickens if the pottery work is to be considered, and my pottery is there. I know the Indians, and they know and respect me and frequently write for my return. The field is a broad one as Laguna embraces Pahaute, Paraje, Cassa [*sic*] Blanco and Seami, while Acoma and Acometi [Acomita] are only eighteen miles away, while Isleta and El Rita [Rito] are en route from Albuquerque. Of course I would be more comfortably and delightfully associated at Santa Fe, but to good, effective work I should be in the very midst of the Indians. I had my choice as to where I might plant the pottery and I chose Laguna because the Acoma and Laguna Indians make the best pottery. The Hon. Bradford L. Prince[23] and others used every argument to induce me to stay at Santa Fē but I decided that the best thing to do was to bury myself in the midst of the best potters. The Office at Washington gave me to understand that chicken raising would come under my supervision as field matron and if you do not object I should like to make that my first object, as it bids fair to be a good industry. I suffered for lack of nourishing food while at Laguna; there were chickens in abundance among the Indians, but they were so thin and tasteless as to be revolting as food. If I am allowed to take up this work I will endeavor to banish every Indian chicken and substitute the very best breeds as soon as possible when I will be able to arrange for sale of eggs at first in my own name because there is in Albuquerque and elsewhere a serious objection to Indian eggs on account of the poorly fed chickens. If only the best eggs and chickens are marketed they will soon learn to accept poultry and eggs from the Indians direct. I thank you for your kindness in writing me and will await your further advice.

Yours Respectfully
Josephine Foard
437 Park Ave.
Waverly New York

Letter 22[24]

Oct. 4, 1902.
Miss Josephine Foard,
437 Park Ave.,
Waverly, N. Y.

Dear Madam:-
I take pleasure in informing you that your name has been certified to this Bureau for appointment as field matron at Santa Fe. Your salary will begin when you take the oath of office and report for duty to the Superintendent of the Santa Fe School, upon whose pay roll you will be borne. Your salary will be $60.00 per month. The traveling expenses will be borne by yourself and you may proceed thither at any time which suits your convenience.

Very respectfully,
W. A. Jones
Commissioner.

Letter 23[25]

Oct. 6th 1902
Dept. of the Interior
Indian Affairs
Washington D. C.
Hon. W. A. Jones:

Dear Sir[:]

Yours of Oct. 4th notifying me that I have been appointed Field Matron at Santa Fē is just received and I thank you most sincerely. I am very eager to begin the work and will report for duty as early as possible, as soon as I can get my art materials and other effects stored. I would like also to go to Philadelphia and New York to inquire about some methods or industries which might be beneficial to the Indians. I will be as expeditious as possible.

Yours respectfully
Josephine Foard
437 Park Ave.
Waverly New York

Letter 24[26]

(Letter typed on printed letterhead of the
Department of the Interior, Indian School Service)
Albuquerque Indian School, N.M.
November 22, 1902.
The Honorable Commissioner,
Office of Indian Affairs,
Washington, D.C.,

Sir:-

I have the honor to forward herewith some of the communications I am receiving from Miss Foard, the Field Matron for Laguna, concerning the establishing of the pottery industry.

In order to properly supply her for beginning this work I have the honor to request authority to expend the sum of $182.00, or so much thereof as may be necessary, in the open market purchase of the following:—

15 cords of wood, green cut and dried @ $7.50	$112.50
Pottery glazes, paints, etc.,	20.00
	$132.50
20 days Indian labor @ $1.50 per day	30.00
5 days Indian labor @ $1.00 per day	5.00

And that the Superintendent Chicago Warehouse be instructed to purchase under existing contracts and ship to me at Laguna, N. M.,—

10 Gals. oil, kerosene @ 20 cents———————————————	2.00
25 Yds. Linen, plain white, bleached, for handkerchiefs,	
at 50 cents per yard ————————————————————	12.50
	$182.00

The wood is required for burning pottery for Indians. The glazes and paints for finishing and decorating this pottery. The Indian labor is necessary for firing and care of the kiln and pottery. The oil for lighting the kiln for night work, all for the purpose of starting the potters industry among the Lagunas.

The linen is required for star[t]ing the hemstitched handkerchief industry.

I do not think it advisable to furnish her with a horse or horse feed. If it can be made a success at all it will surely be right there in Laguna. It is surely not practicable to try to have Indian women make pottery at their homes and then try to haul the jars, eight, ten, fifteen and twenty miles in wagons to burn them.

However if you wish to furnish her a horse the expense will be as follows:—

1 pony at ———————————————————————	$40.00
1 buggy at———————————————————————	80.00
1 harness ———————————————————————	15.00
Subsistence for 1 pony for 1 year at Laguna	
(hay 1¢ per lb. oats 1 1/2¢ per pound). —————————————	100.00
	$235.00

Very respectfully,
Ralph P. Collins
Superintendent.

[The two following letters were forwarded by Superintendent Collins with his letter (letter 20). There is no indication of any responses sent on the cover sheets for these letters.]

Letter 25[27]

Nov. 6th 1902
Hon. W. A[.] Jones
Dept[.] of the Inter.
Washington D. C.

Dear Sir:

I arrived at Santa Fē, according to orders from Washington, Oct. 27th, took the office oath Oct. 28th and reported to Supt. C. J. Crandall, who informed me that I was appointed to Laguna N. Mex. instead of Santa Fē which pleased me. I went immediately to Albuquerque and reported to Supt. R. P. Collins Oct. 29th[.] Came to Laguna on the 30th which was as early as I could do so after Supt. Collins heard from Washington. I found my house in an astonishingly good condition after having been closed for two and a half years. It and the pottery need a little repairing externally as the adobe

is washed away a little and I see traces of leaks in three or four places. It is to the credit of the Indians and community that not a thing has been disturbed, not even the bricks and clay that I left outside. So far I have spent my time in cleaning, repairing and getting things in living order. Supt. Collins seemed to think that I was not entitled to fuel or any thing else for house or to run the pottery. In this I was sure that he was mistaken for the Office at Washington stated that some small additional sum for equipment would be assigned me, aside from my salary, during the year. I am trying to form some estimate as to what I may need, but cannot until I get to work. I am abundantly provided with house hold effects, and the only expense out side of that will be repairing the roof and walls to prevent leaks, which may never exceed five dollars per year and may be not that much if attended to in time. I must have a man at once to clean and put the pottery in working order. This I hope may be done in one day at a cost of one dollar. The work is too heavy for a woman. After this, a man will be required for 10 or 15 hours every time the kiln is fired as the firing must extend into the night. Formerly I paid a man .12-1/2 [cents] per hour, now I shall try to get it done for ten cents per hour. For a long time I suppose that I may not fire more than once or twice a month because I shall do my utmost to fire only good pottery and this may be difficult to obtain until I succeed in winning them to different methods of working. I learned when here before that the Indians could patch up poor ware very adroitly, but I succeeded in getting two women to make a decided effort for the better. The work must be a slow one but I think in time it must succeed. Their designs are beautiful and I would not for the world have them changed in the slightest. For glaze there must be a small cost, I cannot recall the price per pound, and my books have not arrived. I think it is in the neighborhood of a dollar per pound but it goes a great way in using. Glazing in the inside only, will help to strengthen the ware and preserve that dull exterior peculiar to the Indian pottery and is so soft and artistic. But there are many tastes to cater to in market and a wholely [*sic*] glazed olla may be in demand. In this case the imported paints must be obtained, for the Indian paints will not stand a glaze. I have enough of those paints and glazes here but do not feel justified in using them unless I pay the parties for them who gave them to me. It will save trouble if the government will buy them or the quantities I may use, but they all will be in demand I think. We had better try glazing on the inside only until the pottery itself is made stronger. This is a simple thing to accomplish if the Indians will only follow my methods. Two things only shall I insist upon now, first that they make the jars or ollas entirely of green, (or new clay) instead of breaking old jars and mixing it with the green clay. This weakens the ware because one part has already been fired and the other not. Secondly they drag the ware to the open air as soon as it is red hot and while it is red hot which is a serious harm. They of course think that they know better than I. If I can induce them to do better firing in their own improvised kilns it will reduce the kiln work to glazing and this will reduce the expense of firing as I shall then only have to fire for the glazing. Supt. Collins gave me a good idea when he suggested that while this transition state from poor pottery to good is taking place no attempt be made to put it on the market excepting by the Indians themselves in their old way. The greatest expense to the Office at Washington must be the fuel and it is a vexed question. Formerly it was hard enough to get wood and worse to bargain for it with an Indian, but now I am told that it is much more difficult. If the work were not for the benefit of the Indians it would be perfectly just, because wood is scarce and is poor and has to be hauled many miles; and the teachers tell me that they can procure only green wood. This will never do for pottery. From a white man fairly good wood can be had at five dollars per cord. This is more expensive than coal because it does not go as far as five dollars worth of coal. Our kiln is unfortunately

made for wood but if the government will furnish me soft coal I think that I may be able to change the wood grate into one for coal at a very trifling expense[,] a car load of coal would be the least expensive and the most desirable as none can be purchased here at retail. I used about a cord of wood at one firing. I shall need coal oil too for lighting the pottery as we must fire at night. While I am waiting for fuel and better pottery work, I shall devote my time to the interests of the Indians, trying especially to get them to make fine hem stitched handkerchiefs for market. If I had enough ordinary linen with which to start them I would be glad. After that I will compel them to buy their own linen. I have already written to Philadelphia and New York asking for an Indian counter [presumably a retail space devoted solely to the sale of Indian-made goods] in large stores. I think that I will get it if I may be able to get enough handkerchiefs to justify it. The Rev. Mr. Moody the missionary here is a wide awake, energetic man and told me that if the men had leather which shoe stores rejected, or rather factories, they might make enough whips to do a good business. I at once wrote to New York and Philadelphia shoe stores asking if they would give the leather if I paid the freight. If they refuse I will try elsewhere. I am pleased to find good workers here among the Government teachers and think they will help me in interesting Indians. I shall visit all the scattered pueblos if I do not find it too expensive. If this is the case I will try to get them to come to me. If we keep up a counter in a large city, it must take the combined work of all the Lagunas not living at Laguna. The Isletas are good needle women and may be interested if I might visit them, but that must not be until the work is well started here. It just occurs to me that a car load of wood instead of coal might be more practical as I know that the kiln will do its work better with it. I have acquainted Supt. Collins as far as I can remember with what I have written and I am hoping that I may have as free a hand to work out these plans as possible. It will be out of the question to do ordinary Field Matron work and carry on pottery work. It requires undivided attention when once begun and I hope to work up the other work before I begin it and between times. Hoping that you will support me in this I am

Yours Very Respectfully
Josephine Foard
Laguna New Mexico

ATTACHMENT

—What is needed in brief—
 as far as I can judge—

House repairs—per year	$5.00
Man to clean pottery	1.00
" " fire—each time from	$1.25—1.50
Glazes—paints—	
Fuel—wood by car load or less.	
Kerosene oil.	
One supply of ordinary linen for handkerchiefs as a beginning, a few yards only.	

There may be incidental expenses which I cannot foresee. J. Foard

Letter 26[28]

Nov. 15th 1902
The Hon. W. A[.] Jones
Dept. of the Interior
Washington D. C.

Dear Sir:

Some days since I wrote you as far as I could judge at the time what would be needed to run the pottery and do other work among the Indians. My hands are somewhat tied until I have something with which to work. I have been trying to get the Indians to take me to Acoma, Paraje—Pahaute Siami &c. without charge without effect. To accomplish anything with pottery I should go to Acoma frequently, because the Indians there are by far the best potters, but no one will take me for less than five dollars each time, and the other places accordingly. Some one suggested my buying a horse, saying that it would cost fifty dollars per year to feed him and that hiring would cost that sum in a very much shorter time. I think it the only thing to do if I am to work vigorously with these people. If the Government will provide me with horse feed at fifty dollars per year I will gladly buy the horse myself. At the above named places are all of the best workers. They left Laguna because they were workers and the country better for agricultural purposes. I find that some of the very ones upon whom I was depending for hem stitched handkerchiefs and fancy work have moved to Casa Blanco. Formerly my best workers were from Siami, Paraji and Pahaute. To get and keep them interested I must of necessity visit them frequently and a horse is a necessity unless I have plenty of money. I prefer the horse because it is the most economical. Mr. Moody the missionary will stable him as he has abundant room. I am pushing things as fast as possible. The pottery has been put in order. I cannot start it until I have enough fuel to go straight ahead. If I start up and then stop the effect will be bad. I am devoting my time as much as possible to those who have attended the Government schools and find several who have returned from Carlisle recently. Some are very interesting and promise to take hold of whatever I suggest. I am teaching hem stitching to some and could interest more if I had enough material with which to work. I brought a little...

[page missing]

...reached by the freight trains by my walking a little ways. If you would kindly allow me the amount of horse feed and let me use my judgment as to its use for horse feed or car fare I will be grateful. I would much prefer not to have the care of a horse if it can be avoided. I hope that I am not infringing upon Supt. Collins rights by writing you personally but if I am I beg his pardon. It is only that I hope to expedite matters by saving time.

Yours Respectfully
Josephine Foard
Laguna New Mexico

ATTACHMENT

—Needs of one year as far as I am able to judge—

24 or more cords of wood (dry) for kiln

5 Gal. or more coal oil. for pottery–

$1.00 for man to clean pottery–

36.00 " " " fire kiln

20.00 " glazes paints &c.

50.00 " horse feed or car fare to visit pueblos

One supply or bolt of linen to make ordinary hemstitch handkerchiefs for men and women

If these are made neatly enough for sale we hope to buy the next supply.

We will practice on coarser material until good work is accomplished.

Letter 27[29]

July 30, 1903.

Jas. K. Allen,

Supt. Indian Industrial School,

Albuquerque, N. M.

Sir:-

Yours of the 21st inst. is at hand recommending that only one field matron be assigned to Laguna instead of the two now there.

I have felt that the supply exceeded the demand in that pueblo and that Miss Josephine Foard's pottery work was an experiment. However, I would like to have the experiment, continued longer and given a *thorough* trial. As she has a home of her own at Laguna (so I am informed,) naturally she would be the one to be allowed to remain there. She will be expected to spend part of her time visiting among the Indians as do other field matrons.

As to Miss Mabel W. Collins, I feel that she should have unusual consideration and be placed as acceptably and comfortably to herself as possible. Where would you propose to transfer her, and what would be her surroundings? Her terrible experience gives her special claims, and I would like to have her consulted as to a change in her location.

[The remainder of the letter does not concern Miss Foard or her work at Laguna. The commissioner's signature is illegible.]

Letter 28[30]

[Printed] Report of Field Matron.

Duties of Field Matron:

The position of field matron has been created in order that Indian women be influenced and instructed in their home life and duties as farmers and mechanics are supposed to direct Indian men in their avocations.

The duties of a field matron are, therefore, to visit Indian women in their homes and give them counsel, encouragement, and help them in the following lines:

- Care of a house, keeping it clean and in order, ventilated, properly warmed (not overheated), and suitably furnished.
- Cleanliness and hygienic conditions generally, including disposition of all refuse.
- Preparation and serving of food and regularity in meals.
- Sewing, including cutting, making, and mending garments.
- Laundry work.
- Adorning the home, both inside and out, with pictures, curtains, homemade rugs, flowers, grass-plots, and trees, construction and repair of walks, fences, and drains.
- In this connection there will be opportunity for the matron to give to the male members of the family kindly admonition as to the "chores" and heavier kinds of work about the house which in civilized communities is generally done by men.
- Keeping and care of domestic animals, such as cows, poultry, and swine; care and use of milk, making of butter and cheese, and curds; and keeping of bees.
- Care of sick.
- Care of little children, and introducing among them the games and sports of white children.
- Proper observance of the Sabbath; organization of societies for promoting literary, religious, moral, and social improvements, such as "Lend a Hand" clubs, circles of "King's Daughters," or "Sons," Y.M.C.A., Christian Endeavor, and Temperance Societies, etc.

Of course, it is impracticable to enumerate all the directions in which a field matron can lend her aid in ameliorating the condition of Indian women. Her own tact, skill, and interest will suggest manifold ways of instructing them in civilized home life, stimulating their intelligence, rousing ambition, and cultivating refinement.

Young girls, particularly those who have left school, should find in her a friend and adviser, and her influence should be to them a safeguard against the sore temptations which beset them. She should impress upon families the importance of education, and urge upon them to put and keep their children in school.

Besides faithfully visiting Indian homes, the matron should have stated days or parts of days each week when Indian women may come to her home for counsel or for instruction in sewing or other domestic arts which can advantageously be taught to several persons at one time.

The time actually devoted by the field matron to the above outlined work should be not less than eight hours per day for five days in the week, and half a day on Saturday.

The matron shall make reports of her work monthly to the agent and quarterly, through him, to this office, upon blank herewith. On August 15th of each year she shall make an annual report, to be forwarded by the agent to the Indian Office for publication.

[Miss Foard's answers were filled out on the printed form accompanying the instructions; her written responses are transcribed in italics.]

REPORT of services performed by *Josephine Foard*, Field Matron, on the *Laguna New Mexico* reservation, from *October 1st* to *November 1st, 1903*. Days occupied in visiting Indian homes, *25*; Number of Indian families visited, *63*. Number of families previously visited, *all*; Number visited for the first time, *none*. Number of persons in above families, *300*; Number of families living in houses, *all*. Number of families living in tepees, or other Indian habitation, *none*. Number of Indian women actually instructed in the lines referred to above, giving details:

- *As formally commended rather than found fault. Instruct one daily in my own home.*
- *Only three or four homes are absolutely dirty and those families do not speak English and we must wait.*
- *One in my own home. This is not so great a necessity as they do well with their limited resources.*
- *One in my own home. Others in the laundry are looked after by some one else.*
- *One in house plants. I learned this month of the great success in flowers of one to whom I gave government seeds in the Spring.*
- *Chickens I am always trying to introduce and was fortunate in helping to cure three sick horses for an Indian.*
- *Made eighteen visits to the sick, sometimes giving medicine, sometimes a delicacy in the way of food.*
- *Superintend Sunday school for which we have choir practice on Wednesday evenings.*

In other ways, *73 Indians visited me in my home or in the pottery, always in quest of something, medicine information, letter writing or reading or some object. They are learning not to come and sit out of mere curiosity. This had caused me great annoyance and loss of time and I rejoice at the change. I have succeeded in teaching them also that they must not crowd about my windows and look into the room. When I go into their houses I try not to intrude upon their privacy & meal hours, just as I try not to have them do in my house. I am learning also that they appreciate the situation and any kindness done them.*

Other results obtained, *The pottery work has absorbed much of my time and we hope to have a firing early this coming coming* [sic] *month.*

This report is made out Oct. 28th because I go to Acomita in the evening to stay several days to get the women to work on pottery for the firing. I made 114 visits.[31]

Suggestions or recommendations, *I failed to go to Acomita because the Indians were all leaving for a feast dance. In the remaining three days I visited 13 families and 5 sick people.*

I certify on honor that the above statements are correct.
(signed) *Josephine Foard*
Field Matron

Letter 29[32]

Oct. 16, 1903.
Miss Josephine Foard,
Laguna, New Mexico.

Sir:-

 Yours of the 20nd ult. is at hand in regard to sending specimens of Indian pottery fired in your kiln to the St. Louis Exposition. I think it an excellent idea. Please correspond about it with S. M. McCowan, Chilocco, Oklahoma. He will have charge of most of the Indian Office exhibit at St. Louis.

Yours Very Respectfully,
A. G. Tonner
Asst. Commissioner.

Letter 30[33]

May 20, 1904
Jas. K. Allen,
Supt. Indian School,
Albuquerque, N. M.

Sir:-

In compliance with her request and your recommendation of the 9th inst. 30 days leave of absence with pay is hereby granted Josephine Foard from June 1st.

Very respectfully,
A. G. Tonner
Acting Commissioner.

Letter 31[34]

June 21, 1904.
Miss Josephine Foard,
Laguna, New Mexico.

Madam:-

Yours of the 11th ult. in regard to your pottery experiment at Laguna has been very carefully considered. As I understand it you have given the experiment a faithful two years trial and found

- That with three firings the Pueblo pottery may be strengthened and finely glazed so as to be portable, but
- That imported paints must be used, as the Indian paints will not receive a glaze;
- That there is no market for the glazed pottery in the vicinity of the pueblos. The curio seeker either wishes the old native style because it *is* native or is not a judge of pottery and wants only what is cheap.
- That the only way to dispose of the ware would be for you to reside in the east, work up a market and have the Indians to whom you furnished the paints send the pottery to you for its final glazing and firing in New York or some other centre where a suitable kiln is to be had and where the cost of firing will be no greater than in Laguna.

I am sorry not to be able to give your suggestions hearty endorsement. The Office was ready to have the experiment tried among the Indians and is cognizant of your faithful work and helpful influence in the pueblo under your appointment as field matron. But I do not think it would be justified in continuing you on its field matron rolls while you were residing away from the Indians notwithstanding you were devoting yourself to their interests. The working up of such

a business as you propose, while I very much wish that it might become a success, belongs rather to philanthropic societies than to the Government, just as lace making and basketry have been worked up by Miss Carter and Mrs. Doubleday and Mrs. Bradford.[35]

If, as you say, there is practically little more that you can accomplish by living at Laguna—and I am constrained to believe that that is the fact—I think your services as Government field matron should terminate with the close of your vacation. I feel that you have done your best at Laguna and I trust that what you have taught the women there will be of real help to them indirectly, even though the direct results which you anticipated have not been realized. The experiment was worth trying and it may be, as is often the case, its main value will be in its "by-products."

You ask about Government transportation. The Office has nothing of the sort. Sometimes school superintendents make special rates with the railroads, on their own account; but that is a matter entirely outside of this Office.

You speak of being asked to Picuris to help start a pottery work there—but I infer that you hardly consider it a practical suggestion and I agree with you.

I suppose you know that if you wish to attend the Indian Institute in St. Louis June 25 to July 1 the time required will be allowed you in addition to your vacation.

Very respectfully,
A. G. Tonner
Acting Commissioner.

Letter 32[36]

July 21, 1904.
Miss Josephine Foard,
Flushing, L. I.

Madam:

Yours of the 12th inst. is at hand, in which you accept the decision of the Office, that since you do not consider it advisable to remain longer at Laguna as Field Matron in charge of the pottery experiment there, your services as such Field Matron will have to be discontinued; the discontinuance will take effect at the close of your vacation, which I understand was the 30th of June last.

I am glad your interest in the work of glazing and thus strengthening the Pueblo pottery continues. You ask for permission to use the paints etc. which you have on hand by sending them to the Indians prepared for use. I should be glad to have you do anything of the sort which you can to continue the work for which you went to Laguna.

A copy of this letter has been sent to Supt. Allen, Albuquerque for his information.

Yours respectfully,
A. G. Tonner
Acting Commissioner.

Letter 33[37]

March 24, 1905.
Miss Josephine Foard,
213 Sanford Ave.,
Flushing, New York, N. Y.

Madam:

Yours of the 13th instant is at hand in regard to the glazing of Pueblo pottery.

I am much interested in what you say as to the development of the art and the difficulties in the way of making it a success financially. I shall be glad to do anything I can to help make an Indian industry profitable to the Indian artisans.

I am interested to notice that you propose to glaze only the inside of the pottery, so as to strengthen it, leaving the outside to be wholly characteristic of Indian art and workmanship in finish, design and color.

Your experience would indicate that it is not practicable to glaze Pueblo pottery and work up a market for it in the Indian country.

I should like to know more definitely just how you wish for help in having the fragile, unglazed pottery packed in Laguna for shipment to you at New York.

If the Laguna field matron, Mrs. Babbitt, should oversee the packing and the Government should furnish the boxes, would that enable you to proceed with your plan of glazing the pottery in the East and finding for it an Eastern market?

If the Government should find it practicable and desirable to rent your house in Laguna, would you like to rent it and at what rates? In that case would not the income from the rental supply you with the necessary funds for the expense of the pottery business at the Laguna end of it?

Yours respectfully,
F. E. Leupp
Commissioner

Letter 34[38]

April 7, 1905.
Mr. James K. Allen,
Supt. Albuquerque School,
Albuquerque, N. Mex.

Sir:

Two letters have recently come to me from Miss Josephine Foard, now of New York City, in regard to her experiments with glazing Pueblo pottery while she was field matron at Laguna.

She is now of opinion that by glazing only the inner surface of the pottery its Indian characteristics of color and finish, as well as design and form, can be retained, and yet it can be strengthened so as to be much more valuable and salable than is the very fragile ware which the Pueblos now make.

Miss Foard now proposes to have the pottery shipped from Laguna or Acomita to her at New York, where she will fire it and market it, and return to the Indians the net proceeds.

She seems very much interested in this and ready to give her own time and effort to the work without compensation. Of course it is still an experiment; but I should not like to have the experiment fail for want of reasonable cooperation on the part of this Office. What Miss Foard says she needs at this time is assistance in getting the pottery packed for shipment to her for the Indians have neither boxes nor packing material.

Is there any reason why the Laguna field matron should not oversee the packing of the pottery by the Indians, nor why she should not be furnished with necessary boxes, paper, excelsior &c? If this is practicable, please let me know what expense will be involved.

You have already frankly stated your own feeling on this matter. You consider that glazing it takes the "Indian" out of the pottery, and you believe that the practice of selling poor pottery at the R. R. stations to tourists is deteriorating both to the Indians and their art. I do not controvert either point; but there can be nothing demoralizing in making the best pottery possible and selling it in New York, glazed or not glazed; and, as I said above, if others are disinterestedly concerned in preserving and developing a native Indian art, which is not without real artistic value, I should much prefer to give encouragement, rather than discouragement, to their projects. Moreover, anything which which [*sic*] promises revenue to the Indians as the result of their labor is to be sought after, even though its first popularity be temporary only. No small part of self support among civilized people comes from supplying what people want even though it happens [to] start in a more popular mania.

Yours respectfully,
F. E. Leupp
Commissioner.

Letter 35[39]

April 26, 1905.
Mr. James K. Allen,
Supt. Albuquerque School,
Albuquerque, N. Mex.

Sir:

Referring to Office letters to you of the 7th and 24th instant I inclose [*sic*] copy of letter just received from Miss Josephine Foard in which she states that she would like to rent to the Government the building at Laguna which she has hitherto occupied. The suggestion of renting it originated in this Office on the understanding that suitable buildings for the use of employes [*sic*] were hard to secure among the Pueblos.

Will this building be needed and for what purpose, and what would be a fair rental for it?

Yours respectfully,
C. F. Larrabee[40]
Acting Commissioner.

Letter 36[41]

May 27, 1905.
Miss Josephine Foard,
213 Sanford Avenue,
Flushing, N. York.

Madam:

On receipt of yours of April 21 in regard to the rental by the Government of your house at Laguna, the matter was referred to the Superintendent of the Albuquerque school. He replies as follows:-

While it is true that we have difficulty in renting buildings at this place, the one owned by Miss Foard is located on the railroad right of way, within a few feet of a switch, and trains are constantly passing. It is not supplied with water and could not be utilized for the use of the Matron, where water is required for laundering purposes. It possibly could be used for teachers quarters, but at a rent not to exceed $5 per month.

The question of quarters for field matron and teachers at Laguna for the next fiscal year will not be decided for some weeks yet and I cannot now say whether your building can be rented or not. It looks rather doubtful.

As the Superintendent also deprecates turning over to the field matron, or any of the Government employes [sic], the work of packing the pottery, because the packer would quite naturally be held responsible by the Indians for any breakages, I think it will be best for you to carry out the suggestion which you made that the work be entrusted to the missionary, if you find him willing to help you out in that way.

I am sorry that the Office is not able to extend as much help to your projects as was hoped.

Yours respectfully,
C. F. Larrabee
Acting Commissioner.

Letter 37[42]

June 27, 1905.
Mr. James K. Allen,
Supt. Albuquerque School,
Albuquerque, New Mexico.

Sir:

Inclosed [sic] please find letter on the 21st instant from Miss Josephine Foard in regard to her success in disposing of Pueblo pottery and need of boxes and packing material for the shipment of other pottery. The Office has intimated to Miss Foard that it would try and help her out to the extent of supplying the boxes or barrels and the packing material. How can you best arrange for it?

Please return her letter.

Yours respectfully,
C. F. Larrabee
Acting Commissioner.

Letter 38[43]

July 20, 1905.
Miss Josephine Foard,
1100 North Front St.,
c/o Rev. V. H. Bergham [Berghaus],
Harrisburg, Pa.

Madam:

Replying to yours of the 21st ult. I take pleasure in saying that arrangements have been made by which the Albuquerque School Superintendent will furnish the packing material necessary for the shipment to you of Indian pottery from Laguna. You can let him know what will be required and when.

Yours respectfully,
C. F. Larrabee
Acting Commissioner.

Letter 39[44]

Feb. 12, 1906.
Miss Josephine Foard,
1100 N. Front St.,
Harrisburg, Penn.

Dear Madam:-

I have read with care your letter of January 21 in regard to fostering the pottery industry among the Pueblo Indians.

If I understand your plan it is that you return to your Laguna home, superintend the making of the pottery by the Indians; fire it there in your kiln; ship it thence to such eastern dealers as you have interested in Pueblo pottery, train an educated Indian man to glaze and fire and to keep accounts, and trust some women to glaze at their own homes. In seasons when the Indians are absorbed in other work or dancing and will give no attention to their pottery, you propose to travel east and west and try and work up an interest in the pottery which will result in orders.

If, in spite of the meager results thus far obtained, you still feel like returning to the pueblo to resume your personal work at that end of the line, I do not wish to discourage you. I am myself much interested in the preservation and development of native Indian art and wish that Pueblo pottery, of the best sort, might be put upon a paying basis of manufacture and sale. Whether or not this is practicable does not seem yet to be fully proven, and I am aware that little faith in the

scheme exists in the Pueblo country; yet I am ready to give it my cooperation in hope that something worth while may grow out of it.

As I understand it, you will not want to return to Laguna for some time, as the planting season is at hand. Meantime I would like to know what Indian you have in mind to teach the work of firing, what his qualifications are and what his wages would have to be. I do not see how the Office can furnish much, if anything, more than your salary, and, as before, you would have to be appointed a field matron and receive not exceeding $60.00 per month. Certainly the expenses of any traveling, such as you propose, could not be paid from Government funds.

Before you leave Harrisburg I wish you would visit the Carlisle Indian school and talk over the art and manufacture of Indian pottery with Miss Angel Decora.[45] She is a Winnebago Indian whose genuine artistic ability has been brought out by training under Howard Pyle and in the art school at Smith College. She has done some excellent painting and illustrating, and her pictures have been shown at various expositions.

I have just appointed her teacher of drawing at Carlisle in the hope that she will be able to call out the native talent of the Indian pupils, and get them to produce decorative work on lines distinctively Indian which will have a genuine and permanent aesthetic value and fill its own place in the world's great art mosaic, just as Japanese and Chinese and Moorish products fill theirs.

From your experience you will probably be able to give Miss Decora some valuable ideas as to pottery designs and possibilities and you will be interested to see the school and what she is preparing to do there.

Yours respectfully,
F. E. Leupp
Commissioner

Letter 40[46]

February 26, 1906.
Miss Josephine Foard,
213 Sanford Ave.,
Flushing, L. I., New York

Dear Madam:-

Your letter of February 15 in regard to resuming the glazing and burning of pottery at Laguna is at hand. As I said in my letter of the 12th, I am ready to help you continue the experiment. I will return you to Laguna as a field matron at $60.00 per month and I will pay the salary of an Indian man as assistant at $25.00 per month if you think that, with such help, you can get along.

It is quite impracticable for the Office to furnish you with any funds for buying ollas from the Indians or for the purchase of wood, glazes, gums, brushes, &c. It is to be a *business*, and the capital for starting the business must come from other than Government funds. The most the Government will do will be to pay the salaries of two persons to manage the business.

When you decide as to when you wish to go to Laguna, and as to your assistant, please let me know, that I may arrange the necessary appointments.

Yours very respectfully,
F. E. Leupp
Commissioner

Letter 41[47]

April 14, 1906.
Supt. Albuquerque School,
Albuquerque, New Mexico.

Sir:

As you know, the preservation and development of Indian arts and industries is a matter in which the Office takes great interest. Consequently when Miss Josephine Foard wrote recently that she would like to make one more trial with Pueblo pottery, I told her that I would again appoint her a field matron at Laguna, and would let her select an Indian man as assistant and pay him $25.00 per month.

When Miss Foard reports to you for duty and takes the oath of office she may be reported on your rolls at $60.00 per month. You may also employ, at $25.00 per month, as an irregular laborer, the Indian whom she shall select as her helper.

Miss Foard has done a good deal since she left Laguna to arouse an interest in Indian pottery which may make a market for good specimens of the art, and I am very desirous that her project shall be successfully carried out, or, if it fails, that it shall not be on account of lack of cooperation on the part of this Office and its officials.

Yours respectfully,
F. E. Leupp
Commissioner

Letter 42[48]

April 16, 1906.
Miss Josephine Foard,
213 Sanford Ave.,
Flushing, L. I., New York.

Madam:

On receipt of yours of April 12, the Superintendent at Albuquerque was notified of your appointment as field matron, by letter of April 14, of which copy is enclosed.

You may go to Laguna at your convenience and your salary will begin when you take the oath of office and report to the Albuquerque Superintendent for duty.

You may select your own assistant after you reach Laguna; but you must notify the Superintendent who he is and when he enters on duty, so that the Superintendent may report his name to this Office and pay him his salary. It will be better to employ him by the month, then you can employ some one, temporarily, until you can find the right one for the work. Your own salary is stated by the month; but it is just the same as $720.00 per annum.

As I said in my letter of February 26th, the Office cannot pay the incidental expenses of the pottery experiment. The two salaries are all the assistance to the enterprise which it is practicable for the Office to give.

Yours respectfully,
C. F. Larrabee
Acting Commissioner.

Letter 43[49]

October 25, 1906.
Supt. Moqui Indian School,
Keams Canyon, Arizona.

Sir:

Your predecessor's letter of September 12 says that Miss Josephine Foard wished him to "purchase for her some Hopi Pottery that she may glaze and fire it and put it on exhibition and sale. She reports herself as an employe [*sic*] with the authority of the Commissioner to travel and improve the pottery."

Miss Foard has long been anxious to interest people in the East in Indian pottery, with its characteristic and artistic designs, and to make a market for the ware. But it is so fragile that it is difficult to ship it anywhere. Therefore she is trying to teach the Indian women to give their pottery a glaze that will make it more durable and hence more salable and more serviceable for some uses.

What success she can attain remains to be seen. At this time when there is so much of interest in Indian manufactures generally, the Office does not want to lose an opportunity to utilize a market for Indian wares, and therefore it has done everything practicable to forward Miss Foard's project. It is an experiment, but if it fails it will not be for lack of cordial cooperation on the part of this Office.

Miss Foard furnishes her own house at Laguna, and the Office assistance is given only in the way of her salary as field matron and the pay of an Indian youth to help in the firing. If she wants you to buy Hopi pottery for her to experiment on I see no reason why commissions of the sort should not be filled—at her expense. I should like to have her work on Hopi as well as Laguna and Acoma pottery.

Yours respectfully,
C. F. Larrabee
Acting Commissioner

Letter 44[50]

November 5, 1906.
Supt. Albuquerque Indian School,
Albuquerque, New Mexico.

Sir:

Yours of October 27 submits the request of Miss Josephine Foard, field matron, for a leave of absence which she proposes to use in visiting the East and working up an interest in Pueblo pottery.

As the Office informed her in its letter of February 12, all the Office can do to help along the project is to give her a salary as field matron and the pay of an assistant. A field matron salary can be paid her only while she is at work in the pueblo and while she takes her regular vacation. For vacation she may be allowed 30 days leave exclusive of Sundays and holidays. Leave in excess of that must be taken without pay.

Yours respectfully,
C. F. Larrabee
Acting Commissioner

Letter 45[51]

Nov. 22, 1906
Supt. Indian School,
Albuquerque, N. M.

Sir:—

In compliance with her application and your recommendation of the 10th instant, 30 days leave of absence with pay is hereby granted Miss Josephine Foard, field matron, from Nov. 29, 1906 to Jan. 5, 1907, both dates inclusive.

Yours respectfully,
C. F. Larrabee
Acting Commissioner

Letter 46[52]

November 30, 1906.
Miss Josephine Foard,
Through Supt. Albuquerque School,
Albuquerque, New Mexico.

Sir:

For the Jamestown Exposition the Office is preparing an exhibit which will show what the Government is doing for Indians, the work of the Government schools, etc., and for contrast and for decorative purposes specimens of Indian art and utensils will be wanted. Will you have, to loan, say half a dozen pieces of good Pueblo pottery which can be included in the Indian Office exhibit? I think it will attract attention and interest, and a brief statement of what you are trying to do to strengthen the pottery can be attached to the exhibit. Possibly it might be well to show both sorts of pottery—yours with inside glaze and the native pottery with no glaze at all, provided the latter can be shipped safely.

The Exposition will open April 27 and everything should be on the grounds by the latter part of March. The expense of packing and shipping will be borne by the Government.

Yours respectfully,
C. F. Larrabee
Acting Commissioner

Letter 47[53]

Jan. 15th 1907
C. F. Larrabee Esq.
Office of Indian Affairs
Washington D. C.

Dear Sir:

Since my return to Laguna I have been on the lookout for good specimens of pottery for the Jamestown Exposition in accordance with your request. It is fortunate that I had some left from former shipments because this is not the season for good pottery. I will go to Albuquerque in a few days and try to secure some Santo Domingo and other makes so as to have a variety. I can ship some that is not glazed quite safely, I have an order for Boston in February and I am glad that the Jamestown need not go so early but I would like to ship it the last of this month because of delays on trains. It most always takes three or four weeks or longer. I never had any go through in less than three weeks. Will you please give me full directions as to how and where the box is to go? Six if large will require two boxes. You said that the expense of packing and shipping would be borne by the Government. Do you mean by that that the boxes and packing material will be sent me or shall I provide them myself and the Government settle the account? I have bought boxes by the dozen and hay by the bale and find it expensive but cheaper than singly. One doz. boxes cost me nearly $14.00 but I often cut them in half when large. A bale of hay costs .75 may be a little more. Nothing can be gotten here at Laguna. My trip to New York, Boston &c I hope may be productive of good as a very great interest was created. The news papers did their part in bringing Indian pottery. Reporters amazed me by getting things some what mixed but it was pottery notice if not correct. I could have disposed of much more silverware [presumably Navajo silver jewelry] if I had been fortunate enough to have had it. I will try to work up that interest in connection with the pottery. I am making it a point to use Indian names instead of Spanish or English—for instance I say duonnē not olla for water jar.

I thank the Department of Indian Affairs for giving me this opportunity or vacation to work up this affair. I did work and with the exception of Sundays, Thanksgiving and Xmas I did not take a holiday, but there was pleasure in work and in meeting so many who expressed interest in my Indians. I wrote to Mr. Custer about the Jamestown pottery some days since.

Yours Very Respectfully
Josephine Foard
Laguna
New Mexico

Letter 48[54]

Feb. 9th 1907
Hon. F. E. Leupp
Dept. of the Interior
Washington D. C.

Dear Sir:

 I have six Indian jars ready to ship to Jamestown Exposition according to your request through Mr. Larrabee. I will send them by freight as soon as I learn from you where to send them. I will also make a brief statement regarding them as you desired. I have selected some glazed ones and some just as I bought them from the Indians getting as great a variety as I could in shapes and sizes. It is a difficult thing to get good duonnēs at this season. Had I not had some in reserve it would have been impossible. I could not select the colors that I wanted but the specimens are good. When I ship them I will send you a copy of the statement.

Yours Very Respectfully
Josephine Foard
Laguna
New Mexico

Letter 49[55]

February 27, 1907.
Miss Josephine Foard,
Laguna, New Mexico.

Madam:

 In answer to your letters of January 15 and February 9, I inclose [*sic*] one label and one set of invoices. Please have the pottery which is to go to Jamestown, securely packed, put this label on it, and send it by freight at an early day. The label should have the weight, point of shipment and contents.

 On the invoices should be written the names of all roads over which the freight is to go, ending with Norfolk and Southern. The Baltimore and Ohio and Norfolk and Western roads will probably make better deliveries at the grounds than other roads.

 The original invoice (blue) must be given to railroad agent, the duplicate (yellow) and the triplicate (pink) may be sent to Hon. J. E. Wilson, Assistant Secretary of the Interior, Washington, D. C.

 You should also notify the Office when the shipment is made.

 If you need assistance, the Superintendent of the Albuquerque School will help you in making the shipment and filling out the invoices, unless you can find some one nearer at hand to do it.

Yours respectfully,
C. F. Larrabee
Acting Commissioner

Letter 50[56]

Mar. 5th 1907
Hon. Francis E. Leupp
Office Indian Affairs
Washington D.C.

Dear Sir:

Yesterday I shipped one box of six pieces of Acoma pottery to Jamestown as directed by Mr. Larrabee, pasting on the red label as well as printing on the box the same address. Four ollas were glazed and two were just as I bought them from the Indians. There were no two alike in shape or decoration and were fine specimens I think and very securely packed. I sent the duplicate and triplicate invoice to Hon. J. E. Wilson as directed. All went off on the 4th March having gotten your address for the whole the day before, Sunday. I will write a description or rather statement of our work and forward it immediately.

Yours Very Respectfully
Josephine Foard
Laguna
N. Mex.

Letter 51[57]

March 16, 1907.
Miss Josephine Foard,
Laguna, N. Mexico.

Madam:

Yours of March 5 and 8, in regard to the shipment of Pueblo pottery to Jamestown have come to hand. I am gratified to know that you have been able to obtain such satisfactory specimens of the native art for exhibit.

At any time within the next five months you can inform the Office as to how you want the pottery disposed of at the close of the Exposition.

It will not be too late to send from New York the two other bits of pottery which you mention, provided they can reach Jamestown not later than April 20; otherwise it will be too late to install them.

I trust that your "new idea" about remedying defects in Hopi pottery will work out satisfactorily.

All the information which you give about the different specimens adds to their interest to the intelligent public. As to the explanatory card which you say Yamie is working on, let me suggest that you leave out the words "under the auspices of the Commissioner of Indian Affairs" and substitute "in a modern kiln at Laguna, N. Mex., under the supervision of Josephine Foard, field matron," or something to that effect.

Yours respectfully,
C. F. Larrabee
Acting Commissioner

Letter 52[58]

March 16th 1907
Hon. Francis E. Leupp
Dept. of the Interior
Washington D. C.
Indian Office

Dear Mr. Leupp:

I will send by express a card to be placed with the Laguna pottery briefly stating what the pottery is. You may not think it neat enough to go to the Jamestown Exposition if so, please reject it. It was done by Yamie his very first attempt at card printing, consequently the angles of the lettering are antagonistic but it is Indian. I tied some blades of amole [yucca] plants with buckskin cord to show the paint brushes used by the Indians, buckskin being a common cord used by them. I had Yamie sign his full Indian name [Yeyutetacewa] instead of Leeds. I also enclose in the package a short statement of our work. It is very brief thinking that you wished it so. But if you wish a fuller statement please write me and I will try to make it so, but you see that I am not gifted in that way. The card should have gone with the box but time was too short and I hurried it off thinking that this card could get there long before the box.

Yours Respectfully
Josephine Foard
Laguna
New Mexico

P.S. I would have liked very much to put the statement on cards, many of them, but there is no way to get material &c here. Mr. [George] Pradt kindly did that one sheet with his typewriter.[59]

Letter 53[60]

March 20, 1907.
Miss Josephine Foard,
Laguna, New Mexico.

Madam:

Yours of March 16 is just at hand in which you speak of sending by express a card made by Yamie to go with the Laguna pottery, and some other explanatory statements as to your work.

If it is not too late, please send the card and statements, with the Amole plant and cord, to this Office by *mail* instead of express. Envelopes of the right size and card for stiffening will be sent you for that purpose, if you need them. Please put on the statements whatever you think may be of interest, and the briefing and final lettering on cards can be done here.

There is no need of having these explanations here before the first of next month.

Yours respectfully,
C. F. Larrabee
Acting Commissioner

Letter 54[61]

Mar. 21st 1907
Hon. Francis E. Leupp
Dept. of the Interior
Washington D. C[.]

Dear Sir:

In reply to Mr. Larrabee's of Mar. 16th in regard to the correction of the card which Yamie printed for the Jamestown pottery I must say that I greatly regret that it has gone to you. I will put Yamie to work on another card tomorrow having him make the change suggested. It certainly is much better than my clumsy way of expressing it. The same correction should be made in the paper which I sent you. I do not know how to manage that as Mr. Pradt did it as a favor to me I cannot ask him again. I would rather have cards, many of them. I will see what may be done in Albuquerque. Yamie wishes that he had a printing press with which to do it. He learned to print at Carlisle. Will you kindly hold the card and have some one transfer the buckskin cord and paint brushes to this one? I think Yamie may do better work as I have been giving him some ideas.

Yours Very Respectfully
Josephine Foard
Laguna
N. Mex.

Letter 55[62]

March 27, 1907.
Miss Josephine Foard,
Laguna, New Mexico.

Madam:

Yours of March 21 is just at hand. When I wrote you about the large card and other cards I supposed you had not sent them. They have since been received. You need not trouble yourself to make another. All labels will be made here. Just give me the substance of what you would like on the label.

Yours respectfully,
C. F. Larrabee
Acting Commissioner

Letter 56[63]

Mar. 25th 1907
Hon. Francis E. Leupp
Dept. of the Interior
Washington D. C.

Dear Sir:

Mr. Larrabee's letter of Mar. 20th was a great comfort when he stated that the final lettering on the cards could be done in Washington for nothing can be gotten here. I had Yamie do the card over but alas poor fellow the more I tried to help the more confused or rather the less he improved but perfectly willing to do his best. Unfortunately he could not see that his letters were a variance. I send the corrected card though it is poor enough. I am quite disappointed because I wanted it to be Indian work but good. He has been out of school many years. [He graduated in 1891.] I send a little statement also of my own instead of the one that I sent some days since. I hope that it may be of some use. I would have liked it if I could have it on a dull brown tinted sheet, but feel comforted that you are to correct it and make it presentible [*sic*] at the Office.

Very Respectfully Yours
Josephine Foard
Laguna
New Mex.

I send the card in a separate wrapping.

ATTACHMENT

Indian Pottery

The Pueblo Indian pottery, an entirely native industry, made without tools, models or brushes has been thought heretofore so frail that it was not deemed advisable to put it on the market excepting as a curio.

In reality it is not so frail as it looks.

The Indians have for ages used it for carrying and holding water as well as for cooking purposes.

With buckskin cords the spoonas, or canteens, are carried on their backs by the men when going to work, and while they are working the spoonas are buried in the ground in order to keep the water cool.

We buy this pottery directly from the Indians, carefully testing it; rejecting all defective pieces. If deceived once in a while we call them seconds and sell at a lower figure. To preserve the Indian character we glaze them on the inside only and subject them to a hard fire, thus strengthening and adding to the richness of their colors.

Our object is to give the beautiful industry, which is entirely uninstructed, a commercial value in order to preserve it to the Indians as an industry, and to improve it strictly on Indian lines, encouraging them to aim higher and higher[.] To get the clay the women walk miles, then climb a rough trail to the top of a mesa, where they crawl in a small opening to dig out small pieces at a time. This they put in a bag and carry down on their heads.

Yamie Yeyutetacewa Leeds, a graduate of the Carlisle Indian School, is employed to do the kiln and general pottery work after we buy the duonnes from the women who make them. He makes the saggars, and is making artistic tiles for architectural purposes of which we hope to make a success.[64]

Other Indians may in time be employed in the pottery so that more than one may understand the management.

Until recently we have confined our efforts to the Acoma and Laguna wares, but are now introducing the Hopi, Santa Clara and Santo Domingo.[65]

So far the Acoma duonnes have stood the test of quality better than any others.

We have shipped much pottery to New York City, Philadelphia, Boston, Pittsburgh and to the Harvey Curio department at Albuquerque N. Mex. and we are arranging for new fields.

Pueblo Indian Pottery
(stamp) Josephine Foard, Laguna
New Mexico

Letter 57[66]

April 2nd 1907
Mr. C. F. Larrabee
Indian Office
Washington D. C.

Dear Sir:

I enclose a label list as requested by you. I have forgotten what I put on the jars; whatever it was it was on the bottom with prices. For my sales I always label as I have done on the enclosed list—#1–2–3–4 &c with the makers and designers—Exhibitor & address price &c. If you think best to leave off the price please do so. If nothing is to be sold of course that will be best. But all other exhibits to which I have sent make sales. I had already sent the extra card when your letter came.

Yours Respectfully
Josephine Foard
Laguna
N. Mex.

ATTACHMENT

Pottery shipped to
Jamestown Exposition

		LIST		
Number	Designer & Maker	Exhibitor	Address	Price $
# 1	Acoma Indian	Josephine Foard	Laguna N. Mexico	8.00
" 2	" "	" "	" "	6.00
" 3	" "	" "	" "	5.00
" 4	" "	" "	" "	3.50
" 5	" "	" "	" "	5.00
" 6	" "	" "	" "	4.00

Letter 58[67]

November 9, 1907.
Miss Josephine Foard,
Laguna, New Mexico.

My dear Miss Foard:

Your kind offer of October 16 to Assistant Commissioner Larrabee has been brought to my attention on my return to the Office. I am, as you know, interested in your pottery experiments at Laguna and am told that you sent some very fine jars to the Exposition.

While heartily thanking you for the offer of one of them, I feel that I must adhere to my policy of not accepting any gift from any one in the Indian Service, no matter under what circumstances it is offered. It often seems almost rude to refuse a courtesy which is extended merely as an expression of cordial good will, but I cannot wisely deviate from that policy. If you would like to have one of those glazed jars on exhibition in the Indian Office, I will gladly give it a conspicuous place. But if you can find a sale for them would you not prefer to dispose of *all* the jars in that way, so that the proceeds may be used again to promote the industry among the Pueblos?

Yours very truly,
F. E. Leupp
Commissioner.

Letter 59[68]

November 27, 1907.
Miss Josephine Foard,
Laguna, New Mexico

Dear Miss Foard:

Accept my thanks on behalf of the Office for the duonne which you have kindly said may become the property of this Office at the close of the Exposition. I have given instructions to have one of the jars sent here; the others will be shipped to #237 South 11th St., Philadelphia, as requested by you.

Yours very truly,
F. E. Leupp.
Commissioner.

Letter 60[69]

January 18, 1908.
Mr. J. C. Boykin,
Government Building "A,"
Exposition,
Norfolk, Va.

Sir:

As it has been decided that the Indian Office is not to have a representative at the Exposition to pack up its exhibit, I suppose the immediate oversight of the packing will fall to you.

I therefore send to you the instructions which otherwise would have been given to our representative, and I will ask you to be kind enough to see that all the articles are disposed of as

indicated. Few of them belong to the Indian Office, most being loans—some of considerable value. The Office is therefore especially anxious that all should be accounted for and returned to their owners unsoiled and without other injury.

A list of the articles in the exhibit is inclosed [*sic*]. This is not complete because, owing to a loss of labels during the installation of the exhibit, it became impossible to list many of the articles, especially a number of those in the case of lace and embroidery.

Please affix securely to *each article* its *label*. Sometimes the label is just laid beside the article insecurely attached to it.

The Curtis Indian photographs in the large brown frames are to be returned [illegible] Washington, D. C.

The colored photograph in decorated frame and the rug on the wall and the other decorated articles from the school go back to Carlisle.

The best piece of Pueblo pottery (in the small display case) which is *glazed inside* comes to the Indian Office. If a 2-handled one is glazed inside, save that. The others go by express to Daedalus Arts and Crafts, 237 South 11th St., Philadelphia, Pa.

The seven pieces Catawba [?] pottery and all other articles in the book case come to the Indian Office.

The frieze could be usefully taken down and rolled up and sent to the Indian Office.

The articles lent by the Hampton school should be returned to it.

The two cases of [illegible] school room work will be wanted in June and they should be sent to the Indian Office, packed for re-shipment. And with them, if the railroad will let us have it, should be the lost table, made at Carlisle on purpose to fit those cabinets.

The bark house, the horses and wagon and the settee come to the Indian Office, packed for re-shipment.

The hay baler, with its [illegible], and the model house go to Supt. Frank A. Thackery, Supt. Indian School, Shawnee, Okla.

The two large and the small cases and the column with swinging frames may be stored with other Exposition furniture belonging to the Government.

Everything not enumerated above may come to the Indian Office.

Please be particularly careful about the packing of the pottery which is even more fragile than ordinary pottery, because it is not so well baked. The plaster heads are equally fragile and should be wrapped first in tissue paper.

The embroidery and laces should be packed flat between clean *white* papers. The pillows should be put in so that the covers will not be creased. The large square basket is old and valuable and needs careful handling. The corn in it is *not* wanted.

Yours respectfully,
C. F. Larrabee
Acting Commissioner

ATTACHMENT

Crow Creek:
 1 Doll's skirt, with waist.
 1 Doll's chemise, unbleached.

 1 Doll's drawers, unbleached.

 1 Belt, with fringe, maple leaf.

 1 Sample woodwork.

Flathead:

 1 Quilt, doll's.

Miss Foard:

 6 pieces Pueblo pottery.

Letter 61[70]

March 6, 1908.

Daedalus Arts and Crafts Club,

237 South 11th Street,

Phila., Pa.

Gentlemen:

In accordance with the request of Miss Josephine Foard of Laguna, New Mexico, a box of Pueblo pottery which she sent to the Jamestown Exposition has this day been forwarded to you, by Adams Express, as per inclosed [*sic*] invoice, which please return signed.

Please acknowledge its receipt both to her and to this Office.

Yours respectfully,

C. F. Larrabee

Acting Commissioner

NOTES

Foreword

1. The pieces were transferred from the Anthropology Department to the gallery in 1978, but there are no records documenting when or from whom the department acquired them. Miss Foard donated "a valuable and interesting collection of minerals, fossils, Indian relics, Indian pottery, etc." to the now-defunct Society of Natural History of Delaware in 1901 (receipt in the possession of Mrs. John E. Berghaus), however, and the objects in the University Gallery may be part of that collection.

2. Erik Krenzen Trump, "The Indian Industries League and Its Support of American Indian Arts, 1893–1922: A Study of Changing Attitudes Toward Indian Women and Assimilationist Policy" (PhD diss., Boston University, 1996).

3. Dwight P. Lanmon and Lorraine Welling Lanmon, "Waterproofing Pueblo Pottery: The Work of Josephine Foard at Laguna Pueblo," *American Indian Art Magazine* 27, no. 4 (2002): 46–55.

4. John Berghaus was Louisa Foard Berghaus's grandson and Charles Berghaus's son. Josephine Foard addressed many of her "Letters from Among the Lagunas" to Louisa and Charles.

5. Mrs. Berghaus generously donated the letters to the School for Advanced Research.

6. Letter 15 (appendix 1).

7. See also Lorayne Ann Horka-Follick, *A Vestige of Medievalism in Southwestern United States, Los Hermanos Penitentes* (Tucson: Westernlore Press, 1987); George Wharton James, *New Mexico, Land of the Delight Makers* (Boston: The Page Company, 1920), 274–75; Charles F. Lummis, *The Land of Poco Tiempo* (1893; repr., Albuquerque: University of New Mexico Press, 1952), 62–78; and Marta Weigle, *Brothers of Light, Brothers of Blood* (Albuquerque: University of New Mexico Press, 1976), 171.

Chapter One

1. The Presbyterian Board of Home Missions sent Mary Dissette to Zuni Pueblo in 1888 to "convert and civilize" the Indians there. She stayed almost twelve years, working first as the Presbyterian mission schoolteacher, then as superintendent of the Presbyterians' Zuni Indian School, then as Bureau of Indian Affairs schoolteacher, later as a nurse during the smallpox epidemic of 1898–99, and finally as field matron. Dissette worked for the next thirty years on various aspects of Indian education, serving as superintendent of Pueblo day schools in the early 1900s, teaching at Paguate Day School (Laguna Pueblo) and Santo Domingo Pueblo Day School in the 1910s and 1920s, and working as a librarian at the Santa Fe Indian School. Later, she was employed at the U.S. Indian School in Chilocco, Oklahoma, before returning to live in Santa Fe; see Margaret D. Jacobs, *Engendered Encounters: Feminism and Pueblo Cultures, 1879–1934* (Lincoln: University of Nebraska Press, 1999), 29. She was listed in the 1910 federal census as a government teacher and resident of Paguate (Laguna Pueblo). She died in 1944.

2. Trump, "Indian Industries League and Its Support," 104–14.

3. Statement of purpose of the Indian Industries League, an organization in Boston that supported the preservation of Indian arts and crafts through direct financial aid, aiding the work of women in the field, and providing outlets for their sale, between 1893 and 1922. Indian Industries League Incorporated, *Annual Report*, Boston, 1906, 18.

4. Francis E. Leupp, *The Indian and His Problem* (1910; repr., New York: Johnson Reprint Corp., 1970), 300.

5. "Works Among New Mexico Indians in Manufacture of Pottery, Miss Josephine Foard Tells of Her Efforts to Aid the Pueblos and Find a Market for Their Wares, Aims to Teach Economy and Simplicity in Methods, Without Changing Character of Their Work," *New York Herald*, January 27, 1907, Brooklyn section; Valerie Mathes, "Nineteenth-Century Women and Reform: The Women's National Indian Association," *American Indian Quarterly* 14 (1990): 13.

6. See J. J. Brody, "The Creative Consumer: Survival, Revival, and Invention in Southwest Indian Arts," in *Ethnic and Tourist Arts: Cultural Expressions from the Fourth World*, ed. Nelson H. H. Graburn (Berkeley: University of California Press, 1976), 74–75: "Pottery dealers were . . . inhibited by their inability to discover new utilitarian purposes for the product . . . Pueblo pottery containers have no appeal to utility-minded consumers of the urban–industrial society and are useless except as decorative objects."

7. Augustine Herrman, a Czech émigré and cartographer from Prague, charted the headwaters of the Chesapeake Bay, a previously unmapped region. Cecilius Calvert, Lord Baltimore, the English proprietor of the Maryland colony, rewarded Herrman with more than four thousand acres in what is now Cecil County in recognition of his work creating the map, and Herrman named the county in his honor. Herrman called his own land Bohemia Manor. In addition to his role as cartographer, Herrman acted as a developer for the area, enticing colonists in England with the opportunity for rich land and wealth. The map, which took several years to complete, was finished in 1670 and engraved and printed in London in 1672. Although Lord Baltimore conveyed the land to Herrman, the cartographer also paid the Susquehannock Indians for it to become its legal proprietor. In 1717, Bohemia Manor became the county court and seat at "Court House Point"; see Kelly, "Finding Bohemia on the Chesapeake," *Baltimore Sun*, October 26, 2003. The map, Augustine Herrman's, "Virginia and Maryland, 1670 [1679]," is held in the map collections of the Library of Congress, MdHR C 1213–480. A map of 1838 shows that the Bohemia Manor land had been inherited and subdivided many times. (Map of Thomas G. Bradford, Maryland, 1838 [1841], Maryland State Archives.) Bohemia Manor was still recognized as an area of Cecil County, but the county seat had been relocated to Elkton, Maryland, in 1778, close to the Delaware and Pennsylvania borders.

8. U.S. Senator James Ashton Bayard, Jr. (Civil War era), and U.S. Senator Thomas Francis Bayard (who succeeded his father, was a Democratic nominee for president, and served as U.S. secretary of state) are two of many prominent Bayard family members born in Delaware, direct descendants of the Bohemia Manor Bayards and relatives of Josephine Foard. Documents and family history also identify Anna Stuyvesant, sister of Peter Stuyvesant, governor of New Amsterdam, as a Bayard ancestor.

9. Obituary of Josephine Foard's paternal uncle, Samuel Bayard Foard, *The Cecil Whig*, March 26, 1881, Cecil County Historical Society.

10. Samuel Bayard Foard, Josephine's paternal uncle, married Alice Rebecca Cochran, sister of Delaware Gov. John P. Cochran. Cecil County Historical Society, Marriage Licenses, 1777–1840; Maryland Historical Society, the Mallery Papers by Rev. Charles Payson Mallery, pastor of Presbyterian Church, Chesapeake City, Maryland; notes of Richard J. Foard, Maryland Historical Society; will of Ann B. Foard, Cecil County, Maryland, #9, pp. 293–95 names her sons Edward L., Samuel B., and Richard J. Foard.

11. Mary Ann Jefferson Henry was the daughter of a well-to-do, noted sea captain, James Henry,

originally of Appoquinimink Hundred in New Castle County, Delaware, who was involved in coastal trade from New England to Cuba and other Gulf ports. Captain Henry was married three times; he and his second wife, Ann Jefferson, had four children, including Josephine Foard's mother. Her brothers were James Jefferson Henry (who died at a very young age), James Bonaparte Henry, and John Jefferson Henry. Ann Jefferson Henry died in 1826. Captain Henry had married for the third time by 1842; the union produced three additional children. Captain Henry died on April 28, 1869, and was buried in St. George's Presbyterian Church graveyard, near Delaware City. (Obituary of Captain Maxwell, in genealogical papers, the Henry Family, the Historical Society of Delaware.)

12. Josephine's siblings went on to become prominent citizens of Delaware, Maryland, and elsewhere. Josephine's older sister, Annie Bayard Foard, married Captain Maxwell, a prominent citizen of Delaware City, sea captain, and president of the Delaware City National Bank. Josephine's brother, Richard Foard, married Mary Bowen of Cecil County. They resided in Elkton, Maryland with their two children, Annie Bayard Foard and William Foard. Richard became involved in Elkton commerce. Annie B. Foard married George Carter (b. 1865), of Smyrna originally and editor of the *Evening Journal* for many years; he also owned and managed a large vineyard in the Smyrna area. Their children were Mildred Lee Carter Affleck, Dr. Bayard F. Carter, and Dr. George Gray Carter. Both sons held Rhodes Scholarships and were graduates of the University of Delaware and Johns Hopkins University. Josephine's younger sister, Louisa Clayton Foard, married an Episcopal clergyman, Valentine Hummell Berghaus, in 1873 in Delaware City. Although the Henry family bible (in the Historical Society of Pennsylvania) does not specify Josephine's birth date, death records from the state of New Jersey attest to it. This information, and many other leads and important points, are credited to Millicent Berghaus's diligent fact-finding. The name Berghaus appears in the letters in this volume, associated with the family of Josephine Foard's sister, by marriage.

13. Mary Ann Henry Foard was listed in the 1850 federal census as a resident of Delaware City, Red Lion Hundred, with her four children. 1850 Delaware Census, New Castle County, Delaware Public Archives.

14. 1860 Delaware Census, Delaware Public Archives. Family letters written much later and family oral traditions document this separation.

15. By 1864, Mary Ann Jefferson Henry Foard was living in Pleasant Hill, Missouri (a suburb of St. Louis); she was admitted to the Centenary Methodist Episcopal Church in St. Louis in 1864. She remained there at least until 1867. A letter written to her from the president's office of the Pacific Missouri Railroad was addressed to Pleasant Hill in 1867 (Collection of Millicent Berghaus). She died on December 28, 1883, and was buried in Mason, Florida, where she had moved some years previously.

16. "Works Among New Mexico Indians in Manufacture of Pottery, Miss Josephine Foard Tells of Her Efforts to Aid the Pueblos and Find a Market for Their Wares, Aims to Teach Economy and Simplicity in Methods, Without Changing Character of Their Work," *New York Herald*, January 27, 1907, Brooklyn section.

17. Edward Levi Lingen Foard died on April 5, 1865, and was buried next to the grave of his mother, Ann Bayard Foard, in St. Augustine Cemetery, Bohemia Manor. Pea Patch Island, a Civil War prison for Confederate troops, was located in the middle of the Delaware River, opposite Delaware City.

18. This is not unusual when researching unmarried females or women before their marriages. We are often able to determine information through tax records, censuses, or other legal documents, but at this time, no further records have shed light on the thirty-year period of Foard's life. We have no letters, written records, family records, or oral traditions concerning

any possible marriage and children by Josephine Foard. In fact, she was known by her family as being totally dedicated to her work among the Pueblo Indians.

19. Letter 7 (appendix 1). Some of her early attempts at pottery are in collections in Delaware, including the Delaware State Museums and the University of Delaware's University Gallery. A small undecorated glazed bowl made by Josephine Foard, date unknown (acc. no. 1973.13.42), is in the University Gallery, University of Delaware, Josephine Foard Collection.

20. "A Work for Red Men. Miss Foard Employed by Government to Help Indian Potters," *New York Tribune*, January 7, 1907; also Henry E. Fritz, *The Movement for Indian Assimilation, 1860–1890* (Philadelphia: University of Pennsylvania Press, 1963), 202.

21. Fritz, *The Movement for Indian Assimilation, 1860–1890*, 198–99; Leupp, *The Indian and His Problem*, 307; Mathes, "Nineteenth-Century Women and Reform," 5. It was initially formed in 1879 and reorganized under other names in 1880 and 1881. The Indian Rights Association, formed in 1882 in Philadelphia, previewed its national platform at the Lake Mohonk Conference of Friends of the American Indian, first held there in 1883 and continued for about two decades; see Mark Thompson, *American Character: The Curious Life of Charles Fletcher Lummis and the Rediscovery of the Southwest* (New York: Arcade Publishing, 2001), 156.

22. Advertisement of the Indian Industries League, "Notice of Address Change," nd; Leupp, *The Indian and His Problem*, 307. The league was associated briefly with the Women's National Indian Association; it withdrew from that association in 1901 (see Indian Industries League Incorporated, Book Second, *Records*, December 1898–18 December 1903, 17, 76–78). The papers of the Indian Industries League are in the Massachusetts Historical Society in Boston.

23. Letter 15 (appendix 1).

24. Robert W. Rydell, *All the World's a Fair: Visions of Empire at American International Expositions, 1876–1916* (Chicago: University of Chicago Press, 1984), 40.

25. The idea of having replica villages may have been derived from those that were included in the World's Fair in Paris in 1889; see Curtis M. Hinsley, Jr., "The World as Marketplace: Commodification of the Exotic at the World's Columbian Exposition, Chicago, 1893," in *Exhibiting Cultures: The Poetics and Politics of Museum Display*, ed. Ivan Karp and Steven Levini (Washington DC: Smithsonian Institution Press, 1991), 348.

26. Robert A. Trennert, "Fairs, Expositions, and the Changing Image of Southwestern Indians, 1876–1904," *New Mexico Historical Review* 62, no. 2 (1987), 139.

27. Thomas J. Morgan to the secretary of the interior, February 10, 1892, National Archives and Records Administration, Washington DC, Letters Sent, Miscellaneous vol. 7, Record Group 75; *Annual Report of the Commissioner of Indian Affairs, 1891* (Washington DC: Government Printing Office, 1892), 79. Quoted in Trennert, "Fairs, Expositions, and the Changing Image," 134.

28. Curtis M. Hinsley, Jr., *Savages and Scientists: The Smithsonian Institution and the Development of American Anthropology, 1846–1910* (Washington DC: Smithsonian Institution Press, 1981), 350; Trennert, "Fairs, Expositions, and the Changing Image," 127.

29. A scale model of Ácoma Pueblo in the collection of the Peabody Museum of Archaeology and Ethnology, Cambridge, Massachusetts, may be the one displayed at the fair (catalog number 79–86–10/20433). It was modeled by photographer William H. Jackson and was purchased from him in 1879.

30. See J. J. Brody, *Beauty from the Earth: Pueblo Indian Pottery from the University Museum of Archaeology and Anthropology* (Philadelphia: University Museum of Archaeology and Anthropology, University of Pennsylvania, 1990), 63–64, figure 19.

31. Frederick Ward Putnam, draft of a speech, September 21, 1891: Frederick Ward Putnam Papers, Pusey Library, Harvard University, Cambridge, Massachusetts. Quoted in Hinsley, "The World as Marketplace," 348.

32. Congress founded the Bureau of Ethnology in 1879 as an adjunct of the Smithsonian Institution; see Jacobs, *Engendered Encounters*, chapter 2.

33. The Heye Collection is now in the National Museum of the American Indian, Smithsonian Institution.

34. For example, James Stevenson, "Illustrated Catalogue of the Collections Obtained from the Indians of New Mexico and Arizona in 1879," in *Second Annual Report of the Bureau of Ethnology*, 311–465 (Washington DC: Government Printing Office, 1883), and "Illustrated Catalogue of the Collections Obtained from the Pueblos of Zuni, New Mexico, and Wolpi, Arizona, in 1881," in *Third Annual Report of the Bureau of Ethnology*, 511–94 (Washington DC: Government Printing Office, 1884); Frank Hamilton Cushing, "A Study of Pueblo Pottery as Illustrative of Zuni Culture Growth," in *Fourth Annual Report of the Bureau of Ethnology*, 467–521 (Washington DC: Government Printing Office, 1886).

35. Jackson's 1881 *A Century of Dishonor* exposed the government's atrocities in dealing with seven different Indian tribes; her novel *Ramona* in 1884 dealt with the abuses of the Mission Indians in California.

36. Frank Hamilton Cushing, *My Adventures in Zuñi* (New York: The Century Co., 1882).

37. Among the many Lummis publications that contained compelling descriptions of the Southwest and its fascinating cultures that were published before Miss Foard journeyed west were *A New Mexico David* (1891), *Some Strange Corners of Our Country* (1891), *The Land of Poco Tiempo* (1893), and *The Spanish Pioneers* (1893).

38. Charles F. Lummis, *A Tramp Across the Continent* (1892, 1916; repr., Albuquerque: Calvin Horn Publisher, 1969), 161–62; Patrick Houlihan and Betsy Houlihan, *Lummis in the Pueblos* (Flagstaff, AZ: Northland Press, 1986), 39. Lummis also published similar descriptions of Laguna in a series of articles titled "Letters from the Southwest," which appeared in the Chilicothe, Ohio, newspaper, *The Leader*, and in the *Los Angeles Times*; see James W. Byrkit, ed., *Letters from the Southwest, September 20, 1884, to March 14, 1885* (Tucson: University of Arizona Press, 1989), 198–99.

39. Houlihan and Houlihan, *Lummis in the Pueblos*, 39.

40. Thompson, *American Character*, 184.

41. Thompson, *American Character*, 127–29.

42. Thomas Donaldson, *Extra Census Bulletin, Moqui Pueblo Indians of Arizona and Pueblo Indians of New Mexico* (Washington DC: United States Census Printing Office, 1893), 131.

43. C. S. Carter, "The Plateau Country of the Southwest and La Mesa Encantada (The Enchanted Mesa)," *Journal of the Franklin Institute* (June 1906): 456.

44. "A Work for Red Men. Miss Foard Employed by Government to Help Indian Potters," *New York Tribune*, January 7, 1907. In "This Woman Will Try to Make Indians Useful to Themselves" (*New York Times*, April 29, 1906), it was reported that "as made by the native workers it was seldom sufficiently baked—it lacked strength and it was unglazed. From experiments with the paints and clays and glazes Miss Foard [*sic*] found that the pottery would take an inside glaze where it was not painted, and that the clay with the paints would stand a thorough firing. This made the pottery more serviceable for use, strong enough to admit of transportation, and at the same time the native effectiveness was retained."

45. "Works Among New Mexico Indians in Manufacture of Pottery, Miss Josephine Foard Tells of Her Efforts to Aid the Pueblos and Find a Market for Their Wares, Aims to Teach Economy and Simplicity in Methods, Without Changing Character of Their Work," *New York Herald*, January 27, 1907, Brooklyn section.

46. *Thirty-First Annual Report of the U.S. Board of Indian Commissioners, 1899* (Washington DC: Government Printing Office, 1900), 84–85; "Works Among New Mexico Indians in Manufacture of Pottery, Miss Josephine Foard Tells of Her Efforts to Aid the Pueblos and Find

a Market for Their Wares, Aims to Teach Economy and Simplicity in Methods, Without Changing Character of Their Work," *New York Herald*, January 27, 1907, Brooklyn section. Correspondence in 1898 between Foard and the Division of Indian Affairs is recorded in the index of letters received and sent, but the actual letters are missing from the files.

47. Letter 3 (appendix 1).

Chapter Two

1. Letter 2 (appendix 1).
2. Letter 2 (appendix 1). The collection belonged to the Historical Society of New Mexico, of which Prince was president. The collection was later transferred to the Museum of New Mexico, and the Indian materials are at the Museum of Indian Arts and Culture in Santa Fe.
3. Letter 2 (appendix 1).
4. Letter 2 (appendix 1).
5. Letter 1 (appendix 1).
6. Letter 2 (appendix 1).
7. Letter 4 (appendix 1).
8. Letter 3 (appendix 1).
9. Letter 3 (appendix 1).
10. Letter 3 (appendix 1).
11. Letter 3 (appendix 1).
12. Letter 3 (appendix 1).
13. Letter 9 (appendix 1).
14. Governor Prince wrote that "though one of the smallest [Tesuque] is yet the most visited of all the pueblos, owing to its proximity to S. Fe, and the fact that it is on the list of the 'proper thing' to be seen by every tourist visiting that city." LeBaron Bradford Prince, "Tesuque," in "Note on Pueblos, 1906–1918." Box 14020, folder 16, 1, LeBaron Bradford Prince Papers, ca. 1885–90, New Mexico State Library.
15. George Dorsey, *Indians of the Southwest* (n.p.: George T. Nicholson, Passenger Department, Atchison Topeka & Santa Fe Railway System, 1903), 41–42.
16. Hyman Lowitzki bought out Jake Gold's curio store in Santa Fe in 1899. Bertha Fisher to cousin H. L. (Hyman Lowitzki), October 24, 1899, Jake Gold Papers, Fray Angélico Chavez History Library and Photographic Archives, Santa Fe, New Mexico.
17. Prince, "Tesuque," 1.
18. Letter 4 (appendix 1).
19. Letter 4 (appendix 1); Duane Anderson, *When Rain Gods Reigned: From Curios to Art at Tesuque Pueblo* (Santa Fe: Museum of New Mexico Press, 2002).
20. See Jonathan Batkin, *Clay People* (Santa Fe: Wheelwright Museum of the American Indian, 1999), for a discussion of the history of Pueblo figural pottery. See Anderson, *When Rain Gods Reigned*, for a comprehensive description of the history of making and marketing "rain gods."
21. Letter 21 (appendix 2).
22. Letter 4 (appendix 1).
23. Letter 5 (appendix 1). Although an Episcopalian, she boarded with the Presbyterian missionary because the latter Protestant faith was established at Laguna, while the Episcopalian was not.
24. Letters 10 and 19 (appendix 1).
25. Letter 10 (appendix 1).
26. Letter 11 (appendix 1)
27. Letters 7 and 10 (appendix 1).
28. Letter 26 (appendix 1).
29. Letter 6 (appendix 1).

30. "This Woman Will Try to Make Indians Useful to Themselves," *New York Times*, April 29, 1906. Zaweta *may* have been the potter who made a small white-decorated red jar that Miss Foard glazed (see plate 3). Miss Foard also mentioned Yiwite, whom she identified as an Ácoma potter, in the article "Pueblo Indian Pottery: Josephine Foard," printed by the Indian Industries League, Boston (n.d., n.p.), reprinted from the *Southern Workman*, about 1907–8.

31. He has been identified as the father of Hiuwec, the Laguna tribal council secretary who negotiated the agreement with the Atlantic and Pacific Railroad for traversing Laguna Pueblo land in 1880. At the time of those negotiations, Lorenzo was said to be away, "actively pursuing parties of Apache and Navajo raiders"; see Kurt Michael Peters, "Watering the Flower: Laguna Pueblo and the Santa Fe Railroad, 1880–1943," in *Native American and Wage Labor, Ethnohistorical Perspectives*, ed. Alice Littlefield and Martha C. Knack (Norman: University of Oklahoma Press, 1996), 181.

32. Letter 11 (appendix 1).

33. Letter 14 (appendix 1).

34. Letter 13 (appendix 1).

35. Letter 6 (appendix 1).

36. Letter 29 (appendix 1).

37. Letter 9 (appendix 1).

38. Letter 31 (appendix 1).

39. Letter 9 (appendix 1).

40. Letter 16 (appendix 1).

41. Stereopticon, "Art as understood by Pueblo Indian Women," published by the Keystone View Company, Meadville, Pennsylvania, number V23208. Copy at National Anthropological Archives, Smithsonian Institution (cat. No. NAA INV 09918300).

42. Letter 6 (appendix 1).

43. Her request on April 30, 1899, is referred to in a letter of May 31 from the U.S. Indian agent in Santa Fe (letter 1a, appendix 2), but her original letter is missing from the Office of Indian Affairs correspondence files. Any earlier correspondence is also missing. The location of the property is described in Letter 1a (appendix 2).

44. Four letters, dated between May 31 and July 13, 1899, detail the offer of land (letters 1–4, appendix 2).

45. Letter 20 (appendix 1).

46. Letter 21 (appendix 1). The five-dollar annual rental fee is mentioned in Board of Indian Commissioners, *Thirty-First Annual Report of the Board of Indian Commissioners to the Secretary of the Interior, 1899* (Washington DC: Government Printing Office, 1900), 85.

47. Letter 21 (appendix 1).

48. Letter 21 (appendix 1).

49. Letters 21 and 22 (appendix 1).

50. Letter 22 (appendix 1).

51. Letter 22 (appendix 1).

52. Molly H. Mullin, *Culture in the Marketplace: Gender, Art, and Value in the American Southwest* (Durham, NC: Duke University Press, 2001), 74; Jacobs, *Engendered Encounters*, 26.

53. Letter 25 (appendix 1).

54. Letter 25 (appendix 1).

55. Letter 24 (appendix 1).

56. Letter 26 (appendix 1).

57. Letter 26 (appendix 1).

58. Letter 26 (appendix 1).

59. Letter 26 (appendix 1).

60. Letter 27 (appendix 1).

61. Letter 28 (appendix 1).

62. A photograph of the same house is reproduced in a 1910 article by Francis E. Leupp, where it is identified as "Miss Foard's adobe home and pottery at Laguna, N. M." The same house is shown in the article in the *New York Herald*, January 27, 1907, where it was captioned "Kiln for Baking Pottery." In another article, "Pueblo Indian Pottery," which Miss Foard wrote, the same building is identified simply as "A Pueblo Home."

63. The authors have identified neither the remains of the house nor the kiln at Laguna.

64. Board of Indian Commissioners, *Thirty-First Annual Report*, 85.

65. The California Limited was the star train of the ATSF. Service began on November 27, 1892, and it ran daily, east and west, between Chicago and Los Angeles, for nearly four years. It was occasionally discontinued, and the frequency of service changed. While Miss Foard was at Laguna, it ran two, three, or four times a week in both directions; see James Marshall, *The Railroad That Built an Empire* (New York: Random House, 1945), 380.

66. Letter 31 (appendix 1).

67. Letter 32 (appendix 1).

68. Letter 32 (appendix 1).

69. Letter 15 (appendix 1).

70. Letter 32 (appendix 1).

71. Letter 33 (appendix 1), alluding to H. W. Longfellow's "Song of Hiawatha."

72. Letter 34 (appendix 1).

73. Charles Berghaus (Miss Foard's nephew) was confirmed at Trinity Church in Athens, Pennsylvania, in 1898. Millicent Berghaus, personal communication to Lanmons, August 10, 2005.

74. Letter to former Governor Prince, June 8, 1906 (Letter 36, appendix 1).

75. The drawings have not been found.

76. Letters 6, 7, 9 (appendix 2).

77. Paul Weideman, "All Aboard—at Lamy Station," *Santa Fe Real Estate Guide, Santa Fe New Mexican*, December 2005, 22.

78. Letter 11 (appendix 2).

79. Letter 11 (appendix 2).

80. Letter 11 (appendix 2).

81. Letters 12–20 (appendix 2).

82. Letters 18 and 19 (appendix 2).

83. Letter 21 (appendix 2).

84. Letter 19 (appendix 2).

85. Letter 22 (appendix 2).

86. Peters, "Watering the Flower," 186.

87. Letter 25 (appendix 2).

88. SAR, IARC, catalog card and Indian Arts Fund record book, IAF.1458, School for Advanced Research, Santa Fe.

89. Letter 25 (appendix 2).

90. Letters 25 and 31 (appendix 2).

91. Letter 25 (appendix 2).

92. Letter 31 (appendix 2).

93. It is not evident to the authors why the second firing was required.

94. Letter 26 (appendix 2).

95. Letter 24 (appendix 2).

96. Letter 28 (appendix 2). We speculate that the number of visits was either grossly exaggerated

or is an error. To make that number of visits would require making the 23 1/2 mile round trip nearly three times a day.

97. Letters 50 and 57 (appendix 2).

98. Letters 24–26 (appendix 2).

99. Letter 25 (appendix 2).

100. J. K. Allen to McCowan, Albuquerque Indian School April 24, 1904: "I have had some difficulty in securing the pottery makers to make the trip; the Miss Foard you had been corresponding with befuddled matters somewhat; I came from Acoma yesterday; two or three families promised me faithfully that they would go; one of the women only is a good pottery maker; one is a painter and two others are bread makers. The bread is the same as the Moki [Hopi] piki call paper bread. I think the grinding of the meal and making of the bread will be a curiosity. There is another family that are half inclined to go, who are good pottery makers. I will wire you in two or three days when I will start." Chilocco Indian School, Fair Correspondence, Box 219, April 1904, Oklahoma Historical Society, Oklahoma City, collected May, 2001. Courtesy of Nancy J. Parezo.

101. Letter 31 (appendix 2).

102. Letter 31 (appendix 2).

103. Letter 31 (appendix 2).

104. Letter 32 (appendix 2). It is uncertain why or with whom she was living in Flushing. She may have been with her niece, Anne, and her husband George Carter, or another relative.

105. "This Woman Will Try to Make Indians Useful to Themselves," *New York Times*, April 29, 1906.

106. Indian Industries League Incorporated, *Annual Report*, Boston, 1906, 6.

107. Indian Industries League Incorporated, *Annual Report*, Boston, 1905, September 28.

108. Letters 33 and 34 (appendix 2).

109. Letters 35 and 36 (appendix 2).

110. Letters 36–38 (appendix 2).

111. Josephine Foard was residing at the Berghaus family home in Harrisburg in 1905 (letter 38, appendix 2). The Berghaus family homestead was in Harrisburg. Valentine Berghaus was ordained in St. Steven's Church there in 1872. He established the church in Lykens, Pennsylvania, in 1872, was at St. Paul's Church in Doylestown, Pennsylvania (1876–83), Trinity Church in Chambersburg, Pennsylvania (1884–93), Trinity Church, Athens, Pennsylvania (1895–1901?), was living at the family homestead in Harrisburg by 1904, and was there at least until 1908. He died on March 22, 1910. Charles Berghaus, Valentine's and Louisa's son, was born in Carlisle, Pennsylvania, in 1884 and was baptized there in St. John's Church. He attended Princeton and Philadelphia Divinity School. Millicent Berghaus, letters to Lanmons, August 10, 2005 and August 24, 2005.

112. Indian Industries League Incorporated, *Annual Report*, Boston, March 1, 1906, and January 1907.

113. Letter 39 (appendix 2).

114. Letters 40–42 (appendix 2).

115. Indian Industries League Incorporated, *Annual Report*, Boston, 1906.

116. Indian Industries League Incorporated, *Annual Report*, Boston, 1907, 7.

117. Josephine Foard to Governor Prince, June 8, 1906 (letter 36, appendix 1).

118. Letter 43 (appendix 2).

119. Letter 43 (appendix 2).

120. Letters 44 and 45 (appendix 2).

121. Indian Industries League Incorporated, Book Third, *Records*, September 27, 1906.

122. "A Work for Red Men. Miss Foard Employed by Government to Help Indian Potters," *New York Tribune*, January 7, 1907; "Works Among New Mexico Indians in Manufacture of Pottery, Miss Josephine Foard Tells of Her Efforts to Aid the Pueblos and Find a Market for Their

Wares, Aims to Teach Economy and Simplicity in Methods, Without Changing Character of Their Work," *New York Herald*, January 27, 1907, Brooklyn section.

123. Miss Foard showed both Indian pottery and silver jewelry at the exhibition, which ran December 3–15, 1906; see Eva Lovett, "The Exhibition of the National Society of Craftsmen," *International Studio* 30 (1906): lxxv, and Annia M. Jones, ed., "Arts and Crafts Department, The National Society of Craftsmen," *The Scrip* 2 (1907): 124–25.

124. In an article about Miss Foard ("Pueblo Indian Pottery, Josephine Foard," n.d., n.p.), she says that "it is positively the first place where Indian pottery has been glazed since the art was lost in prehistoric times." Miss Foard's comments about glazing not being done since prehistoric times indicate she was aware of the Pueblo Glaze wares made from the 1200s to about 1700.

125. "A Work for Red Men. Miss Foard Employed by Government to Help Indian Potters," *New York Tribune*, January 7, 1907.

126. The National Arts Club in collaboration with the National Society of Craftsmen, *Catalogue, Arts and Crafts Exhibition, November twentieth to December eleventh, 1907* (New York: National Society of Craftsmen, 1907), 1.

127. Letter 47 (appendix 2).

128. "Announcement of salesroom openings," Indian Industries League Incorporated, *Annual Report*, Boston, 1907, 9.

129. This statement appears in two public announcements that were probably printed in January 1907, when the league opened its shop at 9 Hamilton Place, Boston. The same statement appears again in an announcement that was probably printed in November 1907. Indian Industries League Incorporated, *Annual Report*, Boston, 1907, 9; "Announcement of salesroom openings," and "The Indian Industries League" (printed announcement of the sales shops, amended twice by hand).

130. February 1907, at 9 Hamilton Place
 November 1907, at 15A Beacon Street, next to the Bellevue Hotel
 January 1908, at 2A Park Street (upstairs)
 November 1908–June 1909, at popular summer resorts, notably Lake Mohonk
 December 1909, at 2 Park Street (1st floor)
 January 20, 1910, closed stores after selling Indian goods for sixteen years.
 See Indian Industries League, *Annual Reports*, Boston, 1907–11.

131. Letter 46 (appendix 2).

132. Letters 46–51 (appendix 2).

133. Miss Foard makes a point in her letters of calling ollas by the Keres word for the form, which she consistently spells duonne. According to Wick Miller, the correct phonetic spelling is dyuúni; it refers exclusively to a container for storing water in the house; see Robert R. Gill, "Ceramic Arts and Acculturation at Laguna," in *Ethnic and Tourist Arts: Cultural Expressions from the Fourth World,* ed. Nelson H. H. Graburn (Berkeley: University of California Press, 1976), 107.

134. A tile made by Yamie Leeds is shown in plate 14.

135. See plates 4 and 5 for examples of Hopi pottery Miss Foard glazed. No examples of Santa Clara or Santo Domingo pottery Miss Foard glazed are known to the authors.

136. Her sale of glazed Pueblo pottery in Pittsburgh is otherwise undocumented. See plate 9 for a piece of glazed pottery that may have been sold through one of the Fred Harvey Company stores.

137. Letter 13 (appendix 1).

138. Letters 60 and 61 (appendix 2). The authors have not located the jar.

139. Trump, "Indian Industries League and Its Support," 226–27, citing the Indian Industries League Incorporated, Book Fourth, *Records*, March 1, 1909, 177.

140. For a discussion of the chronology of the Indian Industries League's sales of Indian goods, see Trump, "Indian Industries League and Its Support," 244–53.

141. She remained a league member until 1915. Trump, "Indian Industries League and Its Support," 227, citing Indian Industries League Incorporated, Book Third, *Records*, May 5, 1911, 231, and Book Fourth, *Records*, January 20, 1915, 2.

142. Federal census, 1920, family number 118.

143. Betty Toulouse, *Pueblo Pottery of the New Mexico Indians: Ever Constant, Ever Changing* (Santa Fe: Museum of New Mexico Press Guidebook, 1977), 43.

Chapter Three

1. Marc Simmons, "History of Pueblo-Spanish Relations to 1821," in *Handbook of North American Indians, Southwest*, ed. Alfonso Ortiz (Washington DC: Smithsonian Institution Press, 1979), 9:178–81.

2. Simmons, "History of Pueblo-Spanish Relations to 1821," 9:181; Albert H. Schroeder, "Pueblos Abandoned in Historic Times," in *Handbook of North American Indians, Southwest*, ed. Alfonso Ortiz (Washington DC: Smithsonian Institution Press, 1979), 9:239.

3. Florence H. Ellis, "Laguna Pueblo," in *Handbook of North American Indians, Southwest*, ed. Alfonso Ortiz (Washington DC: Smithsonian Institution Press, 1979), 9:438.

4. Simmons, "History of Pueblo-Spanish Relations to 1821," 9:191–92.

5. Kurt Michael Peters, "Watering the Flower: The Laguna Pueblo and the Atchison, Topeka and Santa Fe Railroad" (PhD diss., University of California, 1994), 178; Patricia James Broder, *Shadows on Glass: The Indian World of Ben Wittick* (Savage, MD: Rowman and Littlefield, 1990), 163.

6. Marshall, *The Railroad That Built an Empire*, 168; Frederick E. Hoxie, *A Final Promise: The Campaign to Assimilate the Indians, 1880–1920* (Lincoln: University of Nebraska Press, 1984), 43.

7. Hoxie, *A Final Promise*, 143.

8. See Jacobs, *Engendered Encounters*, 11.

9. Dorsey, *Indians of the Southwest*, 23.

10. Cheryl J. Foote, *Women of the New Mexico Frontier, 1846–1912* (Niwot: University of Colorado Press, 1990), xiii–xiv.

11. Presbyterian Historical Society, *American Indian Correspondence, the Presbyterian Historical Society collection of missionaries' letters, 1833–93*, Box L, letter 290, William F. M. Arny, secretary and acting governor of New Mexico, to Rev. J. C. Lowrie, 1872, 1, 2; see also Foote, *Women of the New Mexico Frontier, 1846–1912*, xiv. In Letter 23 (appendix 1), Miss Foard uttered her own criticism of the Roman Catholic priests and their record of educating the Pueblo Indians. She repeated a story of a Spanish priest at Ácoma who, pursued by the natives and facing death, leaped several hundred feet from the top of the mesa where the village was located. As she recounted the seemingly miraculous event, "to the amazement of all, he escaped with little injury, owing to the umbrella and robes, which broke the force of the fall.... The Indians considered that the priest had been preserved through some enchantment, and received him in their midst, accepting his faith as far as outward form is concerned. He lived among them fourty [*sic*] years. One cannot help thinking that it might have been better for the Acomas if the priest had perished, for Spanish teachings and superstitions, combined with his heathen practices have held the Pueblos in thrall and prevented their receiving better things."

12. Flora Warren Seymour, *Indian Agents of the Old Frontier* (New York: Appleton Century Co., 1941), 202.

13. Francis Paul Prucha, *The Churches and the Indian Schools, 1888–1912* (Lincoln: University of Nebraska Press, 1979), 689, and *The Great Father: The U.S. Government and the American Indian*. Lincoln: University of Nebraska Press, 1984), 689; Leah Dilworth, *Imagining Indians in*

the Southwest: Persistent Visions of a Primitive Past (Washington DC: Smithsonian Institution Press, 1996), 13, 28–29; Hoxie, *A Final Promise*, 488; Jacobs, *Engendered Encounters*, 10.

14. The last Indian student graduated in 1923. Hampton Normal and Agricultural Institute is now Hampton University.

15. Lottie Atsye is the only Laguna person whom we have documented as attending the Hampton School (see chapter 5).

16. Pratt served in the army from the time of the bombardment of Fort Sumter in 1861 until 1865. He reenlisted in 1867 and was sent to Fort Arbuckle in the Indian Territory, serving in the Indian Territory and Texas for eight years. Pratt was appointed second lieutenant in the Tenth U.S. Cavalry in 1867 and received brevet ranks of first lieutenant and captain for bravery during the American Civil War. Thereafter, he was addressed as Captain. He received official promotion to first lieutenant later in 1867. After taking up the post at Carlisle, he was promoted to captain in 1883, major in 1898, lieutenant colonel in 1901, colonel in 1903, and retired from the cavalry later in 1903. He was advanced to brigadier general by act of Congress in 1904. Pratt served as the Carlisle School's first superintendent, from 1879 to 1903; see Richard Henry Pratt, *Battlefield and Classroom: Four Decades with the American Indian, 1867–1904*, ed. Robert M. Utley (New Haven: Yale University Press, 1964), x.

17. Board of Indian Commissioners, *Thirty-Second Annual Report of the Board of Indian Commissioners to the Secretary of the Interior, 1900* (Washington DC: Government Printing Office, 1901), 12. Operation of the Carlisle School continued until 1918, when the Bureau of Indian Affairs closed it. The primary source of information about the Carlisle School is Pratt, *Battlefield and Classroom*, ix–xviii, 218; see also Hoxie, *A Final Promise*, 54–57.

18. The Presbyterians opened an Indian boarding school in Albuquerque in 1881. When the government took it over in 1884, the Presbyterians opened a second boarding school there. Mark T. Banker, *Presbyterian Missions and Cultural Interaction in the Far Southwest, 1850–1950* (Urbana: University of Illinois Press, 1993), 125. The United States Industrial Training School was founded at Lawrence, Kansas, in 1884. Today, it is the Haskell Indian Nations University.

19. Margaret Connell Szasz, *Education and the American Indian, The Road to Self-Determination Since 1928*, 2nd ed. (Albuquerque: University of New Mexico Press, 1977), 10.

20. Banker, *Presbyterian Missions and Cultural Interaction*, 126.

21. Banker, *Presbyterian Missions and Cultural Interaction*, 124.

22. Board of Indian Commissioners, *Thirty-Second Annual Report*, 68–69.

23. Mary Perry, student number 2899, entered the Carlisle School on July 31, 1880, and was discharged in 1884. She entered the school a second time, on August 24, 1884, and was discharged in 1886. She spent two summers in the "outing" system, in 1881 in Cumberland, Pennsylvania, and in 1882 in Range, New York. Benjamin Thomas, student number 5250, also entered the Carlisle School on July 31, 1880, and was discharged on June 17, 1884. He spent the summer of 1883 in the "outing" program, in Langhorne, Bucks Country, Pennsylvania. He reentered the school on October 31, 1886, and was discharged on July 8, 1889; he spent the summer of 1887 in Middlesex, Cumberland County, Pennsylvania, and three months of 1888 in Penns Park, Bucks County, Pennsylvania. He entered the school a third time on August 24, 1889, and was discharged in September 1890. The Carlisle School records for John Chaves have not been located, but he was also enrolled there in 1880.

24. Quoted in Leupp, *The Indian and His Problem*, 122.

25. Quoted in *The Indian Helper, A Weekly Letter from the Carlisle Indian Industrial School to Boys and Girls* 5, no. 5 (July 11, 1890), 2.

26. Quoted in *The Indian Helper, A Weekly Letter from the Carlisle Indian Industrial School to Boys and Girls* 5, no. 8 (August 1, 1890), 1.

27. David Wallace Adams, *Education for Extinction: American Indians and the Boarding School*

Experience, 1875–1928 (Lawrence: University of Kansas Press, 1995).

28. Paraphrased from an address by Inspector Haworth to the annual meeting of the Education Association's Department of Superintendence in 1884. Quoted in Hoxie, *A Final Promise,* 63.

29. Herman ten Kate relates a story of a Zuni girl who in 1883, upon returning home from the Carlisle School, found the living conditions so foreign that she lived at first with Frank Hamilton Cushing, the ethnologist from the Bureau of Ethnology in Washington, and his wife. Within a few weeks, however, social pressure caused her to give up her "American" clothing and speech, and she resumed tribal life; see Herman F. C. ten Kate, *Travels and Researches in Native North America, 1882–1883,* trans. and ed. Pieter Hovens, William J. Orr, and Louis A. Hieb (Albuquerque: University of New Mexico Press, in cooperation with the University of Arizona Southwest Center, 2004), 289.

30. Edward Everett Dale, *The Indians of the Southwest: A Century of Development under the United States* (Norman: University of Oklahoma Press, 1949), 193–94.

31. Szasz, *Education and the American Indian,* 10.

32. Board of Indian Commissioners, *Thirty-Second Annual Report,* 68–69.

33. *The Indian Helper, A Weekly Letter from the Carlisle Indian School* 6, no. 12 (November 21, 1890), 2. James Miller was interviewed by Thomas Donaldson in 1890. His comments are quoted in Donaldson, *Extra Census Bulletin,* 443, where he is not identified by name, and Thomas Donaldson, *Report of Indians Taxed and Not Taxed in the United States Except Alaska at the Eleventh Census 1890* (Washington DC: United States Census Printing Office, 1894), 126, where he is.

34. Banker, *Presbyterian Missions and Cultural Interaction,* 125.

35. Robert M. Kvasnica and Herman J. Viola, eds., *The Commissioner of Indian Affairs, 1824–1977* (Lincoln: University of Nebraska Press, 1979), 224; Szasz, *Education and the American Indian,* 10–11.

36. Donaldson, *Extra Census Bulletin,* 131, n.a.

37. Donaldson, *Extra Census Bulletin,* 130.

38. See Trump, "Indian Industries League and Its Support," for a detailed discussion on the change of philosophy among the leadership of the Indian Industries League.

39. Letters 1, 5, 6, 14, 18, 19, 31 (appendix 1)

40. Letter 6 (appendix 1). The story of a Pueblo girl who had attended the Carlisle School and received beatings because she would not attend dances is told in Embe's *Stiya, A Carlisle Indian Girl at Home* (Cambridge, MA: Riverside Press, 1891), a book Miss Foard probably knew about and may have read. James and Helen Styia were Laguna Pueblo residents (husband and wife, ages twenty-four and twenty-one, respectively; 1904 Pueblo Census, Laguna, persons number 71 and 72). Whether Helen Styia was the model for the Pueblo girl, "Stiya," is unknown.

41. Letter 6 (appendix 1).

Chapter Four

1. Ellis, "Laguna Pueblo," 9:448; Bertha P. Dutton and Miriam A. Marmon, "The Laguna Calendar," in *The Archaeological Survey of the Pueblo Plateau, Report of the State Archaeological Survey of New Mexico,* ed. Reginald G. Fisher, *Bulletin,* University of New Mexico Anthropological Series 1(1), no. 177 (1930): 3.

2. Florence H. Ellis, "An Outline of Laguna Pueblo History and Social Organization." *Southwestern Journal of Anthropology* 15 (1959): 326, and "Laguna Pueblo," in *Handbook of North American Indians, Southwest,* ed. Alfonso Ortiz (Washington DC: Smithsonian Institution, 1979), 9:439–40.

3. Broder, Shadows on Glass, 153; Ellis, "Outline of Laguna Pueblo History," 328, and "Laguna Pueblo," 9:438, 443.

4. Broder, *Shadows on Glass*, 150, 153; Ellis, "Laguna Pueblo," 9:438; Stanley M. Hordes, "Ethnic Influences on the Pueblos of Ácoma and Laguna: 1680–1880" (preliminary typescript, Indian Arts Research Center, School of American Research, [1986]), 7–8; Elsie Clews Parsons, *Pueblo Indian Religion* (Chicago: Chicago University Press, 1939), 2:888; Lummis, *The Land of Poco Tiempo*, 50.

5. Ellis, "Outline of Laguna Pueblo History," 325.

6. Parsons, *Pueblo Indian Religion*, 2:888.

7. Hordes, "Ethnic Influences," 14, 17–18.

8. Ellis, "Outline of Laguna Pueblo History," 327, and "Laguna Pueblo," 9:438.

9. The populations of individual Laguna villages were not itemized in the 1900 federal census. The populations of the villages listed in the 1904 Pueblo Indian Census Rolls were as follows: (Old) Laguna 314, Paguate 403, Encinal 106, Casa Blanca 100, Mesita 93, Paraje 133, and Seama 219.

10. Students who went to school in the East humorously named the "suburbs" of the Pueblo "New York," "Philadelphia," and "Harrisburg"; see Robert Julyan, *The Place Names of New Mexico* (Albuquerque: University of New Mexico Press, 1996), 194.

11. Frederick Webb Hodge, ed., *Handbook of American Indians North of Mexico; 30th Bulletin of the Bureau of American Ethnology* (Washington DC: Government Printing Office, 1907–10), 752.

12. Rick Dillingham, with Melinda Elliott, *Acoma and Laguna Pottery* (Santa Fe: School of American Research Press, 1992), 174.

13. Federal census figures for 2000 list 3,815 residents in the six Laguna villages.

14. In Letter 7 (appendix 1), Miss Foard also observed the moccasin-worn paths. "In going to the pueblo we took pleasure in following the trail. No danger of loosing [*sic*] it because it is a path worn in the rocks by the constant tread of moccasins for ages, generation after generation. It is deep, and so very narrow that it is hard for me to keep step in it. I do not see how it was possible to form and keep so narrow a path."

15. LeBaron Bradford Prince Papers, ca. 1885–90, New Mexico State Library, acc. no. 1959–74.

16. Parsons, *Pueblo Indian Religion*, 2:888; Ellis, "Laguna Pueblo," 9:444.

17. Hodge, *Handbook of American Indians North of Mexico*, 752.

18. According to Hodge, *Handbook of American Indians North of Mexico*, 752, Pueblo tradition identified the origins of the clans as follows:
 From Ácoma: the Bear, Eagle, Turkey, and Corn clans, along with some members of the Coyote clan.
 From Zuni: the Badger, Parrot, Chaparral-Cock [Roadrunner], and Antelope clans, along with some members of the Coyote clan.
 Probably from San Felipe: the Sun people.
 From Zia: the Water-snake clan.
 Probably from Oraibi: the Rattlesnake clan.
 From Sandia: the Wolf and Turquoise clan.
 From Jemez: the Earth clan.
 From Mount Taylor: the Mountain Lion and Oak clans.
 Unknown origin: the Lizard clan.

19. Parsons, *Pueblo Indian Religion*, 2:888.

20. Alice Alta Blake, *Presbyterian Mission Work in New Mexico: Memoirs of Alice Alta Blake* (Canyon, TX: Aquamarine Publishers, 1997), 7.

21. Blake, *Presbyterian Mission Work in New Mexico*, 7; Foote, *Women of the New Mexico Frontier, 1846–1912*, 12; John M. Gunn, *Schat-Chen, History, Traditions and Narratives of the Queres Indians of Laguna and Acoma* (Albuquerque: Albright and Anderson, 1917), 93; Jacobs, *Engendered Encounters*, 10. Gunn states that Gorman was recalled "shortly after the outbreak of the Civil War"; *Schat-Chen*, 93.

22. Donaldson, *Extra Census Bulletin*, 122. The building still stands but has lost its crenellations. It is known in the pueblo as the "smoke house," because it serves as a meeting space for the pueblo, especially its tribal councils. Elizabeth Wacondo, Laguna Pueblo, personal communication to authors, November 28, 2003. Other views of it were published in James, *New Mexico, Land of the Delight Makers*, opp. 418, and *Recording a Vanishing Legacy: The Historic American Buildings Survey in New Mexico, 1933-Today* (Santa Fe: Museum of New Mexico Press, 2001), 96–97, where sectional drawings of the building are reproduced, drawn in 1934 as part of the Historic American Buildings Survey.

23. W. W. H. Davis, *El Gringo: Or, New Mexico and Her People* (1857; repr., Chicago: The Rio Grande Press, 1962), 223–24; also quoted in Donaldson, *Extra Census Bulletin*, 121, n.a. An estufa is a ceremonial structure; it is usually called a kiva in eastern pueblos. Estufas are generally larger than kivas and are usually built aboveground; see William Webb and Robert A. Weinstein, *Dwellers at the Source: Southwestern Indian Photographs of A. C. Vroman, 1895–1904* (New York: Grossman Publishers, 1973), 145.

24. They paid him fifty dollars a month, but he petitioned the Board of Missions for an additional six hundred dollars per year. He wrote to the Presbyterian Board of Missions that "I find that the compensation allowed me is barely sufficient to sustain life nothing more, and unless other assistance be given me I will be compelled to give up my charge and seek other employment, notwithstanding the interest I feel in the work and the unbounded confidence placed in me by the Indians with whom I have become identified. Not only as a teacher but also as a counselor in all subjects connected with their interests." Presbyterian Historical Society, *American Indian correspondence*, Box M, letter 161, Walter Gunn Marmon to Rev. C. J. Lowrie, June 25, 1873. The U.S. Indian agent, Owen Cole, was asked to endorse Marmon's request. He did so, adding that "from my personal knowledge of Mr. W. G. Marmon and the good work in which he is engaged in Laguna Pueblo I would earnestly recommend that all he asks for, in this letter, from the Presbyterian Board of Missions be granted for I know him to be worthy of the same. During the year and a half he has been engaged as a teacher in said Pueblo he has attained greater success than any other who has ever attempted this work. He has the entire confidence of the Inds [Indians] in his Pueblo and has made himself necessary to them." Presbyterian Historical Society, *American Indian correspondence*, Box M, letter 161, First Endorsement to Rev. C. J. Lowrie, June 28, 1873; also see Seymour, *Indian Agents of the Old Frontier*, 202–3; Gunn, *Schat-Chen*, 96; Parsons, *Pueblo Indian Religion*, 2:888; Ellis, "Laguna Pueblo," 9:447; Broder, *Shadows on Glass*, 153; and Presbyterian Historical Society, *American Indian correspondence*, Box M, letter 161.

25. Lawrence R. Murphy, *Frontier Crusader—William F. M. Arny* (Tucson: University of Arizona Press, 1972), 191.

26. S. C. Armstrong, *Report of a Trip Made in Behalf of the Indian Rights Association, to Some Indian Reservations in the Southwest* (Philadelphia: Office of the Indian Rights Association, 1884), 14; Banker, *Presbyterian Missions and Cultural Interaction*, 62, 196.

27. Ruth K. Barber and Edith J. Agnew, *Sowers Went Forth, The Story of Presbyterian Missions In New Mexico and Southern Colorado* (Albuquerque: Menaul Historical Library of the Southwest, 1981), 24; Gunn, *Schat-Chen*, 97; Banker, *Presbyterian Missions and Cultural Interaction*, 62.

28. Banker, *Presbyterian Missions and Cultural Interaction*, 27.

29. Kate, *Travels and Researches in Native North America*, 240.

30. It was reported that he printed 3,875 pages on his press in the first eight months after buying the press (see catalogue information for Laguna Mission Press Collection, Center for Southwest Research, University of New Mexico, Albuquerque, New Mexico); see also Gunn, *Schat-Chen*, 97; Barber and Agnew, *Sowers Went Forth*, 24; Banker, *Presbyterian Missions and*

Cultural Interaction, 63; Kate, *Travels and Researches in Native North America*, 21. Miss Foard, however, casts doubt on the veracity of Menaul's claim to have translated English into Keres. In a letter to former New Mexico Governor Prince, she reported that she made "inquiries about the school books of which you asked. Mr. Pradt who knows all about Laguna says that there were none printed that Dᴿ Menaul had a song book for the church meetings printed and a catechism also in the same binding. But that he himself nor any one could translate it. The only way Dᴿ Menaul could read it was because the English was on the opposite page. In fact it was not Indian at all but a corrupt Spanish. He preached to the Indians in the same language and the poor Indians did not understand a word of it. This Mr. Pradt says was the only book printed here." (Letter 36, appendix 1, Josephine Foard to Governor Prince, June 8, 1906.)

31. Donaldson, *Extra Census Bulletin*, 128–29, reported that "the Presbyterian school [at Zuni] is doing well, even better than ought to be expected. Were the energetic teachers, Miss De Sette [Disette] and Miss Pond, upheld by the usual force back of a government school, their school, no doubt, would equal any of the schools established by Congress, and which have been filled by kidnapping expeditions under the protection of troops among the self-sustaining Indians, or by starving such tribes as receive fortnightly rations or issues of beef, flour, etc., every two weeks, into bringing in their children."

32. B. Benedict, U.S. inspector, to the secretary of the interior, December 31, 1884, in Office of Indian Affairs, *Reports of Inspection of the Field Jurisdictions of the Office of Indian Affairs, 1873–1900*, microfilm.

33. Donaldson, *Extra Census Bulletin*, 93.

34. Donaldson, *Extra Census Bulletin*, 94.

35. Catalog information for Laguna Mission Press Collection. In 1884, the school had an enrollment of 315 students; see Board of Indian Commissioners, *Thirty-Second Annual Report*, 12. The government took control of the school in 1886, which was renamed the Menaul School for New Mexican Boys in 1895; see Banker, *Presbyterian Missions and Cultural Interaction*, 125.

36. Thompson, *American Character*, 157.

37. Thompson, *American Character*, 162.

38. Dr. George Dorsey, curator at the Field Columbian Museum in Chicago (now the Field Museum of Natural History) wrote in 1903 that Marmon's house was conveniently located near the train station. He noted that "Acoma...may be reached from Laguna by means of a carriage in three hours. Conveyance may be secured from Mr. Bibo, the trader at Isleta. Or from Mr. Marmon, the usual fare being five dollars for one passage or three dollars [each] for two. Competent drivers are furnished who speak both English and the Indian tongues."; see Dorsey, *Indians of the Southwest*, 79.

39. Ellis, "Outline of Laguna Pueblo History," 328, and "Laguna Pueblo," 9:447. Pradt later helped Laguna fight raiding Navajos and Apaches and charted the map of Katsímo, known as Enchanted Mesa, for the expedition Frederick Webb Hodge led in 1897; see Laurence D. Linford, *Tony Hillerman's Navajoland* (Salt Lake City: University of Utah Press, 2001), 130e; Charles F. Lummis, *Mesa, Cañon and Pueblo* (New York: The Century Co., 1925), 223.

40. Emil's brother, Solomon, also opened a store at Ácoma Pueblo around 1880 and married an Ácoma woman in 1885; see Floyd S. Fierman, *The Impact of the Frontier on a Jewish Family: The Bibos* (Tucson: Bloom Southwest Jewish Archives at the University of Arizona, 1988), 12–18.

41. See Fierman, *The Impact of the Frontier on a Jewish Family*, 12–18, 51; Jake Gold Papers, 143.

42. *Handbook of North American Indians*, ed. William C. Sturtevant, vol. 9, *Southwest*, ed. Alfonso Ortiz (Washington DC: Smithsonian Institution, 1979), 447. Miss Foard admired both Pradt and Gunn. Speaking of the latter (as reported in the *New York Tribune*, January 7, 1907), she said that Gunn "for twenty-five years has been studying the pueblos and writing about them."

43. Elizabeth Wacondo, Laguna Pueblo, to Lanmons, December 9, 2003; also ; Ellis, "Outline of Laguna Pueblo History," 328; Gunn, *Schat-Chen*, 101.

44. Ellis, "Laguna Pueblo," 9:447.

45. Murphy, *Frontier Crusader*, 186.

46. Ellis, "Laguna Pueblo," 9:447; Dillingham, *Acoma and Laguna Pottery*, 154.

47. Marmon also intended to tear down the Roman Catholic church, but a Laguna priest prevented him from doing so; see Broder, *Shadows on Glass*, 153.

48. Elsie Clews Parsons, "The Laguna Migration to Isleta," *American Anthropologist*, n.s., 30 (1928): 602–3, and Parsons, *Pueblo Indian Religion*, 2:888–89.

49. Broder, *Shadows on Glass*, 150; Ellis, "Laguna Pueblo," 9:448; Parsons, "The Laguna Migration to Isleta," 608.

50. Broder, *Shadows on Glass*, 150.

51. Elsie Clews Parsons, "Notes on Ceremonialism at Laguna," *Anthropological Papers of the American Museum of Natural History* 19, no. 4 (1920): 97–98, 113n6, and "The Last Zuni Transvestite," *American Anthropologist*, n.s., 41 (1939): 333–34.

52. Elizabeth Wacondo, Laguna Pueblo, conversation with Lanmons, November 28, 2003.

53. Peters, "Watering the Flower," 181–82.

54. Dillingham, *Acoma and Laguna Pottery*, 163.

55. Webb and Weinstein, *Dwellers at the Source*, 142.

56. Parsons, "Pueblo Indian Religion," 2:15–16.

57. Letter 19 (appendix 1).

Chapter Five

1. It has been speculated that unfired green pigment on Pueblo pottery indicates ceremonial use within kivas; see Dillingham, *Acoma and Laguna Pottery*, 78–80, figure 4.10.

2. Letter 7 (appendix 1).

3. Letter 7 (appendix 1).

4. She was also identified as Bart Whetmore's mother.

5. Letter 7 (appendix 1).

6. Elsie Clews Parsons, ed., *Hopi Journal of Alexander M. Stephen*, Columbia University Contributions to Anthropology 23 (New York: Columbia University Press, 1936), 482.

7. Letter 7 (appendix 1).

8. Quoted in Edwin Wade, "The Ethnic Market in the American Southwest, 1880–1890," in "Objects and Others: Essays on Museums and Material Culture," ed. George W. Stocking, Jr., special issue, *History of Anthropology* 3 (1985): 169. J. G. Bourke said the station was six miles from the Laguna station, but no such station is identifiable. It was not the McCartys station, which was twenty miles by rail from Laguna (McCartys is an outlying village of Ácoma Pueblo). In any case, trains did not stop consistently at McCartys. The main stops of the ATSF Railway in New Mexico, west of Albuquerque, were at Isleta and Laguna Pueblos, Grants, and Gallup; see Frank McNitt, *The Indian Traders* (Norman: University of Oklahoma Press, 1962), 118.

9. Dillingham, *Acoma and Laguna Pottery*, 163.

10. Regarding Ácoma women transporting their pottery to the Laguna station and breakage, see "A Work for Red Men. Miss Foard Employed by Government to Help Indian Potters," *New York Tribune*, January 7, 1907.

11. Indian Industries League Incorporated, "Pueblo Indian Pottery / Josephine Foard" (Boston: Indian Industries League Incorporated, n.d.).

12. Letter 33 (appendix 1).

13. The first Kansas City–Los Angeles ATSF Railway trains running through Laguna began service on August 21, 1883. There were several passenger trains making the east-to-west and west-to-east

runs daily, as well as several freight trains. The famed California Limited, running between Chicago and Los Angeles, began service in 1892. In the early years, there were as many as seven California Limited trains operating in each direction every day; the maximum number, twenty-two westbound and twenty-three eastbound trains, operated simultaneously; see Marshall, *The Railroad That Built an Empire*, 290.

14. Carl E. Guthe, *Pueblo Pottery Making* (New Haven: Yale University Press, for the Department of Archaeology, Phillips Academy, Andover, MA, 1925), 10.

15. Ruth L. Bunzel, *The Pueblo Potter: A Study of Creative Imagination in Primitive Art* (New York: Columbia University Press, 1929), 64.

16. Marshall, *The Railroad That Built an Empire*, 301.

17. Gill, "Ceramic Arts and Acculturation at Laguna," 110; Dillingham, *Acoma and Laguna Pottery*, 165; and Leslie A. White, "The Acoma Indians," in *Forty-Seventh Annual Report of the U.S. Bureau of American Ethnology, 1929–1930* (1932; repr., Glorieta, NM: The Rio Grande Press, 1973), 33.

18. Donaldson, *Extra Census Bulletin*, 93.

19. The two jars illustrated in figure 20 have recently been located: they are in the Arizona State Museum collection in Tucson (catalog numbers 75-5-1 and 75-5-2). They are not documented as the work of either Minnie Sice or Louise Beeker, but we consider it likely that they are.

20. In the 1900 federal census, the enumerator listed 1,077 people living at Laguna. Of those, occupations were noted for only 365 (34 percent) of the individuals, and all but 6 of those listed were men; 322 (89 percent) were involved with farming, stock raising, and herding, and 23 (6 percent) worked for the railroad. The only occupational listing for females was as servants (6 women; 2 men were also so identified).

21. Dillingham, *Acoma and Laguna Pottery*, 205.

22. Yammie, Yarnie, and Yama Leeds are also listed in the 1904, 1906, 1907, 1910, and 1911 Pueblo Indian Census Rolls, Laguna. When he donated tiles (see plate 14 for one) to the School of American Research (now School for Advanced Research), he gave his middle initial as Z.

23. Letter 56 (appendix 2).

24. Choate Albums, Photo Archives of the Cumberland County Historical Society, numbers 1–50, 2–24, and 56; see also *The Indian Helper, A Weekly Letter from the Carlisle Indian Industrial School to Boys and Girls* 6, no. 40 (June 12, 1891).

25. "This Woman Will Try to Make Indians Useful to Themselves," *New York Times*, April 29, 1906, and Letter 40 (appendix 2).

26. Letters 51–54, 56 (appendix 2).

27. Letters 7 and 14 (appendix 1).

28. Letter 7 (appendix 1). Bert Whetmore attended the Carlisle Indian School at the same time as Yamie Leeds. Leeds graduated in 1891.

29. 1889 Pueblo Indian Census Rolls, Laguna, individuals number 54–56: she was married to Se uah hzie, age fifty-four; their son, Bert [sic] Whetmore (Indian name, K si ush), age sixteen, lived with them at Seami [Seama]. She seems not to have been listed in the 1904 Pueblo Indian Census Roll; Bert Whetmore, however, was listed as age thirty-five, married, and living at Laguna with his wife, Sarah (age thirty), and a daughter, Ethel (age nine months); individuals number 282–84.

30. Letters 7, 14, 21, 31 (appendix 1).

31. Letter 7 (appendix 1).

32. Letter 7 (appendix 1).

33. For instance, see the photograph by H. S. Poley, collection of the Western History/Genealogy Department, Denver Public Library, neg. no. P–1081.

34. See Jon L. Brudvig, *Hampton Normal and Agricultural Institute, American Indian Students*

(1878–1923), Tribal Affiliations, 1996, http://www.twofrogs.com/hampton.html. Pueblo Indian Census Rolls, Laguna, 1904, individual numbers 66 and 67. In the 1910 Pueblo Indian Census Rolls at Laguna, she was listed as age twenty-three (individual number 7). She was also photographed several times by Carl Moon; she also wore her manta tied over her left shoulder in those photographs; see Tom Driebe, *In Search of the Wild Indian: Photographs and Life Works of Carl and Grace Moon* (Moscow, PA: Maurose Publishing Co., 1997), 106, 186, 248, 249.

35. Letter 30 (appendix 1).

36. Acc. nos. 78.13.12 A and B and 78.13.25 A and B.

37. Letter 30 (appendix 1). Thomas Donaldson, who prepared the *Extra Census Bulletin* for the 1890 federal census, met James Miller at Ácoma and learned he had been educated at Carlisle. He also heard Miller's report of mistreatment at Ácoma and his unwavering wish to bring education to his people. Donaldson also met Miller's wife. Miller said he lived at McCartys, a farming community of Ácoma Pueblo. Miller's comments were published in Donaldson, *Extra Census Bulletin*, 443, where he is not named, and in Donaldson, *Report of Indians Taxed and Not Taxed*, 126, where he is identified by name. In neither instance was his wife identified by name.

38. James H. Miller (age thirty-nine) and his wife Annie Miller (age twenty-eight) were enumerated at Ácoma in the in the 1905 Pueblo Indian Census Rolls.

39. *The Indian Helper, A Weekly Letter from the Carlisle Indian School* 6, no. 12 (November 21, 1890), 2.

40. In 1857, W. W. H. Davis saw a man at Laguna, identified as a cacique, painting a new jar "with numerous rude figures in black and red"; see Davis, *El Gringo*, 225.

41. Indian Industries League Incorporated, *Pueblo Indian Pottery / Josephine Foard*.

42. "This Woman Will Try to Make Indians Useful to Themselves," *New York Times*, April 29, 1906.

43. Elsie Clews Parsons, "The Zuni La'Mana," *American Anthropologist* 18, no. 4 (1916): 521–28, and *Pueblo Indian Religion*, 2:38; Will Roscoe, *The Zuni Man-Woman* (Albuquerque: University of New Mexico Press, 1991), 5.

44. Elsie Clews Parsons, "Laguna Genealogies," *Anthropological Papers of the American Museum of Natural History* 19, no. 5 (1923): 166.

45. Parsons, *Pueblo Indian Religion*, 2:338.

46. Will Roscoe, "We'wha and Klah: The American Indian Berdache as Artist and Priest," *American Indian Quarterly* 12, no. 2 (1988): 129.

47. Elsie Clews Parsons, "Notes on Acoma and Laguna," *American Anthropologist*, n.s., 20 (1918): 181.

48. Parsons, *Pueblo Indian Religion*, 2:39n.

49. The earliest known reference to a Pueblo man-woman was recorded in an 1823 census at Tesuque Pueblo, when José Miguel Amejerado, male, age eighteen, was listed as a potter by occupation; see Jonathan Batkin, *Pottery of the Pueblos of New Mexico, 1700–1940* (Colorado Springs: The Taylor Museum of the Colorado Springs Fine Arts Center, 1987), 20; Virginia Langham Olmstead, *Spanish and Mexican Colonial Censuses in New Mexico: 1790, 1823, 1845* (Albuquerque: New Mexico Genealogical Society, 1975), 156. Adolph F. Bandelier also knew about Pueblo men-women, explaining the surname variant, Amugerado, as "the singular being whom I once met at Acomita is Mariano Amugerado...there are about four of such amugerados in the pueblo, and two at least at Santo Domingo. They have no inclination for women.... When such propensities show themselves in a man, the tribe dresses him in a woman's dress, and treats him kindly, but still as a woman. It is affirmed...to be a custom of the Pueblos, who call such people *qo-qoy-mo*."; see A. F. Bandelier, *The Southwestern Journals of Adolph F. Bandelier (1880–1892)*, ed. Charles H. Lange, Carroll L. Riley, and Elizabeth M. Lange (Albuquerque: University of New Mexico Press, 1966), 1:326; Batkin, *Pottery of the Pueblos of New Mexico*, 20.

50. Will Roscoe, ed., *Living the Spirit: A Gay American Indian Anthology* (New York: St. Martin's Press, 1988), 1. For cognates of berdache (a word Pueblo people consider demeaning), see Roscoe, *Living the Spirit*, 225n6. The cross-gender term is discussed in Ramona Ford, "Native American Women: Changing Statuses, Changing Interpretations," in *Writing the Range: Race, Class, and Culture in the Women's West*, ed. Elizabeth Jameson and Susan Armitage (Norman: University of Oklahoma Press, 1997), 50–54.

51. In the earliest published summary of medical examinations of pueblo men-women, a doctor found that men-women at Ácoma and Laguna had male sexual organs, but of decreased size. They were not hermaphrodites (that is, they did not have both female and male reproductive organs, as was sometimes erroneously asserted). See Hammond (1883) 1974:163–172; White 1943:324–325.

52. Roscoe, *The Zuni Man-Woman*, and *Living the Spirit*.

53. Matilda Coxe Stevenson, "The Zuñi Indians, Their Mythology, Esoteric Fraternities, and Ceremonies" in *Twenty-Third Annual Report of the Bureau of American Ethnology* (Washington DC: Government Printing Office, 1904), 37. Two vessels attributed to We'wha and probably signed by him are illustrated in Dwight P. Lanmon, "We'wha, a Zuni Man-Woman and His Pottery," in *The Walpole Society Note Book, 2003-2004* (Privately printed, 2006), 84–103.

54. Roscoe, *The Zuni Man-Woman*, 50, 51.

55. Sue-Ellen Jacobs, "Berdache: A Brief Review of the Literature," *Colorado Anthropologist* 1, no. 2 (1968): 30-32.

56. Letter 19 (appendix 1).

57. In Valentine Queoyoa's testimony (see note 60), he testified that he made pottery and sold it at the train. 1978–003 Records of the U.S. Territorial and New Mexico District Courts for Valencia County, folder 256, 1900, case number 538.

58. Elsie Clews Parsons, "Isleta, New Mexico," in *47th Annual Report, Bureau of American Ethnology* (Washington DC: Government Printing Office, 1932), 246.

59. Parsons, "Isleta, New Mexico," 246.

60. Letter 7 (appendix 1). Valentine Queoyoa was identified in 1899 court records because he was involved in a bizarre murder. He was also identified in court papers as Valentine Kuojiai, Valentine Koriyo, and Valentine Konyo. The murder is documented in the Valencia County District Court records, case numbers 537–39, 591, folder 255. At the instigation of his wife, Margarita Seuni, José Hilario murdered Jesús Seuni [or Sione] with an axe. Hilario and Valentino carried the body to the railroad bridge and placed it on the tracks. The body was discovered the following morning. Later, the murderer and the wife pleaded guilty to murder in the second degree. Hilario was sentenced on March 6, 1902, to nine years at hard labor in the Territorial Penitentiary in Santa Fe; Margarita Seuni was sentenced to seven years at hard labor in the same jail. In addition, Elsie Clews Parsons mentioned the same murder twice in publications. In 1923, she reported that the murder occurred "a few years ago" and added, "[a Pueblo Indian woman was] engaged in the murder of her husband. Her confederates were a lover, the son of Tsiwema...and a man-woman who lived in the woman's household. The three were jailed. On their release, the lover and the woman appeared unashamed, and in time married other persons; the man-woman never went out and is said to have died of the disgrace." Parsons, "Laguna Genealogies," 272. In 1932, Parsons added more details about the man-woman who was involved and changed the outcome slightly in the new rendition: "I heard again of the last man-woman who lived at old Laguna, and who was involved there in a murder. After this 'Valentino' was released from prison he came to Orai'bi [at Isleta Pueblo] to visit his mother's brother, Francesco Torres. Valentino would tell them how he had carried the murdered husband to the railway track..."; Parsons, "Isleta, New Mexico," 246.

61. In the 1885 Pueblo Indian Census Rolls, the Laguna men who dressed as women were identified as Albiyo, single, male, age thirty (person number 150); Konuathe, single, male, age eighteen (person number 553); and Koyoyei, single, male, age twenty-five (person number 869). In the 1886 Pueblo Indian Census Rolls, Laguna men-women were identified as Kowweityere, male, age thirty (person number 101); Alonzo, male, age thirty (person number 150); Kowwatye, male, age eighteen (person number 553); and Koyoyei, male, age twenty-five (person number 869). Given the similarity in the phonetic sounds of the names, the person identified as Koyoyei was probably the man-woman (Valentine Queoyoa) who assisted in the murder mentioned previously. Elsie Clews Parsons also identified a Laguna man-woman named Dyamu, member of the Chapparal Cock (Roadrunner) Clan, who moved with his mother from Old Laguna to Paraje, but she did not say when. She did not identify him as a potter; see Parsons, "Laguna Genealogies," 237.

62. Dwight P. Lanmon, "Pueblo Man-Woman Potters and the Pottery Made by the Laguna Man-Woman, Arroh-a-och," *American Indian Art Magazine* 31, no. 1 (2005): 72–85, and "We'wha, a Zuni Man-Woman, and His Pottery."

Chapter Six

1. Letter 6 (appendix 1).

2. Board of Indian Commissioners, *Thirty-First Annual Report*, 85; "This Woman Will Try to Make Indians Useful to Themselves," *New York Times*, April 29, 1906; "A Work for Red Men. Miss Foard Employed by Government to Help Indian Potters," *New York Tribune*, January 7, 1907.

3. Letter 11 (appendix 1). She also mentioned seeing Pueblo pottery jars being used for parlor plants in Santa Fe homes (Letter 1, appendix 1).

4. Indian Industries League, "Pueblo Indian Pottery / Josephine Foard."

5. "A Work for Red Men. Miss Foard Employed by Government to Help Indian Potters," *New York Tribune*, January 7, 1907. Glazes were not used by any Pueblo potters in the late 1800s. From the mid-1200s until about 1700, however, they often decorated their wares with paints containing ground lead ore, which they fired until fused, forming a glasslike glaze. Pueblo potters never used lead glazes to make their pottery waterproof; see Batkin, *Pottery of the Pueblos of New Mexico*, 92–93, 118–19, 137–38, 163; Dillingham, *Acoma and Laguna Pottery*, 120–30; Larry Frank and Francis H. Harlow, *Historic Pottery of the Pueblo Indians, 1600–1880* (Boston: New York Graphic Society, 1974), 19.

6. Board of Indian Commissioners, *Thirty-First Annual Report*, 85; "Works Among New Mexico Indians in Manufacture of Pottery, Miss Josephine Foard Tells of Her Efforts to Aid the Pueblos and Find a Market for Their Wares, Aims to Teach Economy and Simplicity in Methods, Without Changing Character of Their Work," *New York Herald*, January 27, 1907, Brooklyn section.

7. Letter 14 (appendix 1).

8. Board of Indian Commissioners, *Thirty-First Annual Report*, 85.

9. Letter 14 (appendix 1).

10. "A Work for Red Men. Miss Foard Employed by Government to Help Indian Potters," *New York Tribune*, January 7, 1907. The *New York Herald* article of January 27, 1907, also reported that she said "I have seen them lay the jar [glazed on the exterior] against their faces to feel its smoothness."

11. 1900 Federal Census, born 1861, age thirty-eight, farm laborer, reads/writes/speaks English; 1904 Pueblo Indian Census Rolls, Laguna, no. 143—Hugh Johnson, husband, age thirty; with wife Emily (age twenty-four) and son, Martin (age six months).

12. Letter 14 (appendix 1).

13. Board of Indian Commissioners, *Thirty-First Annual Report*, 85.

14. In her October 11, 1899, report to the Board of Indian Commissioners, Sibyll Carter reported, however, that "the kiln is only a little thing...." Board of Indian Commissioners, *Thirty-First Annual Report*, 85.

15. Board of Indian Commissioners, *Thirty-First Annual Report*, 85, and *Thirty-Second Annual Report*, 94. The kiln is mentioned in Dissette's letter to the Indian Industries League in Boston, received on May 1, 1901. Book Second, Indian Industries League Incorporated, Records from December 1898—18 December 1903, 88.

16. Letter 21 (appendix 1).

17. Board of Indian Commissioners, *Thirty-First Annual Report*, 85.

18. Letter 24 (appendix 1).

19. Letter 24 (appendix 1). Daily is listed in the 1900 federal census at Laguna and the 1904 Pueblo Indian Census Rolls at Seama. Daily did not speak English.

20. Letters 24–26 (appendix 2).

21. The use of saggars is documented in a 1907 letter, where Foard says that Yamie Leeds made them. Whether he used fire clay (the material typically used for saggars) or local potter's clay is unknown. Foard may have imported fire clay for the purpose. It may be the clay that she noted with delight was undisturbed after she returned to Laguna in 1902. See Letters 21 and 52 (appendix 2).

22. A photograph titled "Work and a worker in Miss Foard's pottery," published in Francis E. Leupp, *The Indian and His Problem*, 484, shows an Ácoma or Laguna jar that is about 14? inches in diameter. Foard glazed at least one of the pieces in that photograph (shown in plate 12); whether the jar was glazed is unknown.

23. Letter 17 (appendix 1).

24. Book Third, Indian Industries League Incorporated, *Records*, March 1, 1906.

25. Tiles were probably produced entirely by Yamie Leeds at Laguna (plate 14); the potter Cookone may have been from Laguna (plate 10).

26. Letter 50 (appendix 2).

27. Letter 56 (appendix 2).

28. "A Work for Red Men. Miss Foard Employed by Government to Help Indian Potters," *New York Tribune*, January 7, 1907.

29. Letter 43 (appendix 2).

30. See Barbara Kramer, *Nampeyo and Her Pottery* (Albuquerque: University of New Mexico Press, 1996), 4–5.

31. Letter 10 (appendix 1). She also mentions "experimental clays and glazes" in Letter 14 (appendix 1).

32. Indian Industries League, "Pueblo Indian Pottery / Josephine Foard."

33. One glaze was almost colorless, another was pale yellow, while a third fired to an olive green color. Most of Miss Foard's glazed objects have a dark yellow-amber color, suggesting use of a fourth glaze.

34. See Jones, "Arts and Crafts Department," 123–24; Lovett, "The Exhibition of the National Society of Craftsmen," lxx–lxxi; the National Arts Club, *Catalogue, Arts and Crafts Exhibition*, title page.

35. Yamei is identified as Miss Foard's "government paid helper, to assist at the kiln" in "A Work for Red Men. Miss Foard Employed by Government to Help Indian Potters," *New York Tribune*, January 7, 1907. John Deems is pictured in "Works Among New Mexico Indians in Manufacture of Pottery, Miss Josephine Foard Tells of Her Efforts to Aid the Pueblos and Find a Market for Their Wares, Aims to Teach Economy and Simplicity in Methods, Without Changing Character of Their Work," *New York Herald*, January 27, 1907, Brooklyn section, where he is called "Indian Assistant to Miss Foard."

36. "Ex-Students and Graduates," *The Red Man* 2, no. 6 (1910): 45.

37. "Works Among New Mexico Indians in Manufacture of Pottery, Miss Josephine Foard Tells of Her Efforts to Aid the Pueblos and Find a Market for Their Wares, Aims to Teach Economy and Simplicity in Methods, Without Changing Character of Their Work," *New York Herald*, January 27, 1907, Brooklyn section. John Deems was identified as Miss Foard's Indian Assistant, but his name has not been found in any Laguna or Ácoma censuses, and we speculate that the name may be a reporter's error. If it is not, Miss Foard had two assistants at the same time, Yamie Leeds and John Deems, but she only received salary for one assistant from the Office of Indian Affairs (letters 40–42, appendix 2).

38. "This Woman Will Try to Make Indians Useful to Themselves," *New York Times*, April 29, 1906.

39. "A Work for Red Men. Miss Foard Employed by Government to Help Indian Potters," *New York Tribune*, January 7, 1907.

40. Indian Industries League, "Pueblo Indian Pottery / Josephine Foard."

41. Letters 20–22, 27, 28 (appendix 2).

42. Indian Industries League Incorporated, *Annual Report*, Boston, 1907, 7.

43. Statement of purpose of the Indian Industries League. Indian Industries League Incorporated, *Annual Report*, Boston, 1906, 18.

44. Trump, "Indian Industries League and Its Support," 304.

45. For example, anthropologists Colonel and Mrs. Stevenson photographed two women at Zia Pueblo about 1887 and identified them only as "Sisters, Cleverest Artists in Ceramics in Sia." National Anthropological Archives, Smithsonian Institution, neg. no. 2178; reproduced in Francis H. Harlow and Dwight P. Lanmon, *The Pottery of Zia Pueblo* (Santa Fe: School of American Research Press, 2003), 324. Even as late as the 1930s museum curators often simply noted in accession records, "bought from the maker," without identifying the person by name.

46. Marvin Cohodas, "Washoe Basketry," *American Indian Basketry Magazine* 3, no. 4 (1983): 5.

47. There are four pieces by María Martínez, dating around 1918, that are signed Poh've'ka. She did not begin signing her works consistently until about 1923; see Richard L. Spivey, *The Legacy of Maria Poveka Martinez* (Santa Fe: Museum of New Mexico Press, 2003), 162.

48. In 1978 the pieces were transferred from the Anthropology Department (where they had been recorded in 1968) to the University Gallery, but there are no records documenting when or from whom the Anthropology Department acquired them. It is known, however, that Miss Foard donated "a valuable and interesting collection of minerals, fossils, Indian relics, Indian pottery, etc." to the now-defunct Society of Natural History of Delaware in 1901 (receipt in the possession of Mrs. Millicent Berghaus), and the objects in the University Gallery may be part of that collection.

49. Catalog file, IAF.2319, School for Advanced Research.

50. In the 1906 Ácoma Pueblo census, she was enumerated as person number 149, wife of Juan Stevan. In the 1907 Ácoma Pueblo census, she was enumerated as person number 499 (as Tsiewieta Juan Stevan Vicente), wife of Juan Stevan Vicente. Foard hired a girl named Zaweta to work as her maid; she may have been the Ácoma potter who made the small red jar, but we consider it unlikely. "This Woman Will Try to Make Indians Useful to Themselves," *New York Times*, April 29, 1906.

51. Letter 40 (appendix 2).

52. See Kramer, *Nampeyo and Her Pottery*, 79, 80, 150, 184, 185 (figures 13, 14, A, C, and plate 7).

53. Trump, "Indian Industries League and Its Support," 226–27, citing Book Fourth, Indian Industries League Incorporated, *Records*, March 1, 1909, 177.

54. A glazed jar in the collection of the Indian Arts Research Center of the School for Advanced Research, Santa Fe (cat. no. SAR.2002-4-1), has a similar exhibition label. The potter is unidentified, but the label identifies the source as Ácoma Pueblo.

55. The exhibition is mentioned in "A Work for Red Men. Miss Foard Employed by Government to Help Indian Potters," *New York Tribune*, January 7, 1907.

56. In the 1904 Pueblo Census at Ácoma, Marie José Cito, is enumerated as age forty, wife of José Cito, person number 281. She is also enumerated in 1905 as María José Cito, person number 282; in 1906 as Marie José Cito, person number 285; and in 1910 as María Josecito, person number 198. The second person is enumerated in the 1904 Pueblo Census at McCartys as María Josecito, age forty-eight, listed alone, but probably the mother of José Cito, age thirty-two, person number 26. The same person is enumerated at McCartys in the 1905 census, person number 22, and in 1906, person number 28.

57. A glazed bowl with the same inscription is in the collection of the Indian Arts Research Center, School for Advanced Research, Santa Fe (cat. no. IAF.932). A jar inscribed with the same name, but no visible number, is in the collection of the Science Museum of Minnesota, St. Paul (cat. no. 1-127:153). Another jar with the same name is in a private collection.

58. Science Museum of Minnesota, St. Paul (cat. no. 1-127:153).

59. 1904 Pueblo Census, Ácoma, person number 146. The same person was also enumerated in the 1905 Pueblo Census at Ácoma, person number 144; in 1906, person number 146; and in 1910 as Co Washtie, person number 96.

60. Personal communication of the owner of the jar shown in plate 9 with Dwight Lanmon, August 2005.

61. Miss Foard mentioned selling glazed pottery to the Fred Harvey Company in Letter 56 (appendix 2).

62. We have not found any examples of glazed Isleta pottery, but Foard stated she made some of her first experimental firings using Isleta pottery (letter 14, appendix 1).

63. "A Work for Red Men. Miss Foard Employed by Government to Help Indian Potters," *New York Tribune*, January 7, 1907.

64. Letter 13 (appendix 1).

65. 1899 Pueblo Indian Census Rolls, Paraje, Laguna Pueblo: José María Coo ka nish, person number 62, age fifty, living with his son, person number 63, José María Coo ka nish, single, age twenty-two. 1904 Pueblo Indian Census Rolls, Laguna Pueblo: José María (no last name), person number 68, age twenty-seven, married, living with Juana María, person number 69, age nineteen, and son Lorenzo María, age 5/6 (ten months old); José María Kukanish, person number 77, age fifty-five, living alone.

66. The names inscribed on all but one of the examples of signed pottery are written in block letters. Miss Foard's manuscript correspondence gives no clue whether she inscribed the names on the pottery. All her known correspondence was written in script; we have found none where there are any block letters for comparison. If Yamie Leeds made the inscriptions on the pottery, they would be datable to the years 1906–11, when he worked for Miss Foard as an assistant.

67. Nothing approaching the name Wa-Ki has been found in Ácoma or Laguna censuses.

68. Leupp, *The Indian and His Problem*, 484.

69. Letters 10, 13, 17, 31 (appendix 1).

70. Another bowl (not illustrated) with an Indian Industries League label identifying the potter as María Steye from Ácoma is decorated with similar deer and geometric ornaments (Science Museum of Minnesota, St. Paul, cat. no. 1-112:153).

71. 1904 Pueblo Indian Census Rolls at Ácoma, person number 508. She was also listed in the 1905 and 1907 Pueblo Indian Census Rolls. In the 1907 Pueblo Census Rolls, she is listed after Josalita Iytie, age fifty-eight, who was identified as her mother. In the 1910 census at Ácoma, she is enumerated as Marie Ity Rey, age twenty-seven, person number 325, wife of Torevio Rey.

72. Kathleen B. McCarthy, *Women's Culture: American Philanthropy and Art, 1830–1930* (Chicago: University of Chicago Press, 1991), 100.

73. "A Work for Red Men. Miss Foard Employed by Government to Help Indian Potters," *New York Tribune*, January 7, 1907; see also Letter 52 (appendix 2).

74. Accession numbers 86651–86675. J. J. Brody (*Beauty from the Earth*, 41, plate 19) speculated that Thomas V. Keam may have originated the idea of producing tiles at Hopi in the late 1800s.

75. School for Advanced Research, Indian Arts Fund accessions book record for IAF.1457 and catalog card.

76. See, for example, Batkin, *Pottery of the Pueblos of New Mexico*, 110, 111; Frank and Harlow, *Historic Pottery of the Pueblo Indians, 1600–1880*, 95, figure 89.

77. "Works Among New Mexico Indians in Manufacture of Pottery, Miss Josephine Foard Tells of Her Efforts to Aid the Pueblos and Find a Market for Their Wares, Aims to Teach Economy and Simplicity in Methods, Without Changing Character of Their Work," *New York Herald*, January 27, 1907, Brooklyn section, and Letter 25 (appendix 1).

78. Letter 31 (appendix 2).

79. "Works Among New Mexico Indians in Manufacture of Pottery, Miss Josephine Foard Tells of Her Efforts to Aid the Pueblos and Find a Market for Their Wares, Aims to Teach Economy and Simplicity in Methods, Without Changing Character of Their Work," *New York Herald*, January 27, 1907, Brooklyn section.

80. Federal census, Seama Village, family number 118.

81. Toulouse, *Pueblo Pottery of the New Mexico Indians*, 43; Elizabeth Willis DeHuff, "Pueblo Episodes," undated (after 1916) manuscript, MSS BC99, Box 6, folio 48, Center for Southwest Research, University of New Mexico, Albuquerque, New Mexico, 6–7.

82. Elizabeth Willis was an "author, lecturer, patron of Indian arts, and publicist of the diverse history and culture of the Southwest." She married John DeHuff in 1913 and moved with him to the Carlisle Indian School. He became superintendent of the Indian School in Santa Fe in 1916, where he encouraged several well-known Indian artists in their work; he resigned in 1927. Elizabeth continued her work with Indians and was a prolific writer and lecturer on Indian subjects until about 1945; see "Biography," Elizabeth Willis DeHuff Family Papers, 1883–1981," Center for Southwest Research, University of New Mexico, Albuquerque, New Mexico.

83. DeHuff, "Pueblo Episodes," 6–7.

84. "Works Among New Mexico Indians in Manufacture of Pottery, Miss Josephine Foard Tells of Her Efforts to Aid the Pueblos and Find a Market for Their Wares, Aims to Teach Economy and Simplicity in Methods, Without Changing Character of Their Work," *New York Herald*, January 27, 1907, Brooklyn section.

85. Mrs. Millicent Berghaus, interview by Dominique Coulet du Gard, June 2002.

Chapter Seven

1. "Almost 70, She Begins Farming," *New York Press*, [1912?].

2. Foard's maternal uncle, John Jefferson Henry, resided in Denver in the late 1890s, working in the real estate business. He was enumerated in the 1900 federal census for Arapahoe County as seventy-seven years old, living with George Henry (age thirty-five) and Mary Henry (age thirty-six). He died in 1902, ten years or more before Foard's emigration to Kiowa County, Colorado.

3. "Almost 70, She Begins Farming," *New York Press*, [1912?].

4. Josephine Foard, Sheridan Lake, Colorado, to Charles Berghaus, September 6, 1914 (letter 35, appendix 1).

5. The information that Leeds worked for Foard in Colorado is recorded in the Indian Arts Fund accessions record for a tile, cat. no. IAF.1458, School for Advanced Research.

6. Death certificate, Vital Statistics, State of New Jersey.

7. Millicent Berghaus to Lorraine Lanmon, August 24, 2005. Hackensack Cemetery, section K, row 3, number 621, telephone interview with a cemetery official by Dominique Coulet du Gard, November 23, 2003.

8. Millicent Berghaus to Dominique Coulet du Gard 2002; Obituary, n.d., n.p., source unknown, "Miss Josephine Foard," courtesy of Millicent Berghaus; Millicent Berghaus, interview by Dominique Coulet du Gard, June 2002.

9. Her obituary stated that "Miss Josephine Foard, widely known in art circles and a member of one of America's oldest families, died yesterday at the Hackensack Hospital as the result of a broken hip which she sustained several weeks ago when she fell on an icy pavement. She had been staying recently with her sister, Mrs. V. H. Berghaus, Ridgefield Park, N.J. and funeral services will be conducted at the Episcopal Church there at 4 o'clock tomorrow afternoon. Miss Foard attained distinction as an artist and in recognition of her work on Indian pottery was made a member of the Royal Society of Artists [*sic*], London. She was in her seventy-fifth year, and was a daughter of the late Edward Levi Lingen Foard, Bohemia Manor, Md. The Foard family settled in Maryland prior to 1670."

10. She was a member of the Royal Society for the encouragement of Arts, Manufactures and Commerce (commonly known as the Royal Society of Arts, or RSA) from 1908 until the 1910/1911 session. Information courtesy of Martin Chasin and Lara Webb, personal communication with Dwight Lanmon, May 10 and 11, 2005.

11. Trump, "Indian Industries League and Its Support," 105–14.

12. Trump, "Indian Industries League and Its Support," 131.

13. Trump, "Indian Industries League and Its Support," 131.

14. Spivey, *The Legacy of Maria Poveka Martinez*, 32; Toulouse, *Pueblo Pottery of the New Mexico Indians*, 33.

15. Among them were artists, writers, photographers, collectors, and philanthropists: Mary Austin, Florence Dibble Bartlett, Willa Cather, Maria Chabot, Mary-Russel Ferrell Colton, Erna Fergusson, Sharlot Madbrith Hall, Alice Corbin Henderson, Ethel Hickey, Maie Bartlett Heard, Franc Johnson, Mable Dodge Luhan, Julia Lukas, Nina Otero, Olive Rush, Elizabeth Shepley Sargeant, Dorothy Stewart, Mary Cabot Wheelwright, Amelia Elizabeth, and Martha White.

16. Jacobs, *Engendered Encounters*, 17–19, 112.

17. Trump, "Indian Industries League and Its Support," 299.

18. The Indian Arts Fund collections now reside in the Indian Arts Research Center of the School for Advanced Research and in the Museum of Indian Arts and Culture in Santa Fe.

Appendix One

1. Lewis Wallace (1827–1905), governor of New Mexico, 1878–81; wrote *Ben Hur: A Tale of the Christ* in 1880. Lew Wallace, *An Autobiography* (New York: Harper and Brothers Publishers, 1916), 2:926–36; Robert E. Morsberger and Katharine M. Morsberger, *Lew Wallace: Militant Romantic* (New York: McGraw Hill, 1980).

2. LeBaron Bradford Prince (1849–1922); New Mexico governor, 1889–93. Walter John Donlon, "LeBaron Bradford Prince, Chief Justice and Governor of New Mexico Territory, 1879–1893" (PhD diss., University of New Mexico, 1967).

3. 1904 Pueblo Indian Census Rolls, Casa Blanca, age forty.

4. 1904 Pueblo Indian Census Rolls, Laguna Pueblo, age seventy-five.

5. 1900 Federal Census, Laguna Pueblo, age twenty.

6. She is probably referring to one of the several geology textbooks James Dwight Dana published after 1875.

7. The current spelling is malpais.

8. 1904 Pueblo Indian Census Rolls, Laguna Pueblo, age thirty-five.

9. Miss Foard numbered this letter XII; it is followed by number X. This and the following letters are renumbered to make them numerically sequential.
10. 1904 Pueblo Indian Census Rolls, Laguna Pueblo, Seama, age thirty-five.
11. 1900 Federal Census, Laguna Pueblo, age thirty-five.
12. 1900 Federal Census, Laguna Pueblo, age thirty-eight.
13. 1904 Pueblo Indian Census Rolls, Laguna Pueblo, Seama, age ten.
14. 1900 Federal Census, Laguna Pueblo, age thirty-eight. 1904 Pueblo Census, Laguna Pueblo, age thirty.
15. Margaret A. Bingham was listed as a teacher at Laguna in a letter dated September 27, 1899, in Office of Indian Affairs, *Reports of Inspection of the Field Jurisdictions, 1873–1900*, reel 41, "Employees at Pueblo Agency, New Mexico."
16. A Vroman photograph of F. W. Hodge ascending Katsimo is published in Lummis, Mesa Cañon and Pueblo, opp. 207. The story of Hodge's 1897 ascent is also in Lummis, beginning on 215; see Frederick Webb Hodge, "The Enchanted Mesa." *National Geographic Magazine* 8 (1897): 273–84.
17. A photograph of Charlie Kie, along with Charles Seonia and Frank Paisano, is in the National Anthropological Archives, Smithsonian Institution (06359600).
18. 1904 Pueblo Indian Census Rolls, Laguna Pueblo, age forty-eight.
19. 1900 Federal Census, Laguna Pueblo, age thirty-five. 1904 Pueblo Census, Laguna Pueblo, Seama, age forty-six.
20. 1900 Federal Census, Laguna Pueblo, age twenty-six. 1904 Pueblo Census, Laguna Pueblo, Casa Blanca, age thirty-one.
21. 1904 Pueblo Indian Census Rolls, Laguna Pueblo, age eighteen.
22. 1904 Pueblo Indian Census Rolls, Laguna Pueblo, Paraje, age thirty-four.
23. 1900 Federal Census, Laguna Pueblo, age twenty-six. 1904 Pueblo Census, Laguna Pueblo, Mesita, age forty-five.
24. 1900 Federal Census, Laguna Pueblo, age forty-eight. 1904 Pueblo Census, Laguna Pueblo, age sixty.
25. 1904 Pueblo Indian Census Rolls, Laguna Pueblo, age twenty-eight.
26. 1900 Federal Census, Laguna Pueblo, age thirty-one. 1904 Pueblo Census, Laguna Pueblo, age thirty-five.
27. The story is repeated (but stating that Vincente de Zaldívar made the leap in 1599) in Gunn, *Schat-Chen*, 35–37.
28. 1904 Pueblo Indian Census Rolls, Laguna Pueblo, Paraje, age thirty-four.
29. Miss Foard stresses that she is not a missionary in a letter to W. A. Jones, commissioner of Indian Affairs, on May 13, 1902 (see letter 11, appendix 2).
30. Francis E. Leupp (1849–1918). Member of United States Board of Indian Commissioners, 1862–95; nominated in 1904 by Pres. Theodore Roosevelt as commissioner of Indian Affairs; served from 1905 to 1909. From the introduction by Theodore R. Frisbie for Francis E. Leupp, *In Red Man's Land: A Study of the American Indian* (1914; repr., Glorieta, NM: The Rio Grande Press, 1976).

Appendix Two

All of the letters transcribed in this appendix are in the collection of the National Archives, Record Group [RG] 75.

1. RG75, BIA, Letters Received, 1899–30921. The file contains two letters. The first is a letter from N. S. Walpole, Indian agent in Santa Fe, in response to an earlier (missing) letter from Miss Foard; the second is from Miss Foard to A. G. Tonner, acting commissioner of Indian Affairs.
2. On June 15, 1899 (letter 14, appendix 1), Miss Foard mentioned firing and glazing pottery. She mentions having Isleta pottery to glaze and also refers to glazing a small cup Minnie Sice made.
3. RG75, BIA, Letters Received, 1899–26526.
4. RG75, BIA, Letters Sent, LB408, 461.
5. RG75, BIA, Letters Sent, LB411, 408.

6. RG75, BIA, Letters Received, 1900–63146. Noted as answered on Jan. 9, 1901, but reply has not been located.

7. RG75, BIA, Letters Received, 1901–4722. Noted as answered on Feb. 4, 1901, but reply has not been located.

8. RG75, BIA, Letters Received, 1901–5048. Noted as answered on Feb. 4, 1901, but reply has not been located.

9. RG75, BIA, Letters Received, 1901–10697. No response was noted on the cover sheet.

10. RG75, BIA, Letters Received, 1901–11365. Noted as answered on March 6, 1901, but reply has not been located.

11. RG75, BIA, Letters Received, 1901–16699. No response was noted on the cover sheet.

12. RG75, BIA, Letters Received, 1902–30459. The supporting letter for Miss Foard, sent to the U.S. Civil Service Commission on May 23, 1902, is RG75, BIA, Letters Sent, Misc., Vol. 18A, 208.

13. RG75, BIA, Letters Sent, Misc., Vol. 18A, 209.

14. RG75, BIA, Letters Received, 1902–31605.

15. RG75, BIA, Letters Sent, Misc., Vol. 18A, 239.

16. RG75, BIA, Letters Received, 1902–31566.

17. RG75, BIA, Letters Sent, Misc., Vol. 18A, 240.

18. RG75, BIA, Letters Sent, Misc., Vol. 18A, 241.

19. RG75, BIA, Letters Received, 1902–32717. No response noted.

20. RG75, BIA, Letters Received, 1902–50721.

21. The reply is RG75, BIA, Letters Sent, Misc., Vol. 18B, 15.

22. RG75, BIA, Letters Received, 1902–55354.

23. Miss Foard met the former governor of New Mexico in Santa Fe in April 1899; see Letters 1–4 (appendix 1).

24. Reply is RG75, BIA, Letters Sent, Misc., Vol. 18B, 128.

25. RG75, BIA, Letters Received, 1902–59652. The certificate appointment is RG75, BIA, Letters Sent, Misc., Vol. 18B, 144. The acting commissioner, A. G. Tonner, wrote in error to C. J. Crandall, superintendent of the Indian Industrial School in Santa Fe, on October 23, 1902, advising him of Miss Foard's appointment (RG75, BIA, Letters Sent, Misc., Vol. 18B, 162). He also wrote to Supt. Ralph P. Collins in Albuquerque (RG75, BIA, Letters Sent, Misc., Vol. 18B, 187, 194), to whom the Crandall letter should have been addressed. In the Crandall letter, he confirms Miss Foard's salary, states that she is being assigned to Laguna Pueblo, and notes that "she will live in her own house and will give her special, though not exclusive, attention to the making of pottery by the Indians." Likewise he wrote to Rev. A. Allen in Cranberry, New Jersey, regarding Miss Foard's appointment (RG75, BIA, Letters Sent, Misc., Vol. 18B, 210).

26. RG75, BIA, Letters Received, 1902–70415.

27. RG75, BIA, Letters Received, 1902–70415.

28. RG75, BIA, Letters Received, 1902–70415.

29. RG75, BIA, Letters Sent, Misc., Vol. 19B, 302.

30. RG75, BIA, Letters Received, 1903–72370.

31. The number of visits must be in error, or it was greatly exaggerated. Ácomita is 11 3/4 miles from Laguna.

32. RG75, BIA, Letters Sent, Misc., Vol. 20A, 167.

33. RG75, BIA, Letters Sent, Misc., Vol. 21B, 182.

34. RG75, BIA, Letters Sent, Misc., Vol. 21A, 417.

35. For discussions of the work of Carter and Doubleday, see Trump, "Indian Industries League and Its Support," 196–208.

36. RG75, BIA, Letters Sent, Misc., Vol. 21B, 74.

37. RG75, BIA, Letters Sent, Misc., Vol. 22B, 237.

38. RG75, BIA, Letters Sent, Misc., Vol. 22B, 314.
39. RG75, BIA, Letters Sent, Misc., Vol. 22B, 403.
40. Miss Foard sometimes spells the name C. S. Larrabee.
41. RG75, BIA, Letters Sent, Misc., Vol. 23A, 87.
42. RG75, BIA, Letters Sent, Misc., Vol. 23A, 235.
43. RG75, BIA, Letters Sent, Misc., Vol. 23A, 316.
44. RG75, BIA, Letters Sent, Misc., Vol. 24A, 256.
45. For a discussion of the work of Angel De Cora at the Carlisle School, see Trump, "Indian Industries League and Its Support," 239–40. Her photograph and a description of her work were also published in Francis E. Leupp, "Women in the Indian Service," *Delineator* 75 (1910): 484.
46. RG75, BIA, Letters Sent, Misc., Vol. 24A, 301.
47. RG75, BIA, Letters Sent, Misc., Vol. 24B, 101.
48. RG75, BIA, Letters Sent, Misc., Vol. 24B, 107.
49. RG75, BIA, Letters Sent, Misc., Vol. 25A, 465.
50. RG75, BIA, Letters Sent, Misc., Vol. 25B, 8.
51. RG75, BIA, Letters Sent, Misc., Vol. 25B, 108.
52. RG75, BIA, Letters Sent, Misc., Vol. 25B, 143.
53. RG75, BIA, Letters Received, 1907–6250.
54. RG75, BIA, Letters Received, 1907–15032.
55. RG75, BIA, Letters Sent, Misc., Vol. 26A, 26.
56. RG75, BIA, Letters Received, 1907–25027.
57. RG75, BIA, Letters Sent, Misc., Vol. 26A, 146.
58. RG75, BIA, Letters Received, 1907–27824.
59. See chapter 4 for a discussion of George Pradt.
60. RG75, BIA, Letters Sent, Misc., Vol. 26A, 166.
61. RG75, BIA, Letters Received, 1907–29369.
62. RG75, BIA, Letters Sent, Misc., Vol. 26A, 207.
63. RG75, BIA, Letters Received, 1907–30841.
64. A glazed tile Yamie Leeds made is shown in plate 14.
65. See plates 4 and 5 for examples of Hopi pottery Miss Foard glazed. No Santa Clara or Santo Domingo pottery Miss Foard glazed is known to the authors.
66. RG75, BIA, Letters Received, 1907–33049.
67. RG75, BIA, Letters Sent, Misc., Vol. 26A, 221.
68. RG75, BIA, Letters Sent, Misc., Vol. 26A, 315.
69. RG75, BIA, Letters Sent, Misc., Vol. 27B, 118–24.
70. RG75, BIA, Letters Sent, Misc., Vol. 27B, 410.

BIBLIOGRAPHY

Adams, David Wallace. *Education for Extinction: American Indians and the Boarding School Experience, 1875–1928*. Lawrence: University of Kansas Press, 1995.

Akin, Marjorie. "Passionate Possession: The Formation of Private Collections." In *Learning from Things: Method and Theory of Material Culture*, edited by W. David Kingery, 102–28. Washington DC: Smithsonian Institution Press, 1996.

Anderson, Duane. *When Rain Gods Reigned: from Curios to Art at Tesuque Pueblo*. Santa Fe: Museum of New Mexico Press, 2002.

Anderson, Duane, ed. *Legacy, Southwest Indian Art at the School of American Research*. Santa Fe: School for Advanced Research Press, 1999.

Anonymous. "Acoma Pueblo Album." Center for Southwest Research, University of New Mexico, Albuquerque, New Mexico, ca. 1900–1910.

———. *The Great Southwest Along the Santa Fe*. Kansas City: Fred Harvey Company, 1911, 1921.

———. "Obituary of Josephine Foard." Unknown newspaper, [1918], n.p.

———. *Recording a Vanishing Legacy: The Historic American Buildings Survey in New Mexico, 1933-Today*. Santa Fe: Museum of New Mexico Press, 2001.

Armitage, Susan H., Helen Bannan, Katherine G. Morrisey, and Vicki L. Ruiz, eds. *Women in the West: A Guide to Manuscript Sources*. New York: Garland Press, 1991.

Armstrong, S. C. *Report of a Trip Made in Behalf of the Indian Rights Association, to Some Indian Reservations in the Southwest*. Philadelphia: Office of the Indian Rights Association, 1884.

Avery, F. F. "Indian Reservation Schools." *The Southern Workman* 30, no. 5 (1901): 246–52.

Babcock, Barbara A., and Nancy J. Parezo. *Daughters of the Desert: Women Anthropologists and the Native American Southwest, 1880–1980*. Albuquerque: University of New Mexico Press, 1988.

Baer, Marjorie, and Ann Baggerman Frej. *Pueblo of Laguna: A Project Report*. Washington DC: U.S. Department of the Interior, National Park Service, Historic American Buildings Survey / Historic American Engineering Record, 1983.

Bandelier, A. F. *The Delight Makers*. New York: Dodd, Mead and Company, 1890.

———. "Final Report of Investigations Among the Indians of the Southwestern United States, Part 2." *Papers of the Archaeological Institute of America*. American Series, vol. 4. Cambridge, MA: Archaeological Institute of America, 1892.

———. *The Southwestern Journals of Adolph F. Bandelier (1880–1892)*. Edited by Charles H. Lange, Carroll L. Riley, and Elizabeth M. Lange. 4 vols. Albuquerque: University of New Mexico Press, 1966–84.

Banker, Mark T. *Presbyterian Missions and Cultural Interaction in the Far Southwest, 1850–1950*. Urbana: University of Illinois Press, 1993.

Bannan, Helen M. "'True Womanhood' on the Reservation: Field Matrons in the United States Indian Service." Working Paper 18. Albuquerque: Southwest Institute for Research on Women, 1984.

Barber, Ruth K., and Edith J. Agnew. *Sowers Went Forth, The Story of Presbyterian Missions In New Mexico and Southern Colorado*. Albuquerque: Menaul Historical Library of the Southwest, 1981.

Batkin, Jonathan. *Clay People*. Santa Fe: Wheelwright Museum of the American Indian, 1999.

———. *Pottery of the Pueblos of New Mexico, 1700–1940*. Colorado Springs: The Taylor Museum of the Colorado Springs Fine Arts Center, 1987.

Bibo, Nathan. "Nathan Bibo's Reminiscences of Early New Mexico." *El Palacio* 68, no. 4 (1961): 231–57, and 69, no. 1 (1962): 41–60.

Blake, Alice Alta. *Presbyterian Mission Work in New Mexico: Memoirs of Alice Alta Blake*. Canyon, TX: Aquamarine Publishers, 1997.

Bloom, Lansing B., ed. "Acoma and Laguna." In "Bourke on the Southwest." Special issue, *New Mexico Historical Review* 12, no. 4 (937): 357–79.

Board of Indian Commissioners. *Thirty-First Annual Report of the Board of Indian Commissioners to the Secretary of the Interior, 1899*. Washington DC: Government Printing Office, 1900.

———. *Thirty-Second Annual Report of the Board of Indian Commissioners to the Secretary of the Interior, 1900*. Washington DC: Government Printing Office, 1901.

Broder, Patricia James. *Shadows on Glass: The Indian World of Ben Wittick*. Savage, MD: Rowman and Littlefield, 1990.

Brody, J. J. *Beauty from the Earth: Pueblo Indian Pottery from the University Museum of Archaeology and Anthropology*. Philadelphia: University Museum of Archaeology and Anthropology, University of Pennsylvania, 1990.

———. "The Creative Consumer: Survival, Revival, and Invention in Southwest Indian Arts." In *Ethnic and Tourist Arts: Cultural Expressions from the Fourth World*, edited by Nelson H. H. Graburn, 70–87. Berkeley: University of California Press, 1976.

Brudvig, Jon L. *Hampton Normal and Agricultural Institute, American Indian Students (1878–1923), Tribal Affiliations*. 1996. http://www.twofrogs.com/hampton.html.

Bunting, Bainbridge. Photograph Collection. Bainbridge Bunting Papers, no. 385, box 1, folios 14–16. Center for Southwest Research, University of New Mexico, Albuquerque, New Mexico.

Bunzel, Ruth L. *The Pueblo Potter: A Study of Creative Imagination in Primitive Art*. New York: Columbia University Press, 1929.

Burgess, Larry E. "The Lake Mohonk Conference on the Indian, 1883–1916." PhD diss., Claremont Graduate School, 1972.

Byrkit, James W., ed. *Letters from the Southwest, September 20, 1884, to March 14, 1885*. Tucson: University of Arizona Press, 1989.

Carter, C. S. "The Plateau Country of the Southwest and La Mesa Encantada (The Enchanted Mesa)." *Journal of the Franklin Institute* (June 1906): 451–68.

Casagrande, Louis B., and Phillips Bourns. *Side Trips: The Photography of Sumner W. Matteson, 1898–1908*. Milwaukee: Milwaukee Public Museum, 1983.

Cohodas, Marvin. "Washoe Basketry." *American Indian Basketry Magazine* 3, no. 4 (1983): 4–30.

Cook, Mary J. Straw. *Immortal Summer: A Victorian Woman's Travels in the Southwest*. Santa Fe: Museum of New Mexico Press, 2002.

Cowan, John L. "Bedouins of the Southwest." *Out West* 3 (1912): 107–16.

Curtis, Edward S. *The North American Indian*. Vol. 16. 1926. Reprint, New York: Johnson Reprint, 1970.

Cushing, Frank Hamilton. *My Adventures in Zuñi*. New York: The Century Co., 1882. (Also appeared as a three-part series in volumes 25 and 26 of the *Century Magazine*, 1882–83.)

———. "A Study of Pueblo Pottery as Illustrative of Zuni Culture Growth." In *Fourth Annual Report of the Bureau of Ethnology*, 467–521. Washington DC: Government Printing Office, 1886.

———. *Zuñi Breadstuff*. Indian Notes and Monographs. New York: Museum of the American Indian, Heye Foundation, 1920.

Dale, Edward Everett. *The Indians of the Southwest: A Century of Development under the United States*. Norman: University of Oklahoma Press, 1949.

Dauber, Kenneth. "Pueblo Pottery and the Politics of Regional Identity." *Journal of the Southwest* 32, no. 4 (1990): 576–96.

———. "Shaping the Clay: Pueblo Pottery, Cultural Sponsorship and Regional Identity in New Mexico." PhD diss., University of Arizona, 1993.

Davis, W. W. H. *El Gringo: Or, New Mexico and Her People*. 1857. Reprint, Chicago: The Rio Grande Press, 1962.

DeHuff, Elizabeth Willis. Family Papers, 1883–1981. Center for Southwest Research, University of New Mexico, Albuquerque, New Mexico.

———. "Pueblo Episodes." Undated (after 1916) manuscript, MSS BC99, Box 6, folio 48. Center for Southwest Research, University of New Mexico, Albuquerque, New Mexico.

Dillingham, Rick. *Acoma and Laguna Pottery*. With Melinda Elliott. Santa Fe: School of American Research Press, 1992.

Dilworth, Leah. *Imagining Indians in the Southwest: Persistent Visions of a Primitive Past*. Washington DC: Smithsonian Institution Press, 1996.

Dinome, William. "Laguna Women: An Annotated Leslie Silko Bibliography." *American Indian Culture and Research Journal* 21, no. 1 (1997): 207–80.

Donaldson, Thomas. *Extra Census Bulletin, Moqui Pueblo Indians of Arizona and Pueblo Indians of New Mexico*. Washington DC: United States Census Printing Office, 1893.

———. *Report of Indians Taxed and Not Taxed in the United States Except Alaska at the Eleventh Census 1890*. Washington DC: United States Census Printing Office, 1894.

Donlon, Walter John. "LeBaron Bradford Prince, Chief Justice and Governor of New Mexico Territory, 1879–1893." PhD diss., University of New Mexico, 1967.

Dorsey, George A. *Indians of the Southwest*. N.p.: George T. Nicholson, Passenger Department, Atchison Topeka & Santa Fe Railway System, 1903.

Doubleday, N. DeG. "Aboriginal Industries." *The Southern Workman* 30, no. 2 (1901): 85.

Driebe, Tom. *In Search of the Wild Indian: Photographs and Life Works of Carl and Grace Moon*. Moscow, PA: Maurose Publishing Co., 1997.

Dutton, Bertha P., and Miriam A. Marmon. "The Laguna Calendar." *University of New Mexico Bulletin* 1, no.2 (1936): 1–21.

Ellis, Florence H. "Isleta Pueblo." In *Southwest*. Vol. 9 of *Handbook of North American Indians*, edited by Alfonso Ortiz, 351–65. Washington DC: Smithsonian Institution Press, 1979.

———. "On Distinguishing Laguna from Acoma Polychrome." *El Palacio* 73, no. 3 (1966): 37–39.

———. "Laguna Pueblo." In *Southwest*. Vol. 9 of *Handbook of North American Indians*, edited by Alfonso Ortiz, 438–49. Washington DC: Smithsonian Institution Press, 1979.

———. "An Outline of Laguna Pueblo History and Social Organization." *Southwestern Journal of Anthropology* 15 (1959): 325–47.

———. *Pueblo Indians II*. New York: Garland Publishing, 1974.

Embe [Marianna Burgess]. *Stiya, A Carlisle Indian Girl at Home*. Cambridge, MA: Riverside Press, 1891.

Emmerich, Lisa. "'To Respect and Love and Seek the Ways of White Women': Field Matrons, the Office of Indian Affairs and Civilization Policy, 1890–1930." PhD diss., University of Maryland, 1987.

Fierman, Floyd S. *The Impact of the Frontier on a Jewish Family: The Bibos*. Tucson: Bloom Southwest Jewish Archives at the University of Arizona, 1988.

Foote, Cheryl J. *Women of the New Mexico Frontier, 1846–1912*. Niwot: University of Colorado Press, 1990.

Ford, Ramona. "Native American Women: Changing Statuses, Changing Interpretations." In *Writing the Range: Race, Class, and Culture in the Women's West*, edited by Elizabeth Jameson and Susan Armitage, 42–68. Norman: University of Oklahoma Press, 1997.

Frank, Larry, and Francis H. Harlow. *Historic Pottery of the Pueblo Indians, 1600–1880*. Boston: New York Graphic Society, 1974.

Fritz, Henry E. *The Movement for Indian Assimilation, 1860–1890*. Philadelphia: University of Pennsylvania Press, 1963.

García-Mason, Velma. "Acoma Pueblo." In *Southwest*. Vol. 9 of *Handbook of North American Indians*, edited by Alfonso Ortiz, 450–66. Washington DC: Smithsonian Institution, 1979.

Gill, Robert R. "Ceramic Arts and Acculturation at Laguna." In *Ethnic and Tourist Arts: Cultural Expressions from the Fourth World*, edited by Nelson H. H. Graburn, 102–13. Berkeley: University of California Press, 1976.

Ginzberg, Lori D. "Women and the Work of Benevolence: Morality and Politics in the Northeastern United States, 1820–1865." PhD diss., Yale University, 1985.

———. *Women and the Work of Benevolence: Morality, Politics, and Class in the Nineteenth-Century U.S.* New Haven: Yale University Press, 1990.

Gold, Jake. Papers. Fray Angélico Chavez History Library and Photographic Archives, Santa Fe, New Mexico.

Grammer, Maurine. "Laguna Matriarch Dies at Age 110." *Indian Trader* 19, no. 7 (1988): 7, 13.

Gunn, John M. *Schat-Chen, History, Traditions and Narratives of the Queres Indians of Laguna and Acoma*. Albuquerque: Albright and Anderson, 1917.

Guthe, Carl E. *Pueblo Pottery Making*. New Haven: Yale University Press, for the Department of Archaeology, Phillips Academy, Andover, MA, 1925.

Hagan, William T. *The Indian Rights Association: The Herbert Welsh Years, 1882–1904*. Tucson: University of Arizona Press, 1985.

———. *Theodore Roosevelt and Six Friends of the Indian*. Norman: University of Oklahoma Press, 1997.

Hammond, William A., MD. *Sex, Marriage and Society*. New York: Arno Press, 1974. First published as *Sexual Impotence in the Male and Female*. Detroit: George S. Davis, 1883.

Hardin, Margaret Ann. *Gifts of Mother Earth: Ceramics in the Zuni Tradition*. Phoenix: The Heard Museum, 1983.

Harlow, Francis H., and Dwight P. Lanmon. *The Pottery of Zia Pueblo*. Santa Fe: School for Advanced Research Press, 2003.

Herrman, Augustine. 1670 Virginia and Maryland, [1679] maps. MdHRC, 1213–480, Library of Congress.

Hinsley, Curtis M., Jr. *Savages and Scientists: The Smithsonian Institution and the Development of American Anthropology, 1846–1910*. Washington DC: Smithsonian Institution Press, 1981.

———. "The World as Marketplace: Commodification of the Exotic at the World's Columbian Exposition, Chicago, 1893." In *Exhibiting Cultures: The Poetics and Politics of Museum Display*, edited by Ivan Karp and Steven Levini, 344–65. Washington DC: Smithsonian Institution Press, 1991.

Hodge, Frederick Webb. "Ascent of the Enchanted Mesa (La Mesa Encantada)." *Century Magazine* 56, no. 1 (1898): 15–31.

———. "The Enchanted Mesa." *National Geographic Magazine* 8 (1897): 273–84.

———, ed. *Handbook of American Indians North of Mexico; 30th Bulletin of the Bureau of American Ethnology*. Washington DC: Government Printing Office, 1907–10.

———. "Katzímo, The Enchanted." *The Land of Sunshine* 7, no. 6 (1897): 225–36.

Hordes, Stanley M. "Ethnic Influences on the Pueblos of Ácoma and Laguna: 1680–1880." Preliminary typescript, Indian Arts Research Center, School of American Research, [1986].

Horka-Follick, Lorayne Ann. *A Vestige of Medievalism in Southwestern United States, Los Hermanos Penitentes*. Tucson: Westernlore Press, 1987.

Hoxie, Frederick E. *A Final Promise: The Campaign to Assimilate the Indians, 1880–1920*. Lincoln: University of Nebraska Press, 1984.

Houlihan, Patrick, and Betsy Houlihan. *Lummis in the Pueblos.* Flagstaff, AZ: Northland Press, 1986.

Hurt, Wesley R. "The Spanish-American Comanche Dance." *Journal of Folklore Institute* 32, no. 2 (1966): 116–32.

Indian Affairs Papers, 1695–1903, box 1, folder 9. John H. Robertson, U.S. Indian agent, to the governor of Laguna Pueblo, Mar. 9, 1893. Center for Southwest Research, University of New Mexico, Albuquerque, New Mexico.

The Indian Helper, A Weekly Letter from the Carlisle Indian Industrial School to Boys and Girls, 5:5 (July 11, 1890), 5:8 (August 1, 1890), 6:12 (November 21, 1890), 6:40 (June 12, 1891).

The Indian Industries League Incorporated. *Annual Report.* Boston, 1900, 1901, 1902, 1904, 1905, 1906, 1907, 1908, 1909, 1910, 1911. Massachusetts Historical Society, Boston.

———. Book Second, *Records.* December 1898 to 18 December 1903. Massachusetts Historical Society, Boston.

———. Book Third, *Records.* January 1904 to December 1908. Massachusetts Historical Society, Boston.

———. *By-Laws.* In Book Second, *Records.* December 1898 to 18 December 1903. Massachusetts Historical Society, Boston.

———. "Pueblo Indian Pottery / Josephine Foard." Boston: Indian Industries League Incorporated, n.d. Massachusetts Historical Society, Boston.

Jackson, Helen Hunt. *A Century of Dishonor: A Sketch of the United States Government's Dealings with Some of the Indian Tribes.* Boston: Roberts Brothers, 1886.

———. *Ramona. A Story.* Boston: Roberts Brothers, 1885.

Jackson, W. H. *Descriptive Catalogue of Photographs of North American Indians.* Washington DC: Government Printing Office, 1877.

Jacobs, Margaret D. *Engendered Encounters: Feminism and Pueblo Cultures, 1879–1934.* Lincoln: University of Nebraska Press, 1999.

Jacobs, Sue-Ellen. "Berdache: A Brief Review of the Literature." *Colorado Anthropologist* 1, no. 2 (1968): 25–40.

James, George Wharton. "Acoma and Enchanted Mesa." *Scientific American* (1899).

———. *New Mexico, Land of the Delight Makers.* Boston: The Page Company, 1920.

Jensen, Joan M., and Darlis A. Miller, eds. *New Mexico Women: Intercultural Perspectives.* Albuquerque: University of New Mexico Press, 1986.

Jones, Annia M., ed. "Arts and Crafts Department, The National Society of Craftsmen." *The Scrip* 2 (1907): 123–25.

Julyan, Robert. *The Place Names of New Mexico.* Albuquerque: University of New Mexico Press, 1996.

Kate, Herman F. C. ten. *Travels and Researches in Native North America, 1882–1883.* Translated and edited by Pieter Hovens, William J. Orr, and Louis A. Hieb. Albuquerque: University of New Mexico Press, in cooperation with the University of Arizona Southwest Center, 2004.

Kingery, W. David, ed. *Learning from Things: Method and Theory of Material Culture.* Washington DC: Smithsonian Institution Press, 1996.

Kramer, Barbara. *Nampeyo and Her Pottery.* Albuquerque: University of New Mexico Press, 1996.

Krech, Shephard, III, and Barbara A. Hail, eds. *Collecting Native America, 1870–1960.* Washington DC: Smithsonian Institution Press, 1999.

Kvasnica, Robert M., and Herman J. Viola, eds. *The Commissioner of Indian Affairs, 1824–1977.* Lincoln: University of Nebraska Press, 1979.

LaFarge, Oliver. *Santa Fe.* Norman: University of Oklahoma Press, 1959.

Laguna Mission Press Collection. Center for Southwest Research, University of New Mexico, Albuquerque, New Mexico.

Lanmon, Dwight P. "Identifying Laguna Pueblo Pottery, ca. 1900." *American Indian Art Magazine* 32, no. 3 (2007): 70–77, 93.

———. "Pueblo Man-Woman Potters and the Pottery Made by the Laguna Man-Woman, Arroh-a-och." *American Indian Art Magazine* 31, no. 1 (2005): 72–85.

———. "We'wha, a Zuni Man-Woman, and His Pottery." In *The Walpole Society Note Book 2003–2004*, 84–103. N.p.: privately printed, 2006.

Lanmon, Dwight P., and Lorraine Welling Lanmon. "Waterproofing Pueblo Pottery: The Work of Josephine Foard at Laguna Pueblo." *American Indian Art Magazine* 27, no. 4 (2002): 46–55.

Lee, Molly. "Appropriating the Primitive: Turn-of-the-Century Collections and Display of Native American Art." *Arctic Anthropology* 28, no. 1 (1991): 6–15.

———. "Sheldon Jackson and the Commodification of Alaska Native Art." In *Collecting Native America, 1870–1960*, edited by Shephard Krech III and Barbara A. Hail, 25–42. Washington DC: Smithsonian Institution Press, 1999.

Leupp, Francis E. *The Indian and His Problem*. 1910. Reprint, New York: Johnson Reprint Corp., 1970.

———. *In Red Man's Land: A Study of the American Indian*. 1914. Reprint, Glorieta, NM: The Rio Grande Press, 1976.

———. *Notes on a Summer Tour Among the Indians of the Southwest*. Philadelphia: Office of the Indian Rights Association, 1897.

———. "Women in the Indian Service." *Delineator* 75 (1910): 484–85, 550–51.

Libbey, William. "A Disenchanted Mesa." *Harper's Weekly* 41, no. 2123 (1897): 862–63.

Lindsey, Donal F. *Indians at Hampton Institute, 1877–1923*. Urbana: University of Illinois Press, 1995.

Linford, Laurence D. *Tony Hillerman's Navajoland*. Salt Lake City: University of Utah Press, 2001.

Lovett, Eva. "The Exhibition of the National Society of Craftsmen." *International Studio* 30 (1907): lxx–lxxv.

Lummis, Charles F. *The Land of Poco Tiempo*. 1893. Reprint, Albuquerque: University of New Mexico Press, 1952.

———. *Mesa, Cañon and Pueblo*. New York: The Century Co., 1925.

———. *A New Mexico David*. 1891. Reprint, New York: Charles Scribner's Sons, 1905.

———. *Some Strange Corners of Our Country*. New York: The Century Co., 1891.

———. *The Spanish Pioneers*. 5th ed. 1893. Reprint, Chicago: A. C. McClurg Co., 1912.

———. *A Tramp Across the Continent*. 1892, 1916. Reprint, Albuquerque: Calvin Horn Publisher, 1969.

Mardock, Robert Winston. *The Reformers and the American Indian*. Columbia: University of Missouri Press, 1971.

Marshall, James. *Santa Fe: The Railroad That Built an Empire*. New York: Random House, 1945.

Mathes, Valerie. "Nineteenth-Century Women and Reform: The Women's National Indian Association," *American Indian Quarterly* 14, no. 1 (1990): 1–18.

McCarthy, Kathleen B. *Women's Culture: American Philanthropy and Art, 1830–1930*. Chicago: University of Chicago Press, 1991.

McLuhan, T. C. *Dream Tracks: The Railroad and the American Indian, 1890–1930*. New York: Harry N. Abrams, 1985.

McNitt, Frank. *The Indian Traders*. Norman: University of Oklahoma Press, 1962.

Menaul, John. "Laguna Pueblo, NM." *Rocky Mountain Presbyterian* 8 (1879).

Mera, H. P. *The "Rain Bird," a Study in Pueblo Design*. Memoirs of the Laboratory of Anthropology 2. Santa Fe: Laboratory of Anthropology, 1937.

———. *Style Trends of Pueblo Pottery in the Rio Grande and Little Colorado cultural areas, from the sixteenth to the nineteenth century*. Memoirs of the Laboratory of Anthropology 3. Santa Fe: Laboratory of Anthropology, 1939. [Reprinted as *Style Trends of Pueblo Pottery, 1500–1840*. (Albuquerque: Avanyu Press, 1991).]

Miller, Wick R. "Acoma Grammar and Texts." *University of California Publications in Linguistics* 40 (1965).

Minge, Ward Alan. *Ácoma, Pueblo in the Sky*. 2nd rev. ed. Albuquerque: University of New Mexico Press, 1991.

Morris, Kate. "A Preliminary Report on IAF 1026." Typescript, Summer Seminar 1992 report. Copy at the Indian Arts Research Center library at the School for Advanced Research, Santa Fe, New Mexico.

Morsberger, Robert E., and Katharine M. Morsberger. *Lew Wallace: Militant Romantic.* New York: McGraw Hill, [1980].

Mullin, Molly H. *Culture in the Marketplace: Gender, Art, and Value in the American Southwest.* Durham, NC: Duke University Press, 2001.

———. "The Patronage of Difference: Making Indian Art 'Art, not Ethnology.'" In *The Traffic of Culture: Refiguring Art and Anthropology,* edited by George E. Marcus and Fred R. Myers, 166–98. Berkeley: University of California Press, 1995.

Murphy, Lawrence R. *Frontier Crusader—William F. M. Arny.* Tucson: University of Arizona Press, 1972.

The National Arts Club in collaboration with the National Society of Craftsmen. *Catalogue, Arts and Crafts Exhibition, November twentieth to December eleventh, 1907.* New York: National Society of Craftsmen, 1907.

Newhall, Beaumont, and Diana E. Edkins. *William H. Jackson.* Fort Worth, TX: Morgan and Morgan, Amon Carter Museum, 1974.

New Mexico Business Directory, Including El Paso, Texas, 1905–6. Denver: The Gazetteer Publishing Co., 1905.

Office of Indian Affairs. *Reports of Inspection of the Field Jurisdictions of the Office of Indian Affairs.* Microfilm.

Olmstead, Virginia Langham. *Spanish and Mexican Colonial Censuses in New Mexico: 1790, 1823, 1845.* Albuquerque: New Mexico Genealogical Society, 1975.

Pach, Walter. "Art of the American Indian." *The Dial* 68, no. 1 (1920): 57–65.

Parezo, Nancy J. *Daughters of the Desert: Women Anthropologists in the Native American Southwest, 1890–1980.* Albuquerque: University of New Mexico Press, 1988.

———, ed. *Hidden Scholars: Women Anthropologists and the Native American Southwest.* Albuquerque: University of New Mexico Press, 1993.

Parsons, Elsie Clews, ed. *Hopi Journal of Alexander M. Stephen.* Columbia University Contributions to Anthropology 23. New York: Columbia University Press, 1936.

———. "Isleta, New Mexico." In *47th Annual Report, Bureau of American Ethnology,* 195–466. Washington DC: Government Printing Office, 1932.

———. "The Laguna Migration to Isleta." *American Anthropologist,* n.s., 30 (1928): 602–13.

———. "The Last Zuni Transvestite." *American Anthropologist,* n.s., 41 (1939): 338–40.

———. "Notes on Ceremonialism at Laguna." *Anthropological Papers of the American Museum of Natural History* 19, no. 4 (1920): 85–131.

———. *Pueblo Indian Religion.* 2 vols. Chicago: University of Chicago Press, 1939.

———. "Laguna Genealogies." *Anthropological Papers of the American Museum of Natural History* 19, no. 5 (1923): 133–292.

———. *The Pueblo of Isleta.* Albuquerque: Calvin Horn Publishers, 1974.

———. "The Zuni La'Mana." *American Anthropologist* 18, no. 4 (1916): 521–28.

———. "Notes on Acoma and Laguna." *American Anthropologist,* n.s., 20 (1918): 162–86.

Peters, Kurt Michael. "Watering the Flower: The Laguna Pueblo and the Atchison, Topeka and Santa Fe Railroad." PhD diss., University of California, 1994.

———. "Watering the Flower: Laguna Pueblo and the Santa Fe Railroad, 1880–1943." In *Native American and Wage Labor, Ethnohistorical Perspectives,* edited by Alice Littlefield and Martha C. Knack, 177–97. Norman: University of Oklahoma Press, 1996.

Pratt, Richard Henry. *Battlefield and Classroom: Four Decades with the American Indian, 1867–1904.* Edited by Robert M. Utley. New Haven: Yale University Press, 1964.

Presbyterian Historical Society. *American Indian correspondence, the Presbyterian Historical Society collection of missionaries' letters, 1833–93.* Boxes L and M.

Prince, LeBaron Bradford. *LeBaron Bradford Prince Papers*, ca. 1885–1890. New Mexico State Library, accession no. 1959–74.

Prucha, Francis Paul. *The Churches and the Indian Schools, 1888–1912*. Lincoln: University of Nebraska Press, 1979.

———. *The Great Father: The U.S. Government and the American Indian*. Lincoln: University of Nebraska Press, 1984.

Report on Indians Taxed and Indians Not Taxes in the United States (except Alaska). Washington DC: Government Printing Office, 1894.

Annual Report of the Commissioner of Indian Affairs, 1891. Washington DC: Government Printing Office, 1892.

Reynolds, Terry R. "Women, Pottery, and Economics at Acoma Pueblo." In *New Mexico Women: Intercultural Perspectives*, edited by Joan M. Jensen and Darlis A. Miller, 279–300. Albuquerque: University of New Mexico Press, 1986.

Riley, Glenda. *Women and Indians on the Frontier, 1825–1915*. Albuquerque: University of New Mexico Press, 1984.

Roscoe, Will. "We'wha and Klah: The American Indian Berdache as Artist and Priest." *American Indian Quarterly* 12, no. 2 (1988): 127–50.

———. *The Zuni Man-Woman*. Albuquerque: University of New Mexico Press, 1991.

———, ed. *Living the Spirit: A Gay American Indian Anthology*. New York: St. Martin's Press, 1988.

Rydell, Robert W. *All the World's a Fair: Visions of Empire at American International Expositions, 1876–1916*. Chicago: University of Chicago Press, 1984.

Rydell, Robert W., John E. Findling, and Kimberly D. Pelle. *Fair America: World's Fairs in the United States*. Washington DC: Smithsonian Institution Press, 2000.

Sando, Joe S. "The Pueblo Revolt." In *Southwest*. Vol. 9 of *Handbook of North American Indians*, edited by Alfonso Ortiz, 194–97. Washington DC: Smithsonian Institution Press, 1979.

Schroeder, Albert H. "Pueblos Abandoned in Historic Times." In *Southwest*. Vol. 9 of *Handbook of North American Indians*, edited by Alfonso Ortiz, 236–54. Washington DC: Smithsonian Institution Press, 1979.

Scott, Julian, "Pueblos of Laguna, Acoma, and Zuñi." In *Moqui Pueblo Indians of Arizona and Pueblo Indians of New Mexico (Extra Census Bulletin, Eleventh Census of the United States)*, edited by Thomas Donaldson, 121–31. Washington DC: United States Census Printing Office, 1893.

Sergeant, Elizabeth Shepley. "The Journal of a Mud House." *Harper's Magazine* 145, no. 862 (March 1922): 409–22; (April 1922): 585–98; (May 1922): 774–82; (June 1922): 56–67.

Seymour, Flora Warren. *Indian Agents of the Old Frontier*. New York: Appleton Century Co., 1941.

Silko, Leslie Marmon. *Storyteller*. New York: Seaver Books, 1981.

Simmons, Marc. "History of Pueblo-Spanish Relations to 1821." In *Southwest*. Vol. 9 of *Handbook of North American Indians*, edited by Alfonso Ortiz, 178–93. Washington DC: Smithsonian Institution Press, 1979.

———. "History of the Pueblos Since 1821." In *Southwest*. Vol. 9 of *Handbook of North American Indians*, edited by Alfonso Ortiz, 206–23. Washington DC: Smithsonian Institution Press, 1979.

———. "Solomon's Story: The Jewish Man Who Governed a Pueblo." *Santa Fe New Mexican*, March 22, 2003, sec. B1.

Smith, Page. *Daughters of the Promised Land: Women in American History*. Boston: Little Brown Co., 1970.

Sparhawk, Frances C. "The Indian Industries League." *The Southern Workman* 30, no. 9 (1901): 336–39.

Spivey, Richard L. *The Legacy of Maria Poveka Martinez*. Santa Fe: Museum of New Mexico Press, 2003.

Stevens, J. Darryl. "The Menaul School: A Study of Cultural Convergence." PhD diss., University of Houston, 1999.

Stevenson, James. "Illustrated Catalogue of the Collections Obtained from the Indians of New Mexico

and Arizona in 1879." In *Second Annual Report of the Bureau of Ethnology*, 311–465. Washington DC: Government Printing Office, 1883.

———. "Illustrated Catalogue of the Collections Obtained from the Pueblos of Zuni, New Mexico, and Wolpi, Arizona, in 1881." In *Third Annual Report of the Bureau of Ethnology*, 511–94. Washington DC: Government Printing Office, 1884.

Stevenson, Matilda Coxe. "The Zuñi Indians, Their Mythology, Esoteric Fraternities, and Ceremonies." In *Twenty-Third Annual Report of the Bureau of American Ethnology*, 3–634. Washington DC: Government Printing Office, 1904.

Sturtevant, William C., ed. *Handbook of North American Indians*. Vol. 9, *Southwest*, edited by Alfonso Ortiz. Washington DC: Smithsonian Institution Press, 1979.

Szasz, Margaret Connell. *Education and the American Indian, The Road to Self-Determination Since 1928*. 2nd ed. Albuquerque: University of New Mexico Press, 1977.

Thompson, Mark. *American Character: The Curious Life of Charles Fletcher Lummis and the Rediscovery of the Southwest*. New York: Arcade Publishing, 2001.

Tobias, Henry J. *A History of the Jews in New Mexico*. Albuquerque: University of New Mexico Press, 1990.

Toulouse, Betty. *Pueblo Pottery of the New Mexico Indians: Ever Constant, Ever Changing*. Santa Fe: Museum of New Mexico Press Guidebook, 1977.

Trennert, Robert A. "Fairs, Expositions, and the Changing Image of Southwestern Indians, 1876–1904." *New Mexico Historical Review* 62, no. 2 (1987): 127–50.

Trump. Erik Krenzen. "The Indian Industries League and Its Support of American Indian Arts, 1893–1922: A Study of Changing Attitudes Toward Indian Women and Assimilationist Policy." PhD diss., Boston University, 1996.

Valencia County. Records of the U.S. Territorial and New Mexico District Courts. Folder 256, 1900.

Wade, Edwin. "The Ethnic Market in the American Southwest, 1880–1890." In "Objects and Others: Essays on Museums and Material Culture," ed. George W. Stocking, Jr. Special issue, *History of Anthropology* 3 (1985): 167–91.

Wade, Edwin L., and Lea S. McChesney. *America's Great Lost Expedition: The Thomas Keam Collection of Hopi Pottery from the Second Hemenway Expedition, 1890–1894*. Phoenix: The Heard Museum, 1980.

Wallace, Lew. *An Autobiography*. Vol. 2. New York: Harper and Brothers Publishers, 1916.

Wanken, Helen M. "'Woman's Sphere' and Indian Reform: The Women's National Indian Association, 1879–1901." PhD diss., Marquette University, 1981.

Webb, William, and Robert A. Weinstein. *Dwellers at the Source: Southwestern Indian Photographs of A. C. Vroman, 1895–1904*. New York: Grossman Publishers, 1973.

Weigle, Marta. *Brothers of Light, Brothers of Blood*. Albuquerque: University of New Mexico Press, 1976.

White, Leslie A. "The Acoma Indians." In *Forty-Seventh Annual Report of the U. S. Bureau of American Ethnology, 1929–1930*, [17]–192, 1087–1108. 1932. Reprint, Glorieta, NM: The Rio Grande Press, 1973.

———. "New Material from Acoma." *Bureau of American Ethnology, Bulletin 136*, Anthropological Papers 32 (1943): 301–75.

Wilson, Chris. *The Myth of Santa Fe*. Albuquerque: University of New Mexico Press, 1997.

Winship, George Parker. "The Coronado Expedition, 1540–1542." In *Fourteenth Annual Report of the Bureau of American Ethnology* 14, pt. 1 (1896), 329–613.

Yohn, Susan M. *A Contest of Faiths: Missionary Women and Pluralism in the American Southwest*. Ithaca, NY: Cornell University Press, 1995.

Zetland, Laurence John Lumley Dundas. *The Life of Lord Curzon* Vol. 1. London: E. Benn, 1929.

INDEX

Italicized page numbers indicate illustrations.

Pueblo Indians: blankets, 19, 144; colonization and, 35–37; daily life, 105–6; ethnology and, 6; jewelry, *17*, 19, *21*, *56*, *59*, *74*, 96; literacy and, 38; men's clothing, 18–19, *21*, *40*, *58*, *64*; publications concerning, 6–7; Pueblo Revolt, 36–37; Spanish rule and, 35–36; women's clothing, 16–18, *17*, *21*, *40*, *52*, *54–56*, *59*, *69*, *74*, 109. *See also specific tribes, pueblos, and cultural elements*
Putnam, Frederick Ward, 6

Quarte, 126
Queoyoa, Valentine, 62, 222n57, 222n60

Read, Henry W., 46
Report of the Board of Indian Commissioners, 66, 207n46
Roman Catholic Church, 35, 46, 213n11
Rooster Race, 113–15
Roseberry, Morton H., 32
Roybal, Tonita, 78

San Ildefonso Pueblo, 12, 78
San Miguel church, 12, 90–91
Santa Clara Pueblo, 1, 11, 32, 44, 86, 88
Santa Fe, 11–14, 81–86; Indian Arts Fund, 79; Indian Fairs, 70
Santa Fe New Mexican, 25
Santo Domingo Pueblo, 31
Science Museum of Minnesota, *xvi–xx*, 70
Sebolletto, 110–12
Shorter Catechism, 47
Shosemi, Governor, 139–40
Sice, Minnie Billen [Tzu-Chey], 59, 64, 73, 107, 220n19
Sihu, Frank, 20
Sione, Lillie, 15, *17*, 95, 120, 152
Smiley, Albert K., 8, 25, 164
Smithsonian Institution, 6
Society of the American Indian, 78–79
Southwest Indian Fair, 79
Stephen, Alexander M., 52
Stevan, Tsieweita, 71, 225n50

Stevenson, Matilda Coxe, 61
Szasz, Margaret, 39

Tanoan language group, 48
tempering, 27, 68
Tesuque Pueblo, 13, 88–90, 208n14
Tile Club, 75
Tonner, A. G., 28–29, 75
Toulouse, Betty, 32–33, 76
Tramp Across the Continent (Lummis), 7

Tanoan language group, 48
tempering, 27, 68
Tesuque Pueblo, 13, 88–90, 208n14
Tile Club, 75
Tonner, A. G., 28–29, 75
Toulouse, Betty, 32–33, 76
Tramp Across the Continent (Lummis), 7
turquoise, 114, 131, 141, 152

United States. *See* Foard, Josephine, Office of Indian Affairs and; Indians, U.S. government and

Vargas, Diego de, 36
Vásquez de Coronado, Francisco, 35
Volkmar, Charles, 68
"Volkmar" glaze, *xx*, 68

Wallace, [Lew], 11
Wanamaker, John, 6
We'wha, 61, 62
Wheelwright, Mary Cabot, 79
White, Elizabeth and Martha, 79
Women's National Indian Association (WNIA), 5, 206n21
World's Columbian Exposition, 5–6

Yi-es, 59
Yiwite, 209n30

Zaweta, 15, 209n30
Zuni Indians, 35, 48–49